THE GREAT DALÍ ART FRAUD
AND OTHER DECEPTIONS

The Great Dalí Art Fraud

AND OTHER DECEPTIONS

LEE CATTERALL

BARRICADE BOOKS, INC.
FORT LEE, NEW JERSEY

Published by Barricade Books Inc.,
1530 Palisade Avenue, Fort Lee, NJ 07024

Distributed by Publishers Group West,
4065 Hollis, Emeryville, CA 94608

Printed in the United States of America.

LIBRARY OF CONGRESS CATALOGING-IN-PUBLICATION DATA
Catterall, Lee.
The great Dalí art fraud and other deceptions/Lee Catterall
ISBN 0-942637-63-1 : $22.95
1. Dalí, Salvador, 1904–1989—Forgeries.
2. Art—Forgeries—Economic aspects. I. Title.
N7113.D3C38 1992
760'.092—dc20 92-16971
CIP

IN MEMORY OF BILL COX

CONTENTS

THE GREAT DALÍ ART FRAUD
AND OTHER DECEPTIONS

Preface

Neither my art professor brother nor I had the faintest idea that a phone call he made to me in 1985 would result in a book about the biggest art scandal of this century. John had merely called to say hello, since his WATS line at New Mexico State University connected to Hawaii. In passing he mentioned seeing a suspect advertisement in the *New Yorker* touting an edition of Marc Chagall lithographs for sale at a Hawaii art gallery. He told me the ad was in a recent issue and he could not remember the name of the gallery. At any rate, I was busy on my court beat at the *Honolulu Star-Bulletin*. When I found time to look for the advertisement and began asking questions about it, I became intrigued.

Welcome to the netherworld of art, what some call the "gray" art business, which has grown over the past several decades into a huge industry, run by people with little formal training in art but with a zest for marketing and making money. Abuses are a natural temptation in such a market.

When the abuses described in this book amounted to fraud, many looked the other way. That's not art, it's fraud,

said the art critics, and ignored it in their writings. That's not fraud, it's art, said law enforcement officers, who did not want to be bothered.

How did the scam work? Something like the raffle that Clem proposed to his friend Jeb for getting rid of his horse. Clem explained that Jeb could sell a thousand raffle tickets for ten dollars apiece and pocket ten thousand dollars.

"I can't do that," Jeb responded. "My horse is dead. What would I say when the winner complained?"

"No problem," Clem answered. "Give him his money back."

But the problems came in droves because too many art "investors" found they had bought dead horses, and the galleries fought their attempts to obtain refunds. The victims multiplied and complained to law enforcement agencies across the country.

When I began work on the story, there was no investigation going on in Hawaii, but I soon learned that Judith Schultz, an assistant attorney general in New York, had convened a grand jury, and that Robert DeMuro, a United States postal inspector in New York City, was asking questions as well.

Their early progress and mine were aided by the journalistic efforts of Judith Goldman in *ARTnews* magazine, the late James M. Markham in the *New York Times*, L. Erik Calonius in the *Wall Street Journal* and Alfons Quinta, followed by the team of Márius Carol Pañella, Juan José Navarro Arisa and Jordi Busquets Genover, in *El País* in Spain, all of whom preceded me in writing about the fraud. I had the good fortune of finding Gloria Costa, a University of Hawaii graduate student from Barcelona, who enthusiastically translated—for little pay—a book and articles given to me by Jordi Busquets.

As the prospects for a book improved, I received generous cooperation from numerous state and municipal prose-

cutors and investigators: Judith Schultz and Rebecca Mullane, Schultz's successor in the New York attorney general's office; in New Mexico, Assistant Attorney General Fred Smith and Albuquerque Police Detective Pat Otero; in California, Newport Beach Police Detective Craig Frizzell, Beverly Hills Police Detective John Ambro, Los Angeles prosecutor's investigator Gary Helton, Los Angeles Police Detective Bill Martin and former Los Angeles Assistant District Attorney Reva Goetz, now in private practice; and in Hawaii, former Honolulu prosecutor's investigator Tom Maxwell, now a federal tax counselor in Washington State.

The late gangster "Dutch" Schultz is said to have remarked once that "anybody who robs a post office is an idiot, and I don't want idiots working for me." Perpetrators of art fraud should take the comment to heart; many self-styled art dealers may have underestimated the tenacity of a proud group of officers known as the U.S. Postal Inspection Service. In putting together this book, I am most grateful for the cooperation of Postal Inspectors DeMuro, now a lawyer for the Postal Inspection Service in Newark, New Jersey, Jack Ellis in New York City, James H. Tendick in Chicago and Richard Portmann, who conducted the investigation in Hawaii, now transferred to Phoenix, Arizona.

Federal Trade Commission attorneys David Spiegel and Larry DeMille-Wagman were helpful in furnishing me with many transcripts of proceedings and other documents that led to the downfall of one of the biggest suppliers of fake art. I thank Mr. Spiegel for taking time from his busy schedule to answer further questions about his investigation.

Assistant U.S. Attorney Les Osborne of Honolulu also provided much assistance in my efforts to assemble information about the large and complicated art fraud case he was assigned to prosecute.

Michael Ward Stout, Salvador Dalí's New York attorney for many years, and Albert Field, the artist's designated

archivist, were helpful in adding details for me to their courtroom testimony. A. Reynolds Morse, a friend of Dalí for four decades, was forthcoming beyond my expectations, providing me access to his private Dalí diary in the archives of his Salvador Dalí Museum in St. Petersburg, Florida. His assistance was in accord with his persistent opposition for decades to the sales of fraudulent artworks bearing the name Dalí.

Enrique Sabater and Captain John Peter Moore, Dalí's private secretaries at various times, declined to be interviewed by me. They were interviewed in 1988 by *ARTnews* magazine, and Andrew Decker, a contributing editor, provided me with the contents of those interviews and others conducted in preparation of an article Decker wrote for the magazine.

Robert Descharnes, Dalí's most recent secretary, was willing to spend several hours a day over a three-day period answering my questions in Paris in 1990, and he offered to help in any way after that to see this book reach completion.

I also thank my cousin, Tony Catterall, the Bonn correspondent for the *Observer* of London, for allowing me to use his home as a base during my attempt to secure information in Europe that year. Similarly gracious hosts were James and Susan Benfield in Washington, D.C., Irvin and Kay McKim in New York, and brother Stephen and his wife Susan in Los Angeles.

Many art experts shied away from the fraud. Those experts who had the courage to fight it and the willingness to help me distinguish between the fake artworks and the real ones, were Honolulu appraiser Peter Morse, the late Joseph Feher of the Honolulu Academy of Arts, Clinton Adams of the Tamarind Institute, Virgilia Pancoast of the International Foundation for Art Research in New York, Colorado appraiser Bernard Ewell and Mimi Cazort, curator of prints and drawings at the National Gallery of Canada. I

thank Elizabeth Harris, curator of prints at the Smithsonian Institution, for providing me access to her files. In addition, I remain grateful to my brother John, now chairman of the art department at the University of Florida, for providing the initial tip.

Honolulu lawyers David Dezzani and James Bickerton were aggressive and effective in representing my interests and those of the *Honolulu Star-Bulletin* when we were all sued for libel by Center Art Galleries-Hawaii.

My good Honolulu friends Tony Rogers, Jack Brownrigg, Rita Roy, Alan Matsuoka, and Cynthia Oi gave sustaining support through the years.

Without Bill Cox, this book, and the many newspaper articles of mine that preceded it, never would have seen print. Cox was my managing editor at the *Star-Bulletin* in July 1985 when I approached him about the suspicions raised by my brother regarding the Chagall advertisement. He did not hesitate to authorize my work on the project and remained supportive before, during, and after the newspaper was the defendant in the lawsuit that he fully expected.

On September 1, 1986, Cox announced in a bylined column on the editorial page that it was his last day at the newspaper. "I am going on the disability roll because of illness," he wrote. "My illness is AIDS." When Bill Cox died on May 20, 1988, American journalism lost some of its spirit.

The Dalí Enigma

The
Pitch

Am I on?"

Bernie Schanz stood a few feet in front of Leilani Petranek,
who glanced at the tape recorder she had placed on a small
table. Petranek and her sister were seated on two folding
chairs Schanz had pulled up to the table in the art gallery at
the Ala Moana Shopping Center, Honolulu's giant mall
across the Ala Wai Canal from Waikiki. Schanz stood poised
to deliver his sales presentation.

"Yes, you're on," Petranek responded.

"All right, they've got me on record now, so I've got to be
careful," Schanz wisecracked to the Petranek sisters.

A few shoppers had found refuge in the air-conditioned
gallery from the heat of that day in September 1977. Schanz
noticed them approaching.

"All right," he announced. "Might as well get a group
together around here."

Leilani Petranek had established a comfortable career as
a fashion consultant in Japan at the age of twenty-seven, and
she enjoyed return visits to her native Hawaii as an opportu-
nity to see old friends and to shop at Ala Moana. She had
wandered into Center Art Galleries–Hawaii the evening
before. Schanz had drawn her attention to a framed fine

print by Salvador Dalí titled *Lincoln in Dalívision*, showing a woman's head under a soaring Christ-like icon amid a background of multicolored squares. Standing in front of the print, Schanz explained the advantages of investing in art. Leilani was dissatisfied with the returns she was getting on more traditional investments, and she was intrigued by what Schanz told her. But her fiancé had remained in Japan during her trip, and she was reluctant to make such an investment without first talking with him. Schanz had agreed to let her tape his sales presentation so she could play it back for her fiancé.

"Tell us," Petranek asked, "about what happened when you went to the show at, uh, wherever . . ."

"Okay," Schanz said as people gathered around. "This was introduced at the Basel, Switzerland, show, an art festival that takes place every year, and it's sort of like the Cannes Film Festival. It's where all the major artists get together and try to outdo each other. And in this particular case, Dalí took the whole ball of wax. He wanted to prove he was still *le maître*, the master, and he was."

Gold bracelets danced on Schanz's wrists, and the little man with the neatly trimmed black mustache became animated as he launched into his performance.

"You can try to visualize an auditorium with fifteen thousand or so people involved in this," he said. "The curtains open up and here's this piece projected on a screen. Salvador Dalí is on stage with his agent, who can speak English and Dalí can't, not very well. The agent announces, 'This is the first time in history, in the history of art, that any person has ever done a lithograph, an etching, and a collograph all-in-one.'"

Actually, Dalí spoke English quite well, and he would never have let an agent upstage him. In Basel, he would have spoken French. Many of the other details of Schanz's pitch

were grotesque fictions. As for this so-called first, mixed-media graphics were relatively common in the 1970s. Leilani owned a few lithographs, but she knew relatively little about the process an artist uses to produce them. Her prints were by unknown artists. Schanz seemed to demonstrate a vast knowledge of printmaking, and she was captivated.

"Usually," Schanz continued, "when you buy a limited edition print, you're buying either an etching or a collograph [collotype] or a serigraph, but never all three on the same piece of paper. It is totally, physically impossible to do. Dalí did it. Okay? And this was the first time. He got a standing ovation. It was just incredible."

Schanz pointed to the central area of the print, which was apportioned in squares and blocks. "This part, the abstract part of it, is the etching. The background is the lithograph, and the nude being embossed upward is what they call a collograph. Okay? Now, that alone won him every award." Schanz apparently was unaware that Dalí had never won such a prize anywhere. "But he's not finished yet. Dalí has got to have all sorts of goodies happening to him. So Dalí also went into cubistic forms, which he had never done before. Dalí is noted for his dripping clocks and his weird things that don't really make any sense to anybody but Dalí. And if he tried to explain it to you, you would not understand what he was talking about anyway.

"He's so far advanced beyond us it's incredible, a spaceman or something like that," Schanz continued. "But in this particular case he went into cubistic forms, which marks also a change in his career, and also makes it a valuable commodity, because it's the first. So, with that, everyone stood up again and applauded."

The audience should have been clapping for Leon D. Harmon, a professor at Case Western Reserve University, whose computerized rendition of Matthew Brady's Lincoln photograph appeared in *Scientific American* in 1975. Dalí saw the magazine and extracted the image. Dalí's "cubism" was merely an extension of the professor's version of the Brady photograph, and it nearly prompted a lawsuit for copyright infringement, but the professor chose not to sue.

Schanz said Dalí instructed members of the audience to reach under their chairs, where each would find "a little blue silk jewel box, and in this jewel box was this gold-plated monocle. And if you could see fifteen thousand people holding up this monocle, it was the most incredible sight we've ever seen in our entire life.

"Fortunately, we knew about it the night before, because we had had an audience with Dalí the night before," Schanz said, adding with dramatic pause: "And that's when we were able to purchase these things way far in advance. Very fortunate in that respect. If we had been late, we wouldn't have made it, and they would've been all gone.

"So anyway, it did happen. Through the monocle, the particular piece not only is an etching, a lithograph, and a collograph, and not only did he go into cubistic forms, but it also turns into Abraham Lincoln when you look through the monocle."

Schanz pointed in the middle of the print to the backside of a nude, looking through a large gap in the blocks. At the top of the gap was an overhead view of the Crucifixion.

"The window that she's looking out of is the traditional cross. In other words, Christ was here and his soul is extending into heaven."

The window in the picture really was Dalí's remembrance of a window in his family home in Spain.

"Beautiful piece," Schanz effused. "Spectacular. Beautiful in color and almost totally explained."

Schanz opened a drawer in the table in front of Petranek, removed an eyepiece, and handed it to her. She rose from her seat.

"You stand back about three feet, now, and hold it about a half arm's-length out," Schanz told her. She looked through the eyepiece. "Zap, welcome to the club," Schanz grinned.

"Okay, now," he said. "Through the monocle, the Christ head turns into a bullet wound in Lincoln's forehead. The reason that he used Christ for Lincoln is that they were both shot down in their prime, so there was a symbolistic situation there."

This was Schanz's interpretation, an erroneous one.

"This part," Schanz said, pointing to a figure in the lower part of the print, "where there's a woman pointing to little squares of Lincoln, you know, that turn into Lincoln, is a typical Dalí tease. Now, he loves teasing. He enjoys teasing. He's a character and a half. This is what he's saying: It's Gala saying, 'If you look at me through my monocle, I will turn into Abraham Lincoln.' So that is just a little bit of being a smart ass. Pardon me, you can bleep that if you want to."

Petranek giggled.

Schanz turned back to the print. "This part, the etching part, where it's mostly, totally surrealistic, the reason this is out here is because this is the only thing that resembles Dalí. If that was not there, it would not look like a Dalí and nobody would believe it was a Dalí. Because his signature here doesn't really mean . . ." Schanz looked at the penciled signature at the print's lower right. "Who can read that—right?—besides Dalí?

"Well," Schanz said, "we feel so strongly about this particular piece that most everybody in the art gallery, including the salespeople, have purchased some. One person that I know went into hock up to his elbows," he chortled. "I'm not going to mention any names, 'cause it was me.

"But we know what's going to happen with this piece," he said more seriously. "As far as an investment is concerned, it's superb. We have never seen the growth-rate potential grow so high on a piece so quickly, and there's no end in sight. It's just going to keep on growing forever. I mean, nobody has ever done what you're looking at, and it's the first. Any time there's a first, it makes a valuable commodity. Even if Dalí comes out with it again in something else, it will still be the first, and this makes it a valuable commodity. See?"

Schanz paused, ready for questions.

"When was it done?" Petranek asked.

"Technically," Schanz responded, "it started out seven years ago. It was supposed to come out for the American Bicentennial. That's the reason he used Lincoln. However, he missed it by a year, and it came out at the beginning of this year, actually about May. And then in June and July we had it here in Hawaii."

Several passersby had been drawn to the presentation, and Schanz decided to broaden his speech to encompass other Dalí prints on display.

"A limited edition print means this. I mean, I might as well explain the whole thing to everybody in here. It means that the plate is actually drawn by Salvador Dalí, all the plates it took to make this particular piece. Every color that you see on here is a different plate. That's what makes it so remarkable. And each plate has got to be registered perfectly over one another. In other words, each piece of paper has got to be laid down on the plate just perfect. If it's off a little bit, or it's too small, or whatever the case may be, it'll leave a

blurry image. It's got to be registered perfectly, and that is the reason they usually use only two plates to make a print of some sort.

"In this particular case, they used eleven plates, plus an etching plate, plus a collograph plate. That's totally impossible to do. I mean, you can understand why it's taken this long. Every color is a different plate. It has to be registered perfectly. I think the person who is listening to this will understand what I'm talking about."

In fact, there is nothing impossible about achieving precise registration, which is routinely required of master printers.

"The other thing," Schanz added, "is that each piece is signed and numbered. In other words, there's only 1,125 in the full edition. I'll give you the rundown so you can add it up yourself."

There were European and American editions, he explained, each numbering 350, plus 50 artist's proofs. And there were two investors' groups that backed Dalí while he was doing this.

"There was a German investors' group that Mr. Dalí guaranteed an edition of their own for backing him with marks while he was producing this. And the German investors' group edition goes to them personally, and it's not on the market. In other words, it's not for sale as such. Each one of these bigwigs gets one of these pieces and they hang it up in their office or what have you. And it's never for sale. There were two hundred of those done, numbered one to two hundred in Roman numerals.

"And then comes the goody," Schanz smiled. "The goody was an American investors' group where there was only one hundred twenty-five done. It was done in Arabic numbers, one to one hundred twenty-five. Now, we had one hundred fifty of the three-fifty American edition that sold

out way before we even got back from Switzerland. I mean, eight of them at least, that I know of, were sold sight unseen. By the time we got back here, it was just almost mind-boggling. And then our problem was trying to get more pieces. And what we did is we convinced—somehow or other—the American investors' group to sell us fifty pieces of theirs, which they're not supposed to do, but they did anyway.

"We were very honored," Schanz said, and Leilani was not quick enough with her mathematics to challenge him. The grand total of the editions he mentioned was 1,075, not 1,125.

"Because in the long run," he continued, "when you're breaking it all down, the lower the number, the more valuable it is. Not so much for buying it, but when you go to sell it, it's more valuable."

Well, not really. What Schanz said was true, but only of drypoint etchings, in editions of perhaps twenty-five or less.

"In the old days, this used to be done in stone, and they would never say that they were going to do three hundred or four hundred," Schanz said. "They would just let the printing go until the stone wore off clean. And when you couldn't see what you were printing anymore, that was the time to stop. The plate would almost totally wear out. So the clearer the print was, the lower the number, because it was the sharpest. So, through the tradition, the lower the number, the more valuable the piece was when you went and sold it."

Schanz's Alice-in-Wonderland explanation merely magnified the nonsense. No printer would have pulled impressions until the stone wore out.

"In this particular case, number one is just as clear as number 1,125," explained Schanz, "because now they use zinc and copper, rather than stone."

Again, Schanz mixed his media. Lithographs are not printed from copper and seldom anymore from zinc. Aluminum plates are used as an alternative to stone.

But the half-dozen browsers stood beside the Petranek sisters, enraptured by the little man's knowledge of art. "What protects you," he told the group, "is that when the full edition is completed, everybody is satisfied, including Dalí, that each one of the plates is scored. They take an awl, and they scratch a vertical line right down from the left high point of the plate to the lower left. They can produce from it and print it again, but there'll be a line going down the middle on this thing, so you automatically know it's not supposed to be printed.

"The plate, along with one piece of art, goes to the archives of the Dalí museum in Barcelona, Spain, and it's maintained in the archives forever. Let's say a hundred years from now somebody has this piece and they want to find out whether it's genuine or not. You know, a lot of years have passed. Nobody's around that knew Dalí. How do we tell? Well, you take your piece and you send it to the Barcelona museum, and they match it up against the plates and the one copy they kept in the archives. They can tell you immediately whether it's genuine or a phony. And that's how you're protected.

"Every person has a number, and that number is recorded and registered in Barcelona. In other words, if somebody ripped you off and stole this from you, and they tried to erase the number . . . It's perfectly easy to erase it. It's just pencil on there. But, of course, it would leave a smudge, because this is very soft paper. It's soft on purpose

so nobody will do any hanky-panky. But even if they change
the number, the number can only change to somebody
else's.

"If the guy that ripped you off changes the number, the
people at the Barcelona museum know it belongs to some-
body else. If he leaves your number on it, they automatically
know it's your piece.

"So usually," Schanz assured the group, "they don't fool
around with graphics, because it's too complicated to get rid
of once they've got it. There's no way. If they take it to a
gallery, the gallery checks it out immediately. We do the
same thing here. If we bought a piece from a private indi-
vidual—like a Dalí or a Chagall or a Miró—no problem. We
can check it out at once. We can tell who owned it and how
far it went from one individual to another.

"It has a pedigree," Schanz beamed, "just like a puppy
dog or a horse. It makes it kind of neat that way."

A neat system, yes, but one that does not exist. There is no
Dalí museum in Barcelona, nor is there a record anywhere of
Dalí print owners, except those assembled in later years by
law enforcement authorities fielding calls from angry com-
plainants.

"Can you explain why it's so difficult to make the litho-
graph because of the, uh, registering?" Petranek asked.

"Well," Schanz said, "as I was explaining this to you last
night, there are two hundred problems with graphics. I'm
only going to tell you one, because this one is just mind-bog-
gling. Please look at the piece when I try to explain. Let's say
that you're going to do one of these squares. You take the
plate and your crayon and you draw a waxy finish, a little
square, one inch by one inch. Then you take the plate and
you put it in an acid bath. The only thing that burns away is

the part that is not waxed. The part that is waxed is protected.

"And then it's washed away, and that little square that you put on with the wax has a rise to it, a little bit of rise, okay? Then they take, let's say yellow, and they take this yellow ink and they run it over the whole plate, and they wash it off. The only part that the ink stays on is the little square that was waxed.

"Now the paper is wet, dripping wet, and they lay it face down on the plate. And this massive wheel comes rolling over it at tremendous pressure. They roll over it once and then the paper is lifted off. What they've got on the paper now is a yellow square, one inch by one inch.

"Now you want to put another color on top of it. So you've got to register it out perfectly on a new plate. You do the same thing like you did before with the acid bath, and you put a burnt sienna color over it to give it a feeling of depth, so it's not one solid color.

"Well, the problem now is that when the roller went over the paper the first time, it stretched it. So now it's not one inch by one inch anymore. It's like one inch and an eighth by one inch and an eighth. And if you made a square one inch by one inch on your second plate, you're going to have a square within a square. And it's wrong. That's just one minor detail. You can imagine, with all these squares and all these colors in here, how incredible this thing is."

Incredible *is* the appropriate word, for if Schanz tried to make lithographs by that method, he would encounter insurmountable problems. It would not print out. Acid baths and damp paper are used in the etching process, but not for lithographs.

Schanz explained that thirteen different plates had been used to make *Lincoln in Dalívision* a spectacular feat. He told

Petranek that he would give her a book called *What Is a Graphic?* that she could read during her plane trip back to Japan.

"Then I'll be an expert," Petranek laughed.

"You'll be an expert," Schanz agreed. Just by reading the book, he told her, "you'll get the idea of how incredible this thing is.

"I can talk until I'm blue in the face about this," Schanz added. "But not being in the business, you don't have the same appreciation I do for it, because I have tried this, and I failed. Well, hell, I failed at sandbox in the first grade. If I'm going to paint, I'll paint in oil and let it go at that, but not graphics. Graphics is too complicated. It's an art in itself. It's a technique and art in itself."

Schanz turned to the topic of art as investment, the reason people were buying these prints and the chief point to be made with Petranek's fiancé.

"This particular piece of paper that you're looking at— and I call it a piece of paper because that's exactly what it is—an extremely valuable piece of paper," he said. "It is currency. It is money. I told you about the three firsts—the lithograph and collograph, and etching, and the cubistic forms—and when you're looking through this thing it turns into Abraham Lincoln. I mean, what else do you need? If it could cook, I'd marry it." Petranek laughed. "Right off the bat," Schanz insisted.

"So that is the story of the piece that you're looking at," he told the Petranek sisters and the little group around them, "and it's called *Lincoln in Dalívision*. And I feel that in years to come people will be very proud just to have seen this piece. Because when you think about it, Dalí is such an internationally known artist and there are only eleven hundred and twenty-five of these for the whole world. Now that seems like an awful lot, but when you start splitting it up amongst all the galleries, amongst all the towns and cities

and capitals of the world, that means, oh, my gosh, I mean maybe ten in every city. That's not too shabby. No, it's even less than that. I mean, my gosh. You break it down, it's incredible.

"As far as an investment is concerned, it's superb," Schanz assured the group. "It's already doubled in price since it came out, and that's only two months. And there's no stopping in sight. I mean, there's going to be two price increases this month on it. It's going from $1,950 to $2,250 to $2,500. That I know already, and that's something that's never done. They usually send us a letter saying it's up; they don't say it's going to be up. The second thing is we have a strange feeling that this might go as high as at least $5,000 in a very short period of time.

"It's a good investment," Schanz repeated, sounding more like a stockbroker than an art salesman. "We will keep in touch with you, letting you know what your piece is priced at at any particular time. Every time it goes up again, we send you a revised letter of authenticity. Actually, two copies. One goes to your insurance company, and the other goes for your records, so you can keep track of it. And then when it comes time to sell it, you can show it and say, 'See, look how the price has increased.'

"You know what I mean?" Schanz asked. "You can show them all the different evaluations upward. And it's neat. It sort of puts you in a new game, and it's a fun game, because at least you're enjoying your money. It's not sitting in a bank so the bankers can enjoy your money. It is on your wall, and you're enjoying it. There's a pride of ownership involved, especially if it goes up.

"Let's put it this way," he said. "Art has never gone down. It's either stayed where it's at, or it's zapped way out of sight. Never, ever, in our history, no one has ever lost a nickel on art. They either got their money back, what they paid for it, or they got way, way above and beyond what they paid if they had to sell it."

Unfortunately, art is not so safe an investment, and art-works often have gone down in value, sometimes dramatically so, as was the case with some of the impressionist works that sold at inflated prices in the late 1980s.

"But more important than that," Schanz continued, "every time you receive a letter from us saying that your piece has gone up in value, there's a tremendous amount of pride of ownership. All of a sudden your chest goes out like this, and you say, 'I finally did something right for a change.'

"I mean, I know, man," he laughed sheepishly. "I bought stocks. I bought into a Las Vegas racetrack. Now what the heck could be better than that? And they got as far as building the grandstand, and now it's the Sahara Hotel. Nobody wanted to come out to see the races, and I lost my shirt. I mean, those are sure things, you know, surefire things that have gone disastrous for me."

Not so with art, Schanz assured Petranek.

"Art has always been spectacular. It can't go down, especially a piece like this. There's too many firsts involved in it. Of all the Dalís we have, this is the finest graphic we have in here. I cannot offer you a better one."

Schanz paused and chuckled. "Yes, I can too. But this one is more fun. But, uh, is there any other questions? Does that answer it for you?"

Petranek asked what chance there would be that Center Art would run out of the *Dalívisions* in the time needed for her and her fiancé to arrive at a decision in the following couple of weeks. Petranek was convinced this would be a wonderful investment, but she dared not commit herself to an investment of $1,950 without his approval. Schanz urged her to act quickly.

"We have approximately three or four left now," he said. "If we get the rest of the edition, we'll have about fifteen

more pieces. Now that will be gone within a week. I know that for a fact, because we have a whole bunch of people flying in from the mainland on this, knowing we've got 'em.

"Every major art gallery in the country has called us on the phone, and they've asked if they can buy it from us at retail. Now that's the greatest sign in the world. They're willing to buy it at retail—an art gallery—just to keep it, hang on to it, just to have it. They don't even want to sell the bloody thing. They just want to have it because it brings people into the gallery. That's a good sign.

"And when there's no more available anywhere, that's when the fun begins. Now people start coming in and they start saying, 'Hey, I want to buy it. I don't care how much it costs me.' So now we start going through lists of the people that have already purchased it and we write them letters saying, 'If you'd be interested in selling it, we have an offer of blah, blah, blah.'"

Naturally, Schanz would alert Petranek and her fiancé at the best time to liquidate, and he would not do so prematurely.

"I don't think I'll be bothering you guys unless I think it's worthwhile, because I know when, or I think I know when, to say, 'Okay, let's sell if you're interested in selling.'

"But there's a problem here, and one that I should mention to you," Schanz said. "Dalí is seventy-three years old."

Schanz leaned over the table and looked down at the tape recorder to make sure it was running. "Do I have this thing going?" he asked. "I think I turned it on . . ." The machine was still recording.

"Uh, if he dies," Schanz told the recorder, "and I hope he doesn't, because he's a beautiful man, and he may live, I wish he lives forever. But the law of averages are on my side. Your side, too."

Schanz did not give Petranek the book about graphics that he had promised, but that was an oversight. After she returned to Japan, she played the tape for her fiancé, and they agreed *Lincoln in Dalívision* would be a good investment. Center Art luckily had not run out of them. They bought the print in a custom frame.

Within six months, just as Schanz had predicted, the price of *Lincoln in Dalívision* had begun skyrocketing.

Petranek's relationship with her fiancé came to an end, but not her investment in Dalí artworks. Periodic reappraisals mailed to her by the gallery convinced her that this was a profitable area to place her savings.

In a five-year period, Petranek spent $35,000 on Dalí lithographs, gold and bronze wall sculptures, a second "mixed-media" Dalí graphic and a Chagall lithograph.

And she began waiting for her investment to fully mature, waiting for the law of averages to take effect.

Leilani Petranek was a "small" investor. Others were spending many hundreds of thousands of dollars on allegedly original graphics and wall sculpture by Dalí and other contemporary artists. But no one really seemed to know the extent of the artists' involvement in this plentiful supply of "original" art.

CHAPTER 2

Avida Dollars

In 1979 the organizers of a major Salvador Dalí exhibition in Paris wanted an article written about the flamboyant artist and proposed a title: "Dalí as a Printmaker." They put the idea before Rainer Michael Mason, curator of prints at the Geneva Museum of History and Art. Mason, though, startled the sponsors when he suggested another title for the work: "Dalí as an Engraver? An Iconoclastic Question."

Mason's proposed contribution to the exhibit was rejected, but he holds to his beliefs to this day. Was it possible that the outlandish Spaniard never made a print? Could it be that the talented surrealist, with his now-familiar assortment of tree-branch crutches, flexible violins, lobster telephones and melting clocks, never drew an image onto a printing plate?

Most art experts quarrel with Mason's doubts about *all* Dalí prints. They agree, however, that any Dalí limited-edition print sold in galleries since the 1970s probably is not what it claims to be. It may be genuine if it was sold as a photomechanical reproduction of a Dalí painting, or part of a Dalí painting, having been authorized by Dalí and printed on paper he might have autographed before publication, if at all. Of course, gallery salesmen generally have made loftier claims.

25

Ironically, this scandal arises from the purported signature of the son of a notary, for the artist's father—Salvador Dalí i Cusí—was a highly respected guarantor of documents in Figueras, a village about twenty miles from Spain's Costa Brava. The artist himself was born on May 11, 1904, and given the name Salvador Felipe Jacinto Dalí i Domenech. Throughout his life, he would cling to the belief that he was the reincarnation of a brother who had died in infancy nine months earlier.

Dalí claimed to have begun drawing as a baby, and his arrogance, rebelliousness and exhibitionism were not long to follow. "By the age of six I wanted to be a cook," he began his autobiography, *The Secret Life of Salvador Dalí.* "At seven I wanted to be Napoleon." Each day he would dream up new ways of angering, frightening or humiliating his father. "I threw him off. I amazed him. I provoked him, defied him each time more and more." His parents withheld a new red tricycle from him until he stopped wetting his bed. "I was eight years old, and every morning I would ask myself, 'The tricycle or peeing in the bed?' And after thinking it over dispassionately, sure of humiliating my father, I would pee on the sheets."

Less clear are the germs of Dalí's avarice. It certainly was not inherited, and probably took its roots from the artist's early rebellion against his father. The elder Dalí took pride in his son's artistic abilities, filling a scrapbook with reviews of his early accomplishments and supporting his studies at the San Fernando Academy of Fine Arts in Madrid. Anticipating the young artist's graduation in 1926, the elder Dalí could envision his son becoming an art professor yet believed a career purely as an artist would be futile.

As a professor, the father reasoned, Dalí could secure "an income that would provide him with all the indispensable necessities of life and at the same time . . . the door that

would enable him to exercise his artist's gifts would not be closed to him."

When it came time for the budding artist to appear for the art history part of his examination, Dalí refused to submit: "No. None of the professors of the School of San Fernando being competent to judge me, I retire."

Dalí remembered: "On my arrival in Figueras I found my father thunderstruck by the catastrophe of my expulsion, which had shattered all his hopes that I might succeed in an official career." And he seemed to enjoy the reaction, drawing it into a sketch of his father and sister. "In the expression of my father's face can be seen the mark of pathetic bitterness which my expulsion from the Academy had produced on him."

Dalí had begun to chart a more daring course for himself, one that already held promise. His first exhibition was arranged in 1925 at a Barcelona gallery owned by retired painter Josep Dalmau, who earlier helped the career of another Catalan artist, Joan Miró. Later that year, he visited Paris for the first time and was introduced to the surrealist movement, founded there a year earlier. He also met Pablo Picasso, who kept ties to the surrealist group but was never a member.

Dalí returned to Figueras with new knowledge and ideas to add to what he already had learned from the Metaphysical School, which was in vogue in Spain from 1915 to 1920. It probably was late in 1926 that Dalí painted *Blood Is Sweeter Than Honey*, the first of his surrealistic paintings that, he would write to a friend, "make me die for joy. I am creating with an absolute naturalness, without the slightest aesthetic concern. I am making things that inspire me with a very profound emotion and I am trying to paint them honestly."

Through the surrealist movement, Dalí not only developed the methods that vaulted him into fame, but he met

the woman who knew best how to make that fame very profitable. Without her, Dalí was an eccentric madman. With her, he became the P. T. Barnum of art.

She was called Gala, but was born Elena Diakonoff de Ullina in 1894 in Kazan, a river port in the Volga region of tsarist Russia, about five hundred miles east of Moscow. Her father died searching for gold in Siberia when she was ten, and her mother, despite the scorn of the Russian Orthodox Church, then shared her home with a wealthy lawyer.

Gala told of having been sexually abused both by her stepfather and brother. She was also afflicted as a child with a mysterious illness that required that she be sent to the Clavadel sanitorium in Davos, Switzerland, for treatment in 1912. There she met Paul Eluard, the son of a prosperous Paris accountant.

Eluard, who was at the alpine health spa because he had been spitting up blood, introduced himself to Gala as a poet. Gala had developed a fervent interest in literature and had translated poetry and novels from French to Russian. She was quickly taken with the stylish and articulate Eluard. Both seventeen, they shared poetry, literature and emotions, and by the time Gala was well enough to return to Russia in 1914, they had exchanged emotional commitments.

The outbreak of war delayed their reunion until the summer of 1916, when Gala's parents allowed her to leave Kazan at the age of twenty-one for Paris. Eluard had been drafted into the French army, and Gala lived with his parents, seeing Eluard on furloughs. They married during one of his leaves in February 1917, two years before his discharge from the army.

Eluard had been published as a poet as early as 1913, and was swiftly accepted into the lively cultural scene in Paris. He submitted his poetry to an arts review called *Littérature*, became a friend of André Breton, one of its editors, and joined the Dadaist movement founded by Tristan Tzara and

in which Breton was immersed. Eluard solicited art for Breton's publication, acquiring paintings of such newly fledged artists as Picasso, Miró and Max Ernst. That summer, the Ernsts and Eluards traveled to a Dadaist farm in the Austrian Alps.

At the farm, the attraction between the two couples became more than casual. Ernst could be seen entering the Eluards' bedroom down the hall from his own, and he and Gala did not conceal their desires when the group frolicked naked at a mountain lake. The electricity of the new relationship sizzled to a degree that made the others uncomfortable. "Of course, we don't give a damn about what they do, or who sleeps with whom," said American social historian Matthew Josephson, who was at the camp. "But why must that Gala make it such a Dostoyevski drama? It's boring, it's insufferable, unheard of."

Upon their return to Paris, Ernst left his wife and son and moved in with the Eluards. The ménage 'a trois lasted only about two years. Meanwhile, the Dadaist movement with which Eluard and Ernst was associated took a new turn. Breton had tried to seize leadership of the movement from Tzara and, in 1922, branding him "an impostor avid for publicity," declared the end of Dadaism. Annointing himself pope of the new movement of surrealism, Breton exhorted his growing group of followers to explore their subconscious, their world of dreams, in a more orderly and serious manner.

Eluard followed Breton's new movement, along with writers Louis Aragon and René Crevel. Among the artists drawn to the movement were the Swiss painter Paul Klee and the Italian Giorgio de Chirico. Those who disagreed with Breton—including Ernst—were driven from it.

The surrealist movement was well established at the time of Dalí's first visit to Paris. Upon his return to the City of Light in the spring of 1929, he was introduced by Miró to Breton and others in the movement, was accepted into its

ranks and—foremost in his mind—found a dealer, Camille Goëmans, who agreed to give him a one-man show that autumn. One night, Dalí recalled, Goëmans took him to the Bal Tabarin nightclub, where Goëmans pointed out Eluard. "He is very important, and what's more, he buys paintings," Goëmans told Dalí. "His wife is in Switzerland, and the woman with him is a friend of his." Goëmans and Dalí joined Eluard, and they shared several bottles of champagne. Eluard had heard Dalí was collaborating with Spanish film-maker Luis Buñuel on a surrealist movie, *Un Chien Andalou* Dalí invited him to see his true art, his paintings.

In August 1929 Goëmans and Buñuel traveled to Spain to visit Dalí and complete plans for the movie's debut and the opening of the one-man show, both planned for October. Dalí's family had moved to Cadaqués, a coastal village nestled beneath the stone-terraced, abandoned mountain vineyards along the Costa Brava, near Figueras. The Eluards followed a few days later, staying at the town's only hotel, and they met Dalí on the beach at Cadaqués. Dalí shared drinks with the Eluards. Afterward, Dalí and Gala went on an evening walk. "I spoke with Gala of intellectual questions, and she was immediately surprised by the rigor which I displayed in the realm of idea," he recalled.

The next morning, Dalí went to great lengths to prepare to make an outrageous second appearance. He took his finest shirt, cut it irregularly at the bottom and "artfully" tore holes baring his left shoulder, chest hairs and left nipple. He turned his swimming trunks inside out. He shaved his armpits until they bled, then set out to concoct a "perfume."

"I lighted a small alcohol burner that I used for my etchings, and I began to boil some water in which I dissolved some fish glue. While waiting for this to boil I ran out in back of the house where I knew several sacks of goat manure had been delivered." The smell of goat dung pleased Dalí,

and he mixed it with the glue into a paste. "But the secret of this strong odor that was already beginning to fill the whole house was a bottle of aspic oil which I also used for my etchings, a drop of which was enough to cling to a material with a tenacity that lasted several days. I poured out half the bottle, and—miracle of miracles!—the 'exact' odor of the ram which I was seeking emerged as if by a veritable magic operation." He rubbed his entire body with the mixture. With a red geranium behind his right ear, he was ready for Gala.

Seeing Gala sitting on the beach through his window, Dalí recalled that "her sublime back, athletic and fragile, taut and tender, feminine and energetic, fascinated me as years before my baby-nurse's had. I could see nothing beyond that screen of desire that ended with the narrowing of the waist and the roundness of the buttocks."

"It was for her that I had smeared myself with goat dung and aspic, for her that I had torn my best silk shirt to shreds, and for her that I had bloodied my armpits," Dalí continued in his autobiography. "But now that she was below, I no longer dared to appear thus. I looked at myself in the mirror, and I found the whole thing lamentable."

Dalí washed away the blood, glue and manure, trimmed the geranium and put his shorts on properly before making his appearance. Dalí lavished all his attention on Gala, and she responded in kind. Eluard returned to Paris without Gala, who would remain with Dalí forever and become an integral part of the Dalí enterprise, the Dalí manufactory.

Dalí had entered what later would be regarded as the height of his career. It was during this period that he produced some of his most important works, including *The Great Masturbator* (1929), *The Dream* (1931) and *The Persistence of Memory* (1931). But he had yet to enjoy any of the rewards.

Goëmans's one-man show in 1929 was a sellout, but the dealer was in financial straits, and the artist got little of the money received from the exhibition. "The whole situation assumed in my brain the proportions of an incipient tragedy," he later would recall. At one point, the "intensified feeling of discouragement [over] the intolerable reality of my financial situation" caused him to punish himself by striking his face with his fist. "I hit it several times in succession, harder and harder, and suddenly I felt that I had broken a tooth."

Dalí's distress provided Gala with her first opportunity to act as his financial guardian. Vicomte Charles de Noailles, an ardent supporter of the new art movement, had offered to pay Dalí in advance for a painting. Gala went to Paris and negotiated a price of twenty-nine thousand francs, a trifling amount for the viscount but enough for Dalí to build a small house at Port Lligat, on the bay just north of Cadaqués.

"By the time Gala got back, I was giddy with gold," Dalí would recall, but the couple had yet to realize significant wealth. Dalí and Gala relied heavily on Eluard, moving into his flat in Paris while Gala sought patrons for her new infatuation.

In 1933, she invented a clever solution, presenting it to Prince J. L. de Faucigny-Lucinge. "They were hard up," the prince recalled to Gala's biographer. "She and Dalí were living in a place with two or three rooms. Gala said that unless they got help, Dalí would have to commercialize his work." She proposed that the prince find twelve patrons who would each agree to put up twenty-five hundred francs annually and, at the end of each month, one of them would have the right to choose a large painting or a smaller one and two drawings. The winner would be chosen by lot at a lavish dinner hosted by the Dalís. Gala pulled it off, and the prince rounded up patrons who put up the money. It was called the Zodiak group, and it lasted until the onset of World War II.

The real cash, however, lay in America, where Dalí's art already had a foothold. His paintings had been purchased in 1931 at the first showing of surrealist art, at the Wadsworth Atheneum in Hartford, Connecticut, and Dalí's first one-man show in America was staged at Julian Levy's Gallery of Contemporary Art on Madison Avenue in 1933. Zodiak member Caresse Crosby, the wealthy widow of American expatriate and Paris book publisher Harry Crosby, encouraged the Dalís to travel to America for a second one-man show the following year.

With the help of a $500 contribution by Picasso, the Dalís—Dalí and Gala were married in January 1934—crossed the Atlantic and arrived in New York. The reception was all Dalí could have hoped for. Critics praised his one-man show and Dalí gave the reporters "stories that would make good copy and even better headlines . . . To them, I was the King of Non-Sequitur, the clown, as they might say, the tummeler." The New York show included the first public showing of what would become the source both of his wealth and the controversy—prints by Dalí.

Dalí had been commissioned in 1933 to illustrate *Les Chants de Maldoror*, a book by the French surrealist poet Isadore Ducasse, known as Comte de Lautréamont. Dalí is said to have produced forty-two etchings from copper plates, including in them his now-famous melting watches, crutches supporting limp figures, bones and long shadows.

Geneva curator Mason believes the engravings are not original prints but rather were executed by J. J. J. Rigal, a Paris publisher, using photographic negatives of Dalí drawings, transferring the images to copper plates and then refining them by hand. Mason questions whether Dalí ever was trained in the field of printmaking, and he notes the absence of any mention of such expertise in biographies of the artist. However, Dalí himself touches upon having such

training in his autobiography. He notes that when he attended the Municipal School in Drawing in Figueras, Don Juan Nuñez, its director, "was a very good draftsman and a particularly good engraver" and had received the Prix de Rome for engraving.

Nuñez owned a Rembrandt engraving. In his autobiography Dalí describes how the director "had a very special manner of holding this engraving, almost without touching it, which showed the profound veneration with which it inspired him. I would always come away from Señor Nuñez's home stimulated to the highest degree, my cheeks flushed with the greatest artistic ambition." Dalí did not write specifically of his own training in engraving, but his bizarre references to the gas burner and aspic in describing his preparation for meeting Gala indicate he at least owned the accoutrements for engraving and an understanding of their use.

At the time Dalí wrote his autobiography, there was no controversy over the authenticity of Dalí prints and, thus, no ulterior reason for Dalí to make mention of the tools of engraving. Curator Mason had planned to publish his analysis in detail in 1985, and subsequently said he will make them public at an exhibition in 1993. Until then, his allegations remain unconfirmed.

Any doubts about the authenticity of Dalí prints were nonexistent when the Dalís made their first visit to the United States in 1934. The trip was a financial success. Gala handled the finances, as she would for decades, insisting on payment in cash.

No longer was Dalí the struggling artist. In the years after the New York trip, Dalí's notoriety soared. He graced the cover of *Time* magazine, and lucrative contracts were offered and accepted. He was commissioned to design perfume bottles, tea cozies, dresses—whatever was proposed.

A return trip to New York in 1939 resulted in an uproar that fulfilled any yearning for further publicity. Dalí had agreed to design two store windows for the Bonwit Teller shop on Fifth Avenue for one thousand dollars. In one of the windows, he placed a bathtub lined with lamb's wool and filled it with water and alongside it an undraped mannequin adorned only with red hair and green feathers. The other window displayed a mannequin asleep on a black satin bed covered with a canopy composed of a buffalo head with a bloody pigeon in its mouth.

That night, while the Dalís slept, following the window's completion, the store responded to complaints by removing the bed and replacing the mannequins. Infuriated, Dalí insisted that his creation be restored. When that failed, he stalked into one of the window displays, overturned the bathtub and sent it crashing against the huge pane, spraying glass across the sidewalk. Dalí was arrested and charged with malicious mischief. The charge eventually was reduced to disorderly conduct, and he was given a suspended sentence. News accounts of the incident created long lines at Julian Levy's gallery, and, within two weeks, the twenty-one Dalí works exhibited there had been sold for more than $25,000 each.

In American eyes, Dalí departed for Europe the crown prince of surrealism. In fact, prior to his journey to New York, he had nearly been expelled from the movement. While the surrealists in Paris were identifying with the Communist party, Dalí did not hide his fascination with Hitler. André Breton scolded Dalí for such "nonsense," and later would bemoan Dalí's commercialism, coining the anagram, "Avída Dollars," from the letters in "Salvador Dalí."

In August 1940, as war engulfed Europe, the Dalís returned to America. They spent the next eight years at the seaside resort of Carmel, California, with money-making forays to New York and Hollywood.

Life magazine proclaimed him "America's No. 1 public madman. Society ladies pay as much as $25,000 for his portraits showing them garnished with lizards and sprouting foliage instead of hair. Movie producers, ballet troupes, Broadway managers, women's fashion designers vie for his services turning their products into mental shambles." He would participate, for a price, in advertisments for such items as Ford automobiles, Wrigley's chewing gum, Gruen watches, Gunther's furs, Schiaparelli perfume and products of Abbott Laboratories and the Container Corporation of America. He collaborated with Walt Disney, created designs for a New York ballet and entered into numerous contracts to illustrate books and magazines. At the genesis of each project was Gala.

"She is self-effacing, shrewd, practical," wrote Winthrop Sargeant in *Life* magazine. "She pays the bills, signs the contracts and otherwise acts as a buffer between Dalí and the world of reality. When he goes out by himself on an errand, she carefully ties a tag to his clothing, with his destination plainly written on it so that he will not get lost."

Gala's role was exemplified in the negotiations between Dalí and a New York publisher who wanted him to illustrate a book. As they neared agreement, the publisher asked, "How many full-page color illustrations do you intend to supply?" Dalí, speaking no English during the session, held up five fingers. The publisher arose, as if to leave, and said, "Anyhow, it's been a lot of fun." Gala saved the day by interjecting, "When Dalí says five, he means ten."

Dalí may have regarded printmaking, or print producing, as being somewhere between serious art and mere money-making. In 1945, the prestigious Cleveland Print Club offered Dalí $500 to create an etching that would be produced in an edition of 250. According to negotiations conducted by Henry Sayles Francis, curator of prints at the Cleveland Museum of Art and secretary of the Print Club,

Dalí would be supplied a copper plate on which images of St. George and the Dragon would be etched by the artist, and the Print Club would print the edition on its presses. Dalí would approve the final prints and sign them, and the copper plate would be effaced.

Gala repeatedly announced delays in Dalí's work on the project because of other commitments. When the starting date finally was set, Francis became concerned that Dalí seemed to be asking that someone else do much of the actual etching. Francis expressed his concerns to noted printmaker Taylor Arms, who replied that if Dalí and another person were to share in the work, then both should sign the prints.

Francis arranged for the artistic work to be executed at Atelier 17, a French print shop that was temporarily located in New York during the 1940s. Gala wired Francis in February 1947 that the work on the copper plate had been completed. Atelier 17 owner Stanley William Hayter later sent a bill to Dalí for use of the studio and equipment. Presumably, then, Dalí did the etching, following the accepted rules. At any rate, the Print Club accepted Dalí's work above his signature alone, and *St. George and the Dragon* is cherished today as a truly "original" print by Dalí. One of these prints sold at auction in 1981 for $3,850.

Dalí's more common print practices are illustrated by a project he undertook a few years later, after his return to Europe. From 1950 to 1952, he executed a series of 106 watercolor paintings for the Italian government for Dante's *Divine Comedy*, to be later reproduced as woodblock prints. However, according to Robert Descharnes, Dalí's last secretary, some groused that it was wrong for Dalí to do the work at the behest of Mussolini's one-time minister of foreign affairs. Because of that concern, the printing of most of the plates was halted before completion. Dalí's version is that Italy's minister of education commissioned him to do the

project, and a scandal broke out because a member of the minister's political opposition objected that a foreign artist had been assigned the project. "The government was imperiled. Feeling insulted, I decided to have some fun out of it. The minister, now at wit's end and fearing a hail of rotten tomatoes, came to beg me not to reply, saying that I could keep both the money and the plates I had already done, provided no more was heard in Italy about Dalí's illustrations for *The Divine Comedy*. I kept my word—and sold the rights at twice the price to a French publisher." The publisher was Joseph Foret.

Dalí's first experience with lithography came in 1957, when Foret approached him with the idea. Versions of what occurred here also differ. According to Foret, Dalí stubbornly refused even to speak with him for a week, but Foret persistently returned daily with his proposal. Finally, Dalí agreed to produce lithographs to illustrate *Don Quixote*.

As Descharnes tells it, Foret first wanted Dalí to illustrate some views of Paris, then to illustrate *Don Quixote*, using lithographic stone, and Dalí refused, saying, "I cannot accept. I hate lithography, and I like only engraving in iron. If you come with all this stone, I will have néphrétique [nephritis]."

In a diary, Dalí told of his disdain for lithography in describing the episode: "As it happened, I was against the art of lithography at that period for aesthetic, moral and philosophical reasons. I considered that process without strength, without monarchy, without inquisition. To my point of view, it was nothing but a liberal, bureaucratic, and soft process. All the same, the perseverence of Foret, who kept bringing me the stones, exasperated my antilithographic willpower to the point of aggressive hyperaestheticism."

Finally, Descharnes says, Dalí accepted, but he never drew on stone for Foret. "Mr. Foret came with a lot of stone to Port Lligat, and Dalí used the stone to make a beautiful accident. He broke nails, he put ink in bullets and he shot the stones." He drew the Paris scenes when Foret arrived with the printing material, but on paper, Descharnes says. Only later, Descharnes asserts, would Dalí agree to produce the *Don Quixote* lithographs, but using zinc plates instead of stone. According to Albert Field, Dalí's authorized archivist, Dalí shot nails at the stones with a blunderbuss and then drew on the stones, "which made more problems in the printing, because the stone sometimes would be chipped where the nails hit. But he didn't care; that was interesting. He liked that."

In later years, Dalí created other lithographs from zinc, including portraits of Picasso and Spanish architect Antoní Gaudí, a Catalan landscape and, most notably, a series of four lithographs titled *Hommage à Meissonier*, honoring the nineteenth century French artist Jean Louis Ernest Meissonier. These, says Descharnes, are "perfect, absolutely direct lithographs by Dalí," but these true Dalí lithographs— *Hommage à Meissonier* and others—number only about twenty-five images.

It was during the 1950s that Dalí met one of the men who later would become credited, or blamed, as the catalyst for the artist's excesses. John Peter Moore, born of Irish parents, served eleven years in the British army, much of that time as a captain in the psychological warfare branch in Africa, Italy, Austria and France. After his discharge, he worked as a secretary to British author Graham Greene and as a representative of the Hungarian-born film producer Sir Alexander Korda. According to one source, Moore met Dalí in Rome in 1952, when he tried to arrange payment to Dalí for a painting Dalí had produced for a film version of *Richard III*,

by Korda. Moore had worked with the Vatican's propaganda department during the war years, and Dalí, hoping to have Pope Pius XII bless one of his first religious paintings, *Madonna of Port Lligat*, expressed a desire to meet the pontiff. Moore claims he fulfilled Dalí's wish and says the artist was impressed.

Descharnes disputes this version of Moore's meeting with Dalí, maintaining that it occurred at a New York hotel, where Dalí was having tea with socialite Nanita Kalachnikoff. Descharnes says Kalachnikoff told him they both noticed Moore's smallish stature at the bar, and Dalí likened him to a figure from a Spanish comedy. Moore was without money and immediately attached himself to Dalí, Descharnes says. Michael Ward Stout, who later became Dalí's lawyer, agrees with Descharnes's version. Whatever the circumstances, Moore never again was in need of money to pay his bar tab.

In 1954, when Dalí became involved in the dispute over rights to his renderings of *The Divine Comedy*, Moore came to his assistance, arranging for the sale of those rights to Foret. Moore began working directly for Dalí in 1956, officially signing on as his personal secretary six years later. Gala continued to arrange contracts for Dalí's paintings, while Moore was placed in charge of reproductions.

Even before signing on as Dalí's aide, Moore had realized Dalí's vast commercial potential. In the 1950s, Moore has said, he was able to generate twenty-five thousand dollars for Dalí from one sale in New York. "It was then that I thought, 'I have discovered America,'" Moore concluded, and Dalí embraced the idea that prints were an easy means of achieving wealth. Instead of tediously laboring over a large canvas for weeks, the artist could make a quick sketch or two in the morning, each of which could be speedily and profitably reproduced under contract with a publisher.

Said Dalí: "The captain brings in two copperplates I am supposed to engrave for a Parisian publisher. Each morning after breakfast I like to start the day by earning twenty thousand dollars. I stick the plates down on my belly, raise my knees, and on that stand I set to work with the engraving plate. I take real pleasure in cutting the metal as the steel tip moves along."

Dalí told one of his biographers that he once had collaborated with Picasso on an engraving of a nude woman,executed by Picasso—whose breasts were covered with fried eggs—executed by Dalí—and that the copper plate was left at the atelier of Roger Lacourière.

However, by the early 1960s, Dalí had put an end to printmaking as an art medium. Descharnes says: "Somebody asked Dalí, 'Why don't you want to continue engraving?' And he said, 'Too difficult, because it's impossible now to have somebody put the varnish on the copper like my friend Lacourière did for *Chants de Maldoror* in 1933. It's not so regular. I prefer now to dedicate all of my confidence to mechanical reproductions.'"

In 1965, Moore arranged a grand printmaking contract for Dalí with Sidney Z. Lucas, head of the Phyllis Lucas Gallery in New York, which was to be the exclusive publisher in North America of Dalí hand-signed graphics. Under the contract, the gallery published numerous limited-editions prints, beginning with *The Fishermen* and including *The Bullfight* series, *The Three Graces*, *Fantastic Voyage* and *Spring Explosive*. Photographs show Dalí drawing *The Three Graces* onto a lithographic stone and examining proofs of other works, but some wonder today whether those photos deceive. Dalí did see and approve the trial proofs, marking them *bon-à-tirer*, and hand-signed each one. But, some say, by no means are they original prints of the artist, under the definitions of what the major auction houses and scholars accept as constituting an original print.

"The prints were presented in a numbered series like real, made-from-the-stone lithographs, together with a handful of advertising material inviting the gullible to register his prints with the official 'Dalí archives,'" knowledgeable Dalí collector and supporter A. Reynolds Morse wrote in his Dalí diary after the prints came on the market. "The whole affair is shabby and discreditable, and [Captain] Moore plainly has grandiose schemes for bilking the public, using Dalí's name and fame to boost a $25 piece of paper to a $250 one, just because Dalí signed a reproduction of an image."

Most of the Lucas prints fit into a strange category—and a rather large one—that Albert Field, a retired schoolteacher in Queens, New York, will title "legitimate prints" in the catalogue raisonné that Dalí authorized him to prepare. These, Field says, are prints "where he didn't work on the stones or plates himself, but he did approve of what had been done by artisans. He shouldn't have, perhaps, but he did."

A "legitimate print," Field says, is one produced by artisans copying a gouache that Dalí created for that purpose, in contrast to a picture that reproduces a painting Dalí created as a final work of art. Field is quite meticulous about this distinction, but his category nevertheless causes art scholars to cringe.

As an example, Field points to the one hundred watercolors and gouaches Dalí painted to illustrate the Bible in the 1960s for a project of Foret's. "The printing was so good," Field says, "that when they had a show here in New York City, when they were put up on the wall of a big exhibit here, one hundred originals and one hundred to be printed in the book, you had to look closely to tell which was which, they were so good. Now those were obviously of a quality that Dalí loved. He saw the show, and he approved of it."

How often were these hand-made reproductions authentic prints of fine "quality?" In 1971, Morse and Dalí noticed some prints created by craftsmen for Abe Lublin, who had used sophisticated marketing to turn his small New York print shop into a business having yearly sales of more than three million dollars, allowing him to boast, "I'm the largest print wholesaler in the world."

Viewing the Lublin prints, Morse recalled, "Dalí several times stood looking at them and holding his cane to his lips while his finger followed the line. 'Hmmm,' he would say. 'Ees no exactly me line.' Thus, it was perfectly clear that the transposition by someone else of a work previously existing must inevitably be inaccurate," Morse wrote in his Dalí diary later that day.

Of perhaps greater concern was Dalí's way of expediting such projects. Once his work—painting the gouaches—was completed, Dalí would be ready to return to Europe before the artisans could deliver the prints for his signature. In that case, the paper to be used for the printing would be delivered to Dalí, and he would sign the sheets *before* the printing. This, Moore has explained, was necessary because of the artist's travel plans. "When Dalí was painting three months in Spain, three months in Paris and five months in America, there was no way to deliver an edition unless he left sufficient signed paper behind to print the edition on." He added, "When they buy an engraving, people like to think the artist sweated all night waiting for the print, and then signed it. That's nonsense."

Sometime during the 1960s, Dalí learned that it was not necessary that his signatures on blank paper have a predestined use, according to some associates. The artist learned that his signature at the bottom of a blank sheet large enough for a print was worth $40. With aides at each elbow, one shoving the paper in front of Dalí and the other pulling the signed sheet onto another stack, it was claimed that Dalí

could sign as many as 1,800 sheets an hour for $72,000. The practice provided a quick way to generate payment for a hotel or restaurant bill.

By 1970, with the help of Gala and Moore, Dalí had become a commercial extravaganza, an industry unto himself. He would charge fifty thousand dollars for portraits, and then there was the endorsement money. For ten thousand dollars he appeared on French television and, in a fifteen-second commercial, exclaimed, "I am mad. I am completely mad . . . over Lanvin chocolates." For the same amount, he declared his devotion to Braniff Airways; no matter that he had never flown in an airplane and had no intention of doing so. In France, fifty women wove Dalí tapestries at a factory in Aubusson, thirty glassblowers produced Dalí-conceived heads and tableware in Nancy, bronze casters, jewelers and other craftsmen churned out Dalí products to satisfy the whims of those unable to afford a portrait. He designed shirts, cognac bottles, ties, bathing suits, gilded oyster knives, ashtrays for Air India and stamps for Guyana. Books illustrated by Dalí would sell for $35 to $15,000, and Dalí tarot card decks went for $25 each.

Robert Wernick wrote for *Life* magazine about the Hotel Meurice's Alfonso XIII suite in Paris being turned into "a business showroom, board room and counting house. It was the headquarters of Salvador Dalí, unincorporated, but unmistakably a major art business, netting half-a-million dollars in a bad year after taxes, funneling into the market a constant stream of high-priced objects of all shapes and sizes, from giant Dalichryselephantine candelabra to Dalí ashtrays." After springtime in Paris, Dalí would return to Cadaqués. He would return to Paris in the fall, and in the winter move his headquarters to the St. Regis Hotel in New York, entertaining promoters at every stop.

Moore boasted that at least five hundred commercial contracts a year would be proposed to Dalí. While some

were rejected—such as the American food merchant desiring rights to the second letter of the artist's name so he could call his chain of stores "Dalícatessens"—those that Dalí accepted made him fabulously wealthy. Nor did Moore fare badly culling his 10 percent commission.

Wernick wrote of a wheelbarrow barreling down the corridor of the Hotel Meurice in Paris with twelve hundred lithographs to be signed by Dalí for the French National Railroad. Prints were only one of Dalí's many avenues to riches. On one occasion, Dalí arrived at a Paris printing house to examine his reproductions for a book and discovered a detachment of armed guards. "They are here to greet me. How appropriate," he commented. Moore had to explain that the guards were there to protect an issue of bank notes being printed for the French government. "It is all the same," Dali shrugged. "They might as well be printing them directly for me."

In 1974, Moore arranged for Dalí to produce seventy-eight illustrations of tarot cards for a James Bond movie, and the episode turned stranger than *Goldfinger*. Dalí was late completing the gouaches, and the movie producer backed out of the deal. Moore looked for someone else to salvage the contract and, at a poker game he occasionally observed, found restaurant concessionaire Jerry Jacobs in New York, who then went to book publisher Lyle Stuart. The deal involved editions of 250 "lithographs" for each of the seventy-eight illustrations and a book, plus the original works.

The arrangement quickly became tangled. First, Kitty Meyer, an art patroness whose husband, Alvin, was a regular in the poker game, claimed (and does to this day) that she originated the idea for the tarot cards but was snubbed by Gala and excluded from the contract by Jacobs. Meanwhile, the contract began to look less and less appealing to Dalí.

According to Michael Stout, Dalí's New York lawyer for many years, Dalí "was so angry . . . that he intentionally produced junk." Dalí then agreed to draw remarques—small additions to the bottoms of the tarot images—to spruce them up, but he was slow in doing so, and tempers flared.

Stuart confronted Dalí in the lobby of the St. Regis Hotel and was assured by the artist that the work would be completed.

"Yes, Mr. Stuart, you will have your remarques before I sail in six days," Dalí told him. Stuart was not so sure.

"Dalí," the publisher responded, "do the large ones first."

"I don't understand," Dalí replied quizzically.

"Because," Stuart shot back, "if I don't see some remarques in three days, I'm going to the district attorney and I'm going to have you arrested and you're going to have handcuffs on. Then you will only be able to do the little ones."

Two days later, however, Stuart learned that Dalí was quietly preparing to slip out of New York. Educated by a banking friend in the tactics of doing battle in the financial trenches, Stuart contacted his attorney Jack Albert and had him freeze $300,000 in Dalí's First National City bank account in New York.

Arnold Grant, Dalí's lawyer and best known as the husband of Bess Myerson, former Miss America, was in and out of mental institutions at the time, so his associate, famed attorney Louis Nizer, negotiated a settlement with Stuart: Dalí would sign 17,500 blank sheets of paper for the tarot prints that had yet to be produced. He signed the blank paper at the St. Regis Hotel in 1976 and 1977.

"Through a whole series of things," Stuart recalls, "we ended up with Dalí accidentally signing three thousand more sheets than he should have." Not having any use for the paper, Stuart called a business neighbor in Secaucus, New Jersey, Leon Amiel, a producer of art books and prints.

Stuart named a price for the three thousand sheets, but Amiel said it was too steep.

"Okay, would you like to buy one sheet?" Stuart asked.

"What are you talking about?" Amiel replied.

"Well," Stuart said with a smile, "if you don't buy this paper, I'm putting an ad in the *Times*, and I'm going to say, 'Do your own guaranteed, authentic Dalís. Draw your own pictures. Guaranteed Dalí signatures.'"

Amiel proceeded to buy the three thousand blank signed sheets from Stuart.

By 1974, Captain Moore's relationship with the Dalís had begun to deteriorate. Gala may have resented Moore's increasing importance in Dalí's finances, his direct relationship with the artist and perhaps the wealth he had been able to accumulate from his 10 percent commissions. A tiff arising from a 1974 trip to the Costa Brava by Spain's Prince Juan Carlos drove Dalí to end Moore's tenure as his chief aide. Dalí had invited the prince to visit his Teatro Museo Dalí in Figueras, and Dalí stood on the coastline street in Cadaqués awaiting his arrival by boat. Unexpectedly, Moore arrived and, when Juan Carlos came ashore, persuaded the prince to visit Moore's own museum two blocks away. The prince visited the Moore museum and canceled his trip to Figueras. Dalí was furious.

Moore's exit did not create a void. For about two years, Moore took on an aide who by this time was able and anxious to be promoted into Moore's job.

Enrique Sabater Bonany was born on November 20, 1936, into a mechanic's family in a small village near the town of La Bisbal, near the Costa Brava, the Mediterranean shore north of Barcelona. He claimed to be a talented soccer player, tagged "Sabateta," or "Little Shoe." Sabater said he played on clubs both in nearby Gerona and, for several years, in Switzerland. But his real prowess was for making money. By the age of seventeen, he claimed to be earning more than

a bank president. After this he worked at various jobs, at a travel agency, as a driver for the U.S. Information Agency's Radio Liberty and as a photojournalist for *Los Sitios*, the Gerona newspaper. It was in 1968 in that latter role that Sabater met Dalí, seeking to interview him.

As Sabater has told it, Dalí had difficulties with a camera he was using to photograph one of his paintings. Sabater helped arrange the photo setup and was invited back. On one occasion soon afterward, Dalí became bothered by a fly as they were sitting outside Dalí's house at Cadaqués. Sabater went to the kitchen, returned with a jar of honey and applied a dab of it to Dalí's mustache. The fly quickly perched on the spoke covered with honey, and Sabater snapped a photo of it. The picture was distributed widely, and Sabater was welcomed into Dalí's small circle.

By the end of 1974, Sabater began working as an aide to Dalí, gained Gala's friendship and took over her task of setting the prices for Dalí's paintings. Moore continued to be in charge of reproductions. With Moore's departure, Sabater assumed that role as well.

Sabater's supplanting of Moore closely followed the conflict over the tarot card illustrations, which had left everyone unhappy. Stuart was more interested in publishing books than marketing "lithographs," especially after his brief introduction to the art business. Sabater wanted to retrieve the signed paper from Stuart's warehouse, but Gala refused to buy it back. So Sabater, with Michael Stout's help, organized a consortium of Robert LeShufy, a poker-playing friend of Stuart's who operated a limited-edition printing plant, LeShufy's nephew Barry Levine and LeShufy associate William Levine (unrelated to Barry), with Sabater as a principal. Since Sabater was a nonresident alien, the company could not be created in the United States but could be set up in a country that had a favorable American tax treaty. Thus, in June 1976, was born Dalart Naamloze Vennootschap, or

Dalart NV, in the Dutch Antilles. Its first transaction w
buy back the paper from Stuart, except for the three thou-
sand extra sheets Dalí had mistakenly signed.

Sabater also established a company with Dalí in Gerona
called Dasa Ediciones, combining the first two letters of
their names, which was to publish postcards, posters and a
monthly newsletter, and a third company in the
Netherlands Antilles, Dasa NV. Stout had determined that
creation of the companies could be beneficial to Dalí,
allowing him to avoid paying 30 percent tax to the United
States on any royalties he would receive there. Whenever
Sabater would sell a Dalí painting with commercial poten-
tial, one of the three companies—usually one of the Dutch
Antilles companies—would be granted the reproduction
rights. Thus Dalí would receive payments for both the sale
of the painting and for granting reproduction privileges, and
Sabater would receive commissions for both.

According to Alfonso Quintes, a reporter for the Spanish
newspaper *El País* who investigated the arrangement,
Sabater swiftly became a multimillionaire. Within a few
years, he owned two mansions, one of which was equipped
with closed-circuit television, a heated swimming pool and a
lobster pond. He owned several expensive cars and a yacht
moored at Llafranch, about fifty miles down the Costa Brava
from Cadaqués. Known in his youthful exuberance as the
Peter Pan of Ampurdán, the district that encompasses
Figueras, Sabater had soared to heights of wealth that, by all
appearances, surpassed that of Dalí himself.

The arrangement also was profitable to Barry and Bill
Levine, who arranged for the printing of Dalí images after
reproduction rights to various Dalí images were obtained by
Martin-Lawrence Galleries of California, owned by the son
of penny-stock prince Meyer Blinder of Denver. Martin
Blinder had begun distributing art along the West Coast in
the early 1970s after buying a Dalí print. He says his break

came in 1974 when he called Dalí at the St. Regis Hotel and negotiated the publication of a print series titled *La Jungle humaine*. Access to the presigned paper from the tarot settlement afforded Blinder the means of entering the Dalí business in a big way.

Thus, from the presses of the Levines flowed reproductions of Dalí paintings titled *Lady Blue, Dalí's Dreams, Dalí's Inferno, The Kingdom, Dreams of a Horseman*, and on and on.

But the linchpin to Blinder's success was a painting that Dalí had completed in 1976. Intrigued by Case Western Reserve University Professor Leon D. Harmon's computerized rendition of an Abraham Lincoln bust, published in *Scientific American* magazine in 1975, Dalí decided to put the optical illusion to canvas and, with it, a rear-view nude of Gala.

In the painting a Christ-like icon soars above Gala's head, and the entire painting is separated into multicolored squares. Lincoln's head cannot easily be discerned except at a distance, by squinting one's eyes or by viewing the painting through the wrong end of a magnifier. He titled it *Gala Looking at the Mediterranean Sea, Which From a Distance of Twenty Meters Is Transformed Into a Portrait of Abraham Lincoln (Homage to Rothko)*. The fourteen-foot-by-twelve-foot painting was exhibited at the Teatro Museo in Figueras in 1976, and a year later Dalí recreated the painting in the smaller version, eight feet by six feet.

Dalí collector A. Reynolds Morse looked at the second, smaller painting but was not impressed. "I decided not to buy it, as I did not feel it was his best work. . . . I call it the St. Regis Period, for that was where he worked on it a lot, in between sessions at the bar where Dalí held court."

Blinder bought the painting, and in 1976 began selling the first limited-edition lithographs derived from the painting, which Blinder retitled *Lincoln in Dalívision*. His

marketing strategy was clever; instead of producing an edition of more than a thousand prints, Blinder offered collectors something seemingly rarer. There were American and European editions of 350 each, an International edition of 200 and a German edition of 125. Each print from these editions was described as "an original Dalí lithograph," priced at $750.

As a collector, Morse frowned on what Blinder was preparing to do. He approached Dalí. "When I pointed out to Dalí it was NOT a lithograph but a reproduction of his painting, he produced a small 'original' etching, or drawing, of a small head which was printed in red at the lower right of this limited edition so that the word 'original' could be left in the literature."

The editions quickly sold out. Says Morse: "The subject was then sold, resold and, finally, pirated so often that today it is probably Dalí's most widely reproduced painting."

Copies of the reproduction, created for the most part not by Dalí the artist but by the people around him, and bought and resold by Blinder the entrepreneur, would eventually fetch $25,000 each.

CHAPTER 3

The Dalí
Flood

Old age was turning Salvador Dalí gradually from show-
man to recluse. He was slow in recovering from a urinary
blockage in 1977, and both he and Gala fought off a strain of
Russian flu the following year. During their annual visit to
New York in February 1980, the Dalís again both contracted
influenza. Gala, then eighty-five years old, recovered from it
within a few weeks, but Dalí, ten years her junior, became
absorbed with fear of what he was certain was his first
serious illness. He shunned food at the St. Regis Hotel and
sought out physicians who would agree with his self-diag-
nosis of Parkinson's disease. Sabater was away from the city,
traveling to places such as Japan and the West Indies in order
to keep the $12 million-a-year Dalí enterprise surging.
Michael Stout, the lawyer, had accepted an almost parental
role with the Dalís, and he was relied upon to care for the
ailing artist-client.

After learning of the maestro's plight, Sabater returned to
New York and in March 1980 took the Dalís to the Incasol
clinic, a health spa in Marbella on Spain's Costa del Sol. A
month later, the Dalís returned to Port Lligat. They turned
away old friends, and Dalí complained about trembling. "I
have become a snail," he declared, as physicians disagreed
publicly about the nature of his illness. Friends of Dalí wrote

53

letters to newspapers, accusing Gala and Sabater of hiding Dalí from them.

In "an open letter to Gala Dalí," Jaume Miravitlles, a writer who grew up with Dalí, wrote that he believed Gala was overly interested in her husband's financial side. "You should know, Gala, that several news agencies, two of them international, have asked me to write Dalí's obituary. So far, I have resisted," he wrote in his letter to the editor. "Are you so sure I shouldn't see him?"

Dalí's younger sister, Anna-Maria, joined in the outcry, claiming "anguish over the isolation in which they are keeping him. . . . I believe that my brother has finally [come to understand] the systematic way he is being manipulated." She added, "Even his family and intimate friends cannot see him. This will be fatal, for his health and for his spirit."

Gala dismissed Dalí's longtime physician, Dr. Manuel Vergara, telling him, "You are not curing Dalí. You are no good." Meanwhile, she tried to deflect criticism of her housekeeping, saying, "Dalí is an indestructible rock. Few people, apart from myself, have been able to rise to his heights. His sensitivity and aesthetic sense made him a perfect being."

In May, two old friends of Dalí, Robert Descharnes and A. Reynolds Morse, were allowed to visit the Dalís in Port Lligat and came away deeply troubled. Morse announced the formation of an entity called Friends to Save Dalí, and he arranged for a group of medical specialists—who had examined the artist and agreed on the erroneous diagnosis of Parkinson's disease—to prescribe medication. He accused Gala of having given her husband "tranquilizers which, along with the emotional turmoil, are contraindicated for Parkinson's." He added, "She once even forbade the nurses in Barcelona to give Dalí the proper medication."

Morse wrote: "We proved pretty well that under Gala's untender care and Sabater's terroristic methods, Dalí has

been reduced to a shell of his former self. We are concerned that Sabater's income from Dalí has been more than six times that of his master, and that he is abusing the expense accounts to the tune of about $100,000 a year." Morse added that "Sabater's mismanagement of things Dalínian is appalling."

He cited "shenanigans" that had kept Dalí from receiving book royalties due him and said Sabater was "way out of his depth" in trying unsuccessfully to clear up Dalí's tax situation in Spain. "The Dalís should be Spanish residents, but Sabater duped them into thinking that Monaco was a tax-free haven when it isn't." Complaining of "this essentially tragic case," Morse wrote: "His whole world has simply collapsed around him under Sabater."

Morse did not hold Sabater entirely to blame. "We all felt that Gala has made Sabater rich by her one-payment policy," Morse wrote in his personal Dalí diary. "In the past few years, she would set the price on a watercolor to be lithographed by a client. Sabater would then pay her the cash, getting it from the client, then he would sell the rights of reproduction of the work in the customer's own country to him, while retaining the original work for himself. Then when they went to another stand in another country, Sabater would again sell the right to reproduction for *that* country to still another client, so that he made $500,000 to Dalí's $100,000, and ended up with the only thing of real value at all, the original watercolor. Pretty smart, eh?"

Sabater denied any wrongdoing, telling the *New York Times* that he was "a friend and a collaborator" of Dalí's and "an implacable hunter of art forgers." Sabater said he had "collaborated—cooperated—with the Nassau County Department of Police, specialists in art forgeries, and, namely, with agents Tom Wallace and Bill O'Rourke; in France, with inspector Pierre Keromnes; in the United States, with various members of the FBI [Federal Bureau of

Investigation], and with the Italian and Barcelona police."
He said he had been issued a detective's license in Spain.
"To be a private detective in Spain, one has to pass
demanding tests. A license isn't given to just anyone." He
said he had achieved wealth himself through real estate
while representing Dalí. "You know, in this country, envy is
a very important thing."

Morse and Descharnes were successful in arranging for
Dalí's admittance to a clinic in Barcelona. Dr. Antonio
Puigvert diagnosed Dalí as suffering from flu and overwork.
Dalí's mental confusion, he concluded, had resulted from his
being administered antibiotics after being discharged from
the Marbella clinic. "I sent a psychiatrist to him, but the
psychiatrist died," Puigvert chuckled in an interview with
the *New York Times*.

Indeed, on July 17, 1980, Joan Obiols, a sixty-one-year-
old psychiatry professor at the University of Barcelona and a
longtime acquaintance of Dalí's, suffered a massive heart
attack while sitting with Gala after completing his weekly
consultation with Dalí in Port Lligat. "They called me
immediately," recounted Antonio Pitxot, a painter and
friend of Dalí's who lived nearby. "You can imagine what a
surreal scene it was, dragging the half-dead body of the psy-
chiatrist through Dalí's house, which is the most surreal set-
ting itself, with all those stuffed animals. Gala was
screaming, but Dalí was in another part of the house and
didn't know that Obiols had died."

Dr. Manuel Subirana, a Barcelona neurologist who exam-
ined Dalí at Gala's request, observed that the artist com-
plained of trembling in his right hand and arm and had
difficulty walking and swallowing. The doctor noted that
Dalí's condition improved after "an intense antidepressive
treatment." He deduced that Dalí was suffering from "a
depressive state of the melancholic variety" with a touch of
hypochondria.

That summer, Sabater was strangely distant from the discouraging scene at Port Lligat, throwing parties at his mansion and entertaining Arab oil sheiks and show business personalities. Dalí grew disenchanted with his secretary, reportedly telling one relative that his association with Sabater was "the biggest mistake I ever made in my life." While Gala still defended Sabater, she had developed enough suspicion of his activities to compel her to call the manager of the Hotel Meurice in Paris and direct him not to allow Sabater access to a package of paintings that had been left in safekeeping at the hotel.

On August 18, 1980, at Gala's request, Jean-Claude Dubarry visited Port Lligat and, as he tells it, heard first Gala and then Dalí blame Dalí's depression and financial distress on Sabater. But Dubarry was not a model of moral rectitude. Born poor, he created a fiction about coming from a wealthy French family. He had established a modeling agency in Barcelona and, in 1968, had begun supplying models for Dalí and men for Gala. "I am a little bit the sexual and erotic side of Dalí," he would later say with a laugh. By some accounts, Dalí christened him Jean-Claude Verité (French for *truth*). By others, Dubarry used the name Verité in the 1960s so that his debaucheries "would not tarnish his family name." Amusing, since Dubarry wasn't his family name!

Dubarry offered his assistance to Dalí, agreeing to arrange a few business contracts to prove that Sabater no longer was needed.

"I started to call Dalí's old clients, people Sabater had completely cut off, and told them, 'If you want to do business with Dalí, call me,'" Dubarry recalled. The contracts he brought in amounted to $1.3 million. Sabater was furious when he learned that Dubarry had gone behind his back to arrange the deals, and he spoke of "retiring" as Dalí's secretary.

Apparently to counter the talk that he was incapacitated, Dalí held a news conference on October 25, 1980, appearing in public for the first time in seven months. Dalí and Gala shuffled into the domed central hall of the Teatro Museo Dalí that he had helped establish in Figueras. To the music of *Tristan and Isolde,* Gala threw flower petals toward the photographers.

As Sabater looked on, Dalí tried to demonstrate his enduring wit and physical prowess. "You see how my hand is trembling?" he asked the journalists assembled in the hall. "Well, look now," the artist said. James Markham, of the *New York Times,* reported that Dalí then managed to hold his shaking hand still.

Dalí immediately turned to unveil what Markham described as "a horrible painting he had completed during his isolation in Port Lligat: a grotesque, lurid purple beast, recumbent. Its title: *The Happy Horse.*" Dalí commented, "It is a little rotten. I don't know if you can see that it is a horse, or a donkey, but you can see that it is rotten."

Six weeks later, on December 7, 1980, Descharnes says Dalí telephoned him, at artist Antonio Pitxot's suggestion, and told him, "I have to come to Paris. Come and help me because they are ready to keep everything, to steal everything from me." The Dalís, accompanied once again by Sabater, arrived in Paris on December 23. Within a month, Descharnes had taken steps to put some order into the increasingly chaotic distribution of rights to Dalí images. He had Dalí assign his copyright interests to the Société de la Propriété Artistique et des Dessins et Modèles, or SPADEM, a Paris-based artists' rights organization headed by Claude Picasso, the artist's son. Founded in 1951, SPADEM was an umbrella organization for four French associations that had existed since 1886, and it charged fees for negotiating reproduction agreements with publishers. SPADEM represented the estates as Picasso, Monet, Degas and Rodin. Sabater pro-

vided SPADEM with records of his transactions, and the organization validated contracts arranged by Dubarry. SPADEM's validation subsequently would be cited by publishers as proof that their Dalí editions were authentic.

Within a few weeks, during what Gala had wanted to be the Paris leg of the annual excursion to New York, a bit of startling news emerged from the Hotel Meurice. Dalí and Gala had engaged in physical battles. On one occasion, Gala drew blood by cracking Dalí on the head with her rings. "I wanted him to know he's been hit," she explained afterward. On another, Dalí pushed Gala out of bed, and she was later admitted to an American hospital in Neuilly in February 1981 for treatment of two fractured ribs and a minor arm wound. Apparently, Dalí had objected when Gala insisted on going to New York to see Jeff Fenholt, a young black actor who had played the title role in the Broadway hit *Jesus Christ Superstar*, and to whom Gala had developed an attachment.

By March 1981, amid the domestic bedlam, Sabater's standing with the Dalís had deteriorated even further. Dalí issued a statement through Agence France-Presse, announcing, "I declare that for several years, and above all since my sickness, my confidence has been abused in many ways, my will was not respected. That is why I am doing everything to clarify this situation, and Gala and I are once again resuming our freedom."

Although not named in the statement, an angry Sabater demanded that Dalí issue another statement saying he was not the target of the accusation. No statement was forthcoming. On March 20, Sabater left for good.

Descharnes was called upon to assume Sabater's role, although Dubarry remained present. Descharnes today asserts that Dalí was as afraid of Dubarry as he had been of Sabater.

Dubarry continued to arrange contracts for Dalí repro-
duction rights through March 1982, and publishers flocked
to his call. Some would be included years later among the
list of "players" compiled by New York-based U.S. Postal
Inspector Robert DeMuro in his investigation of fraud in the
Dalí print market.

Descharnes says the publishers who obtained contracts
through Dubarry included Jean-Paul Delcourt of Art
Graphics International and Editions d'Art de Lutèce in Paris;
Klaus Cotta, an importer of television programs and movies
in Barcelona; Rudolph Hugerie of Heidelberg, Germany;
William Gelender of Paris; Beniamino Levi of Milan, Italy;
Jacques Jacut of Paris; Carlos Galofre of Spain; Leon Amiel
of New York; and Parisians Henri Guillard and Gilbert
Hamon.

Hamon, a Paris graphics dealer born in Algiers in 1924,
was by far the most ambitious. Hamon had offered fifty
thousand dollars for reproduction rights to each of more
than fifty Dalí images on behalf of his company, Arts,
Lettres et Techniques. Dubarry approached Gala with the
proposal, and she quickly agreed. The "lithographs"—actu-
ally lithographic reproductions made from photographs of
Dalí paintings—would be printed in limited editions of nine
hundred, plus twenty artist's proofs.

Included in some of Hamon's contracts was a proviso:
"The Publisher declares that he is fully cognizant that the
said lithographic reproductions made from the works of the
artist, but without his direct participation in the printing
thereof, may not be represented or offered to the public as
original lithographs by Salvador Dalí, and agrees to comply
with the regulations in force in all countries respecting the
reproduction and publishing of multiple copies of original
works of art."

Hamon probably never intended to make any representa-
tion to the public. He was mainly a wholesaler, and his con-

tracts allowed him to sell the reproduction rights to publishers.

Some of Hamon's contracts stated that Dalí was to certify authenticity with a stamp bearing his thumbprint, the artist presumably being too ill to sign thousands of prints. The thumbprint, according to the contract, would "be the equivalent of his signature" and would be "the exclusive property of Monsieur Gilbert Hamon, and in no case can be used by anyone else." Other contracts stated that the lithographs "shall bear the handwritten signature 'Dalí,'" without specifying who would sign.

The existence of large quantities of blank sheets of paper bearing the Dalí inscription—besides those he signed in the tarot settlement—had been suspected since 1974, when French customs stopped a small truck going from the tiny country of Andorra into France carrying forty thousand blanks signed "Dalí." The truck driver was employed by Jean Lavigne, a French art publisher then living in Palm Beach, Florida. Lavigne was able to argue successfully that there was nothing illegal about transporting blank sheets of paper with the artist's signature across the border. Sizable stocks of such signed paper were reported to exist at several locations, including an important supply in Geneva. Lavigne would later claim that he was "number three in the world in calendars and I'm number one in the world in Dalí."

To augment the supply, Gala and Peter Moore signed a contract on October 22, 1981, to provide 15,000 presigned sheets to Hamon, 3,500 to Klaus Cotta, 9,500 to Carlos Galofre, and 7,500 to Jacques Carpentier, a Paris art dealer. The validity of the contract is dubious, since it is questionable whether Gala had the authority to enter into it on her husband's behalf. By January 1982, Galofre had accumulated 15,800 sheets of the presigned paper. In 1985, Peter Moore would estimate that Dalí signed 350,000 blank sheets of art paper in his career. Clearly, obtaining the sheets was not a

great stumbling block for a publisher desiring to produce a Dalí limited edition.

Pierre Marcand, a French art distributor who had been selling Dalí editions, got wind of the the activity and approached Martin-Lawrence Galleries, his chief client, about getting a piece of the action. Martin-Lawrence partners Larry Ross and Martin Blinder were in the process of ending their partnership and told Marcand they had a cash-flow problem. By the time Marcand got to Dubarry, all the copyrights he wanted had been sold. Dubarry sent Marcand to Galofre, who had acquired a few copyrights along with his share of the presigned paper. Ultimately, Marcand says he bought 13,060 sheets bearing only Dalí's signature for $520,000 from Galofre. Marcand still was in search of copyrights, and he went to the man in charge, Jean-Paul Oberthur of SPADEM. Oberthur directed him to Hamon and his sometime partner Henri Guillard.

Suddenly, Marcand was in the Dalí print business in a big way. So were a number of other publishers. The problem was that Hamon also was selling the same rights, including presigned paper, to those other publishers to reproduce the very same images. Marcand and the other publishers were also producing their own limited editions of the same images where no copyright was required because those images were in the public domain. Marcand had plenty of presigned paper to go around, and he used the Hamon, Guillard and Galofre paper interchangeably, as needed.

Naturally, the simultaneous publication of "limited editions" of the same images by competing publishers caused a few problems. The conflict is illustrated by the dispute over reproduction rights to *The Cosmic Athlete*, a painting completed by Dalí in 1968.

According to David Paul Steiner, Marcand's Beverly Hills, California, attorney, Hamon signed a contract on October 26, 1983, which, for one hundred thousand dollars,

granted Marcand and his company, Magui France, S.A., reproduction rights to a 1938 painting, *Apparition of Face and Fruit Dish on a Beach*, as well as presigned paper that Steiner contended was "valid and documented." A clause of the contract stated that in the event of a problem in the transfer of rights to the image of *Apparition*, Marcand would be allowed to replace it with *The Cosmic Athlete*.

SPADEM later advised Hamon that he never owned the copyright to *Apparition*, which had entered the public domain with the publication of postcards by the painting's owner, the Wadsworth Atheneum Museum in Hartford, Connecticut, and posters by both the Wadsworth and the Dalí Museum in St. Petersburg, Florida. Marcand exercised the option under his contract and published a limited-edition etching by an artisan who copied *The Cosmic Athlete*.

On September 22, 1983, more than a month before the signing of Hamon's contract with Marcand, California art dealers Ted Robertson of International Multiples, Ltd., in Laguna Beach, and Dana Yarger of Sutter Street Gallery One, in San Francisco, had paid Hamon $180,000 for the "right to buy" limited-edition reproductions of two Dalí images, one of which might be *The Cosmic Athlete*. In the spring of 1984, Robertson and Yarger exercised their option, and Hamon began printing the "lithographs" for them.

To further complicate matters, Center Art Galleries of Hawaii was selling its own "lithogaphs" of *The Cosmic Athlete*, which it had purchased from Leon Amiel, a publisher with offices in Paris and Secaucus, New Jersey. Amiel displayed an April 15, 1970, contract showing that Dalí had authorized him to print *The Cosmic Athlete*. According to the contract, Amiel agreed to send to Dalí's suite at the St. Regis Hotel "five reams of paper that you will have the kindness to please sign." It further stated, "On the bottom and to the right of each sheet we will put a small line which represents approximately the place where to sign."

Marcand, Center Art and Robertson and Yarger became entangled in a copyright-infringement dispute in U.S. District Court in Los Angeles. The lawsuit was settled out of court under terms that remain confidential.

Throughout the growing whirlwind of disputes, the artist remained aloof. A. Reynolds Morse paid a brief visit to him at the Meurice Hotel. By now, Dalí had lost control of his bodily functions. Still under the mistaken belief he was suffering from Parkinson's disease and annoyed by pressure from the press, Dalí boarded a jet on July 6, 1981, and flew to Perpignan, France, near the Spanish border. From there, accompanied by Descharnes and a nurse, he returned by car to Port Lligat.

While Dalí remained in bad health, Gala became increasingly frail as well. In early March 1982, she fractured her thigh and, a few days later, underwent surgery for a urinary tract infection. Gala went into a coma on June 9 and died the following day at Port Lligat at age eighty-eight.

Gala had asked to be buried at a twelfth-century castle at Pubol that, with Peter Moore's assistance, Dalí had bought for her in 1967. She had used the hilltop castle east of Gerona as a refuge, where Dalí was not welcome without a written invitation from her. In Spain, there is a tax when a body is moved from one province to another. There would be several taxes since the body had to be transported through several provinces. To avoid this tax, Gala's body was stuffed into the trunk of a car that was then driven to Pubol. The mayor of Pubol said, "My pigs are buried with more dignity."

Dalí accompanied the remains to Pubol, where they were embalmed and placed in a crypt. He never returned to Port Lligat. Protected by Descharnes, lawyer and longtime friend Miguel Domenech and Catalan artist Antonio Pitxot, Dalí went into seclusion in Gala's castle.

Less than three months later, however, Dalí's private mourning would be shattered by the news that, in Perpignan, Peter Moore had unveiled a grand exhibition of 426 paintings, pencil sketches and lithographs attributed to Dalí. The artist viewed a catalog of the exhibit and pronounced sixty of the works fakes.

On August 2, a lawsuit was filed on Dalí's behalf demanding that the alleged forgeries be confiscated. Moore countered with his own $360,000 suit against Dalí, acknowledging that some of the works were not created by Dalí but accusing Dalí of having signed them anyway and having previously presented them as his own. The lawsuits were settled in July 1983, and Dalí's signature was removed from numerous works.

Dalí returned to his seclusion at Pubol. "He has become obsessed by his own death and talks of it constantly," Descharnes told a Reuters reporter in December 1983. Dalí's weight had dropped to less than 110 pounds. He refused food and slept little behind the castle's shuttered windows. "The doctors say there is nothing intrinsically wrong with him. He is just much weaker and has a very negative approach to most things. He is a victim of deep depression," Descharnes told the reporter. "When I try to talk to him about routine affairs, he tells me not to trouble him with derisory issues. Everything except death is derisory for Dalí."

Descharnes said Dalí had stopped painting. "He has lost the creative urge, but he is still capable of demonstrating that he retains his creative touch," he told the reporter. Descharnes showed him a painting of a violin, an instrument that he said Dalí had taken away from one of his nurses. Dalí had become annoyed by her playing of the violin and "reckoned the best way to shut her up was to turn the offending instrument into a work of art." Descharnes said Dalí traced the outline of the violin and instructed an assistant in completing the painting.

Publishers continued to gravitate to the Costa Brava, but Dalí was earning more than enough from accrued royalties so that all comers were turned away. "We get people calling up to say that they will be flying in tomorrow in their private jets to Gerona airport with checks for several million dollars," Descharnes said. "We have to tell them not to come."

Dalí was bedridden, tended by nurses and servants and protected by the triumvirate of Descharnes, Domenech and Pitxot. On Dalí's bedside table was an electric bell that he would use to summon help to his four-poster, covered with canopies and pillows. On August 30, 1984, the bell apparently short-circuited. *El País* quoted anonymous sources as saying Dalí used the bell so often that it often broke down. Apparently, he was fascinated by the small spark that it produced, and he enjoyed playing with it.

Nurses had begun to ignore the bell, figuring the artist was merely having fun. Descharnes was in bed listening to the news on the radio sometime after four A.M. when he smelled something burning. Dalí's bed had caught fire. "I rushed into the room with two of the nurses who are on duty with him around the clock now, and we found the maestro struggling to get out of bed."

Forty hours elapsed before Dalí was taken to the Barcelona hospital of Nuestra Señora del Pilar, where he underwent a six-and-a-half-hour skin-graft operation for the second and third-degree burns he had suffered over 20 percent of his body. Doctors also found that Dalí was suffering from malnutrition.

Francisco Martinez, the chief judge for Gerona province, announced an investigation into "everything concerning the Dalí affair." It was said that Dalí was unattended on the night of the blaze by his own instructions, and he insisted on the door being closed. After the fire, he refused to be taken to a hospital, finally relenting

only on the condition that he first be allowed to visit his museum in Figueras, some fifty miles in the opposite direction. Dalí reportedly spent twenty minutes outside the museum, viewing the recent addition of a stack of twenty tractor tires topped by a classical statue and a twelve-foot-long fishing boat that had belonged to Gala. "We must do more things, we must do more things," Dalí muttered before being carried back to his car and taken to Barcelona.

Those who had been denied access to Dalí for years arrived on the scene and made further allegations. Pierre Argillet, the owner of Galerie Furstenberg in Paris and publisher of numerous Dalí etchings, said authorities "must find out why close friends were prevented from visiting, why letters and telephone calls never got through. It is nonsense to say Dalí was too ill mentally or physically. A man needs friends at such times."

Argillet and Descharnes confronted each other at the Ritz Hotel in Barcelona, in the presence of reporters. Descharnes says the clash occurred by chance, the Ritz being the favorite gathering spot for the Dalí crowd. According to reporters' accounts, the two men exchanged insults, and Argillet, a few years older than Descharnes but huskier, threw a punch at Descharnes. The two men were separated by other hotel guests.

"If we meet again," Argillet said afterward, "I will not hesitate to try to punch him again. I have been an intimate friend of Dalí for twenty-five years. Now, if I call up the castle, they say, 'He does not wish to see you.' I do not believe it. There is always Robert Descharnes or one of the others to turn us away. It is as if they thought we would interfere with their arrangements. They have organized a sort of prison around him. Either it is because he is easily frightened or it is because of business and money and they fear old friends like me might interfere."

Years later, still angered at Argillet, Descharnes claimed it was Dalí's wish that Argillet and others be turned away. "Many people like him tried to come to visit Dalí, and came to Figueras [in my absence], because I was not there all the time. Dalí had complete freedom to receive or not to receive people, but he didn't want to receive people," Descharnes asserted. "[Dalí] did not want to [be seen] with his disease."

Anna-Maria, Dalí's seventy-seven-year-old sister, also arrived from Cadaqués, not having seen the artist for thirty-five years, and publicly criticized the triumvirate. She was allowed into Dalí's hospital room, but the artist was silent. Within moments, he tried to rise from his bed to physically eject her from the room. So there was at least some truth to Descharnes's argument that Dalí was refusing to see people by his own desire.

Among the critics was A. Reynolds Morse, the American collector who had known Dalí since his first acquisition of a Dalí painting in 1943 and who had amassed the world's largest collection of Dalí works. Morse had remained loyal to Dalí through the years, tolerating Gala's occasional rude outbursts, but he was bitter about having been turned away from Pubol in October 1983 by Domenech. Dalí had become "surrounded by jackals waiting for the corpse," Morse surmised.

Descharnes says he has doubts about the relationship of Dalí and Morse, suggesting Morse was often aggressive in trying to influence Dalí about his personal and business affairs. "Morse is a typical American businessman, typical," Descharnes contends, "and he thought Dalí managed his affairs badly. And many times I said to Morse, 'You have no right to interfere in the Dalí business affairs. If Mrs. Dalí wants to lose all the money in a casino in Monte Carlo, that is our problem. If they want to lose money by inviting girls and boys to a famous restaurant in Paris, it is not your life. You want to manage all things Dalí.'" Descharnes suggests

that Dalí and Morse were on vastly different wavelengths, leading to frequent disputes between the industrialist and the surrealist with a paranoiac-critical method. "It was not so simple, the empire of Dalí. I think . . . the reason for [their] disagreement [was that] Morse talked directly, like a pragmatic man, and Dalí confused everything for Morse continuously."

In October 1984, Dalí had recovered sufficiently from his burns to be released from the hospital. He was taken in his Cadillac not to Pubol but to Figueras, where he was provided a three-room suite in the Galatea Tower, adjoining the museum. Dalí was said to be depressed and gaining weight, and so his windows were unshuttered during the day, but he remained morose, awaiting death.

Worldwide accounts of the fire at Pubol had been accompanied by reports of the growing numbers of Dalí prints on the market and allegations of presigned papers awaiting their turn in the press. The time had come for Dalí to end his involvement in the scandalous proliferation of "Dalí art."

In March 1985, *El País* quoted the artist as acknowledging that he had signed blank pages, but not the 350,000 claimed by Captain Moore. "The figure is incredible, because it would have been physically impossible for me to do it," Dalí was quoted as saying. Descharnes had issued statements in March 1982 and June 1984 disavowing any involvement by Dalí in the burgeoning supply of prints attributed to him. But Descharnes's efforts, too, had seemed to have no effect.

Was it really possible for Dalí to denounce a practice in which he had played such a central role? Could he accuse everyone who had surrounded him of being fraudulent while claiming to be blameless? Was Dalí somehow innocent?

"What a figure Dalí cut!" A. Reynolds Morse wrote in his diary in 1980. "No wonder we were such easy dupes, for

he was all along a magnificent—and shall I say it?—fraud, because he lost control of his own destiny to con men who had perceived that his own greed was rooted right in his own immortal soul."

It was Dalí who amused himself instilling corruption in others. Michael Stout tells of Dalí at a restaurant, goading and teasing those dining with him to tuck away in their pockets a salt or pepper shaker or a piece of silverware. When Dalí's companion would reluctantly do so, the artist would display wicked delight.

Once, during a dispute about money missing from a bank account the Dalís kept in Zurich, Captain Moore sought understanding from Stout. "If you have a trustworthy man who loves you and never has any intention to steal or drink your liquor, and every day you look at him and say, 'Did you drink my whiskey today?'" Moore told him, "finally, the man's going to take the fucking bottle and drink it."

"And that's true," Stout says. "The Dalís were very bad to the people who worked for them, very bad. And they were all vulnerable people who wanted somehow to promote themselves. They were people without education, people without family backgrounds, insecure people who saw a glimmer of fame and possibility, and they seized it, and then began to resent [its source]."

Dalí's dealings with art publishers may have been motivated by his fascination with the ideas of Hitler and Franco.

"It is all a great game to Dalí, one he loves playing, pitting Jewish publisher against Jewish publisher, exploiting both Catholic and Jewish themes to the hilt, the better to catch more suckers with his famous name," A. Reynolds Morse recorded into his diary in 1971.

Three years later, Morse confirmed in his journal that the Dalís looked down their noses at the Jewish art dealers who approached them. The Dalís, practitioners of bad manners, enjoyed ridiculing among themselves the manners of

the Jewish dealers. Gala trusted few people and these only barely, so it was consistent that she refused to permit deals to be made on a promise-to-pay basis. Every deal had to be payment-up-front—preferably in cash. The Dalís' not-very-veiled anti-Jewish sentiment surfaced again and again. In demanding that everyone pay in advance, they blamed their position on bad experiences with Jewish art dealers.

Kitty Meyer, the New York art patroness involved in the tarot dispute, remembers scolding Dalí in the lobby of the St. Regis Hotel. According to Meyer, Dalí left and called Peter Moore down to the lobby.

"Peter Moore came down," Meyer says. "It was three o'clock in the afternoon in the lobby of the St. Regis, and he started screaming at me that I should be burned in Auschwitz, or that people like me should be burned at Auschwitz. He was spitting at me . . . I didn't know what to do."

Meyer sought no further business with Dalí, but many others did. At galleries in Europe and across the United States, Dalí graphics were among the hottest items on the art market, or at least what claimed to be an art market.

Real or Fake?

New York
in Dalívision

Andrew Weiss was greatly agitated. The twenty-seven-year-old Washington, D.C., art wholesaler had left a Miró lithograph on consignment in the booth of Art Fair gallery owner Alan Klevit at the Art '78 Exposition in the D.C. Armory, and it was branded a fake. Gallery Maeght, the Paris gallery with a branch in New York, had a booth at the exposition and had complained to Art '78 organizer Elias Felluss, who told Klevit that the Miró would have to be removed. According to Felluss, Weiss later came to his office, where the print was being held, and punched him in the nose.

Weiss earlier had approached Tom Wallace, who was attending the exposition with his brother-in-law, Long Island art dealer Phil Coffaro. Weiss protested to Wallace that he was being unfairly accused, that his Miró lithograph was real and that he was going to sue the accusers. Wallace said nothing. He had learned quite a lot about art during his weekly routine of driving Coffaro from gallery to gallery in Manhattan to avoid parking tickets. He had listened to Coffaro complain about fake prints in the market that were undermining his own business. Wallace looked at the Miró print, and it did not seem right. It looked flat. The color lacked the vibrancy of a Miró.

Tom Wallace's full-time job was that of a policeman in New York's Nassau County. Upon his return to New York, Wallace heard more about fraudulent artwork being sold all over the country and approached his boss about investigating the situation. He was told to do so only if there was evidence of a crime in Nassau County. Soon afterward, the thirty-two-year-old beat cop said he had found such evidence.

"The information we got was that Metropolitan Art Associates in Lake Success was the major mover of these things, and based on what Coffaro told me, Metropolitan was his biggest competitor," Wallace recalls. A dealer told Wallace he had bought a Chagall lithograph, *Little Peasants*, from Metropolitan, and his children had picked out numerous discrepancies in color and drawing after comparing it with a picture of the lithograph in an art book.

Wallace was teamed up with Detective William O'Rourke, a twenty-two-year veteran of the police force. O'Rourke had been on the special investigation squad and had an interest in antiques, old photographs and memorabilia. The officers enlisted the assistance of Henriette Alban, a representative of the Manhattan office of Gallery Maeght, the U.S. distributor of Chagall prints. While Wallace remained in his car—one of the principals, a man named Richard Greenberg of Metropolitan Art Associates, may have known who he was—O'Rourke and Alban went to the gallery and bought what was represented to be a Miró lithograph titled *A Woman Picking Grapes*. They ordered several other questionable pieces and returned days later to pick them up.

Richard Greenberg was called in to the district attorney's office and questioned about the prints. He told the authorities he had bought them from Melton Magidson, a Manhattan wholesaler who also owned a gallery in San Francisco. The officers went to interview Magidson. First

terrified for his safety, Magidson was given assurances of protection and divulged the names of his suppliers: Andrew Weiss and, ultimately, Charles Piovenetti.

Piovenetti was a young, defrocked priest and the son of a wealthy Puerto Rican family. Wallace and O'Rourke visited Piovenetti's apartment in an elegant brownstone in Manhattan. He balked at answering any questions until he had seen his attorney. A few days later, he and his lawyer, Louis Nizer, appeared at the district attorney's office in Mineola. Piovenetti agreed under a grant of immunity from prosecution to divulge all he knew, which turned out to be an excellent strategy.

"We thought we were getting close to the source," Wallace recalls. "We never thought we had the source." In fact, Piovenetti confessed to being the forger they were seeking. He had created eight Chagall lithographic editions, a half dozen Mirós and one or two Victor Vasarelys. Most were well-executed copies of actual prints, but two of the Mirós were pure fabrications created in Miró's style. Piovenetti had commissioned artisans to prepare the printing plates and pull the prints, and Piovenetti had signed Miró's name.

Piovenetti had once worked as an independent salesman for New Jersey graphics publisher Leon Amiel, and Wallace figures he must have learned his techniques at Amiel's printing plant. Amiel was asked by Wallace to examine the fake prints. "He showed us how they were done wrong, got us involved with the printer at his shop and showed us the technique of manufacturing. He was very helpful," Wallace recalls.

Andrew Weiss, who was indicted by a Nassau County grand jury for grand larceny, pleaded guilty in April 1979 to the misdemeanor of petty larceny for selling alleged fakes to the public and was sentenced to three years probation. Weiss returned to the art business and became a reputable dealer.

Richard Greenberg pleaded guilty to a charge of scheming to defraud, was given a six-month conditional discharge and was ordered to pay $3,800 in compensation to victims. Metropolitan Art Associates was fined $1,000.

In September 1980, a judge dismissed all charges against Magidson, ruling that the grand jury had not been presented enough evidence to show that the forty-three-year-old wholesaler realized the art he was selling was fake.

In August 1981, Tom Wallace took early retirement from the police force and attempted to establish a career setting up security systems for art galleries and conducting private investigations. Unsuccessful in his endeavor, he began working after only a few months as an independent salesman for his brother-in-law Phil Coffaro, who was being supplied Dalí prints by Leon Amiel. In the eyes of subsequent investigators, Wallace the sleuth had become a player in the Dalí fraud.

As the Metropolitan Art case was being put to rest, telephone calls started going out to people's homes from a toll-free number on Madison Avenue.

"Good morning, Mr. Smith," the caller said. "My name is Martin Fleischman. I'm calling long distance from New York. Can you hear me all right? Good. I'm with an art collecting firm here in New York called Original Fine Art. You're probably not familiar with us, but we're the firm that helped pioneer the concept of collecting art for esthetic [reasons] as well as potential capital appreciation.

"Now, the only reason for my call today, Mr. Smith, is to generate some interest in this concept and furthermore to assure you that we're different because we're willing to prove ourselves before asking you to do any business with us. And the only way we can prove ourselves is to send you our credentials, as well as a series of reprints about us from credible sources.

"Now this information is complimentary, Mr. Smith, but I'd like to ask two things of you. Will you promise to read it over and not just throw it out?" Fleischman insisted on an affirmative answer. "Fine. And if after reading our information you like the program and you're satisfied that collecting art can be potentially profitable yet safe and may be beneficial to your tax position, would you be willing to make a small purchase with us as a trial offer? The amount of this initial transaction is not important, let's say two or three thousand dollars." A pause. "Some people have started with less than a thousand dollars. Is that a possibility, Mr. Smith?"

Fleischman explained he was not asking for any immediate commitment but wanted only the opportunity to send Mr. Smith some material. "Let me assure you, the only time we'll contact you is when some important news comes up, do you follow me, Mr. Smith?" He asked if Mr. Smith would prefer being called at his home or office and noted both phone numbers along with his mailing address. "Thank you, Mr. Smith. Please remember our name, Original Fine Art. And do give our information your attention. Thank you."

A few days later, Mr. Smith received in the mail a brochure that screamed: "$50,000 for a $2,000 Investment? It's happening for knowledgeable Investors/Collectors of Art in the ORIGINAL PRINT MARKET." The brochure pointed out how three prints by Picasso, Miró and Chagall had demonstrated that very potential. "The prospect for capital appreciation provides not only a real reason for investing in Art, but at the same time an excellent excuse to buy what one loves," it trumpeted. Art terms were explained. A prestigious group of dealers, publishers and museum curators called the Print Council of America had decided in 1961 that an original print was one in which "the artist alone has created the master image" on the printing plates, and that definition was included and, by implication, adopted in the

brochure. Each print sold by Original Fine Art would include a certificate of authenticity, which "gives our clients the necessary assurance that they are buying a bona fide, pencil-signed, Limited Original work of Art," it stated. "As an added protection, we also offer our clients the privilege of our exclusive 30 Month Exchange Policy should they for any reason, within 30 months of their purchase, wish to rearrange or change the focus of their Art portfolio."

The sales technique was as successful in this case as it has been for boiler room telemarketing operations involving other goods, from magazine subscriptions to Florida swamplands. For Fleischman, it was not entirely unlike his prior work. In the 1960s, he had sold stocks in New York. In the 1970s it was land in Nevada. Those ventures had been disastrous, resulting in what Fleischman regarded as unfair fraud charges brought against him. He had pleaded guilty to a securities fraud charge, even though, he maintained, the stock had doubled fifteen times. His later conviction for land fraud arose from a case in which he failed to pay back seven thousand dollars borrowed from a client at a time when Fleischman was addicted to drugs. In both instances, he later would claim plaintively, his clients had made money.

After less than two years of working for a man named Howard Ray at Original Fine Art, Fleischman at age forty-six was convinced he had found his calling. He became engaged to Carol Convertine, a twenty-nine-year-old department store clerk who had managed a boutique in Cincinnati, and together they decided to start their own art business. They installed their new enterprise in the fall of 1982 in the commodities brokerage offices of acquaintance Dennis Huculiak on West Street in Manhattan. Five desks and telephones were arranged in a barren, carpetless room of the third-floor offices. Salesmen, whom they called "qualifiers," were hired to work the phones, using the same script Fleischman had used when he worked for Howard Ray. Convertine Fine Arts

Limited, owned by Convertine (with Fleischman standing beside her) and Huculiak, was ready to operate, and it set about acquiring prints it could sell.

From Jordane Art Works, Convertine bought Picassos signed by Marina Picasso, the artist's granddaughter. Marina Picasso had sold the reproduction rights of one thousand paintings to Jackie Fine Arts of New York and its associate, Art Masters International, Inc. Jackie Fine Arts, which already had rights to eighty-seven Picasso works, planned to reproduce them in limited editions, to be signed by Marina and to be represented as coming from her collection.

Picasso's three children and a grandson filed suit against Marina, and the case was settled out of court. Jackie Fine Arts and Art Masters International were allowed to go ahead with the publishing. Ergo, Picasso graphics aplenty were available for "limited edition" dealers. Jordane apparently had acquired some of the prints from Jackie and sold them to Convertine.

Convertine prepared catalogs that included Dalí and Alexander Calder prints distributed by A.D.L. Fine Arts on Long Island. The owner, Andrew D. Levine, provided certificates of authenticity for Dalí prints bearing such titles as *Hallucinogenic Toreador, Gala and the Tiger, Diamond Head, Angel of Port Lligat* and *Wailing Wall*.

Loaded with prints, Convertine advertised for sales people to complete the operation, and they attracted an assortment of characters, many of whom quickly went on to form their own competing ventures. For example, James Burke was in a halfway house in Suffolk County, having served a prison term for grand larceny, when he noticed Convertine's classified ad for salespeople in late 1982. Burke's CB radio business had turned into a disaster, and his bouncing of checks brought about his conviction. Large debts remained from the venture. The Suffolk County proba-

tion authorities approved Burke's employment at Convertine.

A chess enthusiast, Burke met chess teacher Larry D. Evans while working at Convertine, and the two men decided in January 1983 to start their own gallery—Larry D. Evans Galleries Ltd. Two months later, the name was changed to give it an air of British-sounding dignity—to Barclay Galleries Ltd. Add to that a lovely British accent: Prudence Clarke, a fifty-eight-year-old English woman who came to the United States after serving in the British army during World War II, had received her training at Howard Ray's Original Fine Art.

Soon after Burke defected from Convertine and Fleischman, Dennis Huculiak decided to set up his own rival company, which he named Worldwide Fine Art. Carol Convertine threatened legal action, and Huculiak agreed to sever his ties to the Convertine business, which then moved out of his offices to Madison Avenue and changed its name to Carol Convertine Galleries.

Another Convertine salesman, George Brandt, departed and established Pierre Galleries, selling Dalí prints obtained from the same source he had used during his days on Madison Avenue with Convertine.

Roy Goldsmith left his Barclay sales job and went to work for Caravan de France, but that employment was brief. Caravan de France owner Alberto Cernishi discovered that Goldsmith had encountered legal problems for boiler room activities and fired him. Goldsmith promptly founded Caravan Galleries and applied the techniques he had learned at Barclay.

Richard Greenberg's Metropolitan Art Associates had remained in business after Wallace's investigation and Greenberg's guilty plea. To be safe, Greenberg now relied on Phil Coffaro (for whom Wallace now worked) and Coffaro's regular supplier, Andy Levine's A.D.L., for his Dalís.

As editions of Dalí prints multiplied, so had the number of outlets where they were being marketed. By early 1984, a print collector in New York could buy a Dalí at Original Fine Art, Convertine, Caravan, Barclay, Pierre, Metropolitan, Worldwide and others. Also by then, some of the purchasers of those Dalí prints realized they had been stung. They filed complaints with the Better Business Bureau of Metropolitan New York and with the New York attorney general's office.

Complaints registered with the attorney general's office in the World Trade Center were referred to Judith Schultz, a spirited deputy attorney general who had successfully prosecuted a securities fraud case involving artworks. Schultz reviewed the complaints and subpoenaed the Better Business Bureau's files of similar grievances.

Most of the complaints were aimed at Original Fine Art, aptly named not for the artworks it sold but for its embryonic role in the Dalí fraud at the retail level. Schultz sought out owner Howard Ray, but he was nowhere around, having left his operation in the hands of a woman named Bellette Hoffman. Schultz subpoenaed her on behalf of the attorney general's office and demanded to know Ray's whereabouts. "He is on vacation," Hoffman answered. Pressed further, she allowed that he was staying at "a special hotel" in Toronto. Did she remember the name of this hotel? Well, Hoffman said, she thought it was a jail.

"That's how you had to drag the information out of these people," Schultz says. Schultz contacted the Canadian Mounties and learned that Howard Ray was serving a jail term for stock fraud in Canada and was phoning his instructions to Hoffman from prison.

Meanwhile, Schultz began exercising her office's power to issue subpoenas for documents in cases where fraud has been alleged in the sale of investment contracts. One subpoena had gone to a bank that handled the account of Barclay Galleries. A perplexed bank officer phoned Schultz.

"Well, now, whose subpoena am I supposed to comply with first?" the bank officer asked.

"You have another one?" Schultz asked. "I'll tell you what. Why don't you tell me who signed the other subpoena and we'll work it out."

The other subpoena bore the signature of Robert DeMuro, a U.S. postal inspector in New York. DeMuro had been forwarded a complaint by Dr. Robert Farner, a physician from southern Illinois who had bought a Dalí print titled *Discovery of America by Christopher Columbus* from Barclay Gallery after answering the telephone sales pitch.

Schultz phoned DeMuro and found they were two Lone Rangers in pursuit of the same culprits. "He had a grip on what was way too big for him to handle, and I had a grip on what was way too big for me to handle," Schultz says. "I think I probably had a broader investigation in terms of the number of subjects. I think he had a deeper investigation into Barclay. We finally agreed that neither one of us was going to get our ego up and do the usual, competitive I'm-going-to-beat-you-to-the-courthouse game." A beneficial partnership was formed.

Schultz and DeMuro sought deeper knowledge into what they both agreed was a vast international fraud. For much of their information, they had only to board a subway that in twenty minutes took them to a small apartment in a brownstone in the Queens neighborhood of Astoria. There they found a retired high school mathematics teacher with a propensity, if not an obsession, to collect things. Atop the kitchen counter was a stack of food coupons clipped from the newspaper. Tucked away elsewhere in the apartment was one of the best playing card collections in the world. Most important, in bookcases, drawers, file cabinets and closets was almost any information anyone would want to know about Salvador Dalí.

In 1941 Albert Field had gone to a Dalí retrospective at the Museum of Modern Art in Manhattan and Dalí had given him his autograph. Field returned to the exhibit several times and became as addicted as one can be to an artist's work. From that point, Field began collecting any information he could about Dalí's works, from libraries, MOMA and media accounts. He wrote onto three-by-five-inch cards the titles of Dalí's works, both in English and in other languages, dates, dimensions, ownership—everything he thought was important to identify a piece.

In the early 1950s—Field forgets the exact year—he began to wonder if his labor could be put to use, and he made an appointment to meet with Dalí at the St. Regis Hotel. Field told Dalí about his card file and asked if there existed a catalogue from which he could draw more information.

"No, no, no. No catalogue," Dalí replied.

"Well, is it all right then, if I make the catalogue?" Field asked.

"Perfect, perfect," Dalí responded. "You are the catalogue."

Field had been granted a special mission in life as Salvador Dalí's archivist, the person to assemble the complete record of the artist's works, his catalogue raisonné. On February 17, 1955, Field returned to the St. Regis and formalized the agreement. Dalí placed his famous signature on a document Field had prepared on MOMA stationery provided by the museum's librarian, asking that owners of Dalí works cooperate in the cataloguer's quest for information. Through the years, Field would return to the St. Regis to have Dalí sign further affirmations of the arrangement. In March 1971, Field had Dalí sign a declaration that it was "now time to begin the publication of the catalogue raisonné, with Mr. Field as editor."

Field had underestimated the task; Dalí works were pro-
liferating at a rate greater than he could track. He became
flooded with reports of print editions to which Dalí had
given his blessing, if not his hand, and Field meticulously
recorded the data.

When Schultz and DeMuro arrived at his apartment,
Field gave them access to the information he had amassed.
Field examined prints the two investigators had been given
by purchasers, compared them with what he had compiled
and gave his opinion, that of a self-acknowledged single-
artist expert. Aware of the Print Council of America's defini-
tion of an original print, Field nevertheless refused to regard
Dalí's shortcuts as unethical. His word for such items was
"legitimate," although not original.

"The artist does not work on the plates for each separate
color," he explained. "No, in all of the images, the perfectly
legitimate ones, they are done by a chromist, and the artist
signs a *bon-à-tirer* when he is satisfied the work has been
done as he wants it to be done."

That did not mean just any hand-produced reproduction
gained legitimacy in Field's estimation. One of his condi-
tions was that Dalí had to have created the image for the
very purpose of having it made into a print. Convertine's
prints—mere reproductions of the paintings *Discovery of
America by Christopher Columbus, Venice Reconstruction,
L'Aventure Medicale* and *The Dentist*—did not meet that
criterion. On the other hand, Field regarded *Lincoln in
Dalívision* and *The Great Masturbator* prints as original
because Dalí had doodled a remarque onto an etching plate,
and the doodle has been added onto what otherwise would
be mere reproductions of paintings. If Dalí wanted it that
way, so be it.

Field's liberal standards were adequate for the immediate
purposes of Schultz and DeMuro. The prints being marketed
by the New York boiler rooms were reproductions and little

else, and they were being sold not only as legitimate but as original prints. Scholars, museum curators and other experts could explain the difference between an original print and a reproduction. The average man in the street could not.

Caron Caswell was schooled in art history at Yale University, apprenticed at the Metropolitan Museum of Art and at the time of the Convertine investigation was art director and production manager at the New York Graphic Society, the world's largest publisher of fine art reproductions. She is an expert in both lithography and the print market. When shown Convertine's Dalí prints, Caswell pronounced them not only reproductions but also bad ones. They were of no value. Caswell had not seen the original *Notre Dame* by Picasso, but she estimated the *Notre Dame* print would be worth twenty-five dollars if it were an accurate reproduction. It did not even bear Picasso's signature; instead it was signed by Marina Picasso, his granddaughter.

In November 1984, DeMuro had Dr. Farner, the Illinois victim, place a call to Barclay and express interest in adding other prints to his *Discovery of America*. Barclay salesman Jeffrey Kasner immediately launched into a lengthy account of the recent fire at Pubol that had caused severe burns to Dalí, already ailing from depression and old age.

"All of these tragic circumstances combined, along with the recent fire, mean that it should only be a matter of time before we lose him," Kasner reported sadly. "Um, you know, we all regret losing him, but the ironic thing for the art market is that when an artist dies, suddenly his art goes up, usually doubles within the same year."

Kasner urged Farner to buy *Caesar in Dalívision*, figured to be "the last one he'll ever produce."

"He didn't physically do the entire thing himself," Kasner added. "He has not been in the kind of health in which he is permitted to do the entire thing himself. But he did supervise the process, the mixing of colors, and of course he individually signed and numbered each one. That he has to do." Kasner arranged to send a new portfolio to Farner.

Indeed, *Caesar in Dalívision* was something special. Initially, like Convertine, Barclay bought its Dalí prints from distributors. Los Angeles dealer and publisher Basil Collier suggested Barclay could enter the publishing business instead of relying on others. It was just a matter of checking with SPADEM, the French copyright protector, to find out what was available. Larry D. Evans says he did just that and learned that a 1930 Dalí painting titled *Horse, Lion and Sleeping Woman* was available. SPADEM director Jean-Paul Oberthur advised him that Gilbert Hamon owned the copyright. Barclay entered into a contract with Hamon, used a printing plant recommended by the Frenchman, had the image printed on a thousand sheets of paper presigned "Dalí" and supplied by Hamon, and renamed the piece *Caesar in Dalívision*.

Barclay also contracted with Hamon for permission to publish Dalí's *Madonna of Port Lligat*, but withdrew after discovering the image was already on the market elsewhere. The gallery went ahead with publication of a second image, from a 1930 Dalí painting called *Ossification prématurée d'une gare*, after securing both the rights and the presigned paper from Hamon.

Barclay applied creativity to even those prints acquired from distributors. After buying black-and-white Dalí etchings titled *Cosmic Warrior, Cosmic Passage* and *Cosmic Arena* from Coffaro, the gallery sent them to a Long Island art teacher named Lucy Taylor, whom they paid fifteen dollars an hour to watercolor them so they could be sold as "original hand-colored etchings . . . by Salvador Dalí."

All the prints, those published by Barclay and the ones acquired from distributors, were printed on sheets of paper presumedly presigned by Dalí. But did they really bear Dalí's signature? If the sweeping Dalí inscriptions on the prints attributed to him were authentic, Caswell suggested they might have some greater value. "You pay a premium, certainly, for the artist's signature," she said. Both Field and Michael Ward Stout were convinced they were not. Most of the prints being marketed had been published after Dalí became ill in 1980. Field and Stout considered the reports of presigned paper beyond those actually signed in the Lyle Stuart settlement to be greatly exaggerated. How was one to determine that a print published in recent years had not been printed on paper Dalí had signed long before? DeMuro and Schultz found the answer at the New York office of Special Papers, a division of Arjomari, the French company that manufactures Arches art paper and the softer and whiter Rives paper, on which most of the Dalí prints had been made. In 1979, because of the difficulties of compiling documentation to answer quality claims against the company, Arjomari began affixing a watermark, an infinity symbol, to its paper.

Depending on its placement and an additional sign, such as a tiny pyramid or a zero, the company could trace the year, month, even the mill run of a piece of paper. The company then could determine how much moisture was put in the paper, the type of rag or cotton used, or whether there was any problem in the manufacture. The watermark served another purpose for DeMuro and Schultz; it could prove that a sheet of paper Dalí had allegedly presigned had not even existed at the time Dalí was supposed to have signed it.

Discovery of the watermark's significance buoyed DeMuro and Schultz. They felt they could show in court that the artist had been too ill after 1980 to sign large amounts of art paper. "I was absolutely convinced we could

prove this case through direct and circumstantial evidence without Dalí himself having to testify," DeMuro recalls.

In April 1985, the Postal Inspection Service and the New York attorney general's office executed a search warrant and raided the premises of Barclay and Convertine galleries, conveniently located on Madison Avenue across from each other, interrupting a chess match between James Burke and Larry D. Evans. Also raided were a second Barclay phone operation in Stamford, Connecticut, and a walk-in Barclay gallery in Southampton, Long Island. The authorities seized an array of prints attributed to Dalí and Picasso along with the business records of both galleries.

The raid effectively shut the galleries down, just as Barclay was preparing to open a new outlet in Scottsdale, Arizona. In little more than two years of operation, Barclay had grossed $3.4 million from sales to more than a thousand people. Convertine's take was more than $1.2 million. Federal and state grand juries were assembled and began hearing evidence not only about Convertine and Barclay but also about Caravan, the Roy Goldsmith offshoot of Barclay.

The issue of the legitimacy of the Dalí signatures remained a potential problem. DeMuro held discussions in New York with Michael Stout and Robert Descharnes. DeMuro thought it important to get Dalí's side of the story, if possible. Descharnes agreed to approach Dalí about signing an affidavit attesting to the limits of his signature.

Thus, on June 1, 1985, Dalí scratched his name onto an affidavit before a notary public in Figueras. It read, in part: "Many abuses are committed which cause serious damage not only to me but also to all the collectors of my works: reproductions without my authorization, reproductions effected pursuant to questionable agreements or contracts, violation of my moral right and lack of respect [for] the original works after which the reproductions are effected, Dalí reproductions adorned with signatures that are not my own,

reproductions or prints which represent works of which I am not the author, but which are attributed to me, reproductions or prints labeled without any reason as original, when I have not participated in its issuance. . . .

"In the face of this situation I remember to have already taken the initiative of calling the public's attention by means of official announcements . . . and I stress particularly that after my arrival in Paris on December 23, 1980, I have stopped signing blank sheets intended for printing, or otherwise."

It closed: "The abuses I denounce and of which I am the first victim, as they concern my reputation and the integrity of my work, are a social phenomenon against which the creator is helpless."

The affidavit was all encompassing, but Stout felt it was not encompassing enough. Stout, who drafted the affidavit for Dalí, had used the date December 1979, the last time the Dalís arrived in New York. This date, however, was mysteriously changed to December 23, 1980 by Robert Descharnes. Stout knew Dalí had occasionally signed his name to official documents after returning to Europe in February 1980, but he could not imagine that Dalí had the strength or was willing to sign limited editions or blank sheets in 1980. Stout contacted Descharnes and asked for clarification. Descharnes approached Dalí again, and, a year after issuing the affidavit, Dalí again signed a statement that he had signed "no blank paper suitable for printing graphic works during 1980, and I signed no complete or whole editions of graphic works that year. In fact, I only signed my name during the entire year of 1980 fewer than one hundred times, which includes not only works by me, but documents, affidavits, contracts, checks, drafts, notes, etc." The requested clarification extended the period back nearly a full year.

DeMuro and Schultz realized the rules of evidence probably would prevent them from using the Dalí statements in

any criminal trial. Still, they could be presented to grand juries, which are allowed to consider hearsay, and thus they did serve to simplify the situation.

In February 1986, a New York state grand jury returned indictments against Martin Fleischman, Carol Convertine, Dennis Huculiak and Dennis Flanagan of Convertine Galleries, and Roy Goldsmith, Jason J. Fern and Dean Thomas of Caravan Galleries, charging them with conspiracy, grand larceny and securities fraud. Schultz broke new legal ground by alleging securities fraud in the sale of artwork, as she believed New York's liberal standards allowed such a charge.

Soon after obtaining the indictment, Judith Schultz was appointed an inspector general by New York Mayor Edward Koch, leaving prosecution of the case in the hands of Deputy Attorney General Rebecca Mullane. In a landmark decision, but one that would not extend beyond New York's boundaries, New York Supreme Court Justice Howard E. Bell ruled on October 9, 1986, that the charge of securities fraud was proper. Caravan Galleries, according to the state's allegations, "not only distributed brochures which characterized prospective purchasers as investors, they also made statements to such purchasers which led them to expect large profits," Bell wrote. Thus, each sale amounted to "an investment contract security," under New York law.

In the Convertine case, Huculiak and Flanagan struck plea bargains with the state, leaving Fleischman and Carol Convertine to go to trial in February 1987. Carrying the baggage of his earlier convictions, Fleischman did not testify, but his wife Carol maintained to the jury that she believed the representations made to purchasers to be true. She understood original prints to be those created by the hand of the artist, and certificates of authenticity provided by distributors described them as original. Even the Picasso print was made from a plate prepared by him, she insisted.

"I know what I believed at the time and I know what I still believe now," Convertine testified, despite having heard expert testimony in the courtroom to the contrary.

She added that she continued also to believe that fine prints—the Dalís and the Picassos—would grow in value.

"What about your prints, the ones you were selling?" Mullane asked.

"I do believe they will appreciate, too," Convertine replied.

Initially, so did numerous investors, including Dr. David Riley, a dentist from Rossberg, Virginia. Dr. Riley was impressed with the knowledge of art displayed over the phone by Fleischman, although he grasped little of it. "If he was talking about how to do a root canal or something like that, I could have figured that out, but he was talking about how to make this lithographic plate," he told the jury. Dr. Riley explained that he understood fully what Fleischman said about the investment value of *Discovery of America;* a $3,000 investment would be worth $5,000 in only two years and, when Dalí died, it would skyrocket. Dr. Riley made the purchase and, well, waited for Dalí to die.

"I don't want to be morbid," Dr. Riley told the jury. "I was sort of excited, like Mr. Fleischman. We were talking about the guy dying and you sort of get excited. You pick up the paper every morning to see if old Sal died."

Dr. Riley then bought another Dalí piece called *Homage to Aphrodite,* which either the gallery or distributor renamed *Gala and the Tigers.* He received it in the mail at his office. "I opened it up after work and looked at it and I chucked it right back in the box, taped that sucker up and put it in a corner, the ugliest thing I ever saw in my life. I mean this thing was like, you know, *Nightmare on Elm Street.*" The good dentist considered returning the print but, after talking to Fleischman, remembered he had bought it purely for investment purposes, so he kept it in the box.

While the state used Field, Stout and Caswell to knock down the gallery's claims about originality and investment potential, the defense had found its own expert: Richard Ruskin, a Los Angeles art dealer and appraiser. He had worked for Abe Lublin's ambitious print-marketing operation for seven years and had gone on to Circle Galleries, to London Arts, a mass-marketing enterprise in the 1970s headed by a former American art history instructor, and to Alex Rosenberg's Transworld Art before going into business for himself in 1978. For one year, he directed one of Upstairs Gallery's eight outlets in California. Ruskin said he had agreed to testify in the Convertine case without pay to help "see the market cleaned up so there is some validity to it."

Ruskin said Convertine was incorrect in calling its Dalí graphics "original," which he agreed "means the artist actually worked on the plates." Still, Ruskin maintained the gallery had not overpriced them. *Discovery of America*, for example, was worth twenty-five hundred dollars, even though Dalí had nothing to do with making it. Its value, he said, was "based upon what is available in the market, and what the publishers and distributors publish it [the price] at." Ruskin's expert testimony was not aided when, under questioning by prosecutor Rebecca Mullane, he acknowledged having twice taken the examination to become a senior member of the American Society of Appraisers, and having twice failed.

As for the charge of misrepresentation, Arien Yalkut, Carol Convertine's attorney, contended that his client was just passing on information that was given to her. If Andrew Levine of A.D.L. Fine Arts knew he was selling counterfeit Dalí prints, he asked, would he have advised the purchaser?

"Not likely," Yalkut told the jurors. If Levine had lied about the prints to his client, he added, his client should not be held criminally responsible. "A.D.L. Fine Arts is in business today. They continue in business unimpeded."

In fact, Postal Inspector DeMuro, working together with the state attorney general's office, had determined that Levine, a major Dalí supplier, was culpable under New York State law. Levine had been offered plea agreements but turned them down out of respect, or fear, of Leon Amiel, his main print source, according to DeMuro. In the end, Levine was never prosecuted.

Mullane suggested to jurors that Fleischman and Convertine should have known that Levine's Dalí prints were fakes. In order to obtain the kinds of prints being sold at Convertine, she said, "You've got to tap into the counterfeit market. You have to tap into the art underworld. You have to find the creatures like Andy Levine who will sell the stuff to galleries all over the place. That is why you pay a [low] price. It is an illicit market."

Most important, she said, Fleischman and Convertine knew what they were paying for the prints and what they were charging Dr. Riley and the others. The average price paid by the gallery for *Discovery of America* was $217; its average retail price was over $2,000. Nearly all the other Dalí prints were bought for less than $300 and sold for more than $1,300. Fleischman and Convertine "didn't even have to know whether they were selling counterfeit or not," Mullane maintained. "The price differential alone is enough."

Indeed, it was enough. On February 20, 1987, the jury returned guilty verdicts to nine felonies for both defendants. Later that year, declaring Fleischman to be a con man and Richard Ruskin, the defense expert, "undoubtedly a charlatan," Justice Robert Haft sentenced Fleischman to a prison term of two and a half to six years. The judge ordered Carol Convertine to serve weekends in jail for six months and placed her on probation for four and a half years.

All three defendants in the Caravan case, which was scheduled for trial a month after the Convertine case,

entered into plea bargains with the state of New York and were placed on probation.

On October 3, 1988, a federal grand jury finally returned a fifty-count fraud indictment against James Burke, Larry D. Evans, Prudence Clarke and Jeffrey Kasner of Barclay Galleries. The cases never went to trial. A year later, Burke pleaded guilty to one count of mail fraud in federal court and was sentenced to two years in prison. Clarke entered a similar plea, was given five years' probation and was ordered to perform four hundred hours of community service. Kasner's guilty plea came a month later, and he was fined three thousand dollars, placed on probation for four years and ordered to do a thousand hours of community service. Evans entered his plea in May 1990 and was sentenced to six months in jail and three years' probation.

Most of those convicted were unrepentant.

Fleischman insisted to the end, as his wife had at trial, that the art he had sold was original. "I still have no proof it was not original," he said at his sentencing.

Evans conceded that the claims made by Barclay about Dalí's supposed participation in creation of the prints was misleading, but he added: "I emphatically deny that portion of the government's allegation that I knowingly sold works which were of poster quality and which I knew had no value and had not been authorized by Salvador Dalí." Both Evans and Burke contended they still believed the prints they sold were genuine, authorized works of Dalí and that they had real value. Clarke explained that she was not privy to any knowledge to the contrary.

Nemesis of the Brigands

A.Reynolds Morse looked with disgust at fifty prints that were laid before him in the Albuquerque police station on August 18, 1986. Two of them were not even copies of Dalí images, although they pretended to be original Dalí prints. The others were either atrocious etchings emanating from Magui Publishing of Beverly Hills, California, or "lithographs" tracing back to Gilbert Hamon. For many years, Morse had feared that the excesses of the master and those around him would finally come to this.

Morse and his wife Eleanor had met Dalí in April of 1943 at the St. Regis Hotel after buying one of his paintings at Dalí's first portrait exhibition at the Knoedler Gallery in New York. From that point on, the Morses had attended nearly every Dalí exhibition in New York, and a friendly relationship evolved between the famous couple from Spain and the Cleveland plastics manufacturer and his wife. The Morses would visit the Dalís whenever they were in New York, and beginning in 1954 would see them in the summer in Port Lligat and accompany them to Paris, London and San Francisco.

The Morses avidly collected Dalí's works, eventually amassing ninety-three oil paintings and even more water-colors and drawings, enough to open a Dalí museum con-

nected to Industrial Merchandising Specialists, Morse's company in the Cleveland suburb of Chagrin Falls, Ohio. In 1980, the Morses gave their paintings and drawings to the state of Florida to avoid breaking up the collection by being forced to sell most of the artworks to pay estate taxes on the remainder. It now is housed in the Salvador Dalí Museum along the waterfront of St. Petersburg, Florida.

A. Reynolds Morse believed that Dalí was one of the great geniuses of his time, but there came a time when he began to fear that the pedestal could crumble. He was shocked in 1965 when confronted with the Phyllis Lucas prints, and he blamed Captain Peter Moore, the private secretary who was the first to commercialize Dalí.

Six years later, Morse discussed the mounting problem with Arnold Grant, then Dalí's New York attorney, and both expressed concern for Dalí's reputation. "We concluded that Dalí's activities in the phony graphic field and Moore's activities would both backfire on the artist sooner or later and could ultimately tarnish his reputation as a great twentieth-century painter," Morse wrote in his Dalí diary. "We said we would both discuss this with Dalí privately in our own ways to convince him of the danger his secretary [Captain Moore] represented."

Both in 1971 and 1972, Morse complained to Dalí and Gala that the prices being charged for reproductions were too high, regardless of how they were made. Dalí ingenuously replied that "one good reproduction" is worth whatever a consumer is willing to pay, and protested that he could not possibly control the market.

Morse walked away frustrated. "One does not get very far with the master in an area where his front man is involved," Morse concluded, "and Moore will stop at nothing to discredit anyone like myself who dares to question the ethics involved in the world of art multiples on paper."

Then there was the matter of Dalí signing blank art paper to be turned into prints the artist might never see. "I told Dalí that I disagreed with him when I found him signing blank sheets," Morse wrote. "I said it made the project marginal because it eliminates quality control of the images entirely from his purview, along with the size of the issue. Furthermore, it opens the door to the forgery of Dalí's signature, which it is already reported Moore is not above doing if enough cash is forthcoming from a publisher."

Morse learned how Dalí had traveled to the French border and signed seven thousand prints within a few hours, the signatures near the end of the session becoming sprawled and illegible. When the dealers who had contracted for the prints expressed concern, Dalí announced to them that whatever he did had to be good.

On November 24, 1972, Morse sat at a table in his room at the Meurice Hotel and lamented the craziness, recording in his Dalí diary: "Even as I write these words, the master's voice booms across the hall, penetrating the thin door and sound-conductive walls. It is in that room precisely where all these abuses begin, a frightening thought. There Dalí receives his entrepreneurs, takes their money, hands them his watercolors and starts the Niagara of works on paper. The veneer of respectability of Dalí's mass productions seems terrifyingly thin. Am I a party to this ploy? How far do I dare go in trying to curb the abuses down the line?"

Dalí's work at his easel had reached a virtual standstill, but Morse was disturbed at the number of so-called Dalí works he had seen in Paris stores, many not numbered but marked EA, or *épreuve d'artiste*, French for artist's proof. "Thousands are appearing in this unnumbered category, which simply means the printing presses roll on and on." The same was true in America, he felt. An art gallery at Kennedy Airport displayed plates from the *Memories of Surrealism* suite, Cory Gallery in San Francisco was pro-

moting its specially commissioned *San Francisco Suite*, and a Chicago gallery used Dalí etchings to promote itself.

"The question," Morse wrote, "really is whether all the stuff pouring out of Room 136 of the Meurice Hotel can really be called Dalí art." It had taken Romanesque art five centuries to spread across Europe, but jets had put "the Dalí factory" into high gear in only five years. "The main danger, as I see it now, is some smart cookie will figure out that Dalí's editions are now, in point of fact, totally unlimited. Different editions are run for different countries, with the hope, for example, that those destined for Sweden will never be tallied against those produced for Germany or Italy. Truly, Moore has set 'Dalí Unlimited' going at an appalling pace.

"It is fascinating as I sit here across from the Dalí factory [to contemplate] what the ultimate repercussions of over-Dalínizing will be on the master's basic image as an artist and on his serious art," Morse wrote. "Who is a good enough friend of the painter to put all this frantic production in its true perspective? Who has the courage or the power to turn off Moore's complex machinations before irreparable harm is done to Dalí's serious works? Will the collapse of the Dalí print market also destroy the images that made him so great and famous in the first place? Certainly, the Dalí print market constitutes one of the great bubbles of all time. What will burst it and when?"

Fifteen years later, Morse found himself in Albuquerque, New Mexico, helping Detective Pat Otero and Bill Slattery from the attorney general's office try to burst the Dalí bubble. The opportunity had arisen because of the tenacity of an asphalt contractor named Hilton Gerald "Duke" McCracken.

In late 1984, while McCracken's girlfriend was working at a new art gallery in Albuqerque's historic Old Town, called Shelby Fine Arts, he attended a seminar on art invest-

ment conducted by owners Ronald and Kurt Caven. McCracken was buying and selling futures in the gold and silver market at the time and knew that art, too, was a big money-maker.

The two brothers, with headquarters in Denver and roots in tiny Shelby, Montana, told the seminar about the wisdom of investing in stone lithographs of Salvador Dalí. As works of Picasso, Chagall and Miró had risen greatly in value after their deaths, so too would those of Dalí: he was very old.

The Cavens' message confirmed McCracken's earlier thoughts about art investment, and soon afterward he drove to Old Town and invested $4,400 in what he was told were two "hand-lifted" Dalí prints, *Slave Market* and *Apotheosis of Homer*, signed by the artist.

McCracken demanded a certificate of authenticity from the publisher, needed for proof when he eventually resold the prints. He was given a Shelby certificate signed by the gallery manager but did not believe it to be sufficient. Two weeks later, McCracken received new certificates signed by Ron Caven, but that was not what he wanted. Caven then sent him certificates from Mondile Art, Inc., in New York, the distributor, asserting that listed information about the prints was "true and correct to the best of our knowledge."

McCracken was leery about the language used in the distributor's certificate. He telephoned Mondile and talked with the owner, Odile Gorse. McCracken asked if her company had published the prints. She responded that she was only the broker.

"I asked her if she would tell me how to get hold of the two publishers of these pieces," McCracken recalled, "and she told me no, she would not, because then I could go to them direct and cut out the middleman."

In calling Gorse, McCracken had tapped into a live wire in the Dalí print circuit. Born in the Ivory Coast of Africa in the mid-1950s into the family of an agronomist for the

French government, Odile Gorse spent her early childhood in foreign countries before her family returned to the environs of Paris. After completing her secondary schooling, she studied art at the Sorbonne, then came with her family to Washington, D.C., where her father had been transferred by his new employer, the World Bank. She felt pressured by her father to succeed in America. "It's a country for you," he told her.

Gorse spent only a year in Washington and then returned to Paris. A friend found her a secretarial job with a picture-framing company, and Gorse came into contact with numerous artists and art businessmen. After only nine months, she realized she could not stand her countrymen anymore and moved back to Washington, finding work as a translator.

In 1978, at the same Washington art exposition where Andrew Weiss had angrily denied showing a fake Miró, Gorse noticed one of the booths occupied by a man she had known from her brief employment at the Paris framing company—Jean-Paul Delcourt, who was exhibiting Dalís and the works of some French artists. They talked a lot, and Delcourt said he would be in touch. Several months later, Delcourt phoned her and asked her help in preparing for other upcoming expositions. Soon afterward, she quit her translating jobs and joined Delcourt full-time at an office they opened on Madison Avenue in New York for his company, Editions d'Art de Lutèce. Delcourt had spent two years in jail in France in the 1970s during what he says was an art fraud investigation stemming from the sale of prints bearing similarities to products of American publisher George Brazilier. But he did not leave the art business. According to American authorities, Delcourt viewed himself as very sly, and able to outfox them.

In October 1983, remaining in the same office, Gorse severed her association with Delcourt and joined acquain-

tance Monique Desani, the wife of a New York lawyer, in founding an art distribution company called Mondile Art. Gorse was well prepared for her venture. Through Delcourt, she had become a friend of Jean-Claude Dubarry, the man who had arranged the Hamon contracts, and achieved a close association with Parisian Henri Guillard, a partner of Hamon in many of the Dalí contracts.

"He was my master in the Dalí business," Gorse would say of Guillard. Postal inspectors judged Gorse and Guillard, nearly twenty years her senior, to be lovers as well. Years later, U.S. authorities were told that Guillard may have been paying off Paris police, particularly those in the art forgery section.

Guillard built an association with Paris and New Jersey art publisher Leon Amiel. Postal investigators were told that Guillard traveled to New York with his son Serge and a man named Paschal in 1983 or 1984 and visited Amiel's warehouse in Secaucus, New Jersey. There, Paschal was said to have forged Dalí's signature on thousands of blank sheets of lithograph paper.

Guillard was Odile Gorse's primary supplier of Dalí graphics. She believed—or said she believed—that Guillard had direct contact with Dalí, and he introduced her to Enrique Sabater and SPADEM official Jean-Paul Oberthur. She was given copies of contracts between SPADEM and Guillard's company, Image.

Monique Desani remained associated with Gorse for less than a year, and authorities regard her as having been, at most, an unwitting participant in any wrongdoing. In November 1984, Gorse changed the name of her enterprise to Castilian Company of Fine Art. Her customers were numerous, including New York dealers Jack Arnold and Frank Fedeli, California dealer Ted Robertson, as well as American Express and Diner's Club. One of her customers was Shelby Fine Arts of Denver.

The Cavens had been seeking a new source of Dalí prints. The source that Kurt had used when he began his involvement in the art business in the 1970s had dried up by the time Ron joined the operation in 1982. Ron knew from his previous jobs that coffeemakers and cookwear come from Westbend Products and that televisions and stereos can be gotten from Motorola and RCA. But buying Dalís in bulk was another matter. He started calling wholesalers as well as searching through trade magazines, in time coming across advertisements placed by Magui Publishing in California and Mondile Art in New York. Caven called the numbers and ordered a few prints each from Magui and Mondile. He was especially impressed with Odile Gorse when she told him of her association with Delcourt and Hamon. Ron had learned that those two were men who were authorized to publish Dalí's work. He checked around further, but nobody could beat Gorse's price of sixty dollars a print, wholesale.

"For some of the pieces, if we bought a lot of pieces, we could get down to five hundred dollars with a couple of distributors," Caven explained. "We might have gotten down to a three hundred dollar figure with somebody else. But we didn't get anywhere near to the price that we were able to get from her."

Through 1983 and the first part of 1984, the Cavens bought a few Dalís at a time, until they had accumulated 245. Kurt Caven explained to the sales people that these were hand-pulled, stone lithographs, done by a lithographer, and they were authorized, approved and signed by Dalí. Ron explained their investment value, about how they would double, triple or even quadruple in price after Dalí's death. The sales people bought Dalí prints themselves for the same reason they were selling them to customers.

In July 1984, the Cavens agreed to buy seven hundred prints of about thirty Dalí images, including *Hallucinogenic Toreador, Slave Market, Apotheosis of Homer* and *Blue*

Unicorn. Odile Gorse delivered the large order personally to Denver, and it was distributed to the growing chain of Shelby galleries. The Cavens suddenly were heavily into the Dalí business, and the potential profitability did not escape Duke McCracken.

Even as McCracken was trying to document the authenticity of his two Shelby prints, he was checking around with distributors, learning that Odile Gorse was right about cutting out the middleman. He checked with Center Art Galleries in Hawaii and Magui Publishing in Beverly Hills. From Magui's manager, Jean Levi, he learned he could buy Dalí etchings for as little as $300. In December 1984, only weeks after buying his Shelby prints, McCracken went to City Hall in Albuqerque and obtained a license to sell Dalí art under the trade name of New Mexico Art Brokers.

"If I was investing some more money," he said, "I was going to invest it at the wholesale level." He bought eighteen prints from Magui and began trying to sell them.

Meanwhile, McCracken continued to demand a publisher's certificate of authenticity from Shelby, finally extracting from Ron Caven a photostatic copy authenticating his *Slave Market* as having been published by Image, in Paris. McCracken had the French translated, and the certificate gave the size of his print as 56 by 96 centimeters. He measured his print. "The calculations would not fit, no matter how you looked at them," he said. "I talked to Ron again and told him this still wasn't what I wanted. At this point, he told me there was nothing else he was going to do for me. I could trade my piece or I could forget about it." Shelby did not offer refunds.

Instead, McCracken filed a claim in Bernalillo County Metropolitan Court, demanding his money back. In February 1986, a judge ruled that Shelby had not proven the prints were authentic, and he ordered that a refund be made. The judge then suggested that McCracken and his attorney

cross the street and let the police there know about his sordid experience.

Three officers listened to McCracken's story, and Detective Pat Otero was intrigued. Otero himself dabbled in art and knew something about printmaking. In contacting experts, he did not have to go far. The Tamarind Institute, a leader in the field, was only blocks away from the police station. Tamarind's Clinton Adams and Garo Antreasian were preeminent authorities, having coauthored the standard text used in college courses on lithography. Otero learned about the New York investigations of the Convertine, Caravan and Barclay galleries. He obtained Dalí's affidavit that he had signed no art paper after 1980; watermarks showed that McCracken's signed prints were on paper manufactured after that year.

On March 1, 1986, only two weeks after McCracken registered his complaint, Albuqerque police raided three Shelby outlets in the city, seizing 138 Dalí prints. Hearing about the raid from a *Denver Post* reporter, a Colorado Springs police detective called the Albuquerque police and, on March 11, seized eleven Dalí prints from the Colorado Springs Shelby outlet.

The Cavens reacted with indignation, issuing a press release claiming their Dalí prints were authentic: "If there are any fakes on the market, we have no knowledge of it or who's doing it. In fact, if someone is doing fakes of any artist's work and signing them, they should be put in jail." In a newspaper interview, Ron Caven added, "We deal with distributors and buyers of Dalís . . . [who] give us certificates of authenticity." He said customers "don't have anything to worry about."

The Cavens certainly had been aware of the Dalí print controversy. In fact, after salespeople had shown Ron a *Wall Street Journal* item from March 1985 which reported that fakes were flooding the Dalí market, he prepared a written

statement to be distributed to Shelby's customers, titled, "Salvador Dalí, Real or Fake?" The statement questioned whether there were any Dalí fakes in the market and suggested that the rumors and gossip were probably a side effect of competition. "Many galleries have developed a sales technique . . . of saying to their customers, 'Our Dalí is OK, but I don't know about the other galleries. Theirs could be fake.' Galleries are causing their own problems by using these techniques."

Naturally, Shelby's customers' reaction to the *Journal* article was mild in comparison with their response to local publicity about the raids in Colorado and New Mexico. Albuquerque gallery manager Betty Slade explained that the gallery was getting to the bottom of it and suggested that the raids were prompted by one angry client by the name of McCracken. Ron and Kurt Caven came down to Albuquerque to reassure people with certificates of authenticity. Customers were very nice, Slade said, but their questions increased as the weeks passed.

Then came good news for the Cavens. In early July 1986, a judge in Albuquerque rejected a complaint brought by a customer seeking a refund of her purchase of Dalí prints. Shelby had brought Richard Ruskin of California and two other experts into court to prove the prints were authentic. The customer paid for no experts. Shelby attorney Louis Vener announced to the press that the judge had determined the prints "were bona fide and not fakes" because of the testimony by the "world class" art experts. He said the judge's ruling would uphold Shelby's reputation as "one of the most honest art galleries in the country." Ron Caven proudly held up his Dalí print, *Transcendent Passage*, for the newspaper photographer.

The judge's ruling did not interfere with the criminal investigation in New Mexico. On September 26, 1986, a grand jury in Albuquerque indicted the Cavens on fourteen

counts of fraud, solicitation and criminal conspiracy. In spite of it all, they continued to maintain their innocence. "We are happy to have a chance to go to court again and prove these latest charges are false," Ron declared. "Dalí himself hasn't charged us or anyone we know with selling fake [Dalí] prints."

Detective Otero and New Mexico Assistant Attorney General Fred Smith had lined up their own experts to counter the supposed "world class" aces the defense would bring into the courtroom.

The Cavens' trial began in February 1987. Both brothers testified they had every reason to believe their Dalí prints were authentic and that Dalí had signed them. They denied telling sales people or customers that the prints had been "hand pulled." Said Ron: "I never did really get into telling how they're done, because I don't know how they're done. When you go in to buy a watch, the sales clerk doesn't tell you how the watch is made," Ron explained. "They don't even know. If you buy clothes, they don't tell you what machines the clothes were made on, or with what wool. You just don't get into that. It's the same way in the art business."

Did Shelby sell these as investments? Of course, Ron answered, because he believed them to be just that.

"It sounds like investment is a dirty word, but it never was," Ron said, "and I still don't feel that it is." He said he had attended diamond investment seminars and that people there asked the same questions of him about their art purchases. "We tried to answer that question and talk to people about the question for people. We really had a lot of fun. Probably the most enjoyable thing was the seminars." Testifying was not so much fun. Twice, Ron Caven broke down in tears on the witness stand, crushed by the allegations that he had been involved in criminal conduct.

Defense expert Pierre Spalaikovitch of California, Pierre Marcand's chromist, showed jurors the old printing press used to print the Dalí images he himself had etched onto copper plates for Magui Publishing. Odile Gorse arrived from New York and assured the jury that the Dalí prints she had obtained from Delcourt were created by the hands of chromists, a tedious process intended to achieve a high-quality lithograph.

Fresh from his testimony in the Convertine trial in New York, Richard Ruskin asserted that the prints at issue in the Shelby case were authentic, hand-produced lithographs or etchings. He appraised them at their retail sales prices minus 40 percent, but that did not make them bad investments. In the long run, he suggested, their values could surpass the amounts paid to the gallery. Secondary markets could be found readily with auction companies that set themselves up in hotels. As for his failure to twice pass the ethics test to become a senior member of the American Society of Appraisers, Ruskin explained that he had become so tired during the four-hour examinations that his handwriting had become illegible.

Colorado Springs art appraiser Bernard Ewell examined the Shelby prints through a magnifying glass under a bright light for the prosecution and determined they were photomechanical reproductions that had been printed on a high-speed press. Ewell concluded they were virtually worthless.

For Dalí expertise, the state called in A. Reynolds Morse, who arrived a day early for his court debut. Defense attorneys James Brandenburg and Donald Lozow were allowed to question Morse before his court testimony, and Brandenburg immediately caught him off guard.

Did Morse know a Washington State art dealer named Joan Wilcox who once had talked with him about buying a half interest in an edition of Dalí lithographs titled *The Discovery of America by Christopher Columbus*, and who

was now very angry with him after her prints were banned from an Art Expo? Morse remembered an incident at the New York Art Expo in 1982. Michael Stout, Jean-Paul Oberthur and Tom Wallace had complained to the show's management about the quality of some of the Dalí reproductions. Some of the more flagrant pieces had been taken down. He told Brandenburg he had had nothing to do with that episode.

Brandenburg then showed Morse photostatic copies of three contracts, dated December 15, 1981, in which Morse had given to Jean-Paul Delcourt the right to produce lithographic editions of *Columbus, Three Young Surrealist Women Holding in Their Arms the Skins of an Orchestra* and *Hallucinogenic Toreador*, the original paintings of which hang in the Dalí Museum in St. Petersburg, Florida, that he founded. Morse recalled typing the *Columbus* contract on an IBM typewiter in an office of the museum but could not remember the other two, and could not verify their authenticity.

"I explained again how Delcourt and his three-person entourage had slunk into town on a Saturday, and how I had been suckered into a deal on the *Columbus*, where I was to get free copies of the reproduction to sell in the museum store when the museum opened," Morse wrote after being questioned by the two defense attorneys. "Again, I related how I had typed the *Columbus* contract and sent it to Delcourt to sign and date, as he was rushing to catch his plane. I related how I had finally contacted Interpol and Stout, and learned that Delcourt was one of the worst Dalí exploiters, having created a menorah from a watercolor and selling it as a Dalí sculpture, when Dalí had nothing to do with its manufacture as an object.

"I related how I had nulled the contract on the *Columbus* by telegram and how Stout had recovered the transparency I had given the man. [My wife] Eleanor was

dead set against the deal from the start, as the sleazy fellow and his two even crummier female accomplices did not fool her as they did me. To this day, she has not forgiven my greed and pigheadedness and stupidity in being taken in by a typical Dalí con man. I related that Delcourt, despite our telegram and cancellation, had signed (but not dated) a Xerox [copy] of the contract and even published it in a print dealer's journal. I said that we had never received any of the reproductions [promised], nor had proofs been submitted to us for approval before printing, so that he actually never kept his side of the deal, proving that it actually had been voided."

Each of the contracts shown to Morse by Brandenburg called for an "original edition" of one thousand lithographs "on signed paper." The museum would have the right to buy one hundred additional copies at a 60 percent discount and more copies at half off. Each would be accompanied by a certificate of authenticity stating the medium as "a colored lithograph hand-made from zinc plates after the original work."

Morse took the witness stand late in the morning of the next day. He told of his longtime association with Dalí and his knowledge of the artist's works. He told of the St. Petersburg Dalí Museum selling reproductions of Dalí's original paintings for less than fifteen dollars, and said the prints in evidence at the trial were little more than that, on more expensive paper but poorly reproducing the original images. He testified that Dalí was too ill to sign prints after 1980, so signatures on paper printed after that date would have to be forgeries.

Questioning by Brandenburg reverted to the Delcourt contract or contracts. Again, Morse admitted signing the *Columbus* document, and he admitted being wrongheaded.

"I wanted something for nothing," he testified, "and I wanted the pictures to sell in the museum. And I thought I had a bona fide deal, and as soon as I got the information that I needed, which involved Interpol, attorneys and everything else, we tried to cancel the contract."

Again, he asserted he could not recall signing similar contracts with Delcourt for reproduction of *Toreador* or *Surrealist Women*.

"You have no recollection of it, or you didn't sign it?" Brandenburg asked.

"I have no recollection of it," Morse replied.

After leaving the witness stand, according to Morse, he telephoned Joan Kropf, the curator at the Dalí Museum and was told there were, indeed, three contracts. He says he immediately notified the prosecuting attorneys at lunch, and they told him to check the situation himself when he returned to Florida and write them a letter. They then would correct the record.

Three weeks later, as the trial was winding down, prosecutors received confirmation from Morse that his testimony had been incorrect. They notified the defense and entered into a written stipulation, to be handed to jurors, advising them that Morse's testimony that he had signed only one of the three contracts was incorrect, and that he had signed all three.

The jury deliberated a full day and was unable to reach a verdict. It had divided nine to three in favor of conviction. Judge Richard Traub declared a mistrial. Darlene Cormier, an office worker for an insurance company, was regarded as the most adamant of the three jurors favoring acquittal of the Cavens. She told Brandenburg afterward that Morse's muddled testimony had been devastating to the state's case. Prosecutors rolled their eyes at the assertion, having discovered during the deliberations that Cormier was the proud owner of a Salvador Dalí print.

Kurt Caven vowed to "go through this as many times as I have to until we get an innocent verdict." Five months later, he reconsidered. On August 31, 1987, on the eve of what had been scheduled to be the beginning of the retrial, the Caven brothers pleaded guilty to one count each of third-degree fraud. Each agreed to pay restitution totaling thirty-five thousand dollars to the ten victims named in the indictment, to stop selling art of any kind in New Mexico and to cease selling Dalí prints anywhere else in the United States without notifying authorities.

Shelby's customers received an amazing declaration of "victory" written by Ronald Caven: "We are ecstatic about the outcome of the court cases we have fought to protect Salvador Dalí's name and his art.

"In the three court cases we went through, Dalís were not proven to be fake," the statement read. "In fact, the only case in which a judge heard both sides and made a decision, we won. The Dalís were ruled authorized and not misrepresented, not fake. In the other two cases, one ended in a hung jury and the other was settled. Fake was not an issue [and was not] mentioned in the settlement. We feel the trials showed [that people had circulated] rumors and hearsay that Dalís were fake. When it gets to court, you have to prove the Dalís were fake. They could not do that. We are able to prove that they are real."

The statement was inaccurate. It did not account for the fact that Shelby had, indeed, lost McCracken's civil case. Also, the only case Shelby won, with the help of their so-called world class art experts, was overturned on appeal. A master at representing a decorative art reproduction as an investment, Ron Caven had tried to twist a guilty plea into a cause for celebration. But there was little to rejoice. Shelby Fine Arts, which at one time had thirty-five outlets, dwindled to a few, and then none.

A. Reynolds Morse, the man who had carried the torch of fidelity in condemning those he called "dealsters" of Dalí fakes, came away from the trial chastened by the harsh interrogation about the Delcourt contracts. Questions remained. How could he have been duped by Delcourt? Why had he not been repulsed by the very terms of the contract, which had called for "lithographs" to be printed on pre-signed paper? Morse's personal Dalí diary reveals that he had developed an antipathy to Delcourt twenty months before signing the contracts, referring in his diary to "the menorah created by the crook Delcourt after one of Dalí's Israeli watercolors." His entry of Saturday, December 12, 1981, three days before the signing of the Delcourt contracts, tells more:

"Today, Eleanor and I took a chancy and bold step toward recouping some of our rights in the *Toreador* from the art brigands in Paris. We agreed to allow one of them, Delcourt, to make zinc lithographs of three of our works, provided full disclosure was made of what they were, with full credit to the museum, and provided there was no false signature used on the cheap editions, only the ones on Arches, Rives and Japon [paper] costing him five to eight dollars a sheet, plus $85 for Dalí's signature to be bought by the printer from Peter Moore. The price will be fair, and the accreditation complete. My idea is to join the gray area, brigand side, setting a sort of backfire which will give us the information we need to cope with the art whores such as Gilbert Hamon, Amiel and the like."

The entry describes financial difficulties at the museum, and adds: "The stress we are under is enormous, and my attempt to get free lithographs for the museum does not have Stout's approval because Delcourt is such a crook with a long record of abusing Dalínian images, including a fake menorah allegedly sculpted by Dalí."

At 10:30 P.M. on the following Tuesday, December 15, some hours after signing, Morse telegraphed Delcourt at a New York hotel, seeking to put an end to his brief and bizarre James Bond-like venture to infiltrate "the brigand side." The telegram declared the three contracts null and void and demanded that the photographic negatives be delivered to Michael Stout's office. The wire and letters from both Stout and Morse over the next several months did not stop Delcourt from proceeding to publish the three editions.

Morse says today that the "backfire" he had in mind was to sell the prints at cost—a fraction of what Delcourt or his retail clients would charge. "That was the whole idea."

Even when confronted by this author with his reference to Delcourt as a "crook" twenty months earlier in his diary, Morse insists, "I knew the guy was shaky, but I didn't know what a crook he was." Only after checking with Stout and hiring former New York detective Tom Wallace, whom Morse knew from the Naussau County investigation, did he learn of Delcourt's earlier conviction in the Braziller case.

"Mike [Stout] was furious at me for getting in with this guy," Morse says. "I was naive and got taken, and learned a lesson."

CHAPTER 6

California
Capers

Late on the night of Sunday, June 3, 1984, a burglar pried his way into an old, rickety business office along West Coast Highway in Newport Beach, California. The thief then sawed through two thin sheets of drywall to gain entrance to the adjacent business, Signature Fine Arts.

When gallery administrator Nicki Anderson came to work Monday morning, she was stunned to find only blank walls where the artwork of Salvador Dalí had been hanging. Gone were two Dalí paintings, *Adolescence* and *Madonna in the Moon*, and sixteen Dalí lithographs and etchings.

"I had just seen them Sunday night, and when I walked in Monday I was in shock," Anderson said. She surmised the burglar was very professional. He took the most expensive of what the gallery was displaying, and he was clever enough to elude the gallery's alarm. "The problem is that if somebody is determined to take something, they're going to get it. It would have taken massive, massive security to stop it."

Burglary detective Craig Frizzell of the Newport Beach Police Department wondered about that. Frizzell could find no alarms at all in the building, unless a cowbell hanging from the rear door counted as one. The gallery had increased its insurance coverage from $40,000 to $200,000, but that came nowhere near the $538,000 value the gallery placed on

ᴛʜᴇ stolen Dalís. Most of the works were there on consign-
ment and were owned by a man named Pierre Marcand of
Beverly Hills. They had been on display at the gallery since
early May. Two days after beginning his investigation of the
caper, Frizzell phoned Marcand, but he was away. Frizzell
expected a prompt return back from the man who faced such
a major loss. Five days later, Marcand returned the call.

In Frizzell's mind, something was wrong here. Usually,
burglary victims knocked down the doors of the police sta-
tion to talk about their plight. Once having contacted the
burglary victim, Frizzell made an appointment to see him
the next day. The young detective arrived at Marcand's
swank mansion at the end of a cul-de-sac above Beverly
Hills and ran into a flurry of activity. A man wearing a
turban emerged from a room designated as an office carrying
drawings or sketches supposedly being done for the
upcoming Olympic Games. Noise emanated from behind
the closed blinds of a room next to the backyard swimming
pool. People were coming or going. Marcand introduced this
one as his chef, that one as his manager, and another as his
secretary.

Marcand described himself as president of Magui
Publishers, Inc., the world's leading publisher of Dalí etch-
ings. Most of the etchings were distributed to Ron Copple,
the owner of Signature, or to the T. R. Rogers Gallery in
Beverly Hills, both of whom had been introduced to
Marcand by Robert Bane, of Lawrence Ross Publishing. He
told Frizzell the stolen artwork had been on display at Art
Expo, the New York exhibition, before being transported
west. Although the gallery had its limited insurance cov-
erage, Marcand himself had insured none of the art, and he
blamed that on his secretary's absentmindedness.

Frizzell put the word out to those he knew in the art
community for leads about who might have taken the art-
work. The next day, he received through the mail, anony-

mously, a copy of an article from the Spanish newspaper *Il Tiempo* along with an English translation of it. The article, dated April 1, 1984, reported that Pierre Marcand, the Paris dealer, had just been convicted in Italy of selling 440 counterfeit lithographs allegedly signed by Salvador Dalí. The judge had sentenced Marcand to a year and four months' imprisonment and fined him two million lire, but then suspended the punishment, perhaps superfluously, since Marcand had been tried in absentia. According to the article, French publisher Pierre Argillet had discovered false editions of Dalí's *Hippies* series hanging in a gallery in Rome. Argillet, who owned copyrights to the *Hippies*, complained to the police and got swift action. (Gallery owners in Rome and Milan also were arrested and brought to trial, but they were released because of insufficient evidence.)

Through Interpol, the international police organization, Frizzell discovered further that Marcand had been charged in France with counterfeiting, forgery and use of forgeries in connection with the existence of hand-colored etchings attributed to Dalí.

"As for the burglary of Signature Fine Arts, Inc.," Frizzell reported to his boss, "it's my opinion that this burglary wasn't committed merely for personal gain, but to assist in exposing the mechanics behind Pierre Marcand and Magui Publishers, Inc. If this theory is in fact true, the suspect(s) behind the burglary succeeded."

Frizzell phoned Michael Ward Stout in New York, A. Reynolds Morse at the Dalí Museum in Florida and Albert Field in Queens, and all agreed to help. Stout attended the Los Angeles Olympics in August 1984 and received photographs of the stolen artworks but rendered no opinion on their authenticity. There was little any expert could do as long as the prints themselves, which Frizzell now believed were probably bogus, remained missing.

Then, two months later, in October 1984, Frizzell got word that Marcand had just been caught transporting sixty-five counterfeit Dalí etchings and lithographs into the airport in Calgary, Alberta, and had been fined $150,000.

In April 1985, Frizzell and his partner went unannounced to the Marcand mansion. The front door was open. Jean Levi, whom Marcand had introduced as his business manager, was on the phone and nodded to Frizzell. The two officers strolled to the swimming pool area. The blinds were raised in the room where Frizzell had heard the noise during his first visit. He could see half a dozen young men and women applying paint brushes to etchings. Frizzell walked back to the office in the front of the house and asked Levi what they were doing.

"They are color-enhancing the prints," Levi told him. Frizzell returned and stood observing the scene. The painters, speaking to each other in French, continued painting and listening to the radio undisturbed by their audience. Frizzell could see a stack of prints signed "Dalí" but not numbered. Levi said Dalí had signed them eighteen months earlier. Another stack was unsigned. Levi told him those were used for practice by the color enhancers. Frizzell left the house, incredulous.

On May 8, 1985, a man in the town of Colton, about fifty miles from Newport Beach, telephoned the Riverside County Sheriff's Department. He told a sergeant he had seen what he believed to be the stolen Dalí artworks in a storage unit in the nearby community of Ontario. Frizzell drove to Riverside the next morning, and he and a Riverside investigator met with the man in Colton. The man told the officers that a fellow he knew only by his first name, William, and a woman named Marianne, had cased the Signature Gallery during the Dalí exhibit and were told by someone named Herbert from Laguna Beach that the artwork was immensely valuable. The informant said William and Marianne had

planned to transport the art to South America and barter it for kilograms of cocaine. The deal apparently fell through, and William had approached the informant through a mutual friend to ask his help in selling the art. The informant had remembered publicity about the burglary. The officers showed the informant color transparencies of the stolen pieces. The informant arranged a meeting with William, who showed him photographs of the art he had in storage. They were the same.

Eleven days later, police from three departments went to the Colton home of William Handrinos, a thirty-one-year-old man who had been involved in other burglaries, arrested him and recovered all eighteen of the stolen artworks.

A month later, Frizzell showed the prints to Beverly Hills art appraiser Dena Hall and handwriting specialist Timothy Armistead of San Francisco. Armistead found "unexplained variations" in the Dalí signatures, and Hall was unable to conclude anything, because the prints were all framed. Hall and Armistead told Frizzell he would have to tear the frames apart for them to examine the prints adequately, but Frizzell had too little evidence of wrongdoing to allow that. Through the glass of the frame, Hall was able to see that one of the prints broke down into halftone dots, proving to her that it was clearly a reproduction, and that another piece apparently was executed with a Magic Marker. As for the Dalí signatures, Hall remarked there appeared to be a "vast variety of signatures."

When Hall's opinions reached the news media, David Steiner, Marcand's lawyer, was indignant. "She is hardly an expert on Dalí," he said of Hall. "He certainly has signed a number of different pieces a number of different ways." As for her remark about the use of a Magic Marker, Steiner said: "My understanding is that [Dalí] did use a Magic Marker in some of his works—as do other artists."

Albert Field arrived from New York, but he was unable to give a firm opinion about the prints. He noted that the etchings all carried printing at the bottom explaining, in French, that they had been executed by an engraver named Pierre Spalaikovitch after Dalí images. Field concluded that anyone would know from the reference to Spalaikovitch that they were simply reproductions.

During a vacation trip to Paris in July 1985, Dena Hall sought Robert Descharnes's opinion. Carrying photographs of the recovered artworks, Hall made numerous phone calls to Descharnes's Left Bank residence, finally reaching his wife. Mrs. Descharnes was annoyed at what she felt was an impetuous request, but agreed to pick up the photographs at Hall's hotel and submit them to her husband. Descharnes later advised Frizzell that he would charge $1,600 to look at the photos and render an opinion. The offer was declined.

Frizzell phoned museum curators and all the people he could find who had been referred to him as experts, but none could say definitely that what the police had recovered from Handrinos were fakes.

Scores of people who had seen or heard news accounts of Frizzell's investigation called him about Dalí prints they had bought. Frizzell took down their names, addresses and phone numbers and asked them to send him slides and any documentation of their prints.

"I never received one slide," Frizzell says. "I think most of the folks we are dealing with could take the loss. They were professional people, attorneys, doctors, guys that owned car dealerships or mobile home sales."

About a year after the artworks were recovered, William Handrinos was convicted of burglary. The evidence was returned to its owners, and Frizzell's investigation came to an end. He had done all he could.

Just how many people received fliers mailed out in the summer of 1987 by a Beverly Hills art gallery called Rogers on Rodeo is not clear, except there was one too many. A San Francisco recipient of the flier who just happened to be an art gallery owner was immediately taken aback by its contents. It announced the sale of three Salvador Dalí original pen-and-ink drawings, pictured in the flyer and titled *Chevalier de la mort, The Fountain of Destiny* and *Lover and Don Quixote.*

The man had seen the images before and believed they were owned by the family of Pierre Argillet in Paris, from whom he had bought Dalí art. He called Albert Field and asked whether Argillet had actually parted with them. Field had not heard of such a sale. The Californian then contacted the Argillet family and learned there had been none. The family telephoned the Beverly Hills Police Department to complain about this transgression. Detective John Ambro advised the Argillets that they had to come to the United States with a Dalí expert in order to file an official complaint.

Jean-Christophe Argillet, Pierre's son, wasted little time in doing so. He was particularly infuriated by one of the forgeries, *Lover and Don Quixote*, depicting a woman standing next to an avant garde, spiraled rendering of a man on a horse. The original was actually a copper etching, the frontispiece for a series of etchings titled *Couples* and presented to the Argillets upon Jean-Christophe's own birth in 1966. *The Fountain of Destiny*, showing a woman sitting on a rock next to a fountain, was like the Argillets' Dalí drawing *Femme à la fontaine*, except the *Femme* original included no fountain. *Chevalier de la mort* appeared to be a bad attempt at copying the Argillets' Dalí drawing *La Femme, le cheval et la mort*, a rear view of a woman next to a skeleton riding a horse and carrying a guitar. Within days, young

Argillet was in Beverly Hills, accompanied by Albert Field, and in Detective Ambro's office venting his anger.

"It was giving his Paris gallery [Galerie Furstenberg] a bad name," Ambro recalls. "He didn't know who these people were. He hadn't had any contact with them. They had no reason to be selling this kind of fictitious art. It was encroaching on the credibility of the Argillets' own publications."

Argillet became angrier upon visiting the Rogers Gallery on Rodeo Drive. He saw on display drawings and watercolors falsely said to be Dalí originals and selling for prices ranging from $40,000 to $160,000 each.

Ambro, who had visited Rogers on Rodeo before the arrival of Argillet and Field, quickly prepared a search warrant. The next day, August 14, police entered the gallery along the famous stretch of luxury shops on Rodeo Drive and seized thirty-seven gouaches, watercolors and oils, twenty-two copies of a print titled *Rome and Cadaqués*, various prints being kept in manila folders and more than two hundred *Lincoln in Dalívision* prints contained in several boxes. Field concluded that none of the stuff was Dalí's original work.

Attorneys for the gallery protested that Field was wrong. "As far as we're concerned, the cops came in based on the opinion of one person," said lawyer Arnold Klein. "But we have experts lined up who are going to verify that the drawings are authentic."

The art market had treated Thomas Reed Rogers better than he had fared in other areas of investment sales. In his native Texas, Rogers had sold stock in Capital Oil Corporation in the early 1970s, making grand claims about the company's drilling success, production, income and profits to investors based on its financial ability to keep on drilling. When the Securities and Exchange Commission took him to court for fraud and obtained a court order in 1972 that he

cease and desist, Rogers went right on selling stock, this time in Republic Energy Corporation, even though it had not been registered with the SEC as required by law. The government hauled him back to court and in 1975 convicted him of contempt. He was placed on five years' probation.

Rogers moved on to Phoenix, Arizona, where he set up a boiler-room operation selling precious gems. Within a few months he turned to peddling chances in a Wyoming oil and gas lease lottery. His activities in Arizona prompted federal and state securities investigations of Rogers's company, Hovic, Inc. When new charges of fraud and racketeering were leveled against Rogers in 1981, he did not contest them. In October 1982, a state judge ordered Rogers to pay more than a million dollars in fines and restitution to investors.

Rogers picked up stakes and continued his journey west, establishing himself as T. R. Rogers, Inc., and opening Rogers on Rodeo Gallery. He found Dalí artwork to be as available as Wyoming lottery tickets (there was such a lottery). He began buying art not only from Pierre Marcand but from the same East Coast distributors that had supplied art to Convertine, Andy Levine and Phil Coffaro. In addition, he bought from Tom Wallace's new company, Geneva Graphics Limited, and from Melton Magidson.

In January 1988, through Galerie Furstenberg the Argillets filed a lawsuit in federal district court in New York, claiming trademark infringement and accusing Rogers and the East Coast distributors of engaging in fraud, unfair competition and racketeering in the sale of drawings, watercolors, lithographs and etchings purported to be works by Dalí. Named as defendants in the suit were Rogers, Coffaro, Wallace, Carol Convertine, Levine, Magidson, their various companies, and Julien Aime, a New Yorker who had been used as an appraiser of the disputed items. The suit main-

tained that profits of $32.5 million had been made from fraudulent sales, and Galerie Furstenberg wanted the money.

David Steiner, Marcand's regular attorney, now representing Rogers, called the suit "preposterous" and said he was sure there would be counterclaims. Arnold Ross, Amiel's regular attorney, who now represented Coffaro, argued the suit was without apparent basis.

The court filing was quite detailed. It cited specific certificates of authenticity issued by Rogers and Aime and invoices of sales made out by Levine and Coffaro to Rogers in 1985 and 1986. While authentic etchings bearing the titles of those sold by Rogers were worth $600 wholesale, Rogers was buying counterfeits for $150. Some of the items sold by Rogers as original drawings by Dalí were really imitations of etchings owned by Argillet. The filing described the variations Argillet had pointed out to Detective Ambro in the three drawings advertised in the flyer. A fourth supposed Dalí image marketed by Rogers lacked a woman's garter that was present in the real one owned by Argillet. Another depicted a supine figure in the foreground where none should have lain. There had been enough abuse, the suit contended, to warrant a criminal indictment for such offenses as mail fraud, wire fraud and money laundering.

Meanwhile, the Beverly Hills police were pursuing the Argillets' original complaint but having difficulty proving criminal culpability. "It's such a complicated subject matter, they're having a hard time," a police spokesman reported more than two months after the seizure of Dalí works at Rogers on Rodeo.

Ambro was confident he could prove the seized artworks lacked authenticity. The problem was proving that Rogers had knowledge of that fact. A common element in cases of art fraud, Ambro found, was the difficulty in proving that dealers were aware of the lack of authenticity of their wares. "They don't want to know about its origination," he said.

"They don't ask, because if they don't ask and they're not told, they're not responsible."

Ambro continued his investigation well into 1988, looking for proof. He was aware of other investigations that involved some of Rogers's suppliers and remained hopeful that evidence showing Rogers's knowledge of the fraud would emerge. None did. What Ambro had collected was presented to a grand jury, but there could be no indictment. Without solid evidence that Rogers knew his stuff was bad, there was no proof that Rogers intended to defraud anyone.

Ambro's investigation came to an end. The seized material remained in the possession of the Los Angeles Sheriff's Department so it could be examined by experts for peripheral investigations. Eventually, it was ordered returned to its owner on Rodeo Drive.

Through their New York attorney, Thomas Ré, the Argillet family obtained a $47 million judgment against Carol Convertine, who was broke. Prolonging the lawsuit against others would have been costly, exceeding its potential return, so Ré dropped the suit.

The Upstairs Gallery was founded in 1965 by Maurie Symonds in an upstairs section of a Lakewood, California, office building. Symonds's previous job had been selling furniture in Long Beach. Capitalizing on the print boom, Symonds bought some art from mass-marketer Abe Lublin and traveled to Europe himself to acquire more. He promoted open-ended payment plans, as he had in the furniture business, and his sales grew. By 1973, Symonds had four galleries in the Los Angeles area. He then decided to move to Palm Springs and divest himself of the galleries. He found the perfect buyer: Forest Lawn Memorial-Park, the nation's largest nonprofit cemetery.

Founded by onetime gold miner Hubert Eaton in 1917, Forest Lawn already was in the art business in its own way.

Its gift shop offered photographs, postcards and souvenirs, including salt and pepper shakers shaped like the cemetery's statuary. Eaton had searched Europe for art treasures to adorn the green fields he had made of the weed-infested acreage. The Vatican bestowed on him the right to produce stained-glass reproductions of Michaelangelo's *Moses*. He bought some of his statuary at fairs.

Forest Lawn had ventured into various businesses, including a Nevada land company, a life insurance company and a mortgage and loan company. Purchasing an art company was a reasonable thing to do.

When Forest Lawn hired former department store executive William McKelvey to run the galleries in 1982, they had been supplied with much of their art through Lublin's sales representative, Lawrence Groeger. A few years later, Groeger resigned from his job with Lublin and started his own distribution company, Collections: A Fine Art Service. McKelvy kept buying from him.

"He had changed the focus of what he was selling, to concentrate more on Mirós, Chagalls, Picassos and a better quality of art," McKelvey said. Groeger told McKelvey that he was getting his art directly from the Amiel family of New York, which McKelvey understood to be the primary distributor of Miró and Chagall artworks. "That went sort of hand in hand with my philosophy to eliminate as many middlemen as possible and get directly to whoever it was, as close to the artist if he were living, and as close to whoever had control over the artwork if he were dead."

Groeger provided the Upstairs Gallery with a wider and more attractive assortment of art than McKelvey had remembered from before. However, he began getting customer complaints questioning the authenticity of Chagall prints sold as *The Lassaigne Suite*. Groeger provided McKelvey and each of the individual gallery directors a packet of documents attesting to the authenticity of the

suite, distributed by Leon Amiel. The gallery directors believed the packet to contain enough ammunition to shoot down any complaints.

"We converted that information to our own certificate of authenticity, as we did with all artwork, and relied upon the information given to us by the supplier," McKelvey asserted.

Attuned to the fake print problem by the investigation of T. R. Rogers, California law enforcement authorities had begun to form their own suspicions about Upstairs artworks in August 1989 when a twenty-four-year-old UCLA dropout who had become an art broker came forward with new information. Stanley R. Lerner had entered the art business in 1986, arranging to pay Robert Bane thirty thousand dollars to produce limited editions.

The deal fell apart, and Lerner tried to assemble a computerized clearinghouse for art dealers and at the same time market an AIDS test that could be administered at home. By November 1988, Lerner had been arrested by the FBI, which alleged that in addition to his other ventures, he had conspired to distribute five kilograms of cocaine. Unable to post bail, Lerner was jailed until the charges were dropped. After his release from prison, Lerner opened his art brokerage and, in April 1989, founded Triangle Galleries. Months later, however, Lerner was reindicted on the cocaine charge. He quickly found a way to avoid going back to prison: he turned state's evidence.

Lerner told authorities he was aware of the forthcoming sale of a Renoir painting titled *Young Girl With Daisies* from an independent art broker named Frank de Marigny, through Lee Sonnier, the manager of the Upstairs outlet near T. R. Rogers's gallery on Rodeo Drive, to two wealthy Japanese businessmen. The price agreed upon was $3.2 million. Los Angeles Police Detective Bill Martin, an art-crime specialist, knew the painting was a fake, because the real one is owned by the Metropolitan Museum of Art in New York City.

On September 27, 1989, policemen, FBI agents and investigators from the district attorney's office awaited the sale in the Little Tokyo section of downtown Los Angeles. As the sale was consummated, they swooped down and arrested de Marigny. Simultaneously, they executed searches at eight Upstairs outlets from the San Fernando Valley north of the city to Costa Mesa in the south, seizing more than sixteen hundred art prints and other works. Several other paintings and an assault rifle were recovered from the posh seaside home in Manhattan Beach where de Marigny, known to art insiders as "Prince Frank," parked his Rolls-Royce and Ferrari.

Lee Sonnier was charged a month later, accused of conspiring with de Marigny to sell the phony Renoir and of failing to deliver three other Renoirs and a Pissaro drawing to the Japanese businessmen, who were out of pocket $872,000 with no art to show for it. In January 1991, a California judge ruled that the dispute was a civil matter, not a criminal affair, and sent the businessmen down the lengthy and tedious road of civil litigation in their attempt to recover their loss.

After a month of perusing the many Chagall and Miró prints gathered from the Upstairs outlets, authorities raided the Hollywood home of Larry Groeger, seizing his business records. He was charged with grand theft.

De Marigny pleaded no contest in June 1990 to two counts of grand theft, five counts of forgery and one count of perjury, and he was sentenced several months later to a prison term of two and a half years. By January 1991, however, the district attorney's office decided to dismiss all five charges against Sonnier, unable to prove he realized he was dealing in bogus art.

Soon after the initial raid, Upstairs Gallery took the offensive, hiring Dalí appraiser Bernard Ewell of Colorado, Chagall expert Martin Gordon of New York and Miró expert

Howard Russeck of Pennsylvania to look at the seized prints. In April 1990, Upstairs attorney E. Timothy Applegate announced that the experts deemed more than fifteen hundred of the prints to be authentic. Applegate called for the return of those "good" prints. As for the "bad" ones, he said: "There was a problem; we were not aware of it. We did the right thing."

Ewell was angered by Applegate's statement. In fact, he said, he had judged the Dalí prints to be "possibly authorized and signed by Dalí" but certainly not created by him. Russeck's word for the seized prints was "incorrect," because "it was not done by the hand of the artist." In fact, he added, Leon Amiel had no contract with Miró, although claiming to be friends of both Miró and Adrienne Maeght, the son of the artist's publisher, Aimée Maeght.

"I know that there were many Mirós that came out of Leon Amiel," Russeck said, "that he took [it] upon himself to reproduce the lithography and [that] he was not authorized by the family to [do so]."

While many of the seized prints had originated with Amiel, the investigators recognized others to have been created closer to home. While Amiel's prints were duplicates of genuine Dalí, Chagall and Míro paintings, these instead were paintings done "in the style of" a famous artist, and prints that were reproductions of those fakes, i.e., fake fakes, or, as their creator preferred to call them, "emulations."

CHAPTER 7

The Great Emulator

Japanese artist Hiro Yamagata was showing relatives around Beverly Hills, California, near his new home in Bel Air, in the spring of 1988 when one of them told the host with excitement that his work was on display. Yamagata walked into the Carol Lawrence Gallery, looked at one of the miniature watercolors hanging from the wall and exclaimed, "I did not paint that!"

Yamagata reported the incident to the Beverly Hills police, who contacted the Los Angeles district attorney's office. In the ensuing months, police posed as customers and placed deposits on works of art at galleries across the state, preparing search warrants and seizing the artworks. In August 1988, police executed search warrants on the home of Mark Henry Sawicki and on Sawicki's art gallery, Visual Environments, in Sherman Oaks, California. They seized original paintings bearing the signatures of Dalí, Chagall and Erté, and purported limited-edition lithographs signed Dalí, Chagall, Erté and Miró.

In Sawicki's records, which were seized as well, police found a key link to what they believed to be a massive art forgery operation. The police felt sure that Sawicki knew all about it. Sawicki had sold the Yamagatas to the Carol Lawrence Gallery. He had told gallery owner Larry Steinman

that he had obtained them "through the back door," in non-comformity with the artist's exclusive marketing agreement with Martin-Lawrence Galleries, an art retail chain unrelated to the Carol Lawrence Gallery. Steinman had paid fifteen hundred dollars apiece for them, triple what they had cost Sawicki. No certificates of authenticity were involved, but Sawicki agreed to refund the money if they were found not to be genuine. With the police involved, Sawicki now would have to do more than that. He would have to lead them to Anthony Eugene Tetro, a modern-day version of renowned art forgers such as Otto Wacker, David Stein and Elmyr de Hory.

Sawicki met Tony Tetro in 1984, when Tetro placed a newspaper ad offering for sale the Dalí lithograph *Lincoln in Dalívision*. Sawicki was aware of Tetro's reputation in the Los Angeles art world as a forger, and Sawicki had been buying his productions unwittingly through distributors; he now wanted to buy direct. Tetro came to Sawicki's home and showed him a portfolio of his work. Images also could be created upon request. Tetro called them "knock-offs"—drawings, watercolors, pastels, oils on canvas as identical as possible to original works by Chagall, Dalí, Miró, Andy Warhol.

Tetro also did lithographs copied after Chagall, Miró or Norman Rockwell. He would buy the original prints and make copies of them by one of two methods. One process employed the use of Mylar plastic and photography, which worked well enough for Mirós and some Chagalls. Later he discovered a computer process that could virtually eliminate the dot pattern that would readily identify his photomechanical technique.

"A photograph in a magazine has one hundred twenty dots per line," Tetro would later testify. "Mine had 700 dots per line. They melted together into a continuous tone, meaning that if you looked at it under magnification, it

looked like a lithograph. It gave the illusion of [being] a lithograph."

Tetro was meticulous in what he did. "There was a lot of waste in the process," he would say in court. "Out of a hundred sheets, I might net thirty. The paper was very expensive. Then I would sign them only when I was happy with the look. They would have to be what I thought was very good. There was waste there also."

His high standard of perfection brought Tetro success and financial rewards. He bought a three-level bachelor's condominium in Claremont and wallpapered it in lizard skin and suede. The first level was decorated with Dalí oil paintings, the second with Picassos and the third with Miró lithographs, all created by Tetro except for a five and a half by eight foot *Lincoln in Dalívision* painting created by an Israeli artist. He cruised around Los Angeles in a Rolls-Royce Silver Spirit, a Lamborghini Countach, or one of his two Ferraris.

Neighbors wondered about the source of Tetro's income, and so did the police. "For well over ten years, every cop in this valley and many people who didn't know me personally were certain I was a drug dealer," Tetro said in a newspaper interview. "I must have heard it myself, conservatively, three hundred times. And the more I defended myself, the more I wasn't believed. Drive down the street in a Ferrari and a cop is certain that you're a drug dealer. And you are constantly harassed, constantly getting tickets for nothing, constantly getting your car searched."

Tetro's customers included dealers Michael Zabrin in Illinois, Mitchell Beja and former policeman Tom Wallace in New York, Basil Collier Fine Arts of Los Angeles and Carter Tutweiler. Mark Sawicki became one of Tetro's clients, buying "original" Dalí, Chagall and Erté paintings and lithographs created by Tetro. In the spring of 1988, Sawicki attended the New York Art Expo and was attracted to an

exhibit of Yamagata's miniature watercolors. He brought a catalogue of Yamagata's works back to California, showed it to Tetro and asked him to create facsimiles.

Tetro had never seen a real Yamagata watercolor, but he agreed to use the catalogue reproductions as models. He drew rectangles and squares of different sizes on sheets of normal-sized art paper, and he painted Yamagatas in each of them. Tetro's prices to Sawicki for the Yamagatas varied from $500 to $750, and they eventually wore price tags of $3,000 to $16,000 in art galleries across the country, two or three times what Sawicki had charged the retailers.

In December 1988, four months after his home and gallery were raided, Sawicki took thirty to fifty lithographs from Tetro on consignment, agreeing to pay him twenty thousand dollars after the prints were sold to retailers. They included pseudo-Chagall lithographs titled *Black and Blue Bouquet, Bouquet Over the Town* and *The Villages*, about a dozen phony Miró prints and a large fake Rockwell print titled *Doctor and Doll*. However, Sawicki was a bit nervous about selling the Tetro prints to galleries while he was apparently under investigation. He held on to them and avoided calls from Tetro.

In March 1989, police arrested Sawicki. He quickly agreed to help them gather evidence against Tetro. On April 17, 1989, Sawicki telephoned Tetro from the district attorney's office, telling him he had sold some of the prints, wanted to return the others and was interested in buying some Miró prints, titled *Prix la Hamecon*. Tetro agreed to meet him the next day at his place.

Sawicki arrived at the Claremont condominium fully wired. Once inside, he explained to Tetro that a dealer had indicated he would buy all the prints Tetro had consigned to him but that the deal fell short of what Tetro had sought. Sawicki had come with only $8,000.

"It's a bitter disappointment," Tetro told him.

Sawicki explained to him that only $6,500 of that came from the consignment. The remaining $1,500 was for three *Prixs*.

"If that's the case, I'm gonna give them to you right now," Tetro said.

"Yeah, if you trust me," Sawicki responded. "I thought you were pissed at me." Sawicki had received calls from a friend of Tetro demanding payment of the money.

"I thought you skipped out," Tetro said. "What am I supposed to think?"

"You called your friend off me, didn't you?" Sawicki asked.

"Yeah," Tetro replied.

"Who is he?"

"I'm not going to give you his name," Tetro said.

"Is he a bone-crusher?"

Tetro explained that the man had not intended to do anything drastic, only to talk to Sawicki in a gentlemanly way.

"Is he a bone-crusher?" Sawicki repeated.

"Yeah," Tetro answered, then changed the subject to the transaction at hand.

In addition to the prints, Tetro had given Sawicki, on consignment, a Dalí replica oil painting titled *Exploding Madonna*, also known as *The Nuclear Disintegration of the Head of a Virgin*. Sawicki told Tetro he still had not sold it for the expected twenty-five thousand dollars.

The *Madonna* had made the rounds. Tetro had first sent it in early 1988 to Steve Burton, a dealer in Fort Lauderdale, Florida. He said Burton later told him he had obtained a bogus certificate of authenticity for the painting bearing the name of Robert Descharnes and another from Dalzell Hatfield Galleries, and that Christie's auction house had agreed to sell it at a suggested price of $350,000 based on those certificates.

"Fucking Christie's blessed the oil [painting]," Tetro exclaimed to Sawicki. "Fortunately, Descharnes was [away] until April twenty-forth. If he would've seen that, all hell would've broke loose."

Tetro related how he had taken the painting off the market. "I don't need the money. I mean, I do, but I don't wanna go to jail. What do you think would happen if Descharnes saw a phony certificate? He would go crazy."

"Fucking Descharnes," Tetro added bitterly. "If Descharnes were to die right now, I could be rich."

Not only had the Dalí passed Christie's scrutiny, Tetro said, but Andy Warhol's Factory had authenticated one of Tetro's replicas of Warhol's Mickey Mouse drawings. A dealer in New York had purchased one of them, and he had then decided to warn the dealer to stay away from the Factory.

"So I called, and it was too late," he recounted.

"He took them down to the Factory. And they go, 'Yeah.' He says, 'Well, there's nine of these.' And they blessed the photograph and everything, okay? Because it was perfect, what I did. I'm serious. I went through such pains in making it perfect."

Tetro also boasted to Sawicki that a Chagall gouache he had executed had been approved by the dead artist's sister.

"There's Ida's letter," Tetro said as he pointed to a piece of paper on the table. "I couldn't believe it."

Sawicki began reading the letter: "I can only tell you that the piece is good. I'm in the hospital, not feeling well at all . . ."

"Pretty interesting," Sawicki said. "Is anything happening in the art business?"

Tetro said things were quiet, the Upstairs Gallery was charging high prices for Chagalls, and the gallery had some of Tetro's replicas.

"Does what's-his-name still call you?" Sawicki asked, aware that every word was being recorded.

"Who, T.R.?" Tetro responded.

"Yeah, he still bothering you?"

"He wants art from me," Tetro said. "I don't want [his business]." The Rogers Gallery on Rodeo Drive had been raided by police only eight months earlier.

They talked about the recent death of Leon Amiel, and Sawicki said someone had called it a great moment for the art industry. Tetro said the only person who did not take Amiel's death well was Tom Wallace. "I think him and Amiel were close," he said.

Sawicki said he would have to leave soon to beat the traffic, and they returned to completing their transaction. Tetro said he would have even more *Prix* prints soon. Sawicki said he would notify the dealers, as soon as Tetro called him, and he left the condo.

Minutes after Sawicki's departure, police converged on the apartment and arrested Tetro. He was booked at the police station and posted bail of ten thousand dollars.

Four months later, in August 1989, Los Angeles District Attorney Ira Reiner convened a press conference to announce that Tetro had been charged with conspiracy to commit grand theft and forty-four counts of forgery. Sawicki was also charged with grand theft and forgery, and he already had agreed to plead guilty and cooperate with the authorities in return for a sentence of probation.

"The forger in this case is the single largest forger of artwork in the United States," Reiner said at the press conference. "He's been in business for a long time."

Tetro agreed that eighteen years was a long time for him to have been in his line of work. His position was made clear a year and four months later, in December 1990, in a press release issued by Exclusive News Relations, his publicity agent. The release announced the unveiling of Tony Tetro's "flawless forgery" of a 1958 Ferrari Testarossa at a one-car auto show. The red sports car took him "six years to

assemble," using "authentic Ferrari parts and pieces" in "a hand-hammered alloy body," the release said.

"I wanted to demonstrate that I could just as skillfully draft and duplicate a rare vintage automobile as duplicate a fine art masterpiece!" Tetro`was quoted as saying. As for the felony charges, Tetro responded: "I do not apologize for my special talent, only that others exploited my work wrongfully." The publicity sheet announced that Jay J. Tanenbaum, Tetro's attorney, would answer questions about the charges at the auto show. Champagne would be served.

Despite the wording of the press release, Tanenbaum insisted that *forgery* was an ugly word that was inappropriate in describing Tetro's artworks. When the trial convened six months later, in May 1991, the Encino lawyer was adamant that witnesses not be allowed to utter the word. Whether they were forgeries was a legal issue to be decided by the jury. When Sawicki took the witness stand and used the word, Tanenbaum objected, preferring the word *image*. When Sawicki explained that he and Tetro had referred to the artwork as *knockoffs*, that term was allowed.

"Would you please tell us what [the term *knockoff*] meant?" asked Assistant District Attorney Reva Goetz late in Sawicki's three-day testimony.

"A forgery or a fake work of art," Sawicki responded.

Tanenbaum exploded, accused Goetz of misconduct for eliciting such an answer and called for a mistrial. Goetz explained that she was merely trying to get Sawicki to explain that Tetro was copying a preexisting work.

Tetro liked the word *emulation* to describe his work.

"I enjoyed emulating," Tetro explained. "It was different, and I enjoyed every minute of it. It's like playing chess. It's getting into the thoughts of the artist that I'm doing."

Under questioning from Goetz, Tetro testified, "It's a painting in the style of another artist," and he maintained he never represented his works as anything else. He created the

paintings, he explained, "because many people want works from famous artists and can't afford them." He also said that some wealthy art collectors wanted his re-creations for insurance purposes.

"It's very expensive to insure art, and many people would like to have their original paintings put away in a vault someplace," Tetro explained. "The insurance is much less . . . if it's in a vault."

Nowhere had Tetro indicated on any of his paintings that these were reproductions, not even in invisible ink.

"My customers wanted these to be as authentic as possible, and if I had put 'reproduction' on them, that would have defeated the purpose," he claimed.

The lithographs could be revealed as re-creations under analysis because of the lack of watermarks on the paper, Tetro testified. He added that he was well aware of that when he produced them. If he had wanted to pass off his Chagall and Miró lithographs as genuine, he would have used the properly watermarked paper, he said. He did not mention, nor was he asked to, where he thought he could have acquired watermarked paper old enough to have been manufactured before the deaths of the two masters.

Asked what steps he had taken to insure that his works were not being misrepresented, Tetro said: "I wasn't concerned. When I sold to a private party, I knew it would go onto their wall. That was the bulk of my business."

Bolstering Tetro's case was Ernest Cummins, president and managing director of Heritage Galleries in Fort Lauderdale, Florida, a company that is in the business of hiring artists to reproduce Old Master oil paintings. About 1980, a friend of Cummins had been searching for ways to decorate a large mansion he had bought in Georgia and turned to Cummins for assistance. Cummins met an old Italian who said he knew how to have copies of great paintings made, and Cummins put his friend and the Italian

together. Fascinated by the concept, Cummins turned such arrangements into a hobby that within a decade turned into a business grossing perhaps $1.5 million a year, using two hundred artists around the world to produce imitations for up to two thousand of his customers.

"We probably do more re-creation work and sell more copies than anyone anywhere in the world," Cummins boasted.

"If you have a well-fortified, burglar-alarmed home and have a painting hanging on the wall," Cummins testified, "it still costs you an awful lot to insure it, because art thieves can defeat most burglar alarm systems. Take the same painting and put it in the vault, and the insurance premiums drop drastically, but you may have a copy on your wall to enjoy. The person who owns the original may be loaning it for exhibition. He may have several homes and want copies for [each of them]."

Cummins had looked at Tetro's work and was impressed.

"Frankly, I was astounded," he said. "The quality is superb. It's as good as anything that we do, as good as anything that any copyist can do. It's fantastic work."

Heritage Galleries, unlike Tetro, marks its product on an eight-by-ten-inch stamp on the back with invisible ink, as a "masterpiece re-creation."

"It's invisible to the unaided eye," Cummins said, "but one of the first things an art appraiser would do is use a black light, and it would show." It is sold in a frame, with a brass plaque listing the title and location of the original and a "Certificate of Re-creation" comes with the painting.

Otherwise, he said, the painting is made to look as genuine as possible, and it may be put through an antiquing process "designed to mimic all of the aging and discoloration and distress that a painting will go through over three hundred some odd years."

Less than 10 percent of Heritage Galleries' work was "emulation," creating paintings in the style of a master without duplicating an actual work, Cummins testified.

The use by Tetro and Cummins of the word *emulation* sent Pepperdine Law School Professor Jessica Darraby, at the behest of prosecutor Goetz, scurrying to her many books for past usage of the word as a term of art. "I investigated through various art dictionaries, through my own collecton of art books and recent compendiums," reported Darraby, a one-time gallery owner. "I searched for the word in dictionaries and indices. I couldn't find it anywhere."

Usually, the word would be *imitation* or *copy*, she said. Imitations typically are created by art students in their training. "When it's done for that purpose, it's perfectly acceptable," Darraby said. "There's a term called *falsification*, referring to imitations that are done and distributed for fraudulent purposes, for purposes of deception."

That was the question for the jury to decide. Did Tony Tetro create his "imitations" for purposes of deception? Nowhere in his tape-recorded conversation with Sawicki on the day of Tetro's arrest did he refer to his paintings or prints as fakes or forgeries. Sawicki testified that Tetro usually used the word *knockoffs*. Tetro did not issue certificates of re-creation, as did Heritage Galleries, but neither did he issue certificates of authenticity.

After seventeen hours of deliberation spread over five days, the jurors gave up. Three votes were taken, and while the panel favored Tetro's conviction, unanimity was not deemed likely. A mistrial was declared on June 9, 1991.

Goetz talked to jurors, and some told her the evidence from the taped conversation was not strong enough to prove deception.

Tony Tetro remained free on bail while awaiting a second trial, but his art production—or art reproduction—had stopped. "I haven't painted since I was arrested," he tes-

tified during the trial. "When you are walking on eggshells, you don't hop."

During Tetro's trial, Gary Helton, the district attorney's investigator, had become curious about Tetro's claims regarding his *Exploding Madonna*. The painting was listed as a defense exhibit to be cited as an example of Tetro's Dalí emulations. During the search of Tetro's house, investigators had found copies of the fake Descharnes and Hatfield certificates of authenticity for the piece, but the painting was not there.

"We didn't know what piece the certificates went to," Helton said. "Unless you can tie it to some transaction, all you've got is these pieces of paper."

Tetro solved the puzzle by producing the painting at his trial. Attached to it was a Christie's certificate, including a lot number.

After the trial, Helton went to Christie's and traced its provenance. He found that a Hollywood character actor, Allen Rich, had agreed to buy it for $350,000 if Christie's were to certify its authenticity. Butterfield & Butterfield, the reputable California-based auction house, already had blessed it, but the money remained in escrow pending Christie's determination. Eventually, as Tetro had feared, Robert Descharnes arrived in New York, visited the auction house and declared the painting to be a fake. The sale collapsed, and the painting went back to its owner. Not only had Christie's not blessed the painting, as Tetro had told Sawicki, but Helton discovered the owner was not Steve Burton of Florida, as Tetro had told Sawicki and had testified at the trial. The owner, the person offering it for $350,000, was Tetro himself.

New charges were filed against Tetro, based on the exhibit Tetro had offered in his first trial. The offering price was new evidence that Tetro had tried to sell the painting not as an "emulation" but as the real McCoy.

"The Well Never Ran Dry"

Tony Tetro's emulations, and the creations of Jean-Paul Delcourt, Pierre Marcand and Leon Amiel, underwent increasing scrutiny as the law-enforcement efforts intensified. The investigation went from gallery to gallery, coast to coast, and expanded from Dalí prints to include those bearing the names of Marc Chagall, Pablo Picasso and Joan Miró.

In the summer of 1987, David Spiegel, a lawyer for the Federal Trade Commission in Washington, was asked to look into art-print fakes as part of his agency's overall interest in consumer frauds. The FTC's role in protecting the marketplace from such things as price fixing and false advertising does not result in criminal prosecutions, but its civil actions can produce results very quickly, and without the heavy burden of proof beyond a reasonable doubt required in criminal cases.

In August 1987, this author had received a call from a Cleveland man who had read one of my articles about the Dalí fraud investigations. The man had spent $1,700 for a Dalí "lithograph" titled *The Temptation of St. Anthony* from Federal Sterling Galleries in Scottsdale, Arizona. The gallery claimed in a letter to be "international distributors of fine art" and sent him a certificate of authenticity with his

"original lithograph." To preempt any questions about what that term really meant, Federal Sterling enclosed an explanation: "Genuine original graphics are works of art which are made by the artist drawing or etching the image on a stone or plate for the explicit purpose of creating an original work of art for reproduction."

Federal Sterling was not timid in touting Dalí graphics for investment purposes. "He is the most recognized artist of our time, eighty-two years old, and in extremely poor health," the gallery had stated in a flier. "He has been diagnosed as having arteriosclerosis and Parkinson's disease. There is no question that Dalí is dying. We all die, so will the legendary Salvador. And when he does, his works will double and triple in value almost immediately."

Complaints from others who had invested in Federal Sterling's Dalís were being made to both DeMuro, who was swamped with investigations of other galleries, and Spiegel, who had chosen the Arizona operation as his first order of business in art-fraud investigation.

Spiegel learned that Federal Sterling had originated in Florida as Federal Sterling Gem Brokers, changed its named to Federal Sterling Philatelic and finally settled on Federal Sterling Galleries in February 1986. Florida law-enforcement authorities almost immediately began receiving complaints about the gallery's business practices. The gallery deserted its Miami Beach offices just as state banking authorities were about to serve it with a subpoena. Partners Robert Sweeney, who sometimes went under the alias of Robert Gannon, and David Kadis, who used the alias Michael Marshall, swiftly reopened their boiler-room operation in Scottsdale, which also operated under the name of Churchill Gallery.

The methods of Sweeney and Kadis were much the same as those used by the New York boiler rooms. Promotional material first was sent to potential buyers throughout the

country, and salesmen would call those who returned cards requesting more information. More elaborate than New York's Barclay, Federal Sterling had an assortment of scripts aimed at closing a sale. There was the "Wife Objection Close," intended to embarrass or shame the man who wanted to talk to his wife before committing himself to a purchase. Other scripts were titled "Lost My Job," "Had an Accident," "Can't Afford It" and "Don't Know Enough About Art." A script titled "Urgency" was used to convince consumers that very few of the Dalí prints were "left in the collection" and would be sure to disappear if the consumer did not purchase right away.

In some cases, the salespeople billed charges to the consumer's credit card even though the consumer had never agreed to the purchase. When he or she complained, the salesman responded with a script titled, "I Gave My Credit Card Number Only So You Could Check My Credit." It began, "I'm sorry that we've upset you. As it turns out, you've benefited enormously by what we did. The edition did sell out and the price has gone up substantially."

Federal Sterling paid $85 to $300 to Pierre Marcand's Magui Publishing and Jean-Paul Delcourt's Art Graphics International for each print, reselling them over the phone for $990 to $3,500. The boiler-room operation turned a staggering $12 million in business over one year, according to the Federal Trade Commission. Spiegel confronted Marcand and Florence Salkin, Delcourt's main sales representative, and both denied being the source of misrepresentations used by Federal Sterling.

In December 1987, Spiegel charged that Federal Sterling had engaged in unfair and deceptive trade practices. In February 1988, a federal judge in Arizona issued a court order shutting the operation down and seizing its assets.

Spiegel's entry into the investigation came at a time when publicity about the Dalí fraud was at its height. Dealers and sales people no longer could claim they were unaware of it. At a San Francisco outlet of Chicago-based Austin Galleries, there was rebellion within the ranks.

Ronald Hunter had worked for Donald Austin for more than a decade at galleries in Chicago and Detroit and at the Pier 39 store in San Francisco, selling countless Dalís, Chagalls, Mirós and Picassos. But lately he had become concerned. "I couldn't understand how Austin Galleries was always able to get more and more prints of supposedly limited edition works by such popular artists," Hunter recalled. "The well just never ran dry."

Hunter was told not to worry, but continued to have his doubts. The vast majority of the Miró prints were numbered "H.C.," for *hors commerce*, a category that Hunter understood rarely exceeded 10 percent of an edition; there were just too many. He had seen duplicate numbers of the same Picasso print, supposedly from a single edition. He was troubled by Chagall "lithographs" that were marked "plate-signed," then reworded to "facsimile-signed," and on close examination he noticed dot patterns suggesting they had been photomechanically produced. He even saw Chagall prints numbered higher than the edition size, for example 51/50, meaning the print was the fifty-first print in an edition of fifty!

Hunter voiced his concerns to Fred Laidlaw, who had been hired by Austin to manage the three San Francisco outlets. Laidlaw agreed that something seemed wrong and confronted Donald Austin and assistant Joanne Granquist. They explained that the Chagall prints were derived from Chagall oil paintings and were made with the permission of the paintings' owners. In the summer of 1987, acting on their own, Laidlaw and Hunter removed all of the Dalí prints and the "plate-signed" Chagalls from the gallery walls, plus

three Picasso prints. They packed them into several large crates, along with some Miró prints, and shipped them back to Chicago. Donald Austin angrily ordered the crates shipped back to San Francisco. Hunter and Laidlaw turned in their resignations.

Nearer to Austin's home office, salesperson Jacqueline Renier had been alerted both by her art history degree from the Univerity of Illinois and from the publicity about the Dalí fraud; something was wrong with what she was selling on Michigan Avenue in Chicago. She, too, had noticed dot patterns on some of the prints, and she, too, was amazed at the large numbers of prints available.

"If our store was running low on these Picasso prints and a customer wanted one, we could order it from corporate headquarters," Renier said. "I cannot recall a single time when these prints were not available and we couldn't fill an order. We sold the prints for $2,695 but gave [inflated] appraisals to customers valuing the prints at $4,000."

Renier received numerous complaints from Dalí print purchasers, and she dutifully referred them to corporate headquarters. There the purchasers would find sympathy. "Please understand that in dealing with anything to do with Salvador Dalí, there are no yardsticks by which to evaluate claims of any kind," the customer would be advised by letter. "This problem was created and perpetuated by Dalí's own desire to remain an enigma." The company's policy was not to give refunds, but if the customer insisted, he could use Austin's five-year exchange policy. He could trade his Dalí for a Miró, a Chagall, or a Picasso.

As David Spiegel investigated Austin's operation, he realized the exchange program amounted to trading a fake for a fake. Austin's Dalí prints were coming from distributors known from other fraud cases, including Andy Levine's A.D.L. Fine Arts, Delcourt's Art Graphics International and Phil Coffaro's C.V.M. Almost all of the Chagall, Picasso and

Miró prints were coming from Michael L. Zabrin Fine Arts in Des Plaines, north of Chicago. Zabrin was a client of Tony Tetro, the master emulator from California, among others.

Spiegel hired Martin Gordon, a New York print dealer who regularly issues a directory of print sales at auctions, to examine the non-Dalí prints. Gordon first looked at the prints at the gallery's corporate headquarters in Palatine, Illinois, then took color slides of the Chagall prints to France to show Chagall expert Charles Sorlier of the Mourlot printing house and Paris art dealer Yves Lebouc, who had published numerous editions of Chagall lithographs.

Among the Austin prints were *Bouquet Over the Town*, *Black and Blue Bouquet* and *The Villages*, three titles of prints produced by Tony Tetro. Sorlier easily spotted *Bouquet Over the Town* as a fake. Sorlier himself had printed the real Chagall lithograph by that title in June 1983 and had numbered that edition, but he had not numbered the one shown on the slide brought by Gordon. Gordon concluded that, for the most part, the Chagall prints sold by Austin were reproductions of Chagall paintings, and bad ones at that, marked by blurring and distortion.

The three Picasso prints sold by Austin—*The Dove, La Ronde* and *Mains aux fleurs*—turned out to be reproductions of drawings Picasso had done. He had given the Communist party of France permission to make lithographic reproductions of them, and twenty-two hundred of these authorized reproductions had been made, Gordon explained. Picasso had autographed and numbered two hundred of them. Were these the prints being sold at Austin in editions of two hundred? Not likely. While at Austin's offices, Gordon noticed stacks of the Picasso prints in front of Donald Austin's desk. Most of them were signed "Picasso" and bore no numbers. If they had been part of the authorized edition, they would have been either signed and numbered or not signed at all.

Port Lligat. Dalí's home for many years on Spain's Costa Brava. Eggs and heads are perched atop the Dalí house, an allusion to the myth of Leda and the swan. (PHOTO CREDIT: AUTHOR)

Dalí's Teatro Museo in Figueras, Spain. In accordance with Dalí's instructions, the renovated 19th century structure was crowned with sculpted eggs alternating with triangular loaves of bread. (PHOTO CREDIT: AUTHOR)

New York Assistant Attorney General Rebecca Mullane with *Discovery of America by Christopher Columbus, The Last Supper,* and a fine print based on a forgery of a Dalí artwork, or "fake fake," entitled *Great Stallion of Port Lligat.* All three prints were sold by Convertine Gallery. (PHOTO CREDIT: AUTHOR)

Archivist Albert Field, annointed with this title by Dalí himself, brouses through his myriad Dalí print files. (PHOTO CREDIT: AUTHOR)

Postal Inspector Robert DuMuro. PHOTO CREDIT: COURTESY OF ROBERT DUMURO)

Talented art "emulator" Tony Tetro. (PHOTO CREDIT: COURTESY OF TONY TETRO)

Shelby Galleries owner Ron Caven, seen here proudly displaying *Transcendant Passage*, a print attributed to Dalí, following a favorable court ruling. The ruling was reversed on appeal. (PHOTO CREDIT: *THE DENVER POST*)

On Spain's Costa Brava in 1979, Salvador Dalí offers to sign his autograph for a boy and the boy's father, while, (l. to r.) William Mett, Enrique Sabater, Marvin Wiseman, Ramon Guardiola and Michael Stout look on. (TRIAL EXHIBIT)

Dalí secretary Enrique Sabater shows Center Art Gallery "expert" Wiseman and owner Mett the *Christ of Gala* twin paintings, after which Center Art will print its lithographs. (TRIAL EXHIBIT)

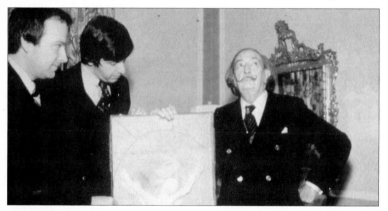

Mett and Wiseman receive the wax mold for the bas relief of *Christ of St. John of the Cross* from Dalí. (TRIAL EXHIBIT)

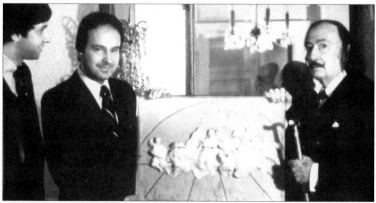

Dalí presents the wax mold for the bas relief of *The Last Supper* to Mett and Wiseman. (TRIAL EXHIBIT)

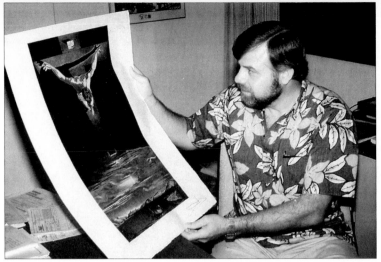

Postal Inspector Richard Portmann views Center Art's rendition of *Christ of St. John of the Cross.* (PHOTO CREDIT: AUTHOR)

Defense attorneys John Wing and Robert Weiner (foreground) lead clients Mett and Wiseman to court during their trial in 1990. (PHOTO CREDIT: AUTHOR)

Assistant U.S. Attorney Les Osborne inspects *The Battle of Tetuan*, a reproduction of an original Dalí painting purchased by Center Art Gallery. (PHOTO CREDIT: AUTHOR)

The man who replaced Sabater as Dalí's secretary, Robert Descharnes. (PHOTO CREDIT: AUTHOR)

Postal Inspector Jack S. Ellis, Jr. (PHOTO CREDIT: AUTHOR)

Robert Descharnes looks over a "fake fake," a print based on an image which itself is not by Dalí, in Descharnes's Paris office. (PHOTO CREDIT: AUTHOR)

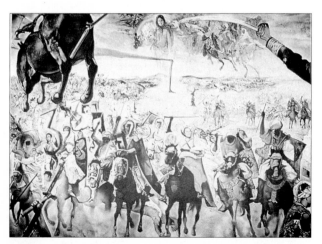

The Battle of Tetuan print. The original 1962 Dalí painting was acquired by Center Art Galleries and reproduced as a "lithograph" in 1982. (PHOTO CREDIT: AUTHOR)

Anthony Quinn, his wife, and William Mett present a Quinn sculpture to President Ronald Reagan. The Reagan administration later complained when Center Art used this White House photograph in advertisements for works by Quinn. (PHOTO CREDIT: U.S. GOVT.)

Tony Curtis paints along the shores of Oahu. How many of Curtis's paintings were actually created by Curtis remains open to question. (PROMOTIONAL PHOTO)

Red Skelton shows *The Philosopher*, one of his many clown pictures. Skelton said he made more than a million dollars from limited-edition reproductions of his work sold by Center Art as "original prints." (PROMOTIONAL PHOTO)

Pierre Marcand displays his truly original Dalí painting, *Adolescence*. Limited-edition prints of the image produced by Marcand's Magui Publishing sold at retail for more than $3,000 each in 1986. (PHOTO CREDIT: AUTHOR)

A. Reynolds Morse with his wife Eleanor. Morse, head of the Salvador Dalí Foundation, which operates the Dalí Museum in St. Petersburg, Florida, battled against the proliferation of fake Dalí prints. (PHOTO CREDIT: AUTHOR)

Leon Amiel of Secaucus, New Jersey, printed scores of Dalí, Chagall and Miró prints that were sold from New York to Hawaii as expensive, original, investment-quality art. (PHOTO CREDIT: LYLE AND CAROLE STUART)

Gordon owned one of the authorized *Dove* prints, signed and numbered, and one of the Austin *Dove* prints had the same number as his.

Gordon concluded that two of the six Miró titles were fakes, using the very method mentioned by Tony Tetro at his trial; the paper did not have a Guarro watermark, the brand of paper Miró used for his prints. Gordon cast serious doubts on the other four Mirós sold by Austin because of the large number of prints numbered "H.C."

By 1988, Spiegel had gathered enough evidence to go before a federal judge in Chicago and ask that the fraudulent sales cease. The Federal Trade Commission charged that Austin was selling "authentic, original, limited edition, hand-signed prints" by famous artists at prices up to $5,000 that were in fact reproductions worth at most $50.

Company president Donald Austin claimed to be at the mercy of wholesalers. "We rely upon our suppliers to authenticate these works, and I'm more interested than anyone [to ensure] that what we buy and sell is authentic," he said in a press release. He insisted neither he nor his gallery had "ever been involved in any lawsuit even remotely suggesting that the works of art sold by us are anything other than what they are represented to be."

Judge Prentice Marshall immediately issued an order temporarily halting Austin's Dalí, Picasso and Chagall "original print" sales and, a few months later, added to the list those bearing Miró's purported signature. After lengthy negotiations and court proceedings, Austin agreed in April 1990 to prohibitions against further false statements, surrendered four hundred counterfeit prints, and agreed to pay $635,000 in refunds to customers.

The Federal Trade Commission's next case was detected not by an angry consumer or a prying investigator but by a judge presiding over a copyright infringement claim.

In 1968, Salvador Dalí agreed for five thousand dollars to paint twelve watercolor illustrations of Lewis Carroll's *Alice in Wonderland* for a Liechtenstein company called Werbung und Commerz Union Anstalt. Dalí gave Werbung reproduction rights, and the company made agreements a year later with Maecenas Press in New York to reproduce the watercolors to illustrate two books. The first edition of the book, published by Random House, was marketed as a deluxe edition containing original colored etchings and signed by the artist. The second bore no signature and sold for much less, since "original etchings" command greater prices than the mere reproductions included in the second edition.

According to the agreement, Maecanas had the right after three years to reproduce the *Alice* in other forms. The company liquidated its assets in 1975 and assigned its *Alice* rights to Collectors Guild, Ltd., which was, along with Maecenas, among a handful of companies organized or taken over by mass-marketer Abe Lublin and former real estate developer Robert LeShufy in the 1960s. In 1984, Max Munn, then president of Collectors Guild, approached his lawyers for their opinion about whether he could reproduce more *Alices*. He received the answer he wanted, and *Alice* reappeared under an agreement with American Express and the Nelson Rockefeller Collection, Inc.

In July 1984, American Express cardholders received brochures offering "original lithographs by Salvador Dalí," inspired by Alice's *Adventures in Wonderland*. The brochure stated there were "no prior states of these original lithographs, and no prior editions." Further, it said, "From Salvador Dalí's original maquettes a master chromiste [sic] prepared the many individual color plates required for these lithographs," and the Arches paper sheets bearing the images "were signed by Salvador Dalí before the lithographs were individually hand-pulled, numbered and custom-framed."

Each of the prints was priced at $975, including a certificate of authenticity and a certificate of evaluation stating "that the *Alice in Wonderland* signed color lithographs are genuine and authentic, new and original works of art by Salvador Dalí."

Werbung und Commerz Union Anstalt cried foul and, in 1984, filed a suit against all companies involved in the new prints. Initially viewing the case as one of alleged copyright infringement, U.S. District Judge Pierre N. Leval, like Alice herself, became curiouser and curiouser. In December 1987, the judge threw out the claim. A coholder of a copyright is entitled to make reproductions without the other holder's permission, he ruled. The judge was more concerned with how the prints were being sold, and especially that they were on supposedly presigned paper.

"The prints appear to have been signed by Dalí, whereas in fact Dalí never saw them or even knew they were printed," Leval wrote in his final judgment of the case. "The Dalí signatures appearing on the prints were intended for some other print. There may be a question whether such merchandise is inherently deceptive and should be sold at all in this form bearing the Dalí signature. Further questions arise from the description of the prints in Collectors Guild's offering circulars." In his ruling, the judge asked rhetorically whether he had "an obligation in the public interest to bring to the attention of the responsible government official the question whether this marketing involves deceptive practices?"

A month later, Leval answered his question affirmatively and sent his decision to New York State and federal authorities. The matter finally landed at the Federal Trade Commission, which in April 1990 filed a complaint accusing Munn and LeShufy of falsely representing Dalí's involvement in the *Alice* prints. Under a consent agreement in September 1991, Munn and LeShufy agreed to stop misrepre-

senting the prints. American Express, which was not named in the FTC's suit, made refunds totaling $2.5 million to cardholders.

Elsewhere in the country, state agencies played a role in trying to halt the fraud. Wisconsin authorities became involved after the Shelby Fine Arts raid in Albuquerque in 1986, when the former manager of Shelby's Madison gallery, encouraged by her state trooper husband, called on the consumer protection branch of the state Department of Justice. She had been bothered about how new Shelby employees were being forced to buy Dalí portfolios as their initiation. Soon, investigator Barbara Matthews began receiving consumer complaints about other galleries.

Hermes International, Inc., a Madison telemarketing operation, sold its Dalís as "art for the serious investor" and as "original limited-edition hand-colored etchings." Actually, they were reproductions supplied by a small publishing company in Minneapolis, and by James J. Raemisch, a farm implement dealer in a small town near Madison who said he added Dalís to his John Deere tractors to please his wife. Raemisch, through Denver lawyer Mark Shaner, claimed to have executed contracts with Dalí's agent, then hired his own chromist and had his prints produced at a print shop on the East Coast. Meanwhile, Raemisch called his own telemarketing enterprise Magnum Opus International Publishers, Ltd., and he made door-to-door sales as Gallery One Fine Art Portfolio.

A man named H. Philipp Huffnagel opened his own boiler room and, using Philips A. Koss, who had worked as a salesman at Hermes and Magnum Opus, sold Raemisch's Dalí product, in addition to Picassos, Chagalls, Mirós and others under the ridiculous names of The Phönix Corporation and Gallerie [sic] de Philipe.

On April 1, 1987, Wisconsin's consumer protection agency filed complaints, charging Hermes, Gallery One, Magnum Opus Phönix and Gallerie de Philipe with violations of the state's deceptive advertising law in the sales of Dalí art. A judge immediately halted all sales, and the defendants ultimately agreed to settlements of the civil complaints.

The action did not halt the shenanigans of Koss, who continued to operate Gallerie de Philipe. In the fall of 1988, Koss advised two Madison men that they could acquire Andy Warhol's original *Campbell's Onion Soup Can* for $82,000 and then sell it through Sotheby's for nearly double that amount. They agreed to put up the money, and Koss bought the art from Illinois distributor Michael Zabrin for $32,000, turning a quick profit of $50,000. Moreover, the painting was authentic. The problem was that the art was not Warhol's onion soup can, but his onion soup box, and it was worth only about what Koss paid for it. Meanwhile, Koss was selling what he said were prints by "Miró the Younger," supposedly a nephew of Joan, but which were nothing of the sort. Wisconsin authorities arrested Koss in January 1989. He was convicted by a jury in March 1990 of theft by fraud for the Warhol deal, pleaded guilty to the Miró the Younger escapade and was sentenced to three years in prison.

In Florida, the state comptroller and Department of Law Enforcement in December 1987 shut down a Miami telemarketer called International Collectors Guild after it sold "original fine art etchings and prints" attributed to Dalí.

Other Dalí sales in the United States went unprosecuted because of the lack of explicit representations or because the sales pitch was laughably transparent.

Postcards sent from Miami and Fort Lauderdale, Florida, invited recipients to enter free lottery drawings to win "the

original Salvador Dalí print" pictured on the card, the print having been "hand-signed and numbered by the artist." The purpose of the scam was to drum up names to generate mailing lists.

In August 1989, subscribers to a financial newsletter based near the nation's capitol received a brochure proclaiming, "HELLO, DALI! Or How a $500,000 Snafu Resulted in Your Getting the Chance to Own the Perfect 'Twin' of a Famous $27,500 Lithograph for a Mere $195." An eight-page letter bearing the signature of a Jay Abraham offered "original lithographs" of *Lincoln in Dalívision* for only $195 plus shipping. The letter told the story of a friend of Abraham named David Avrick, "a world-class art collector" who was given "a run of 1,000 beautiful original lithographs of *Lincoln in Dalívision.*

"They are unsigned," Abraham confessed. "But they are authentic and approved by the prestigious Salvador Dalí Foundation in New York—and, I am told, by the Dalí Institute in Europe." A minor technicality: The Dalí Foundation is located in Florida, where A. Reynolds Morse said he had never heard of Abraham, Avrick or any "Dalí Institute" in Europe.

Attempts were made as early as December 1981 to stop Dalí prints from crossing the border into Canada. When Gallery Hawaii tried to ship one hundred Dalí "lithographs" titled *Raphaelite Head* to Gallery Alberta, the box was stopped at Calgary. If "original," under Canadian customs law the prints would be duty-free. Customs officials questioned their originality and chose to tax them on a value of $500 for each print, based on Gallery Alberta's contract for rights to purchase two hundred fifty of the prints for $100,000 (or $400 per print) and to pay an additional $100 for each print acquired. The prints wore retail price tags of $1,600 in Honolulu and Gallery Alberta planned to sell them for $2,000 apiece.

Gallery Alberta owners Don Stroh and Alan Jewitt contended they qualified as duty-free and, as proof, waved an April 1981 Hamon contract with the artist and a May 1981 contract transferring reproduction rights to Henri Guillard. Customs agents pointed to a clause in the contract that specified the prints "may not be represented or offered to the public as original lithographs by Salvador Dalí."

Gallery Alberta then claimed each of the prints should be taxed at a value of $100, although the retail price at Gallery Hawaii was $1,600 and the price in Canada was put at $2,000.

The issue went before Canada's three-member Tariff Board, which ruled in 1986 that the prints did not qualify for tax-free status. Mimi Cazort, curator of prints and drawings at the National Gallery of Canada, and Pierre Valentin, owner of Galerie de l'Art Français, testified that the prints did not comply with the definition of "original" adopted by the Professional Art Dealers Association of Canada: "An original print is an image that has been conceived by the artist as a print and executed solely as a print, usually in a numbered edition, and signed by the artist. Each print in the edition is an original, printed from a plate, stone, screen, block or other matrix created for that purpose."

Of course, Dalí prints did make their way into Canada and were as difficult to be rid of as acid rain. Quebec police in February 1981 arrested two Frenchmen in Montreal after an attorney for the Swiss-based firm of Les Editions de Francony heard that duplicates of *Hommage à Leonardo da Vinci*, whose copyright it owned, were being peddled by galleries in Montreal and Quebec City for $375 apiece, about one-third the price of the authentic version. The case made a sensation when police said they suspected one of the two men was a Spanish terrorist sought in connection with the 1970 bombing of Iberia's Zurich headquarters.

But the Montreal authorities could not find evidence that sales of the fake prints had taken place. Forgery charges were considered but not initiated. "I heard that maybe Dalí signed some [blank] paper. Anybody could do anything with these [sheets of] paper after that," recalled then-prosecutor François Doyon.

Finally, consumers began complaining in 1990 to Consumer and Corporate Affairs Canada about a Montreal gallery and telemarketing operation called Intercontinental Fine Art, Ltd., which had taken out advertisements in newspapers and magazines across Canada. Readers who responded to the ads were mailed brochures informing them of "The Art of Investing in Original Prints" and "the rare investment opportunity" awaiting them in Montreal or through its cable address of INFINART. Purchasers soon found the Dalí "original etchings" purchased from the company to be worth a small fraction of what they had paid.

In September 1990, the gallery pleaded guilty to ten counts of misleading advertising and enticing buyers with the prospect of spectacular appreciation in the future value of the prints. The "prints" were photomechanical reproductions. The company was fined $100,000.

The conviction was of little consequence for the victims; the plea agreement provided for no restitution.

"The Consumer Affairs went after them, they got a conviction and collected a hundred grand and they said, 'That's it,'" complained victim Paul G. Nagy of Gloucester, Ontario. "They didn't give a damn about the consumers."

While some in the European art world might have chuckled at the print fraud as an American phenomenon carried out at the expense of an unsophisticated populace, the identical fraud prospered from Italy to Scandinavia and in the British Isles. Numerous civil lawsuits were filed, but no significant criminal action was taken until two off-duty gen-

darmes noticed strange sales being conducted at a small gallery in Valence, France, in January 1988.

Gérard Roumier and Christian Roumegoux, both interested in art, saw a rack of Dalí *Unicorn* prints that the owner was touting as "original lithographs." A closer look convinced the two gendarmes that the quality was far below what they would expect from a fine print.

When Roumier and Roumegoux returned to work the next day, they learned about the Dalí fraud, about all the supposed presigned paper and about the watermarks that experts used to identify paper produced after the period in which Dalí had signed any blanks. The officers confiscated the prints at the Valence gallery. All bore recent watermarks. They were able to trace them to a Paris house belonging to two brothers, who still had one hundred Dalí prints—also with recent watermarks—and eventually to a Paris gallery owned by Gilbert Hamon.

Police found 7,310 Dalí prints in Hamon's gallery and later seized more than 100,000 other "Dalís" from Hamon's modest, three-bedroom apartment in Neuilly. With Hamon's arrest on June 17, 1988, a major source in the Dalí print business was shut down.

Through the 1980s, however, the biggest Dalí frenzy was not in Europe or even North America, but in the middle of the Pacific Ocean, in the tourist haven of Hawaii.

Showdown in the Pacific

CHAPTER 9

Pictures
in Paradise

Sometime in 1962, Edward J. Cory, an American food importer by profession, was in Europe doing business when the idea struck him. He had bought some inexpensive paintings at London's Trafalgar Square and imagined he could import them just like food. Upon his return to California, he took his paintings to Ron James, the foreign foods buyer for Safeway, and James agreed to try out Cory's idea. The two men strung the paintings throughout a Safeway supermarket in residential Marin County, California, from the checkout counters to the vegetable section, with price tags starting at $4.99 unframed, $14.99 framed.

"Every painting in our supermarket gallery was sold the first day, and we got plenty of media coverage," Cory recalled years later. "Some of the regular dealers thought we were commercializing art too much, but we looked at it another way. We turned the average person into an art buyer."

Cory, who as a teenager had shared a Greenwich Village apartment with six artists during the Depression, soon dropped his food-import business and devoted himself full time to establishing an art dealership aimed at the common man. By the end of the 1960s, he had opened five galleries in California and took pride in his success. He was a pioneer in

the mass-merchandising of art and in the encouragement of new talent.

"The first things an artist has to learn is how to price the work he does, and how to ask for money," Cory said. "If they can't do it themselves, they need to get an agent and a business manager. Secondly, they should learn how to promote themselves. They should know how to approach gallery owners, design stationery and business cards, write a news release, contact a columnist and conduct a publicity campaign. Being a starving artist is nothing to brag about."

He said, "If we find an undeveloped artist in the sense that he is not exposed to the public, we'll expose him to the public, Hollywood style."

Early in 1970, after several visits to Hawaii, he opened a small Cory Gallery in the Cinerama Reef Hotel along Waikiki Beach. Tourists responded eagerly.

Within a year, Cory had opened a second Hawaii gallery in a prime location, the Ala Moana Shopping Center, near Waikiki but accessible enough to the rest of Honolulu to be the favorite shopping place for locals. Meanwhile, he had added two Hawaii residents to his stable of artists. One of them was Margaret Keane, who is known for paintings of big-eyed children.

The public found them adorable. "Those big eyes are just as well known as the works of *Saturday Evening Post* cover folk artist Norman Rockwell," Cory said in January 1971 in a newspaper advertisement styled to look like an article except for the agate disclaimer. "Keane depicts the melting pot of the world. Every ethnic group is represented— Chinese, Japanese, Negro, Italian or Russian, and so forth. She's presently doing a series of lithographs."

Except for one problem: Margaret Keane did not "do" lithographs. She—or more probably Cory—had them done. Keane had once worked on limestone in her early years in the San Francisco area. But now that her paintings had

grown so popular, she periodically authorized reproductions to be printed in limited editions, and the limited edition was the key to Cory's successful approach to the art business. Having commissioned Salvador Dalí to create etchings in 1970, Cory also sold "lithographs" of works by a wide variety of artists.

Soon after opening the galleries in Hawaii, Cory cut back on his activities "because I was having health problems. Operating eight Cory galleries is a lot of work, and although I was making lots of money, I wasn't having lots of fun."

In January 1973, Cory began searching for a buyer of his Ala Moana lease and stock. A month later, two partners in a clothing business agreed to purchase it for $300,000. William D. Mett, one of the partners, recalled later that they had planned to use the space as an additional outlet for clothing sales. However, as Mett told it, a week after the closing date of the sale, on April 8, 1973, Pablo Picasso died, and the Picassos that were among the inventory skyrocketed in value.

William Mett had known little if anything about art. Born on September 17, 1942, into a middle-class family in Milwaukee, Mett had earned his law degree in 1967 from the University of Wisconsin. Not long after that, Wisconsin law graduate Tobias Tolzmann paid a visit to his alma mater looking for a new associate for his law firm in Honolulu. Mett was working as an assistant to the dean, and Tolzmann's search was a short one.

Mett's emphasis was on business law, and after only a few years with Tolzmann's firm he chose to go into business for himself. The transition was less than smooth. In early 1971, he was looking for investors in a company that was to be called Feegee Sportswear, Inc.

Mett received $42,000 from five people, including $8,000 from his legal secretary. He told them their money would be safely invested in a leasehold interest in a store in Kahala

Shopping Center, in the most prosperous section of Honolulu, that the investment would return profits in two years and that it was so good Mett himself was investing. The investment turned sour, and the five investors sued Mett. In December 1974, a judge ruled that the profit margins predicted by Mett had been "unlikely if not impossible" and that Mett's conduct amounted to common-law fraud. Mett was ordered to return the money, along with interest and attorney fees. By that time, he could afford it, because his art business had taken off, and he had unloaded his interest in the clothing business in return for full ownership of the gallery.

Part of his good fortune can be attributed to his hiring, within months of the purchase, an ambitious and effervescent twenty-nine-year-old named Marvin Louis Wiseman. Wiseman took pride in his humble origin. He told of having been raised in Boston as a foster child, and of having risen in the art business. As a teenager, Wiseman began his first job as a salesman at the Boston's Brodney Gallery. He went from there to Bonwit Teller's, and then to the Hartford Framing Company. He became manager of Boston Galleries in Hartford, was president of Art America, a dealership in New Britain, Connecticut, and, for three and a half years, was manager of the gift shop at the Boston Museum of Science. Wiseman went to Hawaii for "a change of environment," enlisted with a personnel agency and had a job interview with Mett.

To complement Mett's inventory of artworks attributed to Chagall, Picasso and Dalí, Wiseman offered his acumen and his contacts in the art world to the new owner of the gallery. Mett was quick to seize upon both, first in partnership with Ed Cory, who still had his galleries in San Francisco.

In 1973, Cory and Mett began arranging for reproduction of three Dalí gouaches they had acquired from Abe Lublin,

the New York art merchandiser who boasted of being America's largest graphics publisher and distributor. This *Hawaii Suite*, was reproduced in editions of two hundred and fifty, for each painting, with each to be numbered and signed by the artist. One combined a volcanic eruption and a Hawaiian flower. Another focused on the importance of water in Polynesian life. In the third, two people, perhaps Dalí and Gala, walked into a scene that included one of the maestro's famous clocks. Dalí, of course, had never set foot in Hawaii. "I have been on an airplane three times in my life," he told reporters at the hotel, "and I will never fly again. . . . Flying is ugly. All colors on the ground jumble together and I don't like it."

He said, "I have never been to any exotic country or place like Hawaii, but there was no need. The reason is exoticism already existed in my mind, inside my own brain . . . therefore, the suite already existed inside," pointing to his head. Wiseman would later say that Dalí had been sent books, pictures and postcards to assist him in creating the works.

But during the next two years new competition came to Hawaii. In 1975, brothers Gerry and Larry Yaker of Beverly Hills Gallery in California opened an outlet in Waikiki. In October 1976, Gallery Hawaii was launched by Suresh Jhaveri, a native of Bombay whose family for generations had been the leading diamond merchants in India. Jhaveri already had made millions through India Imports International, a company he started in San Francisco after earning his master's degree in political science from the University of California at Berkeley. All three galleries offered their own editions of Dalí prints, sometimes even of the same image. The three-way rivalry soon turned fierce.

Mett's Center Art had acquired numerous *Lincoln in Dalívision* prints from Martin-Lawrence Galleries in California and was raising the price, reflecting what they

perceived to be the print's investment potential. Jhaveri's Gallery Hawaii was advertising the same image, claiming his prints to be legitimate *hors commerce* prints, at twenty-five hundred dollars apiece, less than what Center Art was charging.

Marvin Wiseman dictated a memorandum to Center Art's staff in March 1978, providing ammunition to counter the Gallery Hawaii sales: "There are only sixty-five original H.C. examples of *Lincoln* by Salvador Dalí. Center Art Gallery acquired fifty-five of these from Dalí. If Gallery Hawaii's claims are correct, they acquired more than Dalí ever printed. Last but not least, Gallery Hawaii states in its ad that they make no price differentiation between numbered editions, artist proofs and H.C.'s.

"The bulk of the lesser known artists do all of their own printing; the bulk of the commercial artists do none of their own printing. Salvador Dalí, however, as an internationally recognized and museum-displayed etcher and lithographer, needs no one to do his plates and stones; once having completed the proofs and H.C.'s, Dalí does employ the use of a printer to do the numbered examples, thus making Dalí's personally pulled examples more valuable. Gallery Hawaii, not having had previous access to these Dalí-pulled examples, has unsuccessfully attempted to discredit them."

Wiseman advised the staff of Center Art's intention "to purchase those very pieces" from Gallery Hawaii. If legitimate, they would be a bargain. If not, Center Art would use them to help authorities prosecute the culprits.

The memo restated what Wiseman had told the sales people upon their hiring, that Dalí worked on the plates used in creating his lithographs, making the prints truly "original." Customers were handed sheets describing original etchings, lithographs and serigraphs as being done by the hand of the artist.

The gallery now had to deal with competitors who apparently were selling questionable prints and undercutting Center Art's prices. The best way of doing this would be to assure authenticity of its own works while suing the intruders. Except authenticity had nothing to do with originality, as defined in the flier and as Wiseman himself had instructed the salespeople; it had to do with reproduction rights.

Through Ed Cory's wife, Estelle, Mett and Wiseman found the ideal person to help them accomplish their goals. Parisian-born Brigitte Eitingon had earned her bachelor's degree at New York University and returned to Paris for her master's degree in art history at École du Louvre. For ten years after that, Eitingon raised a family, then she returned to her first love, moving to New York and entering the art business in 1975. In New York, she became a wholesaler of graphics attributed to Picasso, Miró, Leroy Neiman, Norman Rockwell and Dalí. Estelle Cory suggested that she contact Bill Mett. She wrote him in June 1978, offering a *Lincoln* for $1,500 and any other help she could give him in locating artworks. Soon, she became involved not only in locating art for Mett but helping create it. Tagging herself "French Connection I" and Mett's BLAD (Biggest Little Art Dealer), Eitingon raced around Europe making deals at a dizzying rate. "If only those froggies used BAN [deodorant]," she wrote Mett.

Center Art already was doing a brisk business in Dalís, advertising on television and in the print media and selling prints it obtained from Martin-Lawrence. The investment pitch worked not only with middle-income tourists but with an occasional high roller. Such was Roland Vasquez, owner of a large avocado farm north of the Santa Monica Mountains near Los Angeles.

Saleswoman Nora Junk, after only four days on the job, noticed Vasquez and his wife browsing in the gallery at

Waikiki Shopping Plaza, and she approached them. Wiseman had instructed her not to talk with potential customers immediately about art. Junk, vivacious and likable, struck up a conversation with the Vasquezes, learning that she shared with them an enthusiasm for horses; Junk had once owned a tack shop, selling riding equipment. When the subject turned to art, Junk brought in the more knowledgeable saleswoman Roberta Summers.

The vacationing couple agreed to buy a Dalí watercolor titled *Epicene Epiphany*, a Dalí drawing titled *Elephant Lady* and a Picasso etching titled *La Mort au soleil* for a total of $142,000. They made an appointment the next day to visit with Mett about a forthcoming edition of nine hundred Dalí wall sculptures, or bas-reliefs, titled *Moses of Monothéisme*. Within days, Vasquez put down $310,250 for ninety-five sculptures, electroplated in gold, bronze or silver. The sculptures had yet to arrive at the gallery, so Vasquez bought them at prepublication prices ranging from $1,950 for a bronze to $4,950 for a gold.

Upon the Vasquezes' return to California, Mett promptly wrote them a four-page letter on his legal stationery assuring them of the wisdom of their investment. Center Art, he wrote, had served thousands of clients and "seeks to give only advice relating to the most secure art investments." He reported that the *Moses* sculpture had been totally sold out within forty-eight hours of its being offered at the prepublication price. Part of Center Art's reputation was due to the fact that "Mr. Marvin L. Wiseman, formerly of the Boston Museum . . . is one of the most knowledgeable individuals in contemporary art today." Not mentioned was the fact that Wiseman's work at the Boston Museum was as a gift shop employee at the Boston Museum of Science.

A few days later, Mett and Wiseman flew to California and visited Camarillo, where the Vasquez family greeted them warmly, providing motel accommodations, treating

them to Mexican food and giving them avocados to take back for the gallery's staff. Wiseman returned to the farm in November, informing Vasquez of a new offering from Center Art, an edition of bas-reliefs titled *Christ of St. John of the Cross*, patterned after Dalí's most famous religious painting. The Vasquezes visited Hawaii in December, and Vasquez wrote out a check to Mett for $500,000, for 110 of the *Christ of St. John* sculptures, which were due to arrive in late March.

Center Art had arranged to acquire the *Christ of St. John* sculptures from Martin-Lawrence Galleries, where they also had obtained *Moses*. A third bas-relief, *The Last Supper*, also using a Dalí painting as a model, was said to be in the making. All were the projects of a Paris company called Art et Valeur, headed by Yves Gouget and Ariane Lancell, an associate of Pierre Marcand. After the arrival of *Moses* in September 1978, Center Art had begun advertising the piece in magazines.

Months later, during his annual stay in New York, Salvador Dalí came across one of the ads for the *Moses* sculptures, and immediately he voiced his concern to his lawyer, Michael Ward Stout. Dalí had created no such sculpture. The artist had given Gouget and Lancell permission to publish a book of Dalí etchings, and he had instructed them to pattern the book cover in relief after a Michaelangelo sculpture, adding some lightning cracks. The Michelangelo now was being sold as a limited-edition Dalí wall sculpture when it was never intended to be a limited-edition anything. And it carried a Dalí signature. Dalí asked that Martin Blinder of Martin-Lawrence be summoned to New York to explain the matter. According to Stout, both Blinder and Mett had been victimized by the unauthorized production.

About the same time, Dalí's secretary-manager Enrique Sabater noticed a newspaper article mentioning that Center Art was advertising for sale some etching plates that had

come from a book project involving the same publisher, Art et Valeur. Recalled Stout: "Mr. Dalí felt that the etching plates really belonged to him, that they were used in the production of a book and that they should have been returned, and he was interested to know why they were being sold as works of art."

Bill Mett was asked to come to New York in January 1979, and he was very cooperative. The plates had been consigned to him by Martin-Lawrence, which had gotten them from the book publisher. Mett agreed the etching plates would be returned to Dalí.

During their conversation, Stout and Mett realized they had attended the same law school, the University of Wisconsin, at apparently the same time, although Stout could not remember Mett as a schoolmate. "Mett is very personable and chummy and so then he says, 'I'd like to retain you. You could really help us a lot, get the right information. We are interested in buying originals,'" Stout recalled. "They were buying things from really secondary dealers, Brigitte Eitingon and all the people that were her friends."

Stout pointed out there could be a conflict of interest for him to represent both Dalí and Mett. The next day, Stout returned to his office from a meeting and discovered Mett had left him a check for twenty thousand dollars.

"I called him the next day and said I don't want this check," Stout said. "He said, 'Just keep it. . . . We have a lot for you to do.'" Stout agreed to put the money into his escrow account and agreed to draw upon it 'if you have legitimate things for me to do that don't involve any conflict with my primary client.'"

Mett then mailed Stout a gift-wrapped box of macadamia nuts and two first-class plane tickets to Hawaii. Stout accepted the gifts, and Mett reserved a suite at the grand old Royal Hawaiian Hotel on Waikiki Beach. One evening after

being wined and dined, Stout was driven to a mansion on a hilltop overlooking Honolulu. As they entered the house, it seemed empty.

"I walked into this sort of basement family room, and there are seventy-five or one hundred people in card table chairs, mostly Asian or Polynesian, with Marvin Wiseman sitting on a stage with a blackboard, with all these figures and a Dalí slide show," Stout said. "And he says, 'And here is Salvador Dalí's lawyer from New York!' I didn't know what to do. I sort of went over to a corner. All these people wanted to touch me or talk to me. It was like a sales ploy."

On February 23, 1979, with Stout's assistance, Mett signed a contract with William and Barry Levine for the production through their firm, Bab & Company, of an edition of 1,565 metal wall sculptures of *The Last Supper*, for which Dalí would create the mold. Three weeks later, Mett and the Levines arrived at a similar agreement for production of a bas-relief Dalí was to pattern after *Christ of St. John of the Cross*. Dalart NV, the company Sabater had created for selling reproduction rights to Dalí works, was a signatory. Mett retained Ariane Lancell to arrange for the manufacture of the sculptures at a foundry in Paris.

Mett now could boast of being in contact with "the Dalí camp," and he quickly did so. Only three days after Mett signed the pact for *The Last Supper*, Vasquez agreed to buy 140 of the gold-plated plaques for $805,000—a savings of $217,500 from the regular prepublication price. He put down a deposit of $400,000. In a matter of a few months, more than $1.3 million in avocado money had been spent on art, and an additional $400,000 was promised.

By late March, the *Christ of St. John* sculptures had not yet arrived in Hawaii. "A recent conversation with the master indicates that the complexity of the wax mold requires substantially more time for casting than originally anticipated," Mett memoed the staff. Some of the figures

were in bolder relief than others, "all of which creates a very difficult task for the artisans at the foundry." To which "master" Mett was referring remains unclear. An analysis years later indicated that the wax mold would have been fine for casting, but that is not what Center Art had in mind. These sculptures were to be stamped out like hubcaps, and the relief was far too bold for that. Deep incisions had to be filled in at the foundry, so that eight hundred of the plaques could be stamped out. When that was accomplished, and the sculptures arrived at the gallery in May 1979, Mett extolled the work in a staff memo as "a truly magnificent twentieth-century icon which is Dalí's triumphant consummation of his lifelong desire to capture the glory and ecstasy of the Resurrection."

In July 1979, with Stout's help, Mett worked out an agreement, after a series of meetings at the Miami offices of a Venezuelan company called Italcambio, to order the production of 4,500 plaques styled after *Lincoln in Dalívision* and coated in precious metals such as silver, gold and platinum. Center Art's cost was $300 per plaque. Italcambio had purchased reproduction rights to the painting and to reproduce as many as 6,800 of the plaques.

The new relationship between Center Art and the Dalí camp became even closer later that month, when Mett, Wiseman and Stout flew to Paris and then on to Spain. Dalí had just completed a double painting titled *The Christ of Gala*, consisting of two canvases with similar images of a reclining crucifix. The price was $400,000. In a separate contract with Dasa, N.V., Mett, using his home address and a company title of International Graphics, Inc., was granted rights to produce a limited edition of 1,185 *Christ of Gala* lithographs, each to "bear the original signature of the artist," for $150,000.

Meanwhile, the avocado farmer was growing displeased. In April 1979, Vasquez had been advised that the edition of

The Last Supper would be larger than previously described. He had thought his 140 gold-plated sculptures would be half of those available. Not so, because the entire edition, in all metals, would be expanded from 1,265 to more than 1,500. Vasquez demanded a refund of his $400,000 down payment, and he got it. He then proceeded to try backing out of his entire investment, lodging a complaint with Hawaii's Office of Consumer Protection. The Securities and Antitrust Divisions of the state attorney general's office were brought into the ensuing investigation, headed by Robert Miller, head of the antitrust division. In June 1979, Miller began sending out subpoenas to television stations for videotapes of their Center Art commercials. Center Art was forced to turn over a list of current and former employees.

Miller learned that Vasquez had not been the only big-time spender at Center Art. Two months before Miller opened the investigation, Honolulu dentist Robert Miura began a spending spree that would total more than $390,000 worth of Dalís and other art until he began having doubts in early July. Honolulu physician Allan R. Kunimoto was in the process of investing $89,000.

Nora Junk, the Vasquezes' saleswoman, became a cooperative witness for Miller. She had been fired in April 1979 after being caught making copies of client lists; she claimed the lists would verify commissions she maintained were due her. Other employees were interviewed by Miller, and he collected Center Art newspaper advertisements and staff memos, which were routinely handed to customers as part of the sales presentation.

Vasquez lawyers Jeffrey Portnoy of Honolulu and Kelly Bixby of Los Angeles provided Miller their findings from the legal discovery process. In February 1980, the attorney general's office prepared a complaint against the gallery but postponed its filing while it tried negotiating a "consent judgment."

The proposed binding agreement would be stiff and sweeping. Center Art was to provide past and potential customers such information as the amount the gallery had paid for their art, the amount of sales commission paid on a given item, its most recent profit-and-loss statement and the warning that private resale of the art "might be extremely difficult and could yield a substantially lower price" than the amount charged by the gallery. Customers were to be told "that the market for art is cyclical and volatile, with works by any particular artist and in any particular style being subject to unpredictable changes in value which could result in substantial losses to the purchaser."

The gallery would have to stop telling people that it "retains knowledgeable art consultants or experts who are able to assist consumers in purchasing art works for investment purposes." No longer could it sell artworks that it had yet to obtain, as in the case of Vasquez.

Any Dalí purchaser since January 1976 would be offered a refund. The gallery would have to mail to each buyer of a Chagall-attributed lithograph titled *Le Soleil rouge*, or *The Red Sun*, "a clear and conspicuous written disclosure that the art work was not done by Marc Chagall." Refunds were to be offered.

Stanley D. Suyat, then director of Hawaii's Office of Consumer Protection, warned in his cover letter of February 8, 1980, that refusal to agree to the conditions would result in the filing of an official complaint.

The proposed consent agreement went unsigned, and the investigation dragged on. More than a year passed. Details of Miller's investigation remain cloaked in secrecy. Finally, in April 1981, Miller prepared a proposed court order aimed at shutting the gallery down, and he delivered a copy to Vasquez's lawyer Jeffrey Portnoy to scan about four o'clock one afternoon.

"I was the last piece in the review process," Portnoy recalls. "We were very excited that it was finally going to happen. I felt great that after all this time Center Art Gallery was going to be forced out of business." Miller took the proposed court order to the chambers of Hawaii Circuit Judge Arthur Fong, whose approval was needed for the attorney general's office to lock the gallery's doors and seize its property.

Feeling cocky, Portnoy saw a Center Art attorney on a downtown sidewalk and gave him the news, suggesting it might be a good day to settle Vasquez's claim.

Portnoy expected Miller's temporary restraining order to be filed in court the next day. After learning it had not been filed, he phoned Miller.

"I can't talk," Miller told him. "I'm sorry. I can't talk about it."

Portnoy called Miller repeatedly over the next few weeks, but he says Miller refused to discuss the matter except to say he was "frustrated as hell."

"Something political happened that night, no two ways about it," Portnoy says. "Something happened between four o'clock that afternoon and the next day, and nothing happened in the judicial process." He says Center Art's California lawyers had constantly dropped hints that Center Art was politically well connected, and they turned out to be right.

The Pope's Flock

The Hawaii attorney general's investigation chilled Center Art's aggressive pursuits temporarily. No grandiose staff memos have surfaced from that period. There is no evidence that William Mett and Marvin Wiseman were actively seeking to expand their Dalí acquisitions. Yet soon after the probe came to an end, Center Art sprang to life again with new fervor.

Fliers described to customers how the prices of Dalí's prints had risen sharply in a matter of a few years and said that the Dalís sold by Center Art were guaranteed to be authentic.

In a 1982 letter to one customer, Mett gave assurance that the gallery had "the contracts and all appropriate documentation from Mr. Dalí whereby he agrees to personally hand-sign each lithograph produced under our several contracts. In short, every lithograph which is published by Center Art Galleries Inc. has the additional assurance and guarantee signed by Mr. Dalí that the artist will inspect each lithograph and, if it meets his approval, the artist will then sign it."

The Hawaii consumer protection agency's admonition about the volatility of the art market and the risk of investing went disregarded. With Gala's death, the gallery

issued a frantic notice that certain Dalí works "have been removed from sale until further notice. All other Dalí inventory is being quoted on an hour by hour basis only!" It was explained: "Salvador Dalí is already seventy-eight years of age and suffering from the combined effects of Parkinson's disease, cerebral arteriosclerosis and a recent stroke. We fear that Gala's death could be the final blow to his physical and mental health. We all pray for the health and well-being of her surviving husband, Salvador Dalí."

A news report in August 1983 that Dalí's weight had fallen to eighty-three pounds prompted Mett to memo the staff that he personally had confirmed it with Dalí's lawyer. "Due to this extremely serious turn of events," Mett wrote, "Center Art Galleries-Hawaii can no longer guarantee prices on Dalí art for more than twenty-four hours at a time. You are requested to advise clients that the price quoted on the art of Salvador Dalí cannot be guaranteed for more than twenty-four hours, and we furthermore reserve the right to withdraw without notice any or all of the art of Mr. Dalí from immediate public sale. As a result of our recognized international standing in the art community, we believe it our duty to notify clients that Mr. Dalí's deteriorating health makes it incumbent on us to remain flexible in what appears to be a worldwide movement to adjust Dalí prices."

Brochures about certain Dalí prints advised customers that "the time to acquire is now." An asterisk followed with a warning. They were further advised: "Due to the artist's failing health, we sadly reserve the right to withdraw this offering without notice."

In May 1981, a month after Robert Miller was ordered to withdraw the motion to shut down the gallery, Center Art took a step to vastly expand its stock of Dalí graphics, entering into a contract with Gilbert Hamon to buy entire editions of eight images to which Dalí had granted Hamon reproduction rights in contracts of November 1980 and April

1981. Center Art's price was more than $1.2 million, or about $170 per lithograph. Upon signing the contract and making a down payment of $170,000, Center Art immediately received the editions of three images: *The Temptation of St. Anthony, Impressions of Africa* and *Dalí, Dalí, Dalí.* On order were *Metamorphosis of Narcissus, Swans Reflecting Elephants, Corpuscular Assumption, Madonna of Port Lligat* and *Dream Caused by the Flight of a Bee Around a Pomegranate One Second Before the Awakening,* also called *The Two Tigers.*

Before the remaining editions were delivered, and as Mett and Wiseman were proposing to acquire editions of ten other images from Hamon, they saw a disturbing sight. At the annual Art Expo in New York in April 1982, they saw other companies displaying lithographs of Dalí images that were covered in their contract with Hamon. A company called Lithoprint was selling *Swans Reflecting Elephants, Metamorphosis of Narcissus* and *Dalí, Dalí, Dalí.* Distributors from West Germany and Belgium were showing lithographs of *The Temptation of St. Anthony* and *The Two Tigers.*

Center Art immediately went to the French courts for redress, obtaining a seizure of nine lithographic plates of *The Temptation of St. Anthony* at the Dejobert Atelier in Paris. Learning that a Paris dealer, Joll Beres, was selling Dalí lithographs, Center Art had a court bailiff visit him. Beres acknowledged that he had bought *The Temptation of St. Anthony* and *The Two Tigers* lithographs from Hamon. In May 1983, a three-judge panel in Paris ordered Hamon to pay Center Art damages in the amount of $115,000. The contract between Hamon and Center Art was declared canceled because of Hamon's violations.

Mett and Wiseman had not put all their eggs in Hamon's basket. They also had set out to obtain permission to reproduce the Dalí paintings that had been the inspiration for

their two bas-reliefs, *The Last Supper* and *Christ of St. John of the Cross.*

In July 1981, Mett wrote a letter to the National Gallery of Art in Washington, informing the museum that he and Dalí had entered into an agreement to produce "a limited edition of original lithographs" of *The Last Supper*, the painting of which was in possession of the museum. Each of the 1,565 lithographs "would be hand-signed by the artist and individually numbered." Mett asked that the museum forward a transparency of the painting to him.

Carol Cavanaugh, the museum's in-house attorney, consulted with its executive officers. "Typically, the National Gallery would freely and liberally hand out transparencies to anyone who wanted to reproduce works of art, for almost any purpose, so long as there wasn't any claim of originality of value as to the reproduction," Cavanaugh later explained. "Once we know the request is for a limited edition, we would typically say no and not hand over the transparency, and nothing further would be done about it." Cavanaugh not only refused to send Mett a transparency, he threatened to take action if Mett were to imply any approval by the National Gallery.

Cavanaugh's cooperation would have been nice, but it was not critical. Even Cavanaugh agreed that *The Last Supper's* image was in the public domain, as U.S. government property. Center Art needed nobody's permission to reproduce it.

Christ of St. John of the Cross was a different matter. The copyright clearly was owned by the Glasgow Museum in Scotland, where the masterpiece has hung since its purchase in 1952. Mett phoned the museum in June 1981 to inquire about getting permission to reproduce it. In a follow-up letter, he advised the museum's director that Dalí "has personally requested that I publish with your concurrence and enthusiasm a limited edition of hand-signed lithographs of *Christ of St. John of the Cross.*"

Mett told the museum officials that he had been talking with Dalí, that the artist was very interested in the project and that Dalí "would be involved in working with the production of this lithograph," recalled Patricia Bascom, the museum's publication director.

On August 21, 1981, Mett and museum director Alistair Auld signed a contract allowing Center Art to produce a limited edition of 1,565 Christ of St. John lithographs in exchange for five thousand British pounds, with the museum assured approval of the proofs before final publication.

About two months later, Mett was introduced to Zurich lithographer Ruedi Wolfensberger by Jacques Carpentier, Gilbert Hamon's associate and a holder of presigned Dalí sheets. Wolfensberger had produced a number of lithographic editions for Carpentier in the late 1970s, and Mett approached him to produce three editions, *Christ of St. John*, *The Last Supper* and *The Battle of Tetuan*, a twelve-by-twelve-foot Dalí painting Mett had bought that summer in Paris from an Italian collector. Wolfensberger was provided large transparencies taken directly from *Christ of St. John* and *The Battle of Tetuan*. Since that was impossible for *The Last Supper*, Wolfensberger's chromist would have to go to Washington to check the coloring of the proof with the painting hanging in the National Gallery. All the lithographs were to be printed from limestone slabs. These were to be true lithographs.

"We prefer our lithograph of *The Last Supper* to contain a 'blue' highlight to give the work of art a little more life," Mett wrote Wolfensberger. "We request the lithograph contain as much color as possible and will telephone so that we can discuss this matter at greater length." No mention was made of what Dalí might have thought about Mett's artistic decisions.

Salvador Dalí's approval of Mett's projects is indicated in a document in which he purportedly acknowledges that Center Art has the "exclusive lithographic reproduction rights" to all three paintings. "In order to establish the authenticity of the lithographs, I, Salvador Dalí, will sign each print, all of which will be numbered according to the publisher's discretion," it says.

Wolfensberger sent proofs of *The Last Supper* to Hawaii in February 1982, but Mett did not give his artistic approval. "We are pleased with the detail in the face of Jesus. However, all of the proofs are much too dark and too blue, causing the flesh to appear blue-grey. The yellow highlights on the cloak of the Apostle and to the right and left of the table are too bright."

Mett sent Wolfensberger "a brochure we sent to our clients showing a lighter, brighter, warmer overall coloration. Please make the next proof like the brochure. Thank you." In other words, forget the National Gallery's painting. The final product appeared in the Center Art gallery in June 1982.

Three days after directing Wolfensberger to "correct" *The Last Supper*, Mett hit the roof. While Wolfensberger was laboring over *The Last Supper*, Gallery Hawaii had come out with its own *Christ of St. John of the Cross*, an etching. Suresh Jhaveri had sold majority interest in Gallery Hawaii to Martin Blinder and Lawrence Ross of Martin-Lawrence Galleries in California, and to one-time Circle Galleries art salesman Lawrence Ettinger, who was put in charge of the Hawaii operation.

Blinder and Ross had developed a business relationship with Pierre Marcand, and Gallery Hawaii was selling a Marcand edition of one thousand colored prints of *Christ of St. John*. Although etched by Pierre Spalaikovitch, that authorship was not noted in the gallery's promotional material. "This etching, entirely created by hand, is one of Dalí's

most famous creations," it said. "There is no photography, automatic or semiautomatic press involved in the making of this print. The hand-coloring has been done exactly as stated; each and every color, strictly by hand, examined and approved by Dalí and the Glasgow Museum in Glasgow, Scotland, the owner of all rights to this magnificent work." At least Gallery Hawaii did not call it "original."

Mett called Marcand's *Christ of St. John* "an insult to the artist, the painting and the museum." In a seething letter to Glasgow, he volunteered to defend the museum's copyright "to put a stop to this piracy once and for all." The Glasgow Museum was not as distressed. In fact, Marcand had followed Mett to Scotland and signed a contract with the museum to produce the etchings. His only violation was that they were to be in black and white, not in color.

In Marcand's view, Mett was not blameless: he had violated copyright regulations by marketing a *Christ of St. John* bas-relief for which Dalí had created the wax mold for Marcand. Less than two weeks before Mett mailed his letter of protest to Glasgow, Marcand filed a federal lawsuit against Center Art, claiming he owned the exclusive rights to produce *Christ of St. John* bas-reliefs. As with almost all such suits, it was settled out of court.

A year later, Mett's *Christ of St. John* lithograph was still on the drawing stone, and Patricia Bascom of the Glasgow Museum was not pleased with the first proofs sent to her by Wolfensberger. The figure of Christ was angular and weak, the shadows were wrong, detail was lacking and the coloring was off. "I must admit to thinking that originally this was to be an entirely new lithograph by Dalí himself," Museum Director Auld wrote Mett. "From what I have seen, I cannot imagine Dalí having worked much on this lithograph."

Wolfensberger's chromist went to Glasgow in early March 1983 to look at the original painting. Work was com-

pleted four months later, but no final proof was sent to the Glasgow Museum for approval.

In the spring of 1983, Mett decided to create a second edition of *Christ of St. John*, to be printed on lambskin. Brigitte Eitingon was to oversee the project, but Wolfensberger backed out after performing tests on sheep vellum and pronouncing them a failure. "They [Center Art galleries] said they would try and find somebody else," he said. Wolfensberger also ended up not being the printer for *The Battle of Tetuan*. Eitingon found another publisher for both projects.

In anticipation of its arrival, Center Art had developed a creative marketing vehicle: The Vatican Museum Collection: the *Christ of St. John* wall sculpture, a *Christ of St. John* lambskin lithograph and a second lithograph titled *The Angel of Gala*. "From the specially bred and cared for Vatican flock, the lambskin parchment is virtually unblemished and therefore nearly unobtainable," a Center Art flier said. Each collection would be "accompanied by a special Museum Certificate bearing the Vatican's seal and the name of the owner of the Collection, along with a permanent registration number recorded in the Archives of the Vatican Museum."

One of the fliers was forwarded in September 1986 to Msgr. Eugene V. Clark, the Vatican Museum's U.S. representative in New York.

"I laughed first, because, when I read it, I almost thought someone was writing me a joke," Monsignor Clark recalled. "Then, when I realized it was serious, I realized almost everything [in the brochure] that touched on the Vatican was simply untrue."

Monsignor Clark protested in a letter to Mett: "It is a very serious matter to pretend that the Vatican Museum has any association with you, much less to say that you are commissioned by the Vatican to sell these items, that you

have secured lambswool from the Vatican, that the Vatican seal has been placed on these items for sale and that the number is recorded in the Archives of the Vatican Museum." The monsignor received no response. He sent a letter protesting the scam to the U.S. postal inspector in New York, but the letter got lost.

In fact, Center Art had sent a lithograph and bas-relief of *The Last Supper* to the Vatican in August 1982 as a gift and received thank-you letters from Vatican officials.

"These people have almost a fetish of politeness in answering letters," Clark explained. "If you give them a pencil, you get a thank-you letter back."

The paper *Christ of St. John* found its place in what Center Art billed as its Glasgow Museum Collection. Customers were told that collectors' names would be registered with the Glasgow Museum as well as the Dalí Museum in Spain. As with the Vatican Museum, no such registries existed.

Center Art's efforts and large expenditures to create these products ended in their grossly misrepresenting them. Not only did the fliers make the outlandish statements about customers' names being listed in museums, Center Art incorrectly listed Wolfensberger as the printing house for *The Battle of Tetuan* and the lambskin *Christ of St. John*.

Tetuan was printed in 1982 by Paris publisher Gilbert Grous-Radenez. Brigitte Eitingon wrote Mett in November of that year with details about this "Paris Project" that she had helped arrange. No mention was made of presigned paper, and paper costs were tallied at a dollar a sheet for Arches and six dollars a sheet for Japon. Total costs amounted to less than forty dollars a print.

In the same letter, Eitingon advised Mett of Paris publisher Jacques David's estimate of costs for creating editions of two Dalí etchings, *Ascent of Gala* and *Kingdom of Gala*. The estimate included paper costs, to which Eitingon added:

"As further agreed, all etchings will be signed in Paris. We do not believe that there will be an additional charge. If there is, however, it will be minimal. *The Battle of Tetuan* will be signed in either Switzerland or the USA."

In 1982 and 1983, Eitingon arranged numerous other projects between Mett and publisher David, including Dalí prints titled *Homage to Gala, Face of Gala, Head of Christ* on both paper and sheepskin, and *Annunciation*. The most ambitious was a three-dimensional sculpture to be titled *Trojan Horse* and patterned after a Dalí watercolor called *Dalínean Horse*. Mett cited a contract from May 1981 between Center Art and Dalí commissioning him to produce the sculptures. The contract was purportedly signed by Mett, Dalí and Gala.

David began work in late 1983 on a glass maquette for the sculpture and completed it in the fall of 1984. Marvin Wiseman took on an active role, making changes in the placement of a wheel that was part of the sculpture. The St. Maur foundry was to produce at least two hundred of them at a rate of twenty-five a month, for $1,800 apiece. In November 1984, Mett became concerned about the danger of fake reproductions of the sculpture being made if it were produced in France, and he considered taking the prototype to an American foundry.

Eitingon objected strenuously, advising Mett that both David and the French foundry would resent any duplication of their molds. Eitingon herself resented the very thought that her special project, one she called her "Dada Horse," would be taken away from her. Mett relented, and the first batch of *Trojan Horses* was ready at Fonderie St. Maur by the end of that month.

"I am so happy that our *Trojan Horse* is being launched at last," Eitingon wrote Mett. "Needless to say, I am utterly confident that it will be most successful. It is such a beautiful piece and the timing is indeed right. You know very

well that my heart is in our 'Dada Horse,' has been for a long time and that I will do everything I can to make it look glorious and rearing to go to the multitude of clients dying to possess it!!!"

For many other projects, Mett found an American with a French name and a Paris address: Leon Amiel. Starting in 1984, Mett ordered numerous Dalí and Chagall prints from Amiel, listing Amiel's print factory in Secaucus, New Jersey, as Atelier Amiel, of New York and Paris. As with all prints, Mett would have them examined by Suzanne Sixberry, a German citizen who began working at Center Art immediately after Mett purchased it in 1973. In 1980 she resigned but was retained thereafter to assure "quality control" by checking for any flaws in prints before they were hung up for sale. After passing them, Sixberry would number them.

Sixberry was not always happy with Amiel's product. On one occasion in 1984, Mett expressed dissatisfaction with the first thirty-two Japon lithographs Amiel had produced of *Madonna of Port Lligat*, noting that "the registration on almost all of them was unbelievably bad." In the same letter, Mett advised Amiel he would be returning 207 lithographs of *Corpus Hypercubicus*, 278 of *Madonna of Port Lligat*, 145 *Lenin Tigers*, one each of Dalí's *Autumn* and *Don Quixote* and one Miró, titled *Revolutions*. At the same time, Mett ordered editions of *Madonna of the Doves* and *The Pink Angel*, sending Amiel transparencies to be used in the reproduction.

Other Dalí images Mett assigned Amiel to reproduce included *The Arithmosophic Cross, Olympic Athlete, Atelier imaginaire, Swans Reflecting Elephants, Assumptive Corpusculaire Lapislazulina* (renamed *Corpuscular Assumption*), *Dalí Painting Gala, Santiago el Grande, Place de la Concorde* and a horse etching. In November 1984, Mett ordered the printing of Chagall's *Dome of the Paris Opera*, along with a "facsimile" Chagall signature.

At the beginning of 1986, Center Art sent Amiel an end-of-1985 statement showing that the gallery had been billed more than $1.6 million by Amiel but was withholding $378,439 because of damaged pieces, overruns and other graphics returned to New Jersey. These presumably were prints produced on paper presigned by Dalí.

Amiel was not pleased. "In essence," he wrote back to Wiseman, "you are liquidating your debt with merchandise you can no longer use, but from which you have sold a substantial portion and kept the profits thereof. It is one hell of a way of doing business. Nevertheless, I am a big boy and know how to take my lumps, but rest assured that it can never happen again."

No mention was made in the correspondence between Mett and Amiel about the waste of Dalí's many signatures through the gallery's rejection of the flawed prints. As far as Sixberry knew, the prints she was rejecting were signed by Dalí after his inspection of them. That is what she and all other Center Art employees had been told by Mett and Wiseman through the years.

New employees underwent hours of training by Wiseman, and they were told the Dalí prints were definitely not presigned. Salespeople differ about whether it was suggested to them that Dalí created the images on the printing plates, as explained in the definition of what constitutes an original print in the gallery's brochures.

Frank Iverson, who worked at Center Art from 1978 to 1985, said Wiseman told him that Dalí "was very particular about his work, that he actually worked on some of the stones himself, if it were a lithograph. And if not, then he would oversee the work and inspect it very closely upon its completion, and also inspected it regularly as it progressed, if it were done by someone else."

Nora Junk said the message she received from Wiseman was that "Salvador Dalí was very old, and that he was physi-

cally unable to do much of the artwork himself because he was very, very feeble at the time, but supposedly he did pull certain samples, he approved everything and then signed his name to it. He did have many artisans working for him."

Milton Bergthold, a Center Art employee from 1982 to 1984, once approached Wiseman about the rumors of pre-signed paper. Wiseman told him that tens of thousands of sheets of paper had been seized at the Spanish-Andorran border from the trunk of a Renault. Wiseman did not comment about Dalí signatures on the gallery's own wares. Bergthold's curiosity was further aroused when he went into the gallery's vault and noticed a stack of *Annunciations*. All Bergthold saw was the top print in the stack, and the operations manager would not let him look beneath it. "The unusual thing to me was that it was unsigned and unnumbered."

Bergthold was not the only employee to develop suspicions about the Dalí prints and the signatures on them. "There was a lot of talk about it," said Gary Camara. "Rumors would float around quite often, because people were so incredulous about the offers being made. There was talk that Marvin Wiseman had signed them." Camara said a fellow salesman once told him he was asked to sign them. "I know some of the live-in lovers or boyfriends of Marvin Wiseman claimed that Marvin had asked them to sign the Dalís. There was talk that one of the curators was signing Dalís. So it's hard to say. All I know is I don't believe Dalí was signing the Dalís."

Whoever was signing them, people were buying them. Center Art had won the battle against the other two Dalí retailers in Hawaii. The Yaker brothers had closed their Beverly Hills Gallery in Waikiki and taken their Dali "serigraphs" back to California. After suffering a heart attack and undergoing open heart surgery in 1982, Larry Ettinger, who had bought the Martin-Lawrence and Jhaveri shares of

Gallery Hawaii, sold the store to Mett and moved to Las Vegas, where he continued to sell art.

In addition to selling prints bearing the names of Dali, Chagall, Picasso and Miró, Center Art made agreements to represent "celebrity artists." It began to encourage people to invest in the creations of Red Skelton, Woody Woodpecker cartoonist Walter Lantz, Elke Sommer, Anthony Quinn and Tony Curtis.

By 1984, Mett was boasting about being the nation's largest retailer of art, grossing tens of millions of dollars a year. A *Washington Post* business reporter wrote in a flattering article that Mett's claim could not be confirmed, but several New York dealers said Center Art certainly was one of the nation's biggest. The *Post* attributed the gallery's success to "a network of international contacts, the ability to buy art 'cheaply since we use cash,' and aggressive marketing and promotion." The newspaper noted correctly that Mett lectured part-time on business law at the University of Hawaii's business college.

British journalist Nick Rosen was not so taken with Mett's operation. Visiting Hawaii in late 1984, Rosen left with a skeptical impression of Center Art. In *Harper's & Queen Magazine*, Rosen questioned the gallery's sales pitch. "The sophistication of the selling operation is that they have managed to create and then maintain a market in several different editions, all of which the buyer believes to be limited. This is a classic salesman's ploy to transform the buyer's dilemma from *whether* he wants it to *which* one he wants," Rosen wrote. "Like any inflation-proof currency created on some tiny Pacific island, all that is needed to sustain it is investor confidence. But in the long run, Mett may find that is too much to expect."

Ceiling of the Paris Opera

Jennifer McMullan and her husband were attending a business conference at the Hyatt Regency Hotel on Maui in April 1985, and were drawn to what appeared to be a high-class, wood-paneled art gallery next to the main lobby. They were even more delighted upon entering the gallery to see on display the works of Marc Chagall. Some of the paintings in the gallery carried astronomical prices, but alongside were some more affordable lithographs. Featured prominently was a brightly colored circular print in which Chagall had drawn a variety of scenes, all facing the exterior of the circle.

Maureen Harvey, a sales person with Center Art Gallery, approached the Australian couple, identified herself as an art consultant, and shared in their appreciation of the work, titled *Le Plafond de l'Opéra*, also called, *The Ceiling of the Paris Opera*. It depicted the scenes Chagall had painted on canvas to be attached to the ceiling of the Paris Opera House, as a gift to the people of France, the Russian-born master's adoptive home.

Mrs. McMullan was told that Center Art had negotiated for seven years for the rights to the lithograph, which initially was to have been a small, limited edition, to be hand-signed by Chagall and released by the gallery to celebrate his ninety-eighth birthday. Unfortunately, Chagall died March

28 at his home in St. Paul de Vence, so it was decided to change the small edition to one with a run of two thousand carrying stamped signatures.

Mrs. McMullan noticed, however, that the print on display bore the number 267/268, meaning it was the 267th print to be pulled in an edition of 268. It was explained that the lithographs had been run off in small lots in order to keep the standard to a high quality. Ms. Harvey pointed out that a print from a small run is worth more than one from a larger edition.

The print was accompanied by a certificate of authenticity, declaring that the print, *Le Plafond de l'Opéra*, was published in 1985 by Atelier Amiel in Paris, that the artist was Marc Chagall, that the edition numbered two thousand, with no artist's, publisher's, printer's or other proofs outside the edition. The plates/stones were or would be destroyed, effaced, altered, defaced or canceled after the printing of the edition, and the edition was "neither a posthumous one nor a restrike." A fancier "Confidential Appraisal–Certificate of Authenticity," with a frilly, gold border, described *Le Plafond de l'Opéra* as "an authorized, limited edition, original lithograph bearing the name of the artist and individually numbered." Its appraised value was $1,500.

With tax, the amount came to $1,560, and Mrs. McMullan gladly paid it with her American Express card. She recalls being told upon making the purchase that "it will increase in value as soon as you walk out of the door with it."

On the neighboring island of Oahu six weeks later, in June 1985, this author had just removed an old pair of golf shoes needed for traction in mowing my steeply sloped lawn in Makakilo, a small hillside community on the eastern foothills of the Waianae Range, some twenty miles from the

city of Honolulu. I collapsed into a deck chair and popped open a cold beer, when the telephone rang.

The caller was my brother John Catterall. After years of teaching art, he had become chairman of the art department at New Mexico State University in Las Cruces. My youthful interest in art had yielded before his superior skill, and I turned to journalism. In Hawaii, in "paradise," I wrote for the *Honolulu Star-Bulletin*, the city's afternoon newspaper.

Well into the half-hour call, John mentioned that his curiosity had been aroused by a full-page advertisement he had seen in *The New Yorker*. A Hawaii art gallery had offered for sale an edition of Marc Chagall lithographs, he said, but the wording struck him as suspicious. He suggested I check out the ad and find out whether, as he suspected, the lithographs were merely photomechanical reproductions.

I jotted down the information and put it aside to check out during a slow period on my courts beat. Two weeks later, I rummaged through a stack of recent *New Yorkers* in the *Star-Bulletin*'s library and found the ad in the June 17 issue. The full-color display by Center Art Galleries-Hawaii depicted a round picture in Chagall's style, with the famed artist's signature beside it. In large type at the top, it read "Marc Chagall, July 7, 1887–March 28, 1985. The Ceiling of the Paris Opera." In smaller type, it continued:

Marc Chagall's greatest masterpiece floats above the architectural splendors of the Paris Opera House. This domed ceiling was created by the artist as a gift of love to the people of France, his adopted homeland.

Created under the patronage of André Malraux, France's Minister of Cultural Affairs, this magnificent dome is Chagall's homage to the great classical composers, including Mozart, Wagner, Berlioz and Stravinski [sic]. Scenes from their greatest operas and ballets

crown the auditorium in multi-hued splendor, and create a theatrical universe.

Inspired by the genius of the masters of song, the dome echoes loudest the praises of the genius of Marc Chagall.

This lushly colored 24" x 32", limited edition lithograph recreates Chagall's final study for what is considered one of France's national treasures. Each lithograph bears the name of the artist and is individualy numbered. A world-wide exclusive offering from Center Art Galleries-Hawaii.

A week later, the city prosecutor's office agreed to a plea bargain in a murder case that would have filled my time for weeks. The cancellation created a vacuum on the courts beat and gave me a chance to check out the advertisement. As John had suggested, I telephoned the University of Hawaii's art department for assistance. A faculty member agreed to go to one of Center Art's galleries and examine the *Paris Opera* print. The professor also said Joseph Feher, curator of the Honolulu Academy of Arts, was somewhat of an expert on Chagall and could be of help.

Feher, seventy-seven years old, was an art expert of some distinction. Born in Hungary, he had taken up drawing and painting as a youth, graduated in 1928 from the Royal Academy of Arts in Budapest and received more training at the Art Institute in Chicago. He worked as a commercial artist and portrait painter during the Depression. In 1934, he had saved enough money to travel by train to San Francisco and by boat to Hawaii, where he combed beaches for a year. He returned to Chicago, but thirteen years later was back in the islands as an instructor at the Honolulu Academy of Arts. In 1973, Feher was named curator of prints and senior

curator at the academy, which displays a broad range of Eastern and European art.

Feher was at home ill in July 1985 and unable to travel to Center Art Gallery, but he snarled that there was no need. Although he had not seen the *Paris Opera* print, he said he knew it could not be genuine, because Chagall would never have copied one of his own works, the original being the mural on the ceiling of the opera house.

Who would be the world's leading authority on Chagall who could say with finality whether the *Paris Opera* print was authentic?

"His wife, Valentine," Feher said. "He never did anything without consulting her. Even in his old age, he was romancing her. They were so close."

Valentine was Chagall's second wife. His first wife, Bella Rosenfeld, whom he had met at the Zvantseva School in Russia and with whom he emigrated to Paris, had died in 1944. Several years later he met Valentine Brodsky, a divorced Russian, whom he called "Vava."

Bill Cox, the *Star-Bulletin*'s managing editor, agreed that Valentine Chagall should be contacted for her opinion about Center Art's offering. He asked the Associated Press to have its bureau in France call her and ask if she could verify the authenticity of the *Paris Opera* print.

The response from the wire service came the next day, July 11: "Valentine Chagall, the widow of Marc Chagall, said Thursday that the lithograph patterned after her husband's design of the domed ceiling of the Paris Opera being marketed in Honolulu is a fake. 'He never made a lithograph of the ceiling designs,' said Mrs. Chagall from her home in Saint Paul de Vence. 'There was once a poster of the ceiling, but never a lithograph. It's definitely a fake. I have already been contacted in this matter, and I have already protested.'"

But a fake what? How was it being marketed, beyond the vague hype in the magazine advertisement? It was time to

pay the gallery a visit, and Cox agreed that a female reporter and I should pose as customers. Cox chose as my companion Susan Yim, the *Star-Bulletin* features editor, whose tasteful attire and poise produced the appearance of one who had money to spend on art. Cox vetoed, on ethical grounds, the idea of our carrying a hidden tape recorder.

Center's main gallery is in the thick of Waikiki, at the Royal Hawaiian Shopping Center, a complex of stores appealing to upscale guests at the nearby beachside Sheraton hotels, or vacationers walking along Kalakaua Avenue, the mecca's gaudy thoroughfare. Richly carpeted, the gallery displayed two floors of art, some paintings but mainly limited-edition prints. The *Paris Opera* print was at center stage as Susan Yim and I walked into the shop that morning.

We stood gawking at it from a few feet away and soon were joined by James W. O'Brien, a middle-aged salesman wearing nice slacks and a tastefully muted aloha shirt. We feigned interest in the print, and O'Brien reacted as hoped. He directed us to a small side room and hurriedly summoned the help of his boss, a woman who professed more knowledge than O'Brien. The print was taken from the main gallery and hung in the small room, where it was given special, dramatic lighting. The sales pitch began.

It was much like what the McMullans had heard three months earlier. The *Paris Opera* print had been created in an edition of two thousand, selling for $1,500 apiece. There were artist's proofs selling for $1,650. The print was expected to rise in value because of Chagall's recent death.

The woman described how lithographs are made. Chagall did not actually work on the plates used to make the print, she said, because artists do not ordinarily perform such work, especially artists in their nineties. But he did supervise the print's production from the preparation of the plates through the actual printing. The print was "signed in the

stone," meaning that the artist's signature was inscribed in the plate instead of directly on the paper.

We were handed a slick, color folder celebrating the print and a certificate of authenticity identical to the one Mrs. McMullan received, naming Atelier Amiel as the publisher.

"We'll think about it and probably be back in touch with you," I told O'Brien as we prepared to depart. O'Brien gave me his business card: his title was Fine Art Consultant. He asked my name and occupation and whether I was visiting from the mainland. I told him I was a writer living in Honolulu, and we left.

Since Madame Chagall's assertion clearly contradicted Center Art's sales representation, a phone call was placed to Center Art owner William Mett. He was away from his office, but his secretary would tell him that the *Star-Bulletin* was questioning the authenticity of the *Paris Opera* prints, and he would return the call.

Meanwhile, the gallery also had been visited by the university professor. "It looks to be an original Chagall lithograph, signed in the stone," the professor said. Told about Valentine Chagall's accusation, he became puzzled. "If it's a fake, it's a good fake. But if it's a fake, it's not worth the paper it's printed on."

The call to Mett was returned by Renton Nip, one of three lawyer-brothers in Honolulu. Nip was incredulous that the newspaper would consider publishing an article containing accusations that his client was selling fake Chagall prints. He asked that he and Center Art officials be allowed to meet with the *Star-Bulletin*'s management before publication, which was planned for the next afternoon. A meeting was scheduled for six A.M.

Nip arrived promptly at Cox's second-floor office in the newspaper building, an aging structure fronted by a row of royal palms that houses both the *Star-Bulletin* and the morning *Advertiser*. Nip was accompanied by urbane-

looking Marvin Wiseman, and by Mett, who looked limp and forlorn. (I was to learn he always looked like that.) We sat around a conference table that Cox used for his desk, and Nip turned to Wiseman, the expert, to explain how publication of a story containing Madame Chagall's allegations would be rash and premature. The widow could not possibly keep track of the thousands of contracts signed by her husband, Wiseman intoned in an accent suggesting Harvard and high society. The newspaper must contact the lithograph's publisher, Leon Amiel. Wiseman said Amiel had been contacted in Paris, had flown to New York out of concern for the allegations and was prepared to fly to Honolulu. Amiel could verify the arrangement that had been made between him and Chagall before the artist's death. Told only that the newspaper had been tipped off about the *Paris Opera* print by "a printmaker on the mainland" (my brother), Wiseman asked if the tipster was Pierre Marcand, a name I had not heard. He seemed not to believe the answer.

The meeting lasted about an hour, after which Cox agreed that the newspaper should speak with Amiel. Before the three men left, Nip handed Cox a letter of warning. It questioned the newspaper's interpretation of Madame Chagall's remark to the Associated Press that the *Paris Opera* had been reproduced as a poster but not as a lithograph.

According to Wiseman, the letter said, "a poster may be produced by any number of methods, including original lithography and offset printing. When a poster is produced by original lithography, an image is hand-drawn onto a mold by a professional printmaker or artist. That mold is impressed upon the poster medium and the resulting product is called an original lithograph. Each separate lithograph prepared from the mold is termed an original lithograph. Accordingly, what Valentine Chagall refers to as a

'poster' may in fact have been produced by original lithography."

The letter expressed concern about the word *fake*. "Does it mean, as is its clear implication, that someone forged a work by Chagall or produced an image not created by him? Does it mean, on the other hand, 'not authorized,' for which the use of the term 'fake' is misleading?"

The Hawaii-born lawyer then implied that the article we were considering would not play in the backwaters of the Pacific. "In these islands, it is improbable that Chagall art is newsworthy. It is even less probable that news about Chagall art justifies hasty publication."

Publication of Madame Chagall's allegation would be made "in reckless disregard for the truth or falsity of its content, or at the very least, negligently," the letter stated. An ordinary person may successfully sue a newspaper for libel if the paper is negligent in printing false allegations about him. If the person is a public figure—one who has focused attention on himself—he must prove "malice," which the courts have defined as being in "reckless disregard" of the truth or falsity of the allegation. The letter predicted "severe economic loss" that would visit the gallery in the event the story appeared. Also, publication in light of these "grave economic consequences" would be "evidence of actual malice and bad faith," and Center Art would have "no alternative" but to sue the *Star-Bulletin*.

If anything, the threat may have energized Cox. The thirty-five-year-old Kentuckian had been hired by Gannett Corporation to revitalize the *Star-Bulletin* in early 1984, and he came with a reputation for tenacity. During his five years as city editor of the *Louisville Courier-Journal*, that newspaper had won no fewer than fourteen major awards, including the Pulitzer. But neither was he sloppy on a controversial story. He insisted more had to be done. Madame

Chagall had to be contacted directly, and more art experts had to be consulted.

A good starting point was the Tamarind Institute, an adjunct of the University of New Mexico in Albuquerque. My brother had told me of the institute and suggested I call Clinton Adams, its director emeritus. Reached at his home by phone, Adams disputed whether Chagall would have authorized anyone to create lithographs in his name. While Chagall was known to have used apprentices in creating lithographs, Adams said, he "would draw the key stones himself." Even when using apprentices—whom Wiseman called "chromists" and Adams disdainfully dubbed "colorists"—Chagall "was participating in the process all the way through," he said. "The key thing here is the participation of the artist." Everything the artist does to delegate his work on a lithograph is "a retreat from originality." Adams suggested I call Peter Morse, a former associate curator of graphic arts at the Smithsonian Institution who had moved to Hawaii.

Morse seemed hesitant to discuss the authenticity of the *Paris Opera* print, but not because he wanted to avoid controversy. "I usually get paid for this," he groused for a second. First, however, he had to drive his son to school. Once he returned, Morse was reluctant to travel to the gallery to view the print, but he agreed to discuss it. He explained that a lithographic print patterned after a work done by an artist in another medium—in this case Chagall's ceiling mural—was not at all acceptable as an original print. "Certainly the artist has to be involved in some way in it," he said.

I placed a call that evening to Valentine Chagall at the number provided by the Associated Press. In English, she confirmed that she had spoken to the wire service and that the *Paris Opera* print being sold in Honolulu was indeed a fake. Asked what she meant by that word, she said her hus-

band had not done such a lithograph and had not authorized anyone else to do it. "He always did it himself and controlled himself," she said. As she had told the AP, there was a poster done of the ceiling painting, "a very big poster," and it had been reproduced in a book. Asked further about the poster, Madame Chagall seemed to be annoyed and angrily hung up the phone.

I tried without success through the ensuing weekend to make contact with Leon Amiel. He finally came on the line Monday morning with his New York attorney, Arnold Ross. Amiel had been described in Renton Nip's letter as being of Paris and New York and as being decorated with the French Legion of Honor, but he sounded straight from New York. He insisted that Chagall had authorized the *Paris Opera* lithographs, and the plates for them were prepared in early 1984 and that the printing had been completed in October or November 1984.

"Mr. Amiel's relationship with Chagall goes back about thirty years," Ross said, "which resulted in not only seven lithographs of the type that you are discussing, but other lithographs as well as a book. And there was a personal relationship."

"In other words," Amiel added, "this isn't the first one that we've done." He said he was simply "following the dictates of the artist, who wants his works sold all over the world, so that everybody knows him, at fairly reasonable prices, because people generally can't afford to buy all these limited, signed lithographs that go for ten, fifteen, twenty thousand dollars or more."

Ross maintained that Valentine Chagall was "not cognizant" regarding the agreements her husband had made. "I don't know where her use of the word *fake* arose, but [the print] certainly is not a fake, because the only thing that exists is a reproduction adapted from the oils that are on the ceiling of the Paris opera. You can't actually take that oil

down and reduce it in size and make a lithographic plate out of it."

Amiel insisted that Chagall had authorized the production of the lithographs, although not in writing and not with his participation in their creation. Told of Clinton Adams's statement that Chagall always would draw the "key stones" for his lithographs, Amiel responded: "Chagall never did that in his life."

Morse, Adams and Feher had placed a poster value on the *Paris Opera* print. Morse estimated a value of ten dollars, and Adams would double that "if they're beautifully printed."

Responded Amiel: "A photographic offset print may be worth that kind of money, but it certainly costs a heck of a lot more money to produce what we have done than what he (Adams) evaluates it at."

Was this "investment art?" Said Amiel: "I don't know whether they're selling it as a good investment or a bad investment. I'll stand on the fact that these lithographs are every bit as good and as well made and some of them are better made than some of the things that were supposedly signed and overseen by him (Chagall). . . . As far as I could see, Center Art is not selling this as something that it isn't. I don't know how they're evaluating it or how they're telling their people it's worth or whether it's a good investment or not. That's a selling point of view. But it's certainly worth a lot more than ten or fifteen dollars, even though somebody says he wouldn't pay more than that for it."

Would fifteen hundred dollars—the price Center Art was charging—be fair?

"It depends on what the cost of framing is," Amiel responded. "If they would put it in a three-hundred-dollar or four-hundred-dollar frame, if their advertising costs are a tremendous amount—It costs a tremendous amount as you well know. And the overhead, and the . . . It may very well

be worth that kind of money." Center Art's fifteen-hundred-dollar price did not include framing.

"In the business world, as far as I'm concerned, whatever the public is willing to pay, that's a fair price," Amiel said. "I've known Cadillac to sell Cadillacs with Chevy motors for Cadillac prices."

The *Paris Opera* print is "an interpretive lithograph," Amiel said. "It is an interpretation by a chromist, just as all of Chagall's works are interpreted by chromists. They are interpretive lithographs, pure and simple. They are nothing more unless the artist did all the chromist's work himself, and that is almost an impossible thing for ninety-nine point nine percent of all the artists in the world. They are not lithographers."

Although no written contract existed, Ross said at the end of the phone call that Chagall's New York lawyer could confirm that the artist had such an arrangement with Amiel to produce the lithographs.

The next morning, Ross phoned the *Star-Bulletin* and left a message with Cox's secretary: "Spoke to attorney and he does not wish to be bothered." Reached later that morning, Ross refused to disclose the name of Chagall's attorney as "a matter of confidentiality."

A woman at New York's Maeght Gallery, which represented Chagall, told me the artist did not have a New York lawyer. She added that Charles Sorlier of the Mourlot printing house in Paris was the final authority on the authenticity of Chagall lithographs. The Associated Press again was called upon to ask Sorlier the same question that had been put to Valentine Chagall. Sorlier's response: "It's definitely a fake. Amiel has been flooding the American market with Chagall fakes. Some don't even have Chagall's signature. On others, you can see where it has been added."

Cox edited Sorlier's remark to confine the allegation to the *Paris Opera* print. David Dezzani, the newspaper's

attorney, reviewed the lengthy article, predicted the *Star-Bulletin* would be sued but then turned to Cox and added: "You don't deserve to be called a newspaper if you don't publish this."

The article appeared on the *Star-Bulletin's* front page on June 22, 1985, extending to two inside pages. Cox gave a wry grin and said, "This is the first time that I've ever authorized a story to be published knowing full well we're going to be sued."

The article seemed not to make a ripple; other news organizations did not pick up on it. "It would have been nice for us to have been able to do the story, but this was a primary piece," one television news director said. Another news director said his station also lacked time to confirm the story. "If there is a potential of going to the wall on a story, then I want all the ducks lined up. We want our people, not the *Star-Bulletin's*, to check it out."

Or could Nip have been right? Were the people of Hawaii too bucolic to care about controversy in the art world? Did they know who Chagall was, or were their minds fixed on such local phenomena as hula dancing and surfboarding? Or was the influence of Mett and his attorneys showing? At least in one case it was. The Associated Press, although they had helped research the story, chose not to carry it to the mainland after being visited by Renton Nip.

That afternoon, a woman telephoned the *Star-Bulletin* and, in a quivering voice, identified herself only as a former Center Art employee. "I read your story. Your story is just the tip of an iceberg."

In 1988, after suffering what was diagnosed as myalgic encephalomyelitis, an inflammation of muscles in the spinal cord, Jennifer McMullan decided to sell her *Paris Opera* lithograph to pay some pressing bills. She took it to Anthony

Field, an authorized appraiser in Sydney, Australia, who immediately pronounced it a fake. Field took a photograph of the print with him on a trip to Europe and showed it to Charles Sorlier, along with Center Art's accompanying paperwork. He reported back to Mrs. McMullan that Sorlier suggested the print was a photomechanical reproduction, unauthorized and made in the USA, worth about one hundred dollars.

Mrs. McMullan complained to the gallery. On June 20, 1988, Kim von Tempsky, who was in charge of the Maui gallery where she had bought the print, responded that the gallery had "absolutely no doubt about the authenticity of *The Ceiling of the Paris Opera.*" Center Art had been "privileged to sell large portions" of five limited-edition Chagall lithographs bearing the artist's stamp-signed signature, one of which was the *Paris Opera* print, he wrote, and those editions "were advertised and successfully sold throughout the world." Von Tempsky denied that the print had been sold as an investment.

"I believe that any questions which once may have arisen regarding the authenticity of *The Ceiling* have long since been resolved," von Tempsky wrote. "This lithograph continues to sell throughout the world on the merits of its beauty and association with Chagall's most important commission, *The Ceiling of the Paris Opera.*"

The Battle of Tetuan

The *Honolulu Star-Bulletin* article about Chagall's alleged original lithograph, *Ceiling of the Paris Opera*, had pointed out the Hawaii law regulating sales of fine prints defined an artist as one who may have "conceived" the image on the print without necessarily having produced the image on the printing plates and suggested legal surgery was needed. Three bills emerged as the Hawaii Legislature convened in January 1986, the toughest one proposed by state Senator Neil Abercrombie, the bearded, pony-tailed maverick who later was elected to the U.S. House of Representatives. His bill sought to make print fraud a felony, punishable by up to five years in prison or a five-thousand-dollar fine. In addition, it would define the "artist" as the one who created the image on the master plates, not merely the conceiver of the image for someone else to "recreate." At the other end of the spectrum, Hawaii's House Consumer Affairs Chairman Mitsuo Shito offered a measure that gained Center Art's favor. Patterned after the mildly altered California law, it essentially would have preserved the status quo.

Surprisingly, the state's Office of Consumer Protection, which had long looked the other way, came up with a bill that, like Abercrombie's, would ensure that the artist was the creator, not just the conceiver, of the print. Consumer

Protector Mark Nomura, who drafted the bill, said "a reasonable consumer" should be assured that the artist "really had a hand in creating [the print]. It's really got to be quite simple and clear what you're talking about." The proposed law also authorized state consumer protectors and county prosecutors to initiate proceedings against violators, instead of relying on civil actions brought by consumers.

In his testimony on behalf of Center Art, Renton Nip argued that his client was the "only business in Hawaii which is a participant in the international sale of fine prints . . . a local company which supports approximately two hundred fifty employees on the islands of Oahu and Maui. It is a local company which effectively competes with mainland-based companies [and] enjoys international success."

Turning to the issue at hand, Nip explained that it was "commonplace to have someone other than the artist prepare the plates from which the lithograph is produced." Hokusai did not cut his woodblocks, nor did Chagall draw on stone, he suggested. But under the drastic proposals being considered, Center Art would have to advertise a Hokusai as a "Nakamoto" and a Chagall as a "Knifbihler," presumedly the name of an Amiel employee.

To cement his concern about unfair competition, Nip presented the legislature with two advertisements by U.S. mainland companies—American Express Travel Related Services and Austin Galleries.

The American Express ad offered for $155 a "21-color serigraph after Matisse's original cutout of 1950," which it explained "was re-created from the artist's original image by Graphics Original, New York, in 1983 on rag Arches paper"; for $225, a limited edition (of ten thousand!) "original lithographs" by Chagall, titled *Mon village*, published by Gallerie Maeght in 1977; and for $145 a Picasso print, *La Pose du modèle*, apparently a restrike printed in 1971 by Bank Street Atelier, New York, from woodblocks cut by the artist in 1926. The prices for all included the frames.

Austin Galleries offered an assortment of "original lithographs" by Dalí at $399 apiece or $999 for three; by Picasso at $2,295 each, or two for $3,995 and by Chagall at $995 each. At the time of Nip's presentation, federal judge Leval had yet to express concern about the Dalí offerings by American Express, and the Federal Trade Commission had not yet come down on Austin Galleries.

The Hawaii House committee, and then the full House, approved legislation, quietly and casually—so casually that it turned out to be the Nomura version instead of the milder one authored by the committee chairman and supported by Center Art. Suddenly, other galleries, serious collectors and artists perked up. Through a clerical mixup of bill numbers, a measure that could seriously change Hawaii's fine print law was headed at least for a Senate-House conference.

A small group of people gathered on March 9, 1986, at the Manoa Gallery, a small and reputable shop tucked in one of Oahu's valleys, for what was billed as a panel discussion about "How Art Is Priced." The discussion, sponsored by the Jean Charlot Foundation, named after the late artist, inevitably turned to the legislation, which painter, print-maker and University of Hawaii art instructor Kenneth Bushnell said could put an end to "a giant credibility gap" that had made all printmaking "suspicious" to consumers.

"Let's support it," urged ceramicist Lucille Cooper, who ran a small gallery in downtown Honolulu. Thus, an effort was organized to counter the lobbying by Nip, who had been the only person outside of government to testify before the House committee.

Several days later, Kenneth Bushnell, Charlot Foundation president Stephen Murin and others appeared at the Senate's Consumer Protection Committee to endorse tough disclosure laws, which identified the artist as the creator of the image on master plates. "The essential features of an original, or fine arts, print are that the artist alone has made the

image, that the impression is made directly from that original material and that the artist has approved the finished print," Murin told the committee. Charlot had done it that way, and so did Bushnell and other artists of integrity.

Accompanied by Mett and Wiseman, Renton Nip also testified, and responded that many Hawaii artists hire others to make their lithographs, based on their paintings. Robert Lynn Nelson, a Maui artist who paints aquatic scenes popular with the tourists, "depends upon professionals" for that job and regards the proposed disclosure requirement as "ridiculous." Nip said Nelson had told him the only noted artist who worked on the stone was Toulouse-Lautrec. Charlot must have been an exception, Nip asserted.

Another hearing was scheduled, and Center Art rallied its forces. Under the letterhead of David Ezra, the gallery's longtime attorney, there circulated an admonition that the kind of disclosure being considered would cause Hawaii's artists to "suffer unequal treatment under the law, and severe economic injury." Hawaii dealers "will lose substantial revenue, and the state will lose tax income and jobs. Dealers will incur increased costs of doing business and have imposed [on them] burdensome labeling and signage [sic] which may force them to leave the state."

Signing the letter-petition were Kim von Tempsky of Gallery Hawaii (who later would go to work for Center Art), Andrew Fisher of Images International of Hawaii, James E. Kellett on behalf of several other galleries, and artists Margaret Keane, David Lee, Christian Riese Lassen, Will Herrera and Guy Buffet.

When the committee reconvened, the artists were present to further their position. Lassen, whose aquatic scenes were sold by Center Art, and Keane, famous for her paintings of big-eyed waifs, explained that New York publishers produce their fine prints based on their paintings. Lassen put forth the interesting notion that a print based on his

painting was "an original because it's an extension of the artist." Asked the difference between an original print and a reproduction, he simply answered that an original print is "okay[ed] by my signature."

Asked why she would be opposed to full disclosure, Keane, who was treated as a celebrity by the committee, asserted plaintively, "I don't think we should be educating the man in the street at the expense of the artists."

The artists explained that they receive proofs from the publishers and then check the coloring and registration, which is exactly the process Kenneth Bushnell had said he followed in approving twenty-dollar posters of his paintings. He and the other proponents gingerly avoided any reference to fakes or fraud in Hawaii's art market. Bushnell spoke of "a problem in the industry," abetted by state laws that were "so elastic that the public is absolutely confused about what they're buying."

Senator Abercrombie was more blunt. "To me, it's theft by deception. I'm not an artist, but I'm not a fool, either. If the artist did it, it's original. If the artist didn't do it, it's not an original."

The discord was too much for Committee Chairman Steve Cobb to bear. With a congressional campaign on the drawing board, Cobb did not want to annoy anyone. In the middle of the session he received a five-hundred-dollar campaign contribution from Renton Nip, which may or may not have influenced him. He directed the two sides of the issue to get together and reach a satisfactory compromise, which, of course, was impossible.

The Center Art camp retired to a conference room of then-lieutenant governor John Waihee, a close friend of Nip. Nomura, Murin and Bushnell were allowed to peek in long enough to be told when a meeting could be arranged to attempt a compromise.

The two sides met three times in Nomura's offices, but the result was foregone. When the Senate committee reassembled, an exasperated Stephen Murin reported the lack of consensus. "To be sure, it was not for a failure to try," he said. "We labored mightily but succeeded only in learning that the art of compromise is in short supply. . . . My sense of the experience I shared with the community of artists and art dealers is one of frustration. I was, I believe, the only person present at any meeting who spoke to the concern of the consumer—the buyer and potential buyer of art. . . . To be honest, it must be stated that in the long hours of discussion we never *reached* the area of consumer rights, consumer access to remedial action or to dealers' responsibilities to the art buyer."

A compromise of sorts was fashioned between the consumer protector and the dealers, requiring them to inform buyers about the identity of the person, or workshop, that placed the image on the master plates. "This will enable the public as well as the artist to differentiate between work supervised by the artist in the course of combining efforts with technical experts, and works simply sent off someplace and later passed off as 'original' when it appears," Abercrombie wrote in a letter to House committee chairman Mitsuo Shito. "It emphasizes the participation of the artist even if the artist did not directly produce all aspects of the work involved in producing the print. It specifically allows others to do work involved in producing the print without losing the right to label the finished product *original*. Participation and supervisory control are the determining elements, not numbers of technicians or their contributions."

The bill passed the legislature with little further ado, and was signed into law by the governor. While not tampering with the definition of "artist," the bill required art dealers to disclose whether the artist created the image on the

matrices used to create the prints being sold and, if not, the name or names of persons or workshop of those who did. No other state had imposed such a requirement.

More important than the new law was news of a lawsuit that had gone unnoticed until the legislative debate prompted a young Pearl Harbor sailor to call Abercrombie's office. In February 1983, Randy C. Miller lent $9,000 to fellow Navy Petty Officer Third Class David W. Merkel, so Merkel could buy a trio of Salvador Dalí prints from Center Art Gallery. Eight months later, according to an updated appraisal provided by the gallery, the prints were worth $21,700. A few months later, Merkel had fallen behind in his payments to Miller and Merkel gave him one of the prints, *The Battle of Tetuan*, to repay part of the remaining debt of $5,600.

"I thought I had a lithograph that was going to increase in value in time," Miller recalled. In March 1984, he took his single print to the gallery for a new appraisal, and Marvin Wiseman ascribed it a value of $9,500. The sailor had his doubts, and he called Ryk Burgess, a Honolulu art and antiques appraiser, to give him an independent assessment. Burgess refused. "I don't want to get into that kind of hassle," he explained. "It's a can of worms and, as far as I'm concerned, I don't want to be involved in opening it up."

Finally, Miller found Patricia Hammon, owner of a small gallery in Honolulu's Chinatown, to evaluate it. Hammon sought advice from Honolulu Academy of Arts Curator Joseph Feher, three appraisers in Honolulu, a curator at the San Francisco Museum of Modern Art, the Christie's and Sotheby's auction houses and two graphics galleries in Los Angeles. In August 1985, she reported back to Miller: "It is without authenticity and/or provenance." She appraised *The Battle of Tetuan* at eighty-five dollars.

Miller filed suit, not against Center Art, since he did not buy the print there, but against Merkel. And it was sched-

uled for a hearing in Honolulu district court at the very time the legislature was beginning to debate the Fine Print Bill.

An aide to Abercrombie referred Miller to this author, and I prepared an article for the *Star-Bulletin* about his suit. Again, Renton Nip threatened a lawsuit. In a letter, Nip explained that Center Art had a contract in which Dalí, on October 17, 1981, had authorized the gallery to publish 1,565 *Battle of Tetuan* lithographs, that Dalí had "signed each lithograph," that the gallery owned the "original," meaning the painting, and that the gallery had photographs of Dalí at work on the painting.

Accusing me of engaging in a "rush to judgment," Nip asserted that I wished "to place more material before legislators who are now contemplating legislation aimed at Center Art Gallery." He contended: "The record reflects that you [this author] are the root of the entire controversy which has developed over authenticity. The issue was contrived; it did not stem from any existing problem with a customer. The issue was created and developed by you in the press. You drew and encouraged legislative attention, and continue to fuel the issue with irresponsible, inaccurate, and misleading articles with headlines of art fraud."

As in the letter regarding *The Ceiling of the Paris Opera*, Nip questioned whether the story was newsworthy, this time citing "a private survey which [Center Art Galleries] commissioned and the lack of attention by other members of the press."

Editor Bill Cox thought differently, and the story appeared on the front page of the February 20, 1986, editions of the *Star-Bulletin*. Center Art filed suit the next day, alleging libel and asking $10 million in damages. Nip contended in the suit that the article had falsely accused the gallery of selling inauthentic *Battle of Tetuan* lithographs. Center Art had suffered or was bound to suffer "loss of sales, cancellation of orders for lithographs, impairment of reputa-

tion and standing in the community, humiliation and mental distress and suffering."

Cox and I were anything but distressed. The suit could be advantageous. James Bickerton, a bright young attorney with the newspaper's regular law firm, Goodsill, Anderson, Quinn and Stifel, was assigned to the case and was quick to grasp the opportunities. He promptly demanded to see Center Art's company files, deposed Wiseman and, in May 1986, filed a subpoena for the file of the Hawaii attorney general's aborted investigation of 1979–81.

At first, Deputy Attorney General Grant Tanimoto told Bickerton he could not find such a file. Then Bickerton gave him the file number, provided by Bob Miller, formerly of the attorney general's office but now in private practice. Tanimoto replied that he had been given his "marching orders" to block the subpoena. Tanimoto was marching to the beat of the same administration of Governor George Ariyoshi with which Bob Miller had been brought into step. A month later, Bickerton filed a motion in court to compel the attorney general's office to turn over its Center Art file.

Tanimoto brought the three-inch-thick file with him to the courtroom of aging, diminutive Circuit Judge Edwin Honda on July 8, 1986, with every expectation that he would leave with it still in hand. After Bickerton argued at some length about why the newspaper should have access to the file, Tanimoto rose to rebut.

"Unlike Mr. Bickerton, I'll be very brief," Tanimoto responded. "I'm basically prepared to submit this matter to the court based on our memorandum," which claimed the file amounted to attorney work product and was protected by attorney-client privilege between the attorney general and the governor.

"We have investigations ongoing, and they encompass all kinds of matters," Tanimoto added. "If we were to subscribe to Mr. Bickerton's logic, we would have people knocking

down our doors to get our files and our work product. And for those reasons, we would ask the court to deny the motion. And, your honor, by way of background, this motion came up in part because of the parties playing hardball."

Honda was not the team player Tanimoto might have imagined.

"Mr. Tanimoto, your objections are rather general," the judge said from the bench. "The court has no way of knowing where your real objections are."

"One of the main grounds we're asserting, your honor, is work product in this case," Tanimoto replied.

"What work product?" Honda asked. "In connection with what case?"

"In connection with the terminated investigation."

"It's terminated?" the judge asked, showing some surprise.

"Yes, your honor."

"All right. The motion is granted," Honda said with finality.

Tanimoto appeared shaken. The judge had just ordered the attorney general to hand over the details of an extensive fraud investigation to the newspaper. Could he possibly imagine the ramifications?

"Your honor," Tanimoto interjected, his voice quivering, "could we clarify one point on that? I believe we stated numerous authorities in our brief which deal with work product and terminated litigation. There is material in the file relating to correspondence between attorneys and the attorney general's office, between department heads and the governor of the state of Hawaii." The governor during the years of the investigation had been George Ariyoshi.

Honda did not express curiosity, and he seemed unimpressed with Tanimoto's desperate plea.

"Well," the judge told him, "there's nothing in the affidavit that indicates what the precise privilege is. As counsel

[Bickerton] pointed out, it's just a bland assertion of privilege."

"Your honor, in the alternative, could we suggest an in-camera inspection by the court?" Tanimoto asked plaintively. Surely the judge would see, upon privately reviewing the contents of the file the enormous damage that would be caused by its release.

"All right," Honda agreed. "I don't think it will change matters. The court will then take this matter under advisement. Do you have the documents with you?"

Tanimoto left the thick file with Honda's clerk and departed.

The lawsuit appeared ready to backfire in a way that Center Art could ill afford. That same day, Renton Nip agreed to drop the multi-million-dollar suit if the *Star-Bulletin* would drop its subpoena of the Attorney General's file.

Gannett, which could foresee legal costs mounting, cut its losses and agreed to allow the suit to be dropped, balking only at Nip's suggestion that the dropping of the suit be kept confidential. Instead, the *Star-Bulletin* published an article fully disclosing the fact that Center Art had dropped the suit only in return for the newspaper withdrawing its subpoena of the attorney general's office.

Bill Mett issued a press release asserting the gallery remained convinced that the article about *The Battle of Tetuan* was untrue and unfair. "However, as a small, locally based company, we are financially unable to continue costly litigation against a national corporation with unlimited cash resources. We simply cannot fight a financial giant which can bury an adversary in legal costs."

The investigative file was returned to the attorney general's office, but the *Star-Bulletin* was not precluded from seeking it through the state's Freedom of Information Act,

the so-called Sunshine Law. In doing so, Bickerton turned vociferous.

Citing the history of the affair, Bickerton wrote in a court brief: "These facts reveal a pattern of conduct reminiscent of the darkest days of Watergate. The attorney general is for some reason intent on prohibiting inspection by hook or by crook, without regard to whether such denial is proper."

At the hearing on November 25, 1986, Bob Miller of the State Anti-Trust Division stood ready to testify that during his days with the attorney general's office he had prepared a formal complaint against Center Art in the spring of 1981, had placed it on Judge Arthur Fong's desk and, curiously, was later ordered to withdraw it.

The *Star-Bulletin*'s regular attorney, David Dezzani, back from a year's sabbatical in Switzerland, argued in court for the newspaper. But Dezzani was dealing with a different circuit judge, Robert Klein, himself a former deputy attorney general, and without the stringent subpoena powers associated with an ongoing lawsuit. Choosing not to hear Miller, Klein rejected the motion.

Today the file still lies unopened in the attorney general's office. We know, based on the pleas of Deputy Attorney General Grant Tanimoto, that it contains correspondence between that office, state government department heads and former governor George Ariyoshi, but not whether it reveals a pattern of corruption at the highest level of government in the state.

Hook, Line and Sinker

Victims of fraud rarely go on themselves to achieve infamy. An exception is Mark David Chapman, a young man who moved to Hawaii in 1977 and became intrigued by the Waikiki "investment" art galleries two years later. Pat Carlson, who worked at different times as a saleswoman for two of the three competing galleries, said Chapman's interest became "obsessive and consuming."

Chapman, his wife and his mother first entered one of the galleries in September 1979, and a few weeks later his mother bought a Hiro Yamagata print for $300. From another gallery, Chapman bought *Lincoln in Dalívision* for $5,000, borrowing money from his wife and mother. He quit his decent-paying hospital job on windward Oahu, across the Pali Range, and began work in a Waikiki condominium for lower pay. Carlson said Chapman told her it was so he could be closer to the galleries and have more time to devote to art investment.

"From what I could see, his interest in art became an absolute fixation with him," Carlson said. "He spent a fortune on telephone calls to the mainland, checking things, researching things." Carlson would later confirm Chapman's compulsion to newspaper reporters on the condition they not identify the galleries.

At some point in 1980, Chapman took advantage of a gallery's exchange policy and turned in his Dalí for a Rockwell "lithograph" titled *Triple Self-Portrait*, needing an additional $2,500 loan from his credit union to make full payment. In the fall of 1980, Carlson said Chapman "abruptly stopped calling me. The last time I talked to him, he wanted to sell the Rockwell, saying he desperately needed money. He was willing to throw in the other pieces of his "Rockwell collection," all for the original sales price. I told him to hold on to them for a while longer because it was worth so much more than that. But on his behalf, I asked the gallery if it was interested and was told no. I spoke to a few people, but couldn't find a buyer."

In September 1980, Chapman found a buyer—a California man staying at a Waikiki hotel. Craig Travis, the man's nephew and then a public relations man in Honolulu, acted as intermediary. "We had a drink and struck up a deal for my uncle to buy the lithograph for seventy-five hundred dollars," Travis recalled. Later, he said, Chapman "started calling me up at work, saying he wanted to know where the check was because he really needed the money.

He was very insistent, and I had to keep reassuring him." The transaction was completed on October 10, when Chapman and his wife brought to Travis's home the Rockwell print, framed in koa,* the original *Saturday Evening Post* cover that Chapman had successfully located and the certificate of authenticity.

Robert Hollis of the *Honolulu Advertiser* had written a series of articles in July 1980 about the competition among the art galleries, suggesting that the artworks being sold were grossly overpriced. It is not known whether Chapman read those articles or, if he did, how it might have affected his already unstable psyche.

*A hardwood indegenous to the Hawaiian Islands.

The rest is history: In October 1980, Chapman purchased a .38-caliber handgun from a Honolulu shop. On December 8, outside the Dakota, a luxury apartment building in Manhattan, Mark David Chapman shot and killed John Lennon, one of its tenants. Less than a year later, after pleading guilty to second-degree murder, Chapman was sentenced to twenty years to life in prison. (Through his lawyer, Chapman declined to be interviewed for this book.)

Chapman is not the prototypical victim of this fraud. Nor is it easy to draw such a profile. Hans von Hentig, a 1940s pioneer in the still-emerging field known as victimology, wrote of "dull normals," who seem to have been "born to be victimized in many ways. The success of countless swindlers can only be explained by the folly of their victims, not by their own universal brilliance." More suitable is his description of The Acquisitive": "The greedy can be hooked by all sorts of devices which hold out a bait to their cupidity. The excessive desire of gain eclipses intelligence, business experience and inner impediments." Von Hentig noted that bankers or others who have engaged in speculative business are prime targets of scams. During the inflation of the 1970s and 1980s, and especially in Hawaii, that trait was shared by a large part of the population, along with an abysmal ignorance of art.

Howard M. C. Char, a civilian employee at Honolulu's Camp Smith, the Pacific command center for the U.S. Navy, had tried other investments to keep up with the rising expenses of raising a family. He had received $33,000 from the sale of property on the island of Kauai, spent $8,000 of the proceeds on a car and was looking for a new investment. A bad experience with a partnership in rental property had soured him on real estate. A fellow employee told Char about how his *Lincoln in Dalívision* lithograph had nearly tripled in value in only a few years. When Char saw a Center Art Gallery newspaper advertisement of a gold wall sculp-

ture, *Lincoln in Dalívision*, he telephoned the gallery to find that a few still were in stock, then paid a visit. A salesman told him how the sculpture was bound to appreciate, based on past performances of other Dalí works.

"I told him I was looking for an investment for two of my children as a college fund, and that my daughter was going to start college in '85, so he said that now is a great time to buy, because that gives you ample time to have the artwork appreciate," Char said. So right then he purchased one silver and two gold *Dalívisions*. Through February 1983, Char bought a total of six Dalí pieces and one Miró from the gallery. When it came time to liquidate the investment in 1985, Char called Sotheby's auction house, but his pieces were rejected. He tried to get a refund from the gallery, but was told no. "I looked in the newspaper in the ads for merchandise for sale in the miscellaneous column. There were several Dalí pieces there, but it seemed like nobody wanted to buy them." Both of Char's children made it to college, at the University of Hawaii. They had wanted to go to mainland schools.

October 1982 was a bleak time for Janet Owskey, who worked as a hairdresser in the central Oahu outskirts of Honolulu. Her mother was suffering from cancer, and Janet and her brother spent long hours at the woman's bedside at Kaiser Hospital, across the Ala Wai Canal from Ala Moana Shopping Center. Their father had died earlier, and Mrs. Owskey's fate was certain.

To ease the tension, Owskey and her brother, on leave from the air force, would walk across the bridge to the shopping center. Owskey always had enjoyed art, and Center Art Gallery's quarters became a popular browsing spot for her. A few words to her from salesmen made her visits to the gallery seem fortuitous. She told them she was about to inherit ten thousand dollars upon her mother's passing. Both

she and her brother were considering ways of investing the money. Dalí art, they became convinced, was the ticket.

"They told me this was going to be my house in Waialae Iki," a prosperous section of Honolulu, Owskey recalled. "If I held on to this long enough, this was going to be my fortune." Owskey bought a total of four Dalí lithographs for a little less than ten thousand dollars. As years passed, reappraisals mailed to her by the gallery showed her the investment had been wise. According to the gallery, her money had more than tripled in little more than two years.

Owskey burst into tears of outrage after reading about the eighty-five dollar appraisal of the *Battle of Tetuan* in the dispute between the two sailors in February 1986; two of her prints were *Tetuans*. "Truly," she recalled a year later, the tears returning, "they took advantage of me at probably the lowest part of my life. My mom was in the hospital, dying of cancer. They knew the circumstances. I was in there every day, just looking around, not bothering, not asking questions. I did not ask about any artwork whatsoever. They approached me. And I really feel that they preyed upon me They knew, the salesman especially knew, that my mom was dying of cancer and had a very short time to live. And when I read about this [the lawsuit between the two sailors], I was beside myself."

The realization that you are the victim of a fraud is not unlike the reaction felt by victims of many other types of crime. A 1971 study in California revealed that victims of fraud who had received economic compensation still felt emotion. Three out of four said they wanted "someone to . . .help them get back on their feet." These were people who had gotten their money back.

For most victims of the Dalí print fraud, the realization came less suddenly than in the cases of Howard Char and Janet Owskey. Both had the news screamed to them by newspaper accounts that they had been conned. Most of the

purchases, whether in Honolulu, New York, Albuquerque, California or elsewhere, were made by tourists, and enlightenment came more gradually.

A *60 Minutes* segment about Shelby Fine Arts in December 1987 included only a few seconds of the raid on Center Art and nothing of the other investigations. When purchasers who had seen the program called the other galleries, they were assured all was well. Often, the purchasers would accept such assurance, remembering the factors that caused them to make their investments in the first place.

Before Thomas Waltz, a state government official from Vancouver, Washington, purchased Dalí prints from Center Art in 1984, he and his wife had carefully weighed those considerations. "We walked into the gallery and were very much impressed with the chrome, the marble, the lighting, the overall ambiance of the situation at Center Art," he said.

Accompanied most of the time by a salesman, the Waltzes spent about forty-five minutes in the gallery, viewing Dalí prints, discussing Dalí's health and the worldwide demand for his art. *Lincoln in Dalívision* at that time had a $22,000 price tag on it, indicating according to Center Art, how much values had soared in only a few years. Waltz recalled the salesman "indicated that they would close the doors to the gallery that very night if word came to them that Dalí had died. They would then have to wait until the market prices for his work had actually stabilized [before they could offer them again]. We found that very impressive that the gallery was sensitive to the fact that the price of the prints would modulate very significantly if Mr. Dalí died."

The Waltzes were given brochures and Center Art's corporate profile, and they discussed over dinner that evening whether to make the investment. "We were very concerned about the gallery's reputation, and about how we might be viewed if we purchased art from there. Was it fly-by-night? Was it a well-established firm? What is the potential here?

Could this be the investment that's too good to be true, one that can put ahead a little bit as being a moderate-income family?" After dinner, nearing midnight, the Waltzes returned to the gallery and signed papers to make the purchase of three Dalí lithographs for $4,750.

Air Force Lieutenant Colonel Pat Reese began his art investment in 1983, spending more than two thousand dollars on Dalí and Rockwell prints sold by a traveling art gallery sponsored by the Officers Wives Club. Two years later, he began wondering about the value of his Dalí and took it to Center Art to get the gallery's assessment. A manager verified its authenticity but frowned on its investment potential; the number of the print—not the size of the edition—was too high. The best print for investment, he said, was a publisher's proof. Fortunately, because of Center Art's relationship with the artist, it had access to such treasures.

The sales manager must have known "he had a real live one," Reese recalled. The forty-two-year-old pilot from Texas emptied his savings of $13,950 to buy three copies of *Christ of St. John of the Cross*. The salesman assured him that after Dalí's death, he would cash in. Reese said he was told he eventually could sell two of the *St. Johns*, buy a Mercedes and keep the third. Reese never picked up his artwork; the gallery allowed him to store the prints at its warehouse for "temperature control." The gallery assured him they were like money in the bank.

Paper mill foreman Jacob and his wife Carla Hergert took their two *Battle of Tetuans* back to their home in Tacoma, Washington, after buying them at Center Art Gallery in December 1982 for a total of $3,950. At home they kept them in a closet. "Ugly pictures. Really ugly. Something you wouldn't even hang on your wall," Carla Hergert recalled more than five years later during a return visit to Waikiki.

"I didn't buy them to hang on the wall," her husband added. "It was strictly as an investment that they talked me

into buying them. I wouldn't have paid that much money for something to hang on the wall." Indeed, reappraisals sent to the Hergerts from Center Art claimed the two prints had more than tripled in value in less than three months following their purchase. When they rose in value to $19,000, the Hergerts asked the gallery to sell them on consignment. The gallery refused.

Before dismissing the Hergerts as yokels, consider that fake Dalí print investors included the movie star Arnold Schwarzenegger; Raymond Bechtel, a retired professor of counseling psychology at a college; John Benzenberg, a systems analyst for a bank on Wall Street; James Brunner, professor of marketing who for twenty-five years had been chairman of his department at the University of Toledo, in Ohio; and Joryn Jenkins, who bought Dalís at Center Art Gallery in 1983 while on vacation from her duties as an assistant attorney general in Florida, where her job was to prosecute white-collar crime.

Some of the investors were astute businessmen, such as Vassilios Macheras, a native of Greece who had established a successful Italian-Greek restaurant in Anchorage, Alaska. Macheras was on his way to vacationing in the Mariana Islands in 1981 when he first entered Center Art Gallery during a stopover in Honolulu. Then and in the ensuing months, Macheras bought a dozen Dalí prints, including *The Christ of Gala, Sacrament of the Last Supper, Corpus Hypercubicus, the Battle of Tetuan* and *Madonna of Port Lligat.* A choice client, Macheras was invited to Center Art's Anthony Quinn exhibition at the Watergate Hotel in Washington, D.C., in September 1984. There he met Quinn and bought one of his oil paintings, titled *Omar*, for $45,000, not for investment but for the excellent reason that he liked the painting.

"I like Anthony Quinn, too, as the actor," Macheras explained, "playing Zorba the Greek. And also, I know the

history of this painting . . . so all this makes me like and buy this artwork."

But Macheras still was not hooked into the spirit of investment art. He had been offered an original pen-and-ink drawing by Dalí, titled *The Heralding of Angels at Port Lligat*, but he had not responded. After the *Omar* purchase, William Mett telephoned Macheras and proposed a trade: *Omar* in exchange for *Heralding of Angels* and ten Dalí lithographs. It was an irresistible offer, since Center Art had appraised *Heralding of Angels* at $145,000 and each of the lithographs at $1,500, and Macheras agreed. Part of the deal was that Center Art would try to sell the Dalí drawing at its appraised value, taking a 20 percent commission on the sale.

By the spring of 1985, Macheras had become troubled about news of Dalí forgeries, not only of prints but of paintings too. He wrote a letter to Mett asking for a certified, independent appraisal of the work. There is some question about whether Mett received the letter, which bore an incorrect address. Then, too, Macheras was unable to make contact with Mett by phone. By December 1986, *Heralding of Angels* had not been sold, and Macheras had it mailed to him in Alaska. He would later find out that Robert Descharnes, who had been shown reproductive "prints" of *Heralding of Angels*, had judged the image—and thus the drawing itself— to be a forgery.

Not jaded by his experience with the gallery, Macheras returned in early 1987 and bought two Quinn sculptures, *Athena* and *Apollo*, Apollo being the name of his restaurant.

Robert L. Wacloff got the Dalí print bug in 1979, a year before he was to retire from the army as a lieutenant colonel commanding a battalion in Alaska. Wacloff and his wife came upon Center Art's Ala Moana Center gallery while vacationing in April 1979 and were given the pitch by salesmen. "They were talking in terms of escalation, market value of the pieces, how fast they were selling out, what a

great market potential they had for them and what a great investment item they were," Wacloff recalled. "We were just coming out of the military at that time. I had three children that I was trying to get through college at that time and I needed something that could help." He bought a Dalí *Last Supper* bas-relief.

By 1982, Wacloff had retired from the military and begun work as superintendent for materials for British Petroleum at Prudhoe Bay. It was a job requiring him to work seven hundred miles from his Anchorage home but allowing him every other week off. He began wondering how he could occupy himself during his free time and hit upon an idea: Fine Arts of the North, modeled after Center Art. Noticing how his *Last Supper* had quickly risen in value according to Center Art's periodic reappraisals, Wacloff bought two Dalí prints and told his friends about his newfound investment plan.

Wacloff flew to Hawaii and approached a Center Art manager, who agreed to give him reduced prices if he bought in bulk. In February 1983, after taking out a business license for his new art brokerage, he bought fourteen *Glasgow Museum Suites*, and four months later five *Nike* statues by Dalí. He purchased eight prints of *Corpus Hypercubicus*, a *Victorious Athlete* and two Quinn serigraphs. By the end of 1984, he had spent $110,000, including $35,000 of his own, mostly on Dalí art, and had earned $4,900 profit on sales to about twenty-five friends. Plus, the artworks were skyrocketing in value.

"I felt very happy," he said. "As an example, *The Battle of Tetuan*, paying in the high three-thousand bracket and getting a Center Art reappraisal for it at twenty-one thousand dollars, just about a sixfold increase. That's like striking a gold mine."

In Alaska, there is a term for that kind of gold, fool's gold, as Wacloff and his friends eventually would discover.

Wacloff tried to liquidate his investment through newspaper classifieds in Anchorage, New York and Los Angeles, with no success. "I received just one call from the L.A. ad, and it was strictly a searching kind of call. The individual really had no in-depth desire to purchase unless he could pick it up for almost nothing."

The telephone boilerroom of Barclay Gallery also was effective in selling people on Dalí investments, as a Baltimore physician unhappily learned. After hearing the sales pitch in 1984, the doctor decided to put a thousand dollars a month away for investment art. "They sent me two Dalís called the *Alice in Wonderland Suite*, one called *Pig in a Pepper Tree* and the other titled *The Mad Tea Party*. They were gorgeous, very large lithographs." By mid-1985, he had spent $13,300 on four pieces, and he had money on deposit at Barclay toward a fifth. But then he saw a television news report that postal inspectors were investigating Barclay for allegedly selling fake Dalís, and the doctor quickly excercised the gallery's lifetime exchange policy. He traded his four Dalís for four Chagall lithographs, and he received a fifth Chagall by mistake, triggering even greater anxiety. "Barclay still owed me five hundred dollars from my investment plan, so I proposed returning the extra Chagall in return for my money. They refused, and that made me very nervous." An appraiser in Baltimore confirmed the doctor's fear, noting the bad coloring in the prints. "It was obvious to him they were forgeries," the doctor said. "And it was obvious to me that I'd been pretty dumb."

Gayle Dendinger, the owner of an air freight company in Denver, was more irate than embarrassed when he discovered that four Dalí lithographs he bought from an Arizona gallery in 1985 and 1986 lacked authenticity. In February 1987, Dendinger threatened to attend a party the gallery was throwing, and to bring along an Internal Revenue Service

agent, a postal inspector, the Arizona attorney general and a reporter from the *Arizona Republic*. He quickly got a refund. "It was strictly a matter of outbluffing them," Dendinger explained with a smile.

Despite the adverse publicity, Dalí sales continued throughout the country, commanding prices that proved the earlier rosy predictions of the galleries. By 1986, *Lincoln in Dalívision* was tagged at $23,500 at Center Art Gallery, and Denise Wheeler, who owns a permit service for the film industry in Van Nuys, California, proved the price was not fictitious. Wheeler had bought a Red Skelton serigraph from a Center Art outlet on Maui a year earlier, and she took an interest in a print propped on the floor during her return visit.

"Oh, this is a very important piece," salesman Bruce Young told her. "It's called *The Annunciation*. It's made by Dalí. But you wouldn't be interested in this. We have something better for you. No, let me show you this, it's called *Lincoln in Dalívision*." Whereupon Young took Wheeler, her husband and a friend of the couple to a side room and gave an elaborate sales presentation: Dalí worked directly on the printing plates, signed the prints afterward, and "was very ill, and he doesn't paint anymore, and as soon as he passes on, the value will double."

"I told him I felt I was being intimidated into buying it," Wheeler recalled. "And Bruce assured me, with his arm on my shoulder, 'Denise, you never have to worry. If you wanted to return this art, we would give you back your money tomorrow.'" Sold, with a $1,000 discount, at a price of $22,500. And for good measure, *The Annunciation* was thrown in as a gift from Bill Mett.

Upon returning to Van Nuys, Wheeler was glancing through a magazine when she came across a classified ad offering *Dalívision* for $2,500. She phoned Bruce Young and

expressed her concern, and upon his request sent him a copy of the ad. Later, he suggested in a letter that she attend an upcoming party for Red Skelton and trade her *Dalívision* in on a Skelton. "That way, we can get this stupid monkey off our backs once and for all, and you can be here where you belong, at this really fun and special weekend with Skelton." She declined, and the *Lincoln in Dalívision* remained tucked under her bed. "We really honestly didn't trust Bruce anymore . . . and we didn't want any more paintings from that gallery."

For years, such prints remained out of sight, underneath beds, in closets or in Center Art's temperature-controlled warehouse. The owners remained mindful of their existence and of their rising value, until they heard or read news reports to the contrary.

CHAPTER 14

An Untimely Death

The quiet end to the Hawaii attorney general's investigation of Center Art Gallery could not put a cap on the continuing complaints by consumers. The state's consumer protector processed numerous grievances, working out disagreements between the gallery and its customers. Each of the conflicts was settled with a confidentiality clause, allowing business to go on as usual.

Not that Center Art failed to put up a fight each time a consumer demanded a refund. The larger the amount involved, the less willing the gallery became. The hardest fought was the case of Dr. Shigenoba Kojima, the wealthy founder of a hospital complex in Japan. From September 1981 to December 1982, Kojima bought fourteen Salvador Dalí watercolors through Japanese-speaking saleswoman Eleanor Zentkovich for a total of $2.1 million, spending $50,000 to $220,000 per watercolor. The average price was more than $150,000. The art investment served two purposes for Kojima: high returns predicted by Center Art's "former museum curator" Marvin Wiseman, plus a means of possibly escaping the scrutiny of Japanese tax collectors. Neither proved very successful.

The Japanese tax authorities were first to come down on Kojima, accusing him of hiding nearly $4 million by

investing it in real estate and Center Art's Dalí pictures. In evaluating the art, the tax people's total came nowhere near what Kojima had paid for it. Kojima was convicted of tax evasion in March 1985, sentenced to eighteen months in prison and ordered to pay back taxes and penalties.

Kojima filed a complaint with Hawaii's consumer protector and hired Jeffrey Portnoy, who had been Santa Monica avocado farmer Roland Vasquez's Honolulu lawyer, to sue the gallery for a refund. Portnoy had been retained by other Center Art consumers since the end of the attorney general's investigation, and he was growing irritable. Through some research, Portnoy determined that the average price of a Dalí watercolor was about $10,500, less than a tenth the average paid by Kojima. In addition, he figured at least two of the paintings to be fakes. Portnoy filed Kojima's suit against Center Art a month before his client's conviction and then tried to press the state consumer protector for information on past cases. He was told that a dozen complaints were "in various stages of review and completion," but he was denied details.

Portnoy turned accusatory: "This is not the first time our office has been involved in representing customers of Center Art Gallery," he wrote Consumer Protector Mark Nomura in June 1985. "In fact, over the past several years, we have represented at least five people who have demonstrated, to our satisfaction, evidence of misrepresentation, overstatement, violations of statutes and fraud . . . I would be astounded if there were not many other customers who have had similar problems but who have either not had the resources to pursue their claim through legal counsel, or who are ignorant of their potential claims . . . ," he continued. "To my amazement, it appears that the Office of Consumer Protection has done little to stop the gallery from engaging in its practices, which adversely affect tourists as well as residents. . . . Your office is obligated to protect con-

sumers, even those who may not have enough power, money or knowledge to protect their own interests. I urge your office to carry out those responsibilities by undertaking a thorough investigation of the gallery's sales programs and policies."

Nomura replied with an assertion that his office had the right to keep its files closed from the public. He politely thanked Portnoy for "taking the time to express your concerns" and invited him to share "information you have in support of the allegations in your complaint."

Portnoy fired back a letter to Nomura challenging his right to withhold consumer complaint files: "Your attorneys represent the people of this state, and they are entitled to see any documents which are prepared by your office in its representation of the public." Portnoy urged Nomura to put a stop to his "general platitutes" and instead take "direct action which would show some guts and responsibility to the public you are supposed to serve."

"My client has the resources to pursue his claim directly against the gallery even without your office carrying out its legal responsibilities," Portnoy added. "But I am concerned about the scores of other individuals who, either because of lack of knowledge, lack of resources, and/or geographic distance, do not have the wherewithal to pursue legitimate claims. I repeat my statement that it is only a matter of time until this entire house of cards comes tumbling down, and my fear is that the cards are going to fall directly upon the heads of the Office of Consumer Protection."

Portnoy's complaint had no effect on Nomura's office. The state already had conducted the very investigation Portnoy had demanded, and it continued to process the consumer complaints on an assembly-line basis. The accusations made by Marc Chagall's widow and print collaborator Charles Sorlier in the *Star-Bulletin* a month later did not appear to jar that routine, although Nomura did prepare the

bill in the legislature to toughen Hawaii's law and may have even advised Center Art to clean up its act.

It took Hans Wilking, a German-born horticulturalist from British Columbia, to finally blow the lid off the fraud. Wilking, who spends several weeks every winter in Hawaii, bought several Salvador Dalí lithographs and a Dalí pen-and-ink sketch titled *Courtyard of a Spanish Palace* at Center Art in December 1983 for $36,500. Soon afterward, he noticed the same image of his lithographs appearing on other prints being sold in Canada. Upon Wilking's return to Hawaii, he confronted Mett. According to Wilking, Mett told him he was well aware of the problem, and the French police were "already on the heels" of the publisher of the unauthorized prints.

Uneasy about the prints, Wilking wrote to Robert Descharnes, who opined that the lithographs were offset reproductions bearing forged Dalí signatures. Wilking returned them to the gallery and, with extra cash, exchanged them for a second Dalí pen-and-ink titled *Snails and Cycles* in August 1984. The price of $49,500 included the lithographs' exchange. Wilking arranged for his two Dalí sketches to be sent to the International Foundation for Art Research in New York, where director of authentication Virgilia Pancoast sought Descharne's evaluation. They both were fakes, Descharnes concluded.

Wilking returned to the gallery in late 1984 to get his money back, but it was refused. He complained to the consumer protector, Honolulu police, the mayor's office, even the governor's office. "It was a real merry-go-round," he recalled. Although the consumer protector accepted his complaint, he said, "they were not interested in doing anything about it."

Finally, Wilking found the right place: the office of the Honolulu city prosecutor. If there was any informal machinations within Hawaii's political establishment about any-

thing, the city prosecutor's office could be relied upon not to be a part of it.

Charles Marsland was a civil attorney for the city in 1975 when his nineteen-year-old son Chuckers, who worked as a doorman at a Waikiki discotheque, was gunned down in a rural area of the island. Marsland became consumed with trying to find his son's murderers. He joined the prosecutor's office, caused friction through his abrasive and aggressive manner and was fired in 1979. A year later, he ran for election to the office, accusing the incumbent and other public officials of complacency about organized crime, which he blamed for Chuckers's death. He accused Larry Mehau, a rancher on the "Big Island" of Hawaii and a close friend of Governor George Ariyoshi, of being Hawaii's "godfather" of organized crime. Marsland won the election, and became a thorn in the side of the political machine.

Marsland's distrust of Hawaii's ruling forces filtered down to his deputies and investigators, including Thomas Maxwell, an Air Force Academy graduate whose job was to investigate white-collar crime.

On January 9, 1986, Wilking stormed into Maxwell's office carrying a file of documents accusing Center Art of ripping him off with fakes.

"I wasn't sure what I was getting into," Maxwell remembers. "I didn't really know anything about art. I wasn't sure how I was going to handle it, or even what we had here. But then he starts throwing out all the documentation he had on my desk. I made copies. After looking at it, I didn't think I was going to have to be an expert in art, because it was pretty clearly a fraud that had been perpetrated—at least these two drawings. He had a report from IFAR [International Foundation for Art Research] saying they were phony, they were counterfeit. He tried to get his money back based on the fact that he had bought these counterfeits and

that they weren't going to give him his money back. That struck me as kind of odd."

Later that day, Wilking made a similar presentation to the author. Since my story had run in the *Star-Bulletin*, I had been waiting for a victim to come forward, but Wilking was the wrong victim with the wrong goods attributed to the wrong artist. I believed the nature of the scam to be print fraud; a story about two pen-and-ink drawings was too limiting and off-the-point. The Dalí problem was beset with vagaries, and those had been pointed out by the *Wall Street Journal*, the *New York Times* and other publications. I was focused on the Chagalls, where new ground could be broken.

Maxwell began checking out Wilking's complaint, reviewing corporate filings and, based on Wilking's suspicions about political influence, the records of campaign contributions. He called Consumer Protector Nomura for information about other complaints against Center Art. "He said they'd never had any complaints like that before," Maxwell said, reviewing his notes from that day. "Basically, what Mark Nomura said was there were prior complaints about late deliveries, the investment value of the art, trouble about getting refunds back, and more recently questions about the Chagall lithographs. But he said the prior complaints did not have anything to do with the sale of fakes. That's what I was told."

On January 21, 1986, the *Star-Bulletin* published an article I had prepared about the upcoming indictments of Convertine and Caravan galleries in New York, concluding New York Deputy Attorney General Judith Schultz's lengthy investigation. It was the first Maxwell had heard about a criminal investigation into the Dalí fraud, and he phoned Schultz. After being briefed by her, Maxwell went to his boss, who obtained permission from Marsland to go forward with what Maxwell then realized would be a major investigation.

Weeks passed, and Maxwell still had only one victim—Hans Wilking. He had learned about the Kojima case from reviewing court records and interviewed former saleswoman Eleanor Zentkovich, who turned on the gallery in the Kojima case and now provided a wealth of information for Maxwell.

The *Star-Bulletin*'s article on *The Battle of Tetuan* appeared in February 1986, but Maxwell received no immediate complaints. Finally, in May, Marilyn McInnis came to him with her sad story. Illness had forced McInnis from her job as a postal carrier in the late 1970s, and she was living on less than six hundred dollars a month in disability payments.

She did have some savings, and a Center Art salesman knew how she could make the most of it. He told her "that this would be a great investment, if I was planning to send my child through college, which I was," she recalled. She forked over nine thousand dollars for three *Tetuans* in 1982. McInnis was outraged after the newspaper article appeared. She complained to the consumer protector and took out a classified advertisement in the paper, asking other *Tetuan* investors to contact her. Center refunded her money, but other *Tetuan* owners began to assemble.

A month later, Leilani Petranek, the customer who had tape-recorded the Dalí sales pitch in chapter 1, complained to the consumer protector. She had demanded that the gallery inform her whether Dalí and Chagall had created the images on the master plates for any of her many lithographs, and the response was that they had not. After filing her complaint with Nomura, she called me and asked whether I knew where she could file a criminal complaint. Nomura had not informed her of Maxwell's investigation; he later told me he considered such referrals to be "inappropriate."

I discussed with Managing Editor Bill Cox the ethical considerations of my informing Petranek of Maxwell's

investigation. We decided there was nothing wrong with doing so, since she had asked. Subsequent inquiries were handled the same way.

Petranek's tape recording of Bernie Schanz's presentation was a godsend to Maxwell. Schanz, found selling art in California, said Mett and Wiseman had implied to him that Dalí had worked on the plates, as he had told Petranek in grandiose terms.

Maxwell already had begun to gauge the magnitude of the fraud and contacted the local postal inspector, Trent Strausberg. On the afternoon of July 16, 1986, Strausberg and another inspector, Michael Crivelli, paid a visit to Center Art's Ala Moana Shopping Center outlet.

In addition to receiving the standard Dalí investment sales pitch, Strausberg and Crivelli were offered an extraordinary deal. Salesman Dean Hoag handed them a flier stating the prices of *Madonna of Port Lligat* at $3,750, *The Last Supper* silver bas-relief at $10,000, *Corpus Hypercubicus* at $4,150 and the *Christ of Gala* double lithograph at $5,950. Or they could have the entire suite for $5,995, a savings of $17,855.

"I said I especially liked *The Last Supper*, and he said he would sell me that for ten thousand," Crivelli recalled. "And I said, 'Do you mean you can't come down on that at all?' And he said, 'No.' He said, 'So, you can see it would be much more intelligent on your part to purchase the entire suite for fifty-five ninety-five, instead of paying ten thousand dollars for one item.'" The two postal inspectors may have once seen a large tube of toothpaste on sale for less than a smaller tube, or even bought a roundtrip airline ticket for less than it would cost for one way, but this deal was eerie.

Strausberg and Crivelli were shown *The Trojan Horse* sculpture and told that Dalí had created the mold and signed it. They departed the gallery knowing little had changed in the years since Leilani Petranek had begun her investment,

except that the marketing techniques had become so extreme as to defy logic.

Through subsequent visits, postal inspectors found that Center Art's representations also had become schizophrenic, possibly because of the disclosure requirements of the new state law. Lithographs would be referred to as Dalí's creations, yet salespeople would explain that Dalí would supervise the creation although not execute the work on the stones and that he would sign the prints after approving them. Contradictions even showed up in the gallery's literature. A certificate of authenticity for *Madonna of Port Lligat* described it as being hand-signed by Dalí and produced by Leon Amiel in 1983–84, and that the plates had been destroyed or effaced. Then, in compliance with the state law, it stated: "It is not known whether the artist approved the print, the master, the proofs or the techniques utilized in production of the print." Was Dalí forced to sign the print blindfolded?

Customers trickled in to Maxwell, whose investigation was kept confidential, and to Martin Steinberg, the attorney for the Pearl Harbor sailor who had the *Battle of Tetuan*. On March 12, 1987, Steinberg filed a class-action lawsuit against the gallery on behalf of seventeen named purchasers of Dalí works and all other Dalí buyers.

Maxwell contacted Peter Morse, the appraiser, to look at each of the prints or wall sculptures, and each time the results of the examination were the same: Reproductions with little value or outright forgeries.

By the time Steinberg's suit was filed, the Postal Inspection Service had stepped up its investigation. Strausberg was transferred from Honolulu to the mainland and was replaced at the beginning of 1987. Richard Portmann, a Washington State native, had opted for a Hawaii assignment after being branded "iceman" for his stints in northern states, the most recent being inspector in charge of the agency's activities in the northeastern United

States. Strausberg had left on his desk a stack of pending cases. Portmann was intrigued by the Center Art file, promptly grasping the potential size of the fraud.

In New York, Inspector Robert DeMuro had examined the prints seized from the Convertine case and determined that Center Art had sold the same Dalí prints, produced by Leon Amiel, poster-type photomechanical reproductions worth no more than twenty dollars.

DeMuro came to Hawaii and visited the Center Art outlets in February 1987. He reviewed his information with Portmann and provided him a copy of a search warrant that had been used in the Barclay case. Portmann and Assistant U.S. Attorney Les Osborne began preparing for a massive seizure of art and records kept at the gallery's four outlets, the business offices in Waikiki and the nearby warehouse. Portmann gave copies of the search warrant, patterned after the Barclay warrant, to coordinators named for each site. On April 14, 1987, Osborne and Peter Morse conducted a four-hour briefing for thirty postal inspectors, investigators from the city prosecutor's office and Honolulu police officers who would be conducting the raid.

The next morning, tax day, the huge team of federal and city officers—none from the state government—swooped down on Center Art galleries, more than sixteen months after Maxwell had begun his investigation. Yellow strips marked "Crime Scene–Do Not Cross" were stretched across the front doors of the outlets. Over a period of fourteen hours, the officers hauled out loads of artwork, advertising material, artists' contracts, vendor material, customer lists, price lists, computer records. The material filled the backs of five trucks and left the officers exhausted. If Mett and Wiseman were not surprised by the raid, and there is some question about that, they at least were infuriated.

Eva Yeung, Mett's secretary, complained in an affidavit that the officers were rude and bullying. One agent slammed

an employee's briefcase shut and declared it was now government property, she said. Another threatened to do a criminal check on an employee if he refused to complete a form. In one gallery, she said, an agent became frustrated going through the drawers of a file cabinet and finally blurted out, "Fuck it, take all of it." Entire cabinets were then hauled away.

"One agent explained that the search dealt with Dalí lithographs, but there was no effort to limit the search to Dalí-related material," Yeung asserted.

Bill Mett was indignant. "Had they asked me to cooperate voluntarily," he told a television reporter, "we would have done so, but we were presented with a search warrant that was less than the voluntary request."

Wiseman called the raid "unconscionable and, according to our attorney, illegal."

Wiseman did not name that attorney. Center Art quickly hired James Koshiba, a reserved but effective litigator who recently had turned the table on Prosecutor Charles Marsland's grand attempt to convict several alleged accomplices of his son's killer. Nine days after the raid, Koshiba filed court papers alleging the raid was, indeed, illegal by being overly broad. The search supposedly was intended to focus on Dalí artworks and documentation, but the warrant went far beyond that.

Koshiba remained Center Art's attorney for only a short time. The gallery thought the best lawyer available locally was Brook Hart, a native of New York City who began making a name as defender of the downtrodden upon his arrival in Hawaii straight out of Columbia University's law school in 1967. He was named Hawaii's first public defender three years later and was recognized by the National Legal Aid and Defenders Association as best in the country. His skill at winning acquittals was said by some to be the reason for his ouster from that job little more than a year later.

Upon departing the office, Hart talked of setting up a law firm to continue helping the poor. "Of necessity, we will have to do enough paying work to make a living," he remarked. By 1987, Hart had built a reputation not only as one of the best criminal lawyers in the islands but as one of the most expensive.

On June 4, 1987, Robert Miller, formerly of the state attorney general's Anti-Trust Division,then in private law practice, appeared by subpoena to testify before a grand jury meeting for the first day in the federal courthouse, an imposing stone structure with windows looking out upon Aloha Tower, the beacon of Honolulu Harbor. Appearing with Miller was state Deputy Attorney General Grant Tanimoto, protector of his office's secrets. What Miller told the grand jurors, or refused to tell them, with Tanimoto at his side, has not been revealed. It can be assumed that Miller claimed attorney-client privilege, and that Tanimoto defended the sanctity of the file, because information about Miller's investigation never came to light. For whatever reason, the U.S. attorney's office never broke through the state attorney general's silence.

Subpoenas had gone out to Center Art employees, past and present. Purchasers told about their investments that had gone sour. Peter Morse gave the panel a course in art, declaring the case to be "far and away the biggest fraud that has ever happened in the state of Hawaii" and "the biggest fraud in the whole history of art-dealing anywhere on Earth."

The art and documents seized in the April 15 raid were hauled to a vacant room in the federal office building next to the courthouse, a room that soon was dubbed "the war room." There, Postal Inspector Portmann scanned purchase records to mail out hundreds of questionnaires to Dalí investors, determining which would be best to call as victims in the trial. Only ten purchasers had filed criminal

complaints with Maxwell.

Brook Hart's attention was focused on getting the raid to be declared illegal. Such a ruling would have a devastating effect on the government's case.

The federal government was confident that the search was legal and proper. The same wording had been used in the search warrant in the Barclay case in New York and had been upheld. Postal inspectors signed affidavits attesting that all officers involved in the search were advised about precisely what was to be seized.

Hart contended the affidavits were not good enough, and that Barclay, unlike Center Art, was a boiler room, telemarketing operation that was alleged to be illegal in its entirety. The only aspect of Center Art's operation that was alleged by the government to be illegal was the Dalí marketing.

Assistant U.S. Attorney Les Osborne countered that Dalí records were intermingled with other material and, in practicality, could not be separated out under the time constraints of the raid. Evidence gathered during the investigation demonstrated a pattern of fraudulent representations by the gallery "that spans a decade, extends from the highest level of management of the company to the legions of individual salesmen, and involves all Center Art locations," he maintained in court papers. The fraud was "pervasive" and "permeates all the company's records. It would be unreasonable, given such a pervasive pattern, to believe that such behavior was limited to Dalí."

In January 1988, more than nine months after the raid, visiting U.S. District Judge Edward Rafeedie of Los Angeles ruled from the bench that the seizure of documents was illegal. The broadly worded search warrant allowed "a general, exploratory rummaging" of Center Art's records and "carte blanche to the officers to take away anything they saw," the judge said.

The government could keep the artwork, but all else had to be returned. Rafeedie's ruling was a serious blow to the postal inspector's case. For Thomas Maxwell, it was worse.

From the date of the raid, Maxwell later explained, he had focused his attention "primarily on corruption among public officials, in an effort to determine why this fraud had been permitted to continue virtually unimpeded for over a decade. During the course of the next year, in fact, numerous instances of gifts, payoffs and contributions by CAG to a myriad of elected and appointed public officials were documented from the seized corporate business records."

Rafeedie's ruling killed Maxwell's investigation. Not only did the records have to be returned to the gallery, Maxwell was forbidden to use any knowledge he had gained from them to pursue his investigation.

The effect of Rafeedie's ruling on Portmann's work was less severe, due partly to the *Sixty Minutes* segment on television about the Shelby case. Chuck Lewis, Mike Wallace's producer, had been trading information with this author for some weeks before the Center Art raid and telephoned me on the morning of April 15, 1987, to get an update. When I told him the raid was occurring, he asked if I would object to his calling the CBS affiliate in Honolulu so he could obtain videotaped coverage. I had no objection, since the newspaper would already be on the streets by the time the television news aired. As a result, the *Sixty Minutes* segment on Shelby closed with scenes of the Honolulu raid on Center Art, alerting the gallery's purchasers throughout the country. Other Dalí investors who may have missed the program read about the Center Art investigation through post-raid wire service reports and articles in newspapers and magazines. Portmann began receiving numerous calls from Center Art's customers, reducing his reliance on the names of those culled from the gallery's business records.

Because of DeMuro's extensive investigation in New York and the work of Portmann and Maxwell in Honolulu, the documents seized in the raid amounted to mere gravy. The investigation was very much alive after Rafeedie's ruling, and the grand jury kept on schedule. Months passed, as customers and experts appeared before the panel into late 1988.

The Dalí artwork remained in the war room. Although Center Art had its records back, it could not capitalize on the latest news of Dalí's deteriorating health. On November 27, 1988, suffering from pneumonia and possible heart failure, Dalí entered the Hospital Comarcal in Figueras, where he was reported in stable condition. The next day, a blood clot developed in the artist's lung, and he was taken by ambulance to the Quirón Clinic in Barcelona. His condition was said to be extremely critical. "I am all the time worried for my friend," Robert Descharnes told Spanish radio. "He is an aging man and the thing may happen at any time."

Dalí's condition seemed to improve slightly in early December, and King Juan Carlos paid him a visit at the clinic. By mid-December, Dalí was able to return to the Galatea Tower in Figueras. Little more than a week later, he suffered a setback and was returned to a Figueras hospital. After treatment of a small hemorrhage in his stomach, Dalí returned to his home. On January 19, 1989, he was taken to the hospital for the last time.

Dalí died on January 23 from what was diagnosed as "cardiac arrest brought on by his respiratory insufficiency and pneumonia."

Center Art issued a statement mourning's Dalí's passing and extolling his genius. "Dalí, the Siren, sang the song of truth as he understood it," read a passage at the end of the flowery statement. "Both the high-priest and the sacrifice at the ritual of his own cult, Dalí erected a cathedral of his works, from the pulpit where he proclaimed the Dalínian

Manifesto. His sermon of artistic purity will echo through the storied halls of human experience.

"Farewell Salvador Dalí. We never appreciated how rich we were to have you with us; however, the poverty of your absence will endure with us forever."

Three days later, the federal grand jury issued its own statement—a fat, ninety-three-count indictment of Center Art, Mett and Wiseman, charging mail, wire and securities fraud stemming from Dalí sales to thirty-six customers.

That afternoon, Brook Hart appeared with Mett at a news conference in the gallery at the Royal Hawaiian Shopping Center.

"The government waited too long, until, what, about two or three days since what might have been the most important witness in the case died, Mr. Dalí," Hart blustered. "It would have been nice if we could ask him to tell us what was what about his art."

In the glare of television lights, Mett read the following statement:

> Thank you for joining us at the Gallery today.
>
> During the past fifteen years in Hawaii, my staff of 150 people and I have proudly represented over one thousand fine artists—well known and respected both locally and internationally.
>
> We have actively participated in many community affairs. For example, since 1981, Center Art Galleries-Hawaii has donated over a quarter of a million dollars worth of fine art to the Hawaii Chapter of the American Red Cross for their fundraising efforts. Several years ago, we worked with the Office of Consumer Protection to formulate legislation

specifically designed to better inform and protect the art buying public.

Without warning in April 1987, the Post Office raided our premises, and seized our property without telling us what we were supposed to have done wrong. For almost two years since that time, we have had to live with veiled accusations and innuendoes implying wrongdoing without being given the opportunity to refute specific charges.

Finally, after twenty months, the Post Office has made its allegations, which we staunchly deny and will disprove in court. We believe this case is based on the Post Office's poorly informed and ill-advised attempt to define what art is, how it should be created, and how it should be sold.

Federal Judge Edward Rafeedie has *already* ruled that the Post Office's search and seizure was unlawful and unconstitutional. *The only illegal activity in this whole affair was committed by the Post Office itself.* [author's italics]

I look forward to your attending the trial where I am confident that the truth will prevail, and our justice system will vindicate us and the honest, hard-working people who have been associated with Center Art for so many years.

Sow's Ear or
Silk Purse?

"May it please the court, good morning, ladies and gentlemen," Les Osborne spoke in a loud, nasal tone from the center of the expansive, koa-lined courtroom on the morning of December 5, 1989. "As the evidence unfolds in this case, you will find out that this is an old-fashioned consumer fraud matter. It's a case about deceptions and misrepresentations, told to sell a worthless product. You will see that we are dealing here with the same kinds of sales techniques and misrepresentations that one finds in any kind of fraudulent retail business operation, whether it's selling used cars or posters.

"This is a classic example of trying to turn a sow's ear into a silk purse, of trying to sell cheap calendar reproductions as valuable works of art."

Keep it simple, Osborne told himself. There would be plenty of time to gradually fill the minds of these jurors with the fine points they would need to know to grasp the nature of the case. Judge Harold Fong had warned them that this would be an extended trial, one that would run into January and possibly through February, perhaps even beyond that. Fong already had advised them not to be intimidated by the complexity of the case.

"The students, the young, the old, the businessman, the supervisor, the blue-collar worker, the laborer," Judge Fong had intoned to the panel, "you have certain experiences to draw upon in your own background, and utilize your own common sense to arrive at a verdict in this case."

Nearly five hundred questionaires had been mailed to prospective jurors in the weeks preceding the trial, and all but fifty-seven had been eliminated from consideration because of hardship, conflicts, familiarity with potential witnesses or views they had formed from news coverage. Others were knocked off the day before trial, leaving sixteen people who hardly fit the range of employment and background described by the judge. The jurors, including four from islands other than Oahu, were almost to a person young and blue-collar. They were ethnically diverse—Filipino, Japanese, Chinese, native Hawaiian and Caucasian. They were a dime-store clerk, a travel agent, hotel and restaurant workers, electricians, a hospital worker, a telephone repairman, a hospital orderly, a van driver. There was not one year of college among them.

In white-collar cases, that is considered good for the defense. The more complex the issues, the less likely a group of uneducated people will be able to understand them. An expert in the area of jury selection sat with the defense lawyers to advise them on the plusses and minuses of each candidate.

The case had not gone smoothly for the government. In June 1989, Judge Fong had dismissed the eight counts of securities fraud, ruling that under federal law, unlike New York's law, art cannot be considered a security even when sold as an investment.

Three months later, a new grand jury convened by Osborne issued a new indictment, adding twenty counts to the eighty-four remaining from the original charges. Also, several counts alleged fraud in the sales of prints attributed

to celebrity artists Anthony Quinn and Red Skelton and included Tony Curtis prints in the alleged conspiracy. Those also were sold as good investments and as "original prints," defined in the indictment as those "drawn by the hand of the artist to whom the work is ascribed."

"Ladies and gentlemen, that's only one definition held by some people," the jury was advised by New York attorney John R. "Rusty" Wing, who was hired in late 1987 to enter the case as Mett's attorney. "Other people hold different definitions, and you'll hear evidence that some people think an original lithograph is when there is handwork done on the piece by somebody, by a chromist, not necessarily the artist. Other people think that it's an original lithograph if the artist himself personally authorizes: Go out and do this lithograph. And I'm sure you'll hear evidence that there are other definitions and other viewpoints."

Low-key and congenial, Wing's style was anything but flashy, but his reputation was sizable. For twelve years, Wing was an assistant U.S. attorney in Manhattan, the Southern District of New York, known as the nation's most high-powered criminal law office. In his seven years as head of its fraud unit, Wing supervised all sorts of prosecutions of white-collar crime. He left in 1978 to join the prestigious Fifth Avenue law firm of Weil, Gotshal & Manges. He represented potential defendants in New York's insider trading investigation, and now he was far away from his office to defend Bill Mett against accusations of fraud in the running of his art galleries.

"It was Bill Mett's family," Wing said. "In some respects, it was like running a big business like it was a candy store. He employed his friends. His dad and mother, who were living with him, worked at various things for the gallery. He became close friends with other people who went to work there. And because of things like that, it didn't get to be a high-powered General Motors or IBM, with tiers of middle

management and upper management. Instead, just a few people, you know, trying to do a little bit of everything. Because of that, some things fell through the cracks . . . mistakes maybe, but not some effort to defraud people."

Bill Mett and Marvin Wiseman "did the best they could to produce the best images they could," the jury was told by Brook Hart, the flamboyant Honolulu lawyer whose cowboy boots, jeans and large brass belt buckle belied his New York origins. If there was anything extraordinary about the sales of Dalí artwork, he suggested, it could stem from the fact that Dalí "was an extremely unusual person and artist. . . . Everything that Mr. Dalí was involved with, and much that relates to this case, is characterized by his bizarre, unusual, different view of the world."

Wing and Hart were formidable opposition for Assistant U.S. Attorney Osborne, and they were joined by Robert A. Weiner and Lawrence I. Fox, two of New York's top art litigators. Technically, Weiner and Fox represented the Center Art corporation. Since Mett owned all of it, their role was to add art expertise to the less specialized skills of Wing and Hart. This was a perfect team—a local, hot attorney with flare, a white-collar crime specialist of national standing, and a duo with deep knowledge of the nuances of art and the art market.

In cases of multiple defendants, it is wise for at least one of the defense attorneys to reserve his opening statement to the jury until the close of the prosecution's case. Weiner, the lead attorney for the corporation, would wait until Osborne had presented the government's evidence before explaining to the jury where the opposing counsel had gone wrong. By the end of the first day, however, Weiner demonstrated he would not be sitting on the sidelines waiting for that moment.

Dolores Bechtel, an elementary school administrator in New York City, was the government's first witness, and she

told about buying *The Last Supper* bas-relief and lithograph from Center Art in 1979 and 1982. Under cross-examination, she said she also owned two Rockwells that she regarded as "original" lithographs. Fox began asking her about the Rockwells, and Judge Fong upheld Osborne's objection; Rockwells were not part of the case.

At the end of the day, Weiner brought the matter up with the judge, explaining that questions such as those asked about the Rockwells were "particularly important to the defense of the gallery . . . because the term 'original litho-graph,' although there is one definition the government would use, there are many, many others used in the industry in connection with artworks" by Rockwell and others.

Fong agreed to extend leeway to the defense attorneys in their questioning of future witnesses. "I made a mistake on this one, I admit it," he said.

With that, the trial gained new parameters. The govern-ment's experts were subject to grilling not only about Dalí and the celebrity artists but about all other artists who may have wavered from the strict standard for originality defined in the indictment.

In the weeks that followed, art experts from across the country came to Honolulu to offer testimony about the quality of goods sold at Center Art and the methods used in their production, and to answer Weiner's questions about the diverse and uncontrolled practices in the art world.

As to quality, there was not much to be said for the gallery's prints, despite Suzanne Sixberry's "quality control."

Elizabeth Harris, curator of graphic arts at the Smithsonian Institution since 1967, said some of the prints were adequately executed and would gain acceptance into her $25 to $50 bin of reproductive prints, "good, decent quality, available for postcard reproductions." Others were not so good. The registration was sloppy, the ink was exces-sive, the colors murky.

Clinton Adams of the Tamarind Institute judged Wolfensberger's *Christ of St. John of the Cross* to have been printed from "very, very skillfully drawn plates by a very, very competent hand." In other prints, he noticed the same problems pointed out by Harris. Adams, Harris and other experts also agreed that most of the prints sold as lithographs were a combination of hand and photographic processes, reproducing Dalí paintings.

Jennifer Vorbach, former head of the print department at Christie's, agreed with that judgment, but she was less kind about their quality. She said the *Christ of St. John* printed on lambskin, which she doubted was lambskin, went through a high-speed press with "such speed and with such little attention to detail that it produced what I would call a sloppy mess." She could state unequivocally that Dalí had not drawn the images for the prints.

"It's the difference between a dentist who can drill your tooth very finely and with very little pain, and a dentist who goes at it with a very slow drill and inflicts great pain," Vorbach said after examining one of the prints in evidence. "Yes, they're both drilling your teeth, but Dalí was the master of the fine drill and whoever did this is a master of the sledge hammer."

Each of the prints she examined was given a value of zero, an assessment that troubled the judge.

"Suppose a person enjoys the color combination in this particular artwork," Fong said, pointing to the *Lincoln in Dalívision* that had been sold by Center Art for $22,000, "sees in it something that he finds aesthetically pleasing. Well, he wants to buy it, so he's got to pay some money for it doesn't he?"

"Well, some people get given things as gifts, so not necessarily," Vorbach replied.

"But it has to be acquired by an exchange of some value, doesn't it?" the judge persisted. "You don't get it free."

Vorbach grudgingly gave it a value of ten or fifteen dollars as a poster, but defended her zero appraisal.

"I believe that works authenticated as [being by] Salavador Dalí do have value," she explained. "He's a very good painter and paintings that he painted in the thirties and in the early forties that are on canvas and are known to be by his hand have tremendous value, and I would not dispute that. But when it comes to this piece, I would say that it really has the value of the piece of paper, and I would maintain that the [signed, blank sheet of] paper was actually more valuable before it had this put on it, frankly."

It is not a crime to overpraise the quality of merchandise for sale. Center Art's alleged misrepresentations had to do with Dalí's supposed participation in their creation and the claim that he signed the prints after inspecting them. As Robert Weiner questioned the government's experts, Center Art's position became clear, and quite interesting.

The defense did not challenge the assertion that customers were falsely told Dalí created or at least supervised the creation of the prints. They were not informed that presigned paper was used. But did that really matter? Were those misrepresentations of any monetary consequence, or were they merely sales puffery? If Dalí authorized the prints and the use of paper he had signed prior to the printing, the defense contended, the prints were authentic for every legal and artistic purpose. But did it make them original prints?

"This word *original* has become a bugaboo," Weiner told Judge Fong in a hearing between witnesses. Peter Morse had told the grand jury that Center Art's Dalí prints were fake because Dalí did not do the handiwork on the printing plates, depriving the prints of any value.

"That's not true," Weiner explained. "That's the way all of the Dalís were done. He didn't do original lithographs the way Mr. Morse would define the term. He did lithographs as other artists did, as Chagall did, as Rockwell did.

"My point is, your honor, it's not as if these people bought something that, had they wanted the real Dalí, they could have bought across the street. If you are buying Dalí, this is what you get," he said.

With each expert, Weiner tried to drive home the point that the art world allows deviations by artists from the stated standard for originality.

Take the Audubon bird prints, for example. John James Audubon did not execute them, yet they are sold by Sotheby's and Christie's at top prices, alongside those the auction houses can comfortably call original.

"They are given the generic name of Aububon," Vorbach responded with the jury back in the courtroom. "The authorship of the print is not ascribed to Audubon." She showed where a Christie's catalog described them as "aqua-tints and engravings with hand coloring, colored and printed by Robert Havell, Jr." Audubon's name does not appear in boldface, as do the names of artists who executed prints bearing their names. A second edition of the Audubon prints was created by J. Bean after the naturalist's death in 1851. Audubon made the drawings and supervised the Havell prints but, of course, did not even see the Bean recreations, which were "afters." And they were not done photomechan-ically, Vorbach averred.

"Is there a rule in the art world that says that an after can't be made photomechanically?" Weiner asked.

"Not that I'm aware of," Vorbach responded. "There are no rules in the art world. It's an unregulated business."

Vorbach acknowledged that the auction house also sold Sorlier's Chagalls, which were understood to be collabora-tive efforts, and they were described by Christie's as Sorlier "afters."

Nathaniel Currier and Merritt Ives did not create even the original works on which the nineteenth-century Currier

& Ives prints are based, yet those prints are sold at the auction houses.

Indeed, even as the trial was in progress, Sotheby's had sold a print from a twenty-five-image Dalí suite called *Aliyah*, produced in tribute to the Jewish migration to Israel. The prints were published by Shorewood Publishers in 1968 at the Wolfensberger atelier in Switzerland, just as Center Art's *Christ of St. John* had been done. Wolfensberger testified that the *Aliyah* prints were published on presigned paper, and that Dalí never set foot in his shop.

The *Aliyah* prints were marketed as "lithographs based on the artist's original gouaches," but there was no disclosure that they were printed on presigned paper. Was that not misrepresentation, and was it terribly different than the way Center Art marketed *Christ of St. John*?

Sotheby's had even put up for bid Dalí prints titled *Song of Songs*, published by Leon Amiel, the man the government had characterized as a chief creator of Dalí fakes. This was yet another example of a Dalí "after" bearing characteristics similar to those at issue in the trial. Why had these prints been accepted into the art world?

Bernard Ewell, the Colorado appraiser who had testified in the Shelby trial, could offer no explanation. The anomalies cited by Weiner fit into his Category Two of "decorative" prints created after Dalí images and to which he gave negligible values. Yet they had sold at auction. What was the difference between "decorative" art and "fine" art?

"It's not a clear distinction," Ewell said. "I will start out by saying that my personal professional bottom line is that in art, everything is valid except misrepresentation. In other words, you can produce art in any way you wish, using any medium, or media, you wish, with the involvement of as many people as you wish, as long as you tell the public that that's what has been done. And the importance of that is that the art market—and certainly the resale market—is

based on the public either confirming or negating prices which are asked for art."

Ewell seemed to be saying that anything goes, as long as the knowledgeable art world accepts it. Why had Center Art's Dalís been rejected, causing them to lose all value? The defense had an explanation, elicited from Dena Hall, the Los Angeles art appraiser who had helped Beverly Hills Detective Craig Frizzell in his early investigation.

Hall said the Dalí market had been destroyed by the proliferation of Dalí prints, either authorized or unauthorized. For example, the number of *Lincoln in Dalívisions* thrust on the market by Martin-Lawrence Galleries, Meade Publishers, European Art Projects, Gala Editions, had become enormous.

"At one point, there were at least six or seven claiming to be exclusive, and everybody else's was fake," Hall said. "The abuse in this marketplace has destroyed the market. Believe me, this is not a market I created. I don't get any pleasure out of telling individuals how worthless what they've acquired is."

The destruction of the Dalí marketplace had been helped along by the news media, Hall said. Publicity about the various state and federal actions against Dalí sellers "has caused increasing questions about the Dalí print market, and it caused the market to be diminished," she said. Without doubt, the Dalí market was impaired to the point of extinction.

"Suffice it to say," Hall said, "if there is this much confusion in the marketplace about the Salvador Dalí *Lincoln in Dalívison*, it would be like buying pancakes at the pancake house. They would all be about the same, and it wouldn't matter who the publisher is when everybody is going to be so confused."

What if the impairment could be removed? What if Center Art could prove its Dalí prints were authentic and all others were fakes?

"Then there would be value, is that not true?" asked Brook Hart.

"Hypothetically speaking, I would agree with you," Hall responded.

There was the defense. Center Art had taken pains to assure that their Dalís—of no material difference from those Shorewood and Amiel prints offered by Sotheby's—were authentic, but other publishers had destroyed the marketplace. Could Mett and Wiseman be blamed for that?

"I could have one hundred counterfeit hundred-dollar bills and one authentic hundred-dollar bill," Weiner explained. "The fact that there are one hundred counterfeit ones doesn't mean the real hundred-dollar bill isn't worth a hundred dollars."

"If you can't tell the difference, it does," Osborne responded.

In addition, the prosecution experts were convinced that Center Art's prints, or at least many of them, lacked the ultimate measure of authenticity—Dalí's signature. Dalí's affidavit of June 1, 1985, stated that he had signed no blank art paper after December 23, 1980. His unsworn statement of August 13, 1986, went on to state that he signed no "complete or whole editions of graphic works" during 1980. Experts easily could determine from watermarks on paper manufactured after 1979, or at least after 1980, that the Dalí signatures were forgeries. Many of the prints at issue in Center Art's trial lay on paper made after those years, even as late as 1984. Peter Morse, Bernard Ewell, Dena Hall, all experts, had used Dalí's affidavits to quickly determine that the prints were fakes.

Center Art's attorneys contended the circumstances that gave rise to the affidavits "raise more questions than they answer and they cast grave doubt on reliability of the Dalí statements." For one thing, Dalí allowed Dasa, the company created by Sabater, to enter into *The Christ of Gala* contract

with Bill Mett to produce lithographs, and those were published in 1981. In addition, SPADEM and Dalí granted Hamon rights to publish lithographs in 1980.

Dalí once had been quoted as saying, "The difference between a madman and me is that I am not mad," and, "I do not know when I start to pretend or when I tell the truth." Even if Dalí had signed the affidavits, could he be trusted to tell the truth, or was this another of his practical jokes? Was this Dalí's way of tweaking the publishers of his works, just as he had deliberately wet his bed as a youth?

It had been widely reported throughout the 1980s that Dalí had been controlled by those closely around him, to the extent that *El País*, the Spanish newspaper, had referred to him as "the prisoner of Pubol." Dalí's friend bandleader Xavier Cugat was quoted as saying, "If Dalí is not kidnapped yet, he is not far from it."

Judge Fong agreed with the defense attorneys there were too many problems with the affidavits. Allowing them into evidence would be "opening up a Pandora's box" of contentions about Dalí's mental health and allegations regarding his independence from his aides in his old age. Citing "terrible problems of unreliability and trustworthiness" and questioning "whether Salvador Dalí knew what he was doing in 1985," the judge rejected the affidavits as evidence. The government would have to find another way to prove Dalí did not sign the sheets of paper through the 1980s.

Although Osborne persistently tried to get Fong to change his ruling—to the judge's annoyance—he was not altogether surprised by it. He could rely on the Dalí crowd to prove the prints at issue were never seen or signed by the artist.

As he had in the Convertine case in New York, Albert Field went through the prints, one by one, and stated his

opinion as Dalí's archivist on the method of their creation, and that Dalí was not part of the process.

Dr. Juan García San Miguel, who had treated Dalí from May 1983 until his death, told the jury that his patient was "very weak" and suffered from trembling in his right hand, probably as early as a year before his treatment began. Shown signatures on the Center Art prints, San Miguel rejected them as unauthentic Dalí signings, although conceding he was no expert on the matter.

A. Reynolds Morse, qualified as an expert on Dalí's art, described each of the images at issue in the trial as a bad reproduction. He was prepared to defend himself against the accusations that had surfaced in the Shelby trial, and did so. Morse said he had been "conned" by Jean-Paul Delcourt into signing the contract allowing publication of three print editions based on the Dalí Museum's paintings, and added that he might have been "a little greedy" in wanting to help the museum's finances. Morse also acknowledged that the museum's gift shop sold photomechanical limited editions of Dalí images, but he said they were properly represented to customers as reproductive and were priced in the same category as posters.

But Osborne's most important witness to what Dalí did or did not do in the 1980s was the man closest to him, the Frenchman Robert Descharnes, who had been asked to take the artist under his wing after the years of commercial excess.

The Gatekeeper

Robert Descharnes arrived in Honolulu in late January 1990 with his own supportive press corps—a writer and photographer preparing an article on the Center Art trial for *Le Figaro* magazine. He also brought along a significant amount of extra baggage, documentaion of a series of actions he had taken during his nine years at the helm of the Dalí enterprise.

Conservative and even distinguished in appearance, Descharnes had presented a sharp contrast to the demeanor of Enrique Sabater and Captain Moore, and most friends of Dalí initially were pleased with his assumption of control.

As a young man, Descharnes had studied architecture. During the German occupation of France, his health deteriorated. He gave up his goal of becoming an architect and studied painting, writing and photography. In 1951, as a writer and photographer, he met the Dalís through an artist friend who also was publicity director for United States Lines, George McCure. Descharnes agreed to take photographs of Dalí for publicity for the ship line.

Descharnes began visiting Dalí frequently, finding him an avenue of income, about whom he could freelance articles for such publications as *Better Homes & Gardens* and *Paris-Match*. He would visit the artist several times a week

while Dalí was summering in Paris; he would drop in on him in Spain, and he would travel with him to the United States.

Upon Sabater's departure and the brief period during which Jean-Claude Dubarry arranged the many contracts with Hamon in 1982, Descharnes brought a sense of sanity to the Dalí world. He was the one who arranged for SPADEM to control the copyrights to Dalí images. Those who had been concerned about Dalí's treatment were relieved that the artist's rights would be protected by the organization—"the grand old lady," it was called. SPADEM's members included nineteen hundred artists, photographers and designers or their estates, including the estates of Matisse and Picasso. And it had a reputable American affiliate, the New York-based Visual Artists and Galleries Association Inc., or VAGA.

Michael Stout, for one, was very pleased. He met with Jean-Paul Oberthur, SPADEM's director, and, in February 1981, upon his return to New York, wrote Oberthur: "As Salvador Dalí's attorney, I am happy that he has decided to become a member of SPADEM."

Oberthur was quick to respond, but not to Stout. Instead, he enclosed a copy of Stout's letter in an envelope to VAGA attorney Martin Bressler and wrote: "We want to make it clear that Michael Stout is not Salvador Dalí's attorney; he is Sabater's attorney and has handled some matters for Dalí." In a telegram a week later, Oberthur cautioned Bressler to "be very prudent with Stout, who is more Sabater's attorney than Dalí's. All his present and past behavior shows that he is more preoccupied to protect Sabater's interests than Dalí's and you probably know how honest Sabater is."

In the letter to Bressler, Oberthur added that he might "investigate potential markets for Dalí in view of contracts for reproductions on cloth, particularly silk ties and

scarves." Immediately apparent from the letter was SPADEM's role as other than the protector of the artist's rights: distributor of those rights. Annual membership fees to the organization were small, but it received commissions of 23 to 28 percent on the sales of artists' rights to publishers.

On May 23, 1981, a letter was addressed to Stout on Hotel Meurice stationery and signed, in shaky handwriting, Dalí and Helene [Gala] Dalí. In its entirety, the letter said: "Please do nothing about SPADEM. Don't take care of SPADEM. We handle this matter directly."

Jeremy Berman, Stout's law associate, sent a copy of the letter to Bressler with an expression of puzzlement. "We are at a loss to understand the motivation of the letter and the circumstances surrounding its execution," Berman wrote. "For the time being, however, we must accept the letter at its face value."

Within a few months, Oberthur began reconsidering his harsh treatment of Stout, although he wrote Bressler that he believed Stout "will not collaborate with us concerning Dalí and thus [you should] mistrust him." Stout had begun sending SPADEM requests for authorization of publications, and those were potential sources of revenue.

Oberthur's initial feeling about Stout recurred in April 1982, when Berman wrote Bressler's law office about what he saw as a potential abuse of a Dalí image, *Corpus Hypercubicus*. Berman had learned that SPADEM had approached the Metropolitan Museum of Art about reproducing the painting, which hangs in the museum, as a black and white "reinterpretation" in *Softalk Magazine*, and the illustration did appear in the magazine's April issue. The museum had advised SPADEM that it owned the copyright to the painting, and it controlled the granting of permission for such reproduction, never charging a royalty. In Berman's

view, SPADEM was unjustly claiming rights belonging to the museum and then selling them.

Oberthur took the position that *Corpus Hypercubicus* was in the public domain, as it had claimed earlier that month in assessing the reproduction potential of Dalí's *Last Supper*, which hangs in the National Gallery of Art. In fact, Bill Mett had published *The Last Supper*, in October 1981, under a contract signed by Dalí and approved by SPADEM.

Stout became angry that the abuse SPADEM was supposed to be preventing seemed to be proliferating. Within a period of just a few days, he fielded calls from the Museum of Modern Art that it had been asked for permission to reproduce *The Persistence of Memory*, and the publisher indicated that SPADEM had given its consent; from the National Gallery of Art about reports that *The Last Supper* lithographs were being sold in Hawaii; from Pierre Marcand to say he was planning his own *Last Supper* as both a lithograph and a bas-relief sculpture; from Marcand again, reporting that he was to see Oberthur about producing an etching from a Dalí drawing, *Corpuscular Madonna*, belonging to a Birmingham, Alabama, museum; from Ted Robertson of California reporting on his meetings with Oberthur and Hamon and of "a peculiar copyright position which he claims SPADEM takes for the A. Reynolds Morse Collection—that SPADEM controls all rights for Europe."

Stout wired Oberthur in February 1982, begging him to stop the proliferation: "I was embarrassed by the distinguished director of the Guggenheim Museum in New York, who is an old friend of the Dalís, when I attended a meeting of the museum associates last week and learned of the developing attitudes of distress concerning the Dalí reproduction practices. I have been an associate of this museum for many years. There is much communication from the major American museums and collectors about these practices and talk of a coopertive movement to end these ram-

pant abuses which have offended and violated the rights of many. As you may know, my involvement with museum work and my good reputation long predates my meeting with the Dalís. However, I am sincerely interested in protecting them and restoring their fast deteriorating reputation. Some cooperative steps must be taken to avoid serious problems which, please understand, will not emanate from this office. Your New York affiliate, which is much talked about by museums and respected galleries, has not contacted us since April 1981. Therefore we prefer to hear directly from SPADEM."

Discontent also was escalating in Europe, where the Dalís were protected by the "troika" of Descharnes, Miguel Domenech and Antoni Pitxot, while SPADEM was dealing with publishers. *Le Journal du Dimanche*, France's Sunday paper, painted a picture of Descharnes and Domenech, acting in liaison with SPADEM, constructing a legal structure allowing them to "speak, decide, judge and sell in the name of Dalí." Descharnes filed a libel suit against the publication, but the suit was dismissed.

When SPADEM authorized a transaction between Joseph Foret and Carlos Galofre for reproduction rights to *The Divine Comedy*, Jean Estrade, director of the Paris publishing house Les Heures Claires filed suit against SPADEM, which pointed to a letter dated June 12, 1981, signed by Dalí and showing him to be "totally aware" of the deal. The three judges expressed surprise "because the agreement did not take place until the following November 21." *Le Journal du Dimanche* concluded that SPADEM took a blank sheet of paper signed by Dalí and fashioned a letter atop it authorizing the transaction.

In September 1984, Jordi Corachan, the editor of *Interviú*, a Spanish magazine, expressed his dismay that Descharnes had signed a SPADEM authorization only three months earlier for the French editor Jacques Jacut to print a

thousand lithographs. The agreement "has surprised the artistic world in Paris, where Dalí is known to have signed no lithographs since 1979," Coracha wrote. "Can it be possible that the lithographs were printed on blank pages signed by the artist?"

Again, Descharnes filed a libel suit, accusing Corachan and *Interviú* of gravely insulting him. A judge looked at the suit and threw it out, noting that Dalí and his crowd always invited controversy.

In June 1986, the growing problems catapulted Descharnes, Stout and Paris attorney Jacques Sinard to a retreat in the Laurentian Mountains of Ontario. After three and a half days, they emerged with what seemed an equitable way to control the Dalí situation. SPADEM would be thrown out, along with Domenech and Pitxot. To Stout, Descharnes seemed relieved to finally have a mechanism to regulate Dalí's business affairs. When A. Reynolds Morse was informed of the development, he called it "the first ray of Dalí sunshine in six years." The mechanism that Descharnes had constructed would be called Societe Demart Pro Arte B.V.

Under the new entity, Descharnes essentially would be given power of attorney to act in Dalí's place in executing rights to his "intellectual property." Descharnes would be authorized to prohibit or allow public displays and reproductions of Dalí's works. He would be empowered to authorize reproductions, just as SPADEM had. But Descharnes had other plans. He would not authorize publication of limited edition prints; he would publish them himself.

The printing began in 1988 at various print shops in Paris, including Mourlot. Craftsmen, working on zinc plates, reproduced by hand twenty of Dalí's most famous images, including *Lincoln in Dalívision, The Persistence of Memory* and *Metamorphosis of Narcissus*. In early 1989, Descharnes signed an agreement with Artco France Sarl to distribute

them throughout the world. For years, Artco owner Serge Goldenberg had sold Dalí prints at his Paris gallery, through Bowertone Contemporary Arts in London, at the Hotel Meurice in Paris and at the St. Regis Hotel in New York. The U.S. postal inspectors believed the source of Goldenberg's lithographs and etchings had been Gilbert Hamon.

Descharnes's idea was to inject into the marketplace "authentic" Dalí prints, i.e., those authorized by Dalí through Demart, and to accurately describe what they were: handmade lithographs bearing facsimile Dalí signatures, in editions of 1,250. If he reasoned that Demart's stamp of approval on these prints would drive other, higher-priced prints from the market, he was wrong, at least in the short term.

Within months, the Demart prints were being displayed alongside those bearing supposedly real Dalí signatures. At Carlos Galofre's gallery next to the Picasso Museum in Barcelona, a salesman named Edouardo explained that prices for the Demart prints were as low as $600, while others, bearing penciled "Dalí" signatures, ran as high as $5,000. "All is guaranteed, absolutely," he told this author.

Edouardo said the Demart lithographs were "original, by his (Dalí's) permission," although created by artisans after Dalí paintings. Galofre kept a slight distance away, and he declined to discuss the matter after being told the potential customer was a journalist—me—writing about this subject.

In San Francisco, the Demart prints sold for $700 to $1,100 at Rasjad Hopkins's Magna Gallery. Descharnes's price to Goldenberg ranged from $75 to $125 per print, so there was plenty of room for profit by both Artco and the gallery owners. Even at the low wholesale price, Demart would do just fine: $3.5 million, figuring an average price of $100 per print.

Despite Descharnes's entrance into the Dalí print market, federal prosecutor Les Osborne needed him. Descharnes was the best person to tell about Dalí's comings and goings through the 1980s. His testimony would allow the government to present a complete case, in combination with statements by others around the Dalí circle who already had testified.

The Center Art trial was Descharnes's American courtroom debut. Although he speaks good English, he insisted on the aid of an interpreter to assure accuracy. On February 1, 1990, Descharnes took the witness stand and began answering a wide variety of questions.

Supporting Dalí physician Dr. San Miguel's testimony, Descharnes said Dali from 1981 forward "was in a very bad health, and this condition deteriorated considerably at the time of the death of Gala in June 1982. What I saw was a declining Dalí feeding himself with greater and greater difficulties, losing weight to the extent that he had to have injections; serum had to be injected to him. And then he could not get up anymore, and he would be carried from his bed to an armchair in the living room in his residence. . . . There never was any improvement."

Ill as he was, Dalí was able to satisfy the wishes of King Juan Carlos, who visited the artist in August 1981 and asked that Dalí paint for his country. Dalí's infirmity also may have been surprising to those observing other new paintings emerge from the artist's studio, at a rate far greater than during any other period in his career. From July 1981 to March 1983, a total of ninety-two paintings were launched from the ailing artist's easel.

"Yes, that's what we counted," Descharnes said. But please understand that, with a few exceptions, Dalí received help from both Isidoro Bea, the artist's assistant since the early 1950s, and from Descharnes himself. And sometimes Dalí could hold a steady hand during that time.

"There were some paintings created by Dalí without any help from Bea," Descharnes said, although "it was not possible in those days to walk into Dalí's workshop and not see Bea working on a canvas."

Descharnes said, "There were some days when he would get up and it would seem like he would have a firm hand and it was a new beginning again, but usually it did not last very long. It is not so important for an artist to have a firm hand. It is important for the artist to have the hand of a genius."

Descharnes described the creation of *The Swallow's Tail*, reproduced in Descharnes's most recent book on Dalí as the artist's last canvas: "Bea drew it. He had a problem to come back on the next day, and Dalí was impatient, wanted to continue the canvas, and he asked me to finish the geometrical figure. And I did what he asked me, and it was more important for Dalí to be able to continue doing what he wanted with it."

The "Dalí" prints circulating throughout the world were another matter, Descharnes said. Those did not come from the master's studio: his participation in their production was nil. Like the art experts from the Smithsonian, Tamarind and elsewhere, Descharnes judged the prints to be largely photomechanical reproductions of Dalí paintings, with some handwork, but certainly not Dalí's sometimes steady handwork. *The Heralding of Angels* was even further removed: "Dalí never produced an image like this one. The original image is not by Dalí." Descharnes could be sure of that, because the picture appears to be of Port Lligat, but there were gross errors Dalí never would have made. He said he believed that and other fake drawings originated in Italy.

Unlike any of the witnesses before him, Descharnes claimed the ability to recognize Dalí's signature and spot fakes.

"I saw Dalí sign for publishers in Spain," he said. "I saw him sign while he was waiting to embark on the boat. I saw him sign in Paris. I saw him sign many times over a period of twenty years. I have seen Dalí signing several thousand times."

Descharnes learned that Dalí signed his name with a certain rhythm. Some forged Dalí signatures were easy to spot because the "í" in Dalí's name was dotted instead of being capped with an acute accent. "He draws the signature and then puts the accent, and he never forgets that he is Spanish." Two of the Center Art prints at issue had dotted Dalí signatures.

Not only could Descharnes spot fake signatures, he claimed the ability to identify where many of them originated. Shown *The Angel of Gala*, Descharnes proclaimed the Dalí signature to be that of Gilbert Hamon, "because I have seen many of these. I have seen already all those which are on pieces which were confiscated in France, and I have seen some in the court action in which Mr. Hamon is being sued." He said he could tell Hamon's signature because of its "bureaucratic regularity." The signature on *Discovery of America*, he said, was a product of Delcourt, which "is very different from Dalí's signature."

Descharnes even was able to add to the pile of evidence regarding Center Art's knowledge of the falsity of its prints. In early March 1987, Bill Mett had asked Descharnes to stop in Honolulu on his way home from Japan to authenticate some drawings and paintings, and he agreed.

"We had, at that time, very friendly relations," Descharnes said, "and we shared our worry about the proliferation of prints in the world market. I advised Mr. Mett that perhaps he should not continue selling lithographs—prints—of which he was not really sure. I had a rather blunt negative reaction [to Mett's Dalí prints] when I told him that 'You should rather burn them than continue selling them.'"

Descharnes's first day of testimony was everything Osborne could have wished. But Day Two would be the defense attorneys' attack, and they went at Descharnes like pit bulls, from Descharnes' first utterance of the day before.

"Before you testified," Weiner asked Descharnes, "you took an oath. Do you recall the oath?"

"Oui," Descharnes responded.

"And that oath was to tell the truth and the whole truth, is that correct? Did you tell us the whole truth about your current employment?"

During his entire first day of testimony, Descharnes had not mentioned Demart Pro Arte.

"It's a very long story," Descharnes told Weiner. He explained that Demart was created "to protect Dalí's intellectual rights."

"In fact," Weiner shot back, "Demart is a seller of Dalí lithographs, isn't it?"

"Demart published interpretations of Dalís."

"Interpretations, sir? Are they authentic Dalí lithographs?"

"They are authentic lithographs, interpreting Dalí's work," Descharnes answered, and he acknowledged signing certificates of authenticity accompanying the prints. He also said Dalí was aware of the printing and approved of it.

"Dali was, at that time, ill, but he was not incoherent, and he would receive many people," Descharnes said. "We had informed him of everything that Demart has done." As for the prints, "We asked him for his comments when he was able to give us his comments and, in some cases, we were very cautious, and we did everything to have his approval, because he did not always approve." Although some of the prints were produced after Dalí's death, he said, the artist had approved their production before dying.

Descharnes said he had heard about the prices charged for Demart prints at Magna Gallery, "but I was never

directly interested, because it does not concern Demart directly. Mr. Hopkins told us what he intended to charge, but we did not have to tell him yes or no, that we agree or disagree. We had no business in his market."

"We are telling, clearly, what this is," Descharnes testified. "And I must add, again, that we are producing an interpretation of Dalí's painting."

"Who is 'we?'" Weiner asked.

"The 'we' is the Demart company," Descharnes said. "We have had meetings and we have decided to do it that way."

"Well, what about your distributors? Do they do it that way?"

"I hope so," Descharnes answered. "If they don't do it, I would love to know about it."

In fact, Magna Gallery, throughout its flowery language in a flier, did not explicitly misrepresent the Demart prints, although some statements may confuse. For example, it said Demart "has the sole world rights to produce work by Salvador Dalí with the cooperation of the Dalí Museum in Figueras." Of the facsimile signature, it said: "Dalí has decided, as he is physically unable to sign his graphics, that these works are to be stamp-signed in front of certified witnesses, with a stamp officially registered by Dalí with a notary public. All future graphics by Dalí must bear this stamp. This new procedure will be announced publicly in the various media."

Nowhere in the flier does Magna Gallery reveal that the prints are reproductions—or, in Descharnes's word, interpretations—of existing Dalí paintings. These are not "works by Salvador Dalí" but rather reproductions of his work, done by craftsmen, also not mentioned in the flier.

Weiner pulled out a photocopy of a letter on Descharnes's stationery dated March 1988 and addressed to Mett. The letter congratulated Mett on opening a new

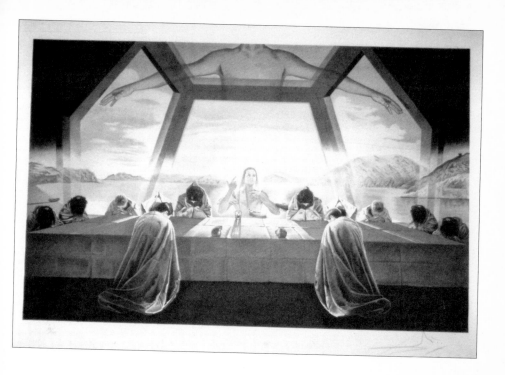

The Center Art print based on *Sacrament of the Last Supper*. The 1955 painting by Dalí hangs in the National Gallery of Art. Atelier Wolfensberger in Switzerland published this limited edition of 1,565 lithographs for Center Art in 1982. The gallery's price six years later was $7,950 each. Pierre Marcand's Magui Publishing also produced a print based on this image. (TRIAL EXHIBIT)

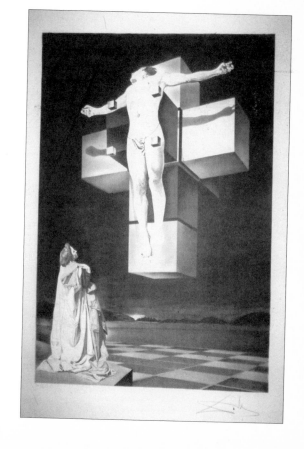

Leon Amiel's print based on *Corpus Hypercubicus*. The 1954 original Dalí painting is in the Metropolitian Museum of Art in New York. In 1984 Leon Amiel produced this limited edition of 1,200 prints, one of which was priced at $4,150 two years later in Hawaii. (TRIAL EXHIBIT)

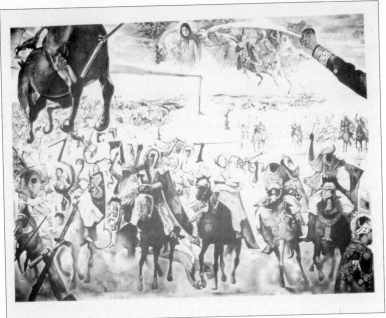

The Center Art print based on *The Battle of Tetuan*. William Mett bought the original Dalí painting in 1981 from a Japanese collector and a year later produced a limited edition of 1,565 prints, one of which was appraised in 1986 at $9,500. Mett auctioned off the painting at Sotheby's in 1987 for $2.42 million, $1 million of which went to help pay off the settlement of a fraud lawsuit brought by Japanese physician Shigenoba Kojima. (PHOTO EXHIBIT)

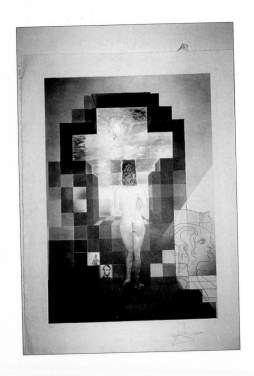

A *Lincoln in Dalívision* print. Dalí completed the painting in 1976 and sold it to California art dealer and publisher Martin Blinder of Martin-Lawrence Galleries. Dalí etched the line profile at lower right so prints produced in 1977 could be called "original." One of the prints was priced in Hawaii at $23,500 in 1986, although an expert said there were so many editions that *Lincolns* were as common as pancakes in a pancake house. (TRIAL EXHIBIT)

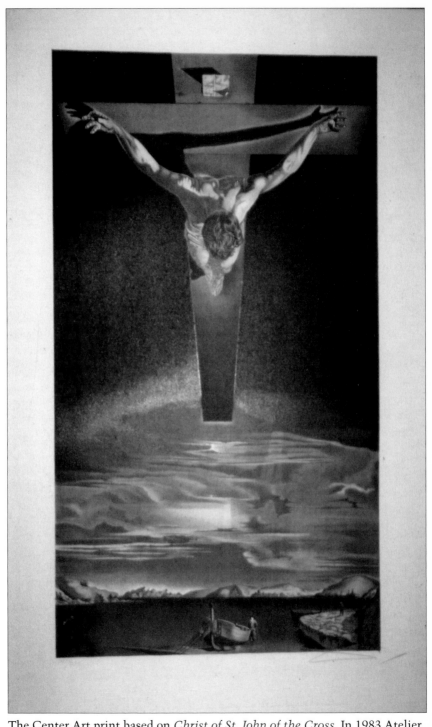

The Center Art print based on *Christ of St. John of the Cross*. In 1983 Atelier Wolfensberger produced a limited edition of 1,565 lithographs based on this 1951 Dalí painting that hangs in the Glasgow Museum. The print was priced at $6,500 at Center Art Galleries in Hawaii only two years later. (TRIAL EXHIBIT)

The Center Art print based on *Victorious Athlete*. The 1968 Dalí painting was "re-created" in at least three editions, one by Pierre Marcand (who titled it *Cosmic Athlete*), one by Ted Robertson, and, here, by William Mett, all in the early 1980s. A three-way copyright infringement suit was settled out of court. The print carried an average price tag of $2,300 in Hawaii. (TRIAL EXHIBIT)

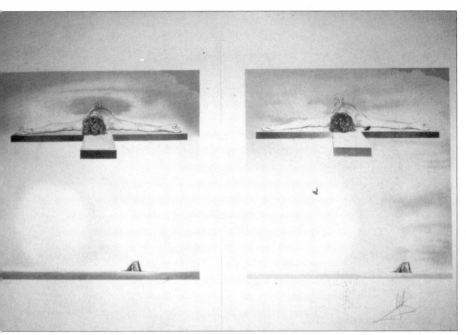

Christl of Gala print. A 1978 painting by Dalí, 1,190 prints of the image were pro-
ıced in 1981 and priced at $5,950 apiece in 1986. (TRIAL EXHIBIT)

ɛon Amiel's print based on *Journey to Bethlehem*. Dalí experts denounced this as a
:ake fake," a print based on an image Dalí did not create. The 999 prints in the lim-
ɛd edition were produced by Amiel in 1984, and sold in Hawaii for an average price
: $2,500. (TRIAL EXHIBIT)

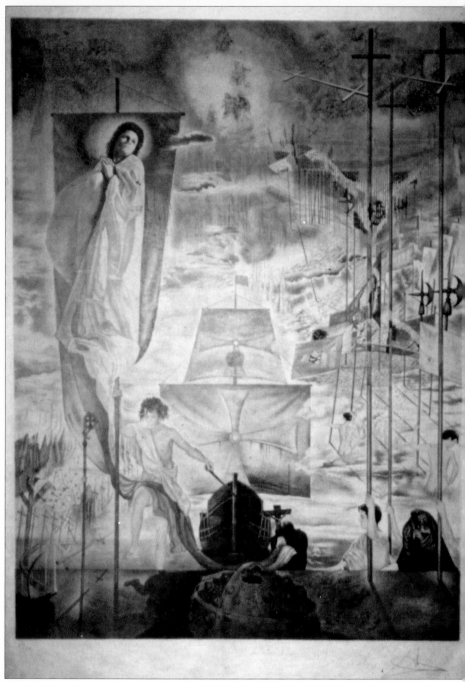

Delcourt's print based on *Discovery of America by Christopher Columbus*. The 1959 original Dalí print hangs in the Salvador Dalí Museum in St. Petersburg, Florida. In 1981, A. Reynolds Morse signed a contract permitting Frenchman Jean-Paul Delcourt to reproduce it in a limited edition, then tried to nullify the contract. Delcourt went ahead in 1982 and produced the prints, which were priced in 1986 at $3,750. (TRIAL EXHIBIT)

enter Art's *The Trojan Horse.* Center
rt paid French art publisher Jacques
avid $2,235 per sculpture in 1986 to
roduce as many as 1,980 in a "limited
lition." Only fifty were produced, and
ey went on sale for $9,950 each.
RIAL EXHIBIT)

he *Last Supper* bas relief. Dalí created
e wax mold in 1979 and presented it
Center Art, which then altered it so
565 "sculptures" could be stamped
t like hubcaps instead of being cast.
he average price at the Hawaii gallery
as $13,225. (TRIAL EXHIBIT)

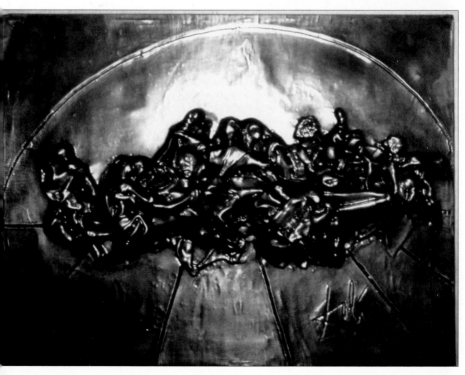

Christ of St. John of the Cross bas relief. Dalí created the wax mold for the sculpture in 1979 for Center Art, which then altered it so that 1,565 sculptures could be stamped out. They were patinaed in bronze, gold or platinum. Those in gold were priced at $15,000 in 1987. (TRIAL EXHIBIT)

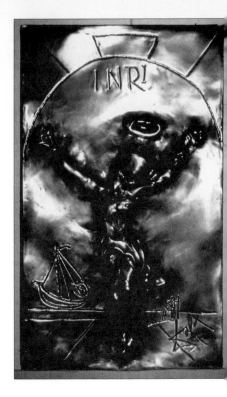

Ceiling of the Paris Opera. In 1985 New Jersey printer Leon Amiel produced 2,000 of these prints, bearing "facsimile" Marc Chagall signatures. Center Art sold them in Hawaii for prices ranging from $1,500 to $1,900, even after Chagall's widow, Valentine, branded them fakes. (TAKEN FROM PROMOTIONAL BROCHURE)

gallery on Maui and expressed pleasure that Mett had "made the decision to communicate directly with the legitimate company of Dalí, and to that company only, to study and plan together the possibility for Center Art Galleries to offer new editions of the master in the future." It was signed Robert Descharnes.

"It looks like my signature, but I have doubts," Descharnes said after being shown the letter.

"Is it Mr. Hamon's signature?" Weiner asked sarcastically.

"My signature is rather easy to forge," Descharnes responded, "and this is not the first time that it would have been forged. I don't remember having ever written this letter, and I'm only being shown a photocopy of a letter."

Making good use of their lunch hour, either the Center Art attorneys or the defendants hunted for the original letter, and they found it. Near the end of Descharnes's testimony, Brook Hart questioned Descharnes about his expertise in detecting forgeries of Dalí's signature. He then showed him again the photocopy of the letter bearing what Descharnes had suggested was a forgery of his own signature.

Descharnes pointed out that the photocopy did not have his address at the bottom of the page, as his stationery does.

"I think it's not my signature," he said.

Hart then revealed the original letter and the envelope in which it came.

"It's your signature on the paper in blue, isn't it?"

"Oui, oui," Descharnes said, then through the interpreter: "Yes, yes. I did not remember this correspondence, which is of a very general nature."

Did Descharnes still deny trying to open discussions with Mett about buying Demart prints?

"No. I recognize here," he said, growing flustered. "Maybe we are in the presence of a case which shows that

my memory failed me, that I recognize that I have written something, but of a very general nature . . . I have had so many dealings with Dalí that I may have forgotten something very general that pertained to a project with Mr. Mett."

As Hart proceeded to prepare the letter for entrance into the stack of evidence, Descharnes kept talking to his interpreter, who then turned to Judge Fong: "Your honor, I would like to perform my duty, to translate." The judge told him to go right ahead.

"Yes, I have changed my opinion," the interpreter said in translating Descharnes's statement, "but my suspicion was very justified, because I have been the victim already of such photocopies on which my address was absent. My signature has been forged on many occasions, even on certificates of authenticity, and since there was no address of this photocopy, I was perfectly justified in my suspicion. Now that you have shown me the original, and that I recognize that my memory failed me once, I do change my opinion."

The explanation did little to soften the sting. The defense had successfully left jurors with the impression that the Frenchman who had authoritatively identified the signature of Salvador Dalí and those of fakers turned out not to be able to recognize his own signature.

Still, Descharnes's testimony was valuable to the prosecution in areas where it coincided with that of other witnesses, especially Dalí's physician. Writer and art book publisher Gilles Neret could return to Paris and prepare a cover story for *Le Figaro Magazine*, portraying Descharnes as a key witness in what the magazine called "The Scandal of the Century."

Meanwhile, the trial went on, for the prints attributed to the dead artist were not the only ones at issue. Suddenly, the pews in the gallery of the courtroom filled up. It became Showtime in Honolulu.

CHAPTER 17

Break a Leg

Alongside the Dalí, Chagall, and Miró prints at Center Art Gallery were those signed with the names of famous Hollywood celebrities. British journalist Nick Rosen noticed in 1984 that the gallery was selling the paintings and reproductions of actors Anthony Quinn, Elke Sommer, and Woody Woodpecker animator Walter Lantz in much the same way as works of the masters. Salesman Nick Otis showed Rosen a Quinn "serigraph," titled *La Femme idéale*, "that sells for $995 in a run of one thousand. And you think to yourself, is one Quinn work really worth a million dollars?" Otis remarked.

Rosen wondered the same thing, and in October 1984 spotted the famous portrayer of Zorba the Greek at The Watergate Hotel in Washington, D.C., where Center Art was putting on a major exhibition of his work. Rosen saw Quinn in the lobby, introduced himself and asked, "Is one Quinn really worth a million dollars?"

Quinn broke into a grin and responded, "It's because I stuff them with gold and hang grab bags off them."

The actor then realized Rosen was serious and became defensive.

"You're asking stupid questions," Quinn said and began walking away. "No one's holding a revolver to anybody's

head so you buy them. That's how much I'm worth." He added: "I didn't set the prices."

Bill Mett had arranged for an elaborate buffet with full bar for Quinn's exhibition at the Watergate. He had sent out eight hundred invitations, two hundred of which were hand-delivered the previous evening to leading politicians and ambassadors. Those who showed up at the black-tie reception, however, were mostly Center Art clients and the staff of a nearby Italian restaurant where Quinn had eaten earlier that week.

The next day, Mett arranged a benefit exhibition, with all of the twenty-five-dollar-a-person ticket sales revenue going to UNICEF. Before leaving Washington, Mett and Quinn would be escorted into the Oval Office, where they would present President Ronald Reagan with two Quinn sculptures as a White House photographer recorded the event.

Reagan wrote the gallery a thank-you note, saying the Zorba sculptures would "make fine additions to our future presidential collection."

The exhibition and sale "was an extraordinary success from every perspective," the gallery gushed afterward in a flier reprinting a flattering *Washington Post* article. "Collectors and investors from all over the world flew in for the event, buying out the entire show. The exhibition was covered by all three major American and four foreign television networks. Newspaper and radio coverage . . . was excellent."

Much of the success can be attributed to Honolulu public relations executive Eileen Mortensen, a former White House aide in the Nixon administration who arranged the Oval Office meeting.

In May 1985, full-page advertisements appeared in *Architectural Digest, Connoisseur, Town & Country* and *Aloha* magazines announcing the availability of *Zorba*, "A

Presidential Collection," the phrase used in Reagan's thank-you note. The ads included photographs of the two sculptures, a Quinn self-portrait and the Oval Office presentation.

What occurred next was a rather awkward flap. Mett and Wiseman might not have known, but Mortensen certainly did, that the White House has a rigid policy against the use of its photos for commercial purposes. Mortensen, who was unaware of Center Art's advertising plans, was humiliated. Within two days of receiving a protest from the Reagan administration, Mortensen resigned her Center Art account.

"This is embarrassing for us," Wiseman said. "We wish we had known about this in advance. We were never told at any time that we couldn't use the photographs." Mortensen disagrees, saying White House officials told her the pictures "were to be used for news purposes only, not for commercial purposes. I passed along that information verbally to Center Art Galleries executives." However it happened and despite the ruffled feathers at the White House, the episode was another brilliant marketing stroke by Center Art.

Mett and Wiseman had learned years earlier they could use almost exactly the same strategy in selling celebrity art as they could the Dalí prints. When Walter Lantz arrived in Honolulu prior to the opening of his show at Center Art in 1978, the accompanying publicity blitz paid dividends. Assistant gallery manager Robert Summers told a newspaper gossip columnist the entire show sold out and the gallery received proceeds of $200,000. "And good news for anyone who paid up to $19,750 for a Lantz original," the columnist wrote. "Prices are expected to double within a year."

When vacationer Denise Wheeler of Van Nuys, California, dropped into the gallery seven years later, in 1985, salesman Bruce Young gave her the sales pitch for the clown faces painted by Red Skelton and reproduced as "original serigraphs."

"He just stated to us that if we were interested in buying this, it would be a very good investment," Wheeler recalled. "It would be better than stocks. It would be better than bonds. It would be for the education of our children—who weren't even at college age yet—and he recommended it very highly. Because Red Skelton was going to die soon and, you know, as soon as he died, this piece of paper was going to be worth a lot of money." She bought it. At this writing, 1992, Red Skelton is alive and well and performing all over the world.

Skelton says he began drawing at age five. His mother encouraged him by hanging his paintings in the living room. A year later, while his grandmother worked at her job as an elevator operator in a small town in Indiana, young Richard sat beside her and sketched her portrait. As he tells it, a man standing next to him asked, "Do you sell those, son?" The tot said yes, and the man gave him a dollar.

"That was my first painting," Skelton says. "And it took me out of the amateur class at the age of six, because I had been paid for something, and I have been painting ever since."

In the mid-1970s, Bill Mett noticed Skelton's art being sold by the Franklin Mint and wrote him a letter, expressing an interest in selling his clowns. Skelton says Mett offered to give him a two-week show. He claims that during the first week, the gallery would cloak his signature and not tell anybody what it was until after the paintings were bought.

"About a half hour after they opened the gallery, Mr. Mett came up to me and said, 'How does it feel to sell your first painting at the same price you got at the Franklin Mint?' I said, 'Yeah.'" He says the woman who bought the painting wanted to meet the artist. "So they brought her over to the Royal Hawaiian Hotel, she opened the door, and she said, 'I'll be a son of a bitch.' And from then on, they started handling my paintings."

Skelton and Center Art eventually entered into an arrangement in which the gallery would have exclusive rights to purchase his original paintings. Along with that, for $50,000, the gallery had rights to reproduce each painting as "original serigraphs." Skelton would make other reproductions—photographic copies printed on canvas and coated with varnish, giving the impression of brush strokes. Produced in the late 1980s in editions of five hundred, they had retail price tags of $5,000 at Center Art. Although sold at thirty-six galleries in the United States and twenty-one in Canada as photomechanical reproductions, the canvases look very much like original paintings, and one wonders how they are represented upon resale.

The business relationship was pleasing to Skelton, and the paintings were something he could work into his incredibly busy schedule: Skelton says he rises daily at 5:30 A.M. After showering and shaving, he writes a love letter to his wife, whether or not he is at home or on the road. Each day, he writes five musical compositions and an outline for a short story. On Sunday, while most of us are resting, Skelton takes what he deems the best of his short story outlines and writes the prose. He gives two-hour concerts seventy-five times a year and returns to his hotel, where he paints until 2:30 A.M., leaving him a full three hours sleep.

"That's my day," Skelton says, so one can imagine his irritation about being called all the way to Hawaii in September 1988 to appear before a federal grand jury questioning the way his art was being sold.

Shown a set of three "serigraphs" tagged collectively as *Freddie's World*, Skelton told the panel he could not recall them being produced as serigraphs, although they bore his signature. Center Art had them printed in 1984 at Accent Studios, a California printing house Skelton never visited.

After returning to his home in Bird Valley, California, Skelton says he was reminded by his wife that he had authorized the reproductions and approved the final proofs.

On February 6, 1990, Skelton was called to Hawaii again to testify at the federal courthouse. He arrived with a tiger's-tooth medallion hanging from his neck. Leaning on an elaborate wooden cane, he told jokes to a small gathering outside the courtroom as he awaited his turn, but he obviously was not happy to be there or to be part of the whole affair.

To a packed courtroom, Skelton dismissed his grand jury testimony as irrelevant. It did not matter where Center Art had his paintings reproduced. "Made no difference at all, if they did good work. As a matter of fact, I think, on these particular ones—now that I recall, when I first answered these questions before, I wasn't even told why I was here. I wasn't told what this was all about."

"I walked in and the grand jury was sitting there, eight people making origamis, and I thought it was a joke, so I was just sitting there," he said. "They asked these questions and I said, 'I'll feel it out and see what's going on.' So I couldn't answer the questions correctly. So I don't know why they are back on this same thing again."

Nor did it matter to Skelton that Center Art sold these reproductions as "original serigraphs."

"It's from my original work, and it's made from that," he said, "done by experts who know what it's all about. I don't know printing. I don't know chemistry. I don't know engraving. I tried it. I can't do it." Skelton said he knew of no artist in history who had done his own prints, except perhaps Toulouse-Lautrec: "He got angry and threw some acid on what they were doing, and the colors came through. And he said, 'That's what I want,' and he walked out."

When prosecutor Les Osborne honed in on the grand jury testimony, Skelton snapped that he recalled the questions and answers.

"I just explained a minute ago that they took me in and I didn't even know why I was there, little fellow. So don't try to put words into my mouth now."

"You couldn't recognize your own serigraphs, then?" Osborne asked.

"They weren't my serigraphs. They were Mr. Mett's serigraphs," Skelton answered.

Asked how much money Center Art had paid him through the years, Skelton said he could not say.

"More than a quarter of a million dollars?"

"Yes," Skelton said.

"More than half a million?"

"Oh, yes."

"More than a million?"

"I would say close to a million dollars."

Skelton testified for less than an hour. At the end, he was asked his age, and he answered, "I am seventy-seven. I would have been seventy-eight, but we spent a year on Maui." The jurors were charmed, and Skelton signed his autograph for one of them before leaving the courtroom.

Outside the building, he blasted the Postal Inspection Service, which he said "wants control of every business. They want the art world." Osborne "has a vendetta against Center Art Gallery. He's trying to close them down." Skelton said the prosecutor should "take shorter steps and let his feet catch up with his mouth."

"If you don't like a painting, you take it back to the gallery, and they'll return your money," Skelton told reporters. "Any gallery will do that."

Of course, that was not Center Art's policy. Only credit toward other merchandise would be granted. If a customer wanted to return his Skelton, he could exchange it for a Dalí or Chagall. More likely, the price range would force him into accepting a Tony Curtis "lithograph."

Curtis did not take his artistic prowess as seriously as did the comedically immodest Skelton, perhaps because he did not receive similar accolades. None of Curtis's ex-wives—actressses Janet Leigh and Christine Kaufmann and model Leslie Allen—encouraged him to paint. "To them it was just a nice way to keep Tony quiet and docile and out of trouble for the afternoon," he told *Penthouse* magazine. "I never felt encouraged by these women, let alone any of my friends."

Still, Curtis said, he enjoyed his art in unusual ways. "I would sleep with a woman, and while we were in bed fondling and caressing each other, I'd have a pad and pencil under the bed and while one hand was embracing, the other was doing sketches of what I thought our bodies looked like on paper. I would do these lightning sketches," he laughed. "I used to ejaculate prematurely; maybe that's why I did it."

In 1980, Curtis entered a period he describes as "coming out of the closet," which involved bringing his tablet out from under the bed. He enrolled at UCLA, and for eighteen months studied art under professor John Stussy.

In the mid-1980s, the husband of a woman who worked in public relations for Curtis visited Hawaii, saw the celebrity art on sale at Center Art and approached the gallery about possibly representing Curtis. An agreement was struck in the spring of 1987, an attractive one at that. Curtis moved to Hawaii and was promised six thousand dollars a month in living expenses. He would get 35 percent of proceeds from all his work or reproductions sold by Center Art and could cancel the contract if that totaled less than one hundred thousand dollars for any six-month period. Local art instructor Phil Samulski would provide him artistic guidance and Nalani Markell, a twenty-three-year-old recent art graduate of the University of Hawaii, would be his live-in studio assistant.

Within a short time, Markell began to wonder about the artist Curtis. When Curtis embarked on a Marilyn Monroe series of paintings, it was Samulski who made transparencies from a Marilyn book, projected the images onto a canvas and helped trace the bodies. For the face, a photocopy of Marilyn's profile was traced on cardboard and then cut with exacto and matting knives.

"I or Phil helped Tony hold the stencil in place while he filled the cuts with paint," Markell recalled.

When Mett asked Curtis to do a painting of the Royal Hawaiian Hotel, Samulski and Markell took photos of the "pink palace" 'from a boat off the Waikiki shoreline. According to Markell, Samulski projected the transparency onto a canvas and drew most of the buildings, with Markell's help. "Tony then painted in Phil's drawing, which was basically a trace-sketch of a transparency."

Asked later about Markell's version of how the painting was done, Curtis told the author: "That's partially the way it was done, but it's not exactly as it was laid out." He declined to elaborate.

If Markell was shocked by Curtis's paint-by-the-numbers artistic methods, she became horrified at another side of his persona. Markell was deeply religious and was proud of her virginity, subscribing to doctrines passed on to her by her father, a retired Marine Corps colonel, and her native Hawaiian mother. When Curtis was asked, upon moving to Hawaii, whether he planned to paint Hawaiian scenes, he said: "I'm not going to paint macadamia nuts, pineapples or palm trees. Only nude Hawaiian ladies. That's as Hawaiian as I want to get." He might have had his attractive studio assistant in mind as a model.

"Time and time again, Curtis would ask me to pose nude," Markell said. "I had the impression that he was implying that it was part of my job. He often referred to me

as 'sweet Leilani,' 'my Hawaiian maiden,' or 'macadamia nut.'

Markell said Curtis would pretend to engage in the "aloha spirit" by hugging people, as he did with her after she cleaned the kitchen one day. "He held me aggressively tight, and before I realized what was happening, he grinded his pelvis into mine, in a state of arousal, his hardness into my pelvis, while he panted and moaned in my ear. I broke free, embarrassed, in shock and felt incredibly ill. Curtis had hugged me so tight that he broke my earring off my right ear."

Finally, in March 1988, Markell received indications Curtis was unhappy with her, and she approached him in the living room, asking him if something was wrong.

"No, nothing is wrong," he said. "Who said that? Who's telling you this?" As Markell relates it, he stood up and came near to her, put his hands on her shoulders. She stiffened, turned her face and abruptly shrugged his hands off her.

Curtis immediately became angry, began lecturing her and suddenly demanded, "Leave! Get out! Get your things and go!"

Markell filed a complaint about her firing and alleged sexual harassment with the federal Equal Employment Opportunities Commission, but it was rejected, and then she filed a lawsuit against Curtis, who denied all her allegations. The suit was awaiting trial at this writing.

Three weeks after Markell's departure, a docile Tony Curtis appeared before a federal grand jury more interested in how his prints were made and sold than in his household romps. He was not sure about any of this, but he thought they were marketed as "lithographs." Had he expressed any reservations about that?

"I have," he said. "I've questioned why these lithographs are called lithographs when, in fact, they are—if they are—

photo reproductions, you know? I've decided that [my involvement in] the next group will be more extensive."

Curtis knew how lithographs were done traditionally, because Professor Stussy had demonstrated it at UCLA. Center Art's photomechanical reproductions of his paintings did not seem to Curtis like lithographs; he had expected prints produced from hand-drawing on stone or zinc plates.

"I asked if I could be involved in the next group," he said, "that I felt in a way that I wasn't contributing enough in the process, that I wasn't being allowed the privilege of following through from the beginning to the end, as I was with my other works. I somehow felt that if I could have some input in that area, perhaps while they were being printed, I could intensify some color, minimize some color."

Which is not to say that Curtis was displeased with his benefactor. Center Art was paying him good money and was footing the bill for the marketing. The gallery had gone out of its way to support his art career, and he had no complaints about that. "Absolutely not," he told the court.

Anthony Quinn was another happy artist in Center Art's stable. Osborne had planned to call him to the witness stand, but the seventy-four-year-old two-time Oscar winner had undergone heart surgery in January 1990 and was in no condition to travel to Hawaii. However, by late March, Quinn had recovered sufficiently to respond to questions by attorneys, and a videotaped deposition was arranged in Rusty Wing's Fifth Avenue law firm of Weil, Gotshal & Manges. The videotape would be introduced as part of the defense case.

Quinn had not been very supportive of Center Art in his grand jury testimony of October 1988, professing ignorance of how the gallery was selling his prints: "It sounds strange but, as an artist, I don't like to really know those things. I have an office down the hall. I have a huge studio. I mean, I

like to know that I'm making money at it, but I don't like to know the specifics."

With the camera rolling, Antonio Rodolfo Victor Emanuel Quinn did as much as he could to come to the gallery's rescue. Bill Mett deserved no less, for it was Mett who had recognized Quinn's enormous stature as an artist, as adept at applying paint to canvas as delivering lines on stage or screen. It was Mett who had described him in 1983 as "the art find of the decade." and Quinn made clear that he believed it.

"Before Mr. Bill Mett had come into my life," Quinn explained, "several other people had offered me a life with them. But I knew they just wanted to exploit me as an actor. I mean that's one thing I hate. I despise being an actor-painter, an actor who paints. A lot of actors paint, a great many, many, many, and some of them damn well. But I know that Tony Bennett is very disturbed by the fact that he is called a singer who paints on the side. And sometimes he sells. I know that Sinatra hates it, and he does some damn good paintings. He just doesn't want to be a painter that's doing it as a hobby. I mean he's a singer and he's an actor. You can be both things. So you don't have to be a hyphenated artist. We all hate that hyphenation. And Bill never treated me as a hyphenation and I was very grateful to him."

Of course, that is total nonsense. The staff memorandum in which Mett crowned Quinn the art find of the 1980s was prompted by the successful Broadway opening of *Zorba*. The smash hit "is extremely significant to Center Art Galleries, to you as art consultants and to your clients," the memo read. "As goes Mr. Quinn's skyrocketing popularity as a performing artist, so goes his reputation as a painter and sculptor." Mett announced that Quinn's art would "dramatically increase in price" six days hence. "Encourage your clients to act quickly to insure they may still acquire a work of art by a man the world is quickly discovering to be one of

the foremost talents of our time. The news is out: Quinn is great!"

The genesis for this supposed greatness began for Quinn, as it had with Skelton, as a child. At age six, Quinn said, he would accompany his father, a cameraman, to Hollywood sets and would sketch the actors, then paint watercolors of them, the likes of Douglas Fairbanks, Antonio Moreno and Rudolph Valentino. He sent them the paintings and suggested they could "send some money" if they liked them; the checks came. When Quinn was eleven, his father died and he went to work carrying water and rock for a man who sculpted headstones for a cemetery. "I guess the passion for sculpting came from him," he said.

Quinn studied architecture at Polytechnic High School in Los Angeles, while continuing to work at odd jobs. He then won a drawing contest that would change his life; the prize was a scholarship to study with Frank Lloyd Wright.

"If such a thing is possible—it has another connotation today—but two men fell in love with each other," Quinn recalled. "I fell in love with him and he fell in love with me, and I almost considered him a foster father."

It was Wright who detected young Quinn's speech problems and sent him for treatment. A doctor discovered an overgrown frenulum, a membrane under the tongue, and removed it. "And then we found out that I didn't know what to do with my loose tongue. It flopped all over inside my mouth." Wright sent him to Kathryn Hamil Drama School in Los Angeles, from which Anthony Quinn the actor would emerge.

"I went on into acting, but I didn't stop painting," Quinn said. "While doing a play I used to do portraits of my friends' children or the wives or so-and-so."

While performing in *A Streetcar Named Desire* in Chicago in 1948 and 1949, Quinn enrolled in the Art Institute of Chicago, where he completed more than 150 paint-

ings. When the play was moved to Milwaukee, a friend suggested that Quinn offer them for sale at a gallery. "To my amazement, we sold everything."

"And then somebody made this snide remark that I had only sold them because I was an actor," Quinn said, "and that if I weren't an actor, I wouldn't have sold one."

Quinn returned to Los Angeles and produced 150 more paintings. To disprove his detractor's assumption, Quinn signed them "Antonio Oaxaca," using his mother's maiden name. "I rented a gallery, and again I showed, and again I sold everything."

As Quinn became consumed by moviemaking, he continued to sketch, paint and sculpt, but did not exhibit his works. By 1980, Quinn was sixty-four years old, and the dinner with Mett was perfectly timed. When Mett asked Quinn whether he could produce paintings for the gallery, Quinn responded, "Sure, if I have a reason."

"I had a reason because the [moving] pictures were falling off at that time," he said. "After a while, actors at a certain age, after they stop getting the girl, they stop getting the big money. And I wasn't getting the girl anymore."

Soon, Quinn was in the big money, now in art.

"I must say that I was making a great deal of money with Bill, and I was making more money with him than I was in pictures." Quinn was promised a 50 percent return on all his art sold at the gallery, amounting to a yearly income of as much as $450,000. He believed the prices asked by Mett were "very courageous."

In 1983, Quinn and Mett agreed to begin reproducing his paintings as limited-edition "serigraphs." Quinn thought a limited edition would total 150 to 200 prints, but he took Mett's word when he explained that the edition would total 950, not counting various "proofs" that would bring the total to 1,000.

"The gallery and I in the first few years were functioning as a family, and I was very, very, very pleased by the association because it seemed that they were handling me with kid gloves, and were protecting me," Quinn said. "And since I had very little history as an artist, I mean the fact that I had sold one hundred fifty once in Chicago and one hundred fifty in Los Angeles, did not prove to me that I was an artist. I was very happy the way they were treating me, seeming to want to nurture me along. They knew what sold and what didn't."

Quinn never visited Larry Olson's Accent Studios, the Los Angeles shop where the prints were made, but he was sent proofs and made corrections, suggesting a shade browner here, redder there.

The process was nothing like what Quinn remembered as a youth. "It was very primitive in those days," he said. "We actually worked with silkscreens. We actually applied the paint on the silkscreen and then imprinted it on the canvas or paper, whatever it was, and then had to put them aside to dry, then applied a second coat, and that took another week or two to dry, and this took an awful long time. I would imagine that in the last forty years the technique has changed tremendously, and that the print can be applied electrically or in ways that I would not be aware of. I am aware of the fact that I feel in many cases the texture in the painting, so I'm aware that some [things] have been done to satisfy me that they [use] a screen process."

The prints were marketed as "original serigraphs" of Quinn, "closely supervised" by him, and as wise investments. *La Femme idéale*, which British journalist Rosen noticed had seen selling for $995 in 1984 was appraised at $1,750 by July 1985. But it could be bought along with *Zorba: A Self-Portrait*, at a combined price of $2,395. By 1988, *La Femme idéale* was worth $2,350 and *Zorba* a

whopping $3,900, according to Center Art's reappraisals. And what would happen if Quinn died?

The artist could not quarrel with the marketing technique.

"I think it would be silly to say you'd better buy these prints now because in two years they're going to be worth twenty-five percent less," he said. "So the fact that he says they are going to be worth more. . . . And I'm sure, and I will guarantee, that after my death, all of these things will be worth a hell of a lot more."

But what are "these things?" Are they original works of art? Would Quinn agree with Les Osborne's characterization of "celebrity art?"

"I would resent it deeply," Quinn said. "In the first place, Mr. Osborne, there is absolutely no definition of art. There is only one that I hold to, by a Professor Granville Hicks. And I followed Tolstoy, Socrates and all the boys looking for a definition of art, since I knew I was going to be devoting my life to art. And Granville Hicks says, 'Art is that without which man can exist, but without which there's no reason for existing.' That's the only definition of art that I find valid.

"And no one can say what is art. A man named Fontana slashes a piece of canvas with a razor blade. I resent it. But I have no right to say it's not art. I have known a lot of people do a lot of strange things in the name of art."

Something is art "once it's framed and up on the wall and not useful, not used as an ashtray," Quinn said. "An ashtray is not a piece of art. A pissoir is not a piece of art. So I don't know how one comes up with the definition of what is art and what is not. I've seen some children's paintings that have been the finest art I have ever seen."

The defense could not have hoped for a more eloquent leadoff witness for its case than Anthony Quinn, even on videotape. The jury had been told to expect a month of testi-

mony supporting Center Art's defense. The defendants and their attorneys had compiled an impressive list of sixty-one potential witnesses. They included current and former Center Art employees, mainland art dealers and publishers, a New York appraiser, a Boston forgery expert, Graphicstudio founder Donald Saff of the University of South Florida, Dalí art world figures Jean-Claude DuBarry and Jean-Paul Oberthur of SPADEM, New York dealers Phil Coffaro and Melton Magidson, and publishers Jean-Paul Delcourt, Robert LeShufy and Barry Levine. And they included Mett and Wiseman themselves.

Where's
the Beef?

The United States rests." After some ninety witnesses and nearly four months, prosecutor Les Osborne gladly made the announcement on the afternoon of March 14, 1990. University of Hawaii art instructor Fred Roster had testified earlier in the day that the Dalí bas-reliefs sold by Center Art had not been cast, as salesmen had said, but had been stamped out like hubcaps. The wax molds created by the master did not lend themselves to the process, and the gallery had altered them so they would.

Roster was the last of the experts to be called by the government. Most of the remaining people on the government's list of prospective witnesses were "investors," one of whom was ill in Florida, and had nothing to add to what already had been said. Osborne said the government would drop twenty-five counts of mail and wire fraud stemming from those sales "in the interest of justice and to avoid calling additional witnesses." Seventy-nine counts remained; quite enough.

A sigh of relief swept the jury box. The young men and women had begun to wonder just how long this would last, when they could return full-time to their jobs. At times, when Judge Harold Fong had allowed them to go home early

in the day or an extra day before Christmas, some jurors had cheered. Finally, the end was in sight.

The judge called a recess to confer with the defense attorneys about their schedule for the remainder of the trial. A few minutes into the recess, whisperings in a corner of the courtroom turned into expressions of amazement. The jury was reassembled. The defense, it was announced, would call no witnesses, except to play the videotape of Anthony Quinn's deposition.

"We think the government called all of them," Brook Hart told the judge. Jurors sat stunned, some leaning forward in their chairs with mouths agape, other sitting erect and somber. Hart said it had become increasingly clear to him and his colleagues that facts they intended to bring to light through defense witnesses had been elicited in cross-examination of the government's witnesses. "This isn't a decision we made overnight."

Fong asked Mett and Wiseman if they concurred. Mett said he did. "Excellent," Wiseman said of the strategy.

The defense faced a difficult choice. Calling a full slate of witnesses, even twenty or thirty from their list of sixty-one, might have annoyed an already weary jury. Calling only a few would require putting both Mett and Wiseman on the witness stand, forcing them to answer harsh questions by Osborne about why they had made statements that were now acknowledged to be untruths, such as Wiseman's spurious curatorship at the Boston Museum, and Mett's memorandum stating that Dalí did the work on the master plates for his lithographs. Any decision to call a few witnesses but not Mett and Wiseman would look strange and evasive. A decision to call no one might look overconfident.

After all, there was no need to call a defense witness. The former employees of Center Art had been called by the government, and they had to stretch their memories to recall precisely what Mett and Wiseman had told them

about the prints. The art experts agreed on little; the same print that was considered by one expert to be hand-drawn was photomechanical to another. When pressed about the rules of the art game, they often hemmed and hawed. Final summations would be a matter of organizing those hems and haws, orchestrating them into a melody of innocence.

On April 11, 1990, the defense adorned the courtroom with the Dalí, Quinn and Skelton prints, each embraced by a large, expensive frame suitable for the finest Van Gogh. The display illustrated how the government had lowered the boom on an art gallery that had engaged only in spreading these treasures into people's dens and living rooms.

Rusty Wing attacked the government for failing to prove wrongdoing. Where was the witness to the forging of Dalí's name? Where was the handwriting analyst to say with authority that the signatures were, in fact, forgeries? "Where's the beef?" he asked. The government's case was "mishmash," aimed at destroying a company that was run like a family. He reviewed the evidence but mainly deferred to Robert Weiner to address the issues at hand.

Weiner had been put in reserve during the other attorneys' opening statements at the trial's outset, and the late strategy had effectively preempted any substantive midtrial address. But he had dominated cross-examination of the government's witnesses and obviously knew much more about the subject than his colleagues. The defendants' last effort would revolve around Weiner's closing, which in turn would focus on two Dalí print editions that were not at issue in the trial.

Aliyah was a series of twenty-five images Dalí had executed as original watercolors in 1968 for Sam Shore's Shorewood Publishers. Shore had the limited editions printed by Wolfensberger in Switzerland, based on the paintings. Wolfensberger testified they had been printed on paper presigned "Dalí." In February 1990, while the trial was in

progress, *Aliyah* was sold at auction by Sotheby's. Nothing was said about the presigned paper, nor was it mentioned that Dalí did no work on the printing plates.

"Well, what is it?" Weiner asked the jury as he began his closing statement. "Is it an original print? Is it an after? Is there something wrong when somebody sells it as an original print and doesn't say anything about presigned paper?"

Song of Songs was published in 1971 by none other than Leon Amiel, the man characterized as a crook by the government. It had gone on Sotheby's auction block in 1988. How was it essentially different from the prints sold by Center Art?

There was no difference, Weiner contended, because supposedly rigid standards in the art world are broken every day. It is the way the art business operates. The imposition of any standards does nothing but inhibit an artist's creativity. Each artist must be allowed to operate in his own way, according to his own style and method.

"It is not the gallery that has determined the way in which the artist will operate; it is the artist," Weiner told the jury. "For whatever reasons, whether it was because Dalí was too lazy, too greedy, didn't care—whatever the reason— Dalí chose to use presigned paper in connection with his prints. If you wanted to sell Dalí prints, that's what you sold. Mr. Osborne suggests that somehow Center Art Gallery is selling something quite different than other galleries. They are selling what he would call fakes. But they're not. There is nothing better. What you see is what you get. That is the way Dalí did it; that's the way he intended it be done."

The government had hired experts to determine what Center Art had sold. And even they disagreed about what constitutes art. Former Christie's official Jennifer Vorbach talked about "fine art prints," while Colorado appraiser Bernard Ewell differentiated between "decorative" and "fine" art prints. The Smithsonian's Elizabeth Harris

declared there is no such thing as an "authentic" print. Clinton Adams of the Tamarind Institute held to his definition of originality and would not tolerate reproductive graphics.

Weiner blasted the government's experts for failing to conduct careful research. Not one had telephoned a publisher to ask how the prints had been made, and the experts disagreed in some cases about whether a print had been photomechanical or whether the underlying image used for the print was actually by Dalí.

"This is a criminal case," Weiner steamed. "This is the case where one would expect these experts to do research, to be careful, to make sure they're correct. Because people's livelihood, freedom, depend on the results of this case and yet, this is treated almost as a joke. It's an embarrassment to the art profession. People come here from out of town, get on the stand and give us an opinion. No one does research."

Weiner characterized them as snobs, thumbing their noses at Center Art's Dalís, Quinns, Skeltons and Curtises, at the presence of a secondary art market beyond the auction houses of New York and at any talk about art as investment. Shame on them, Weiner declared.

Andy Warhol engaged in practices deplored by the art snobs, using photomechanical means to produce his prints. "They're not numbered, many of them," Weiner said. "They're different." And yet Warhol's works "skyrocketed on his death. Skyrocketed! Went up considerably. Not only did his works go up, his prints, catalogue announcements— those little announcements that a gallery sends out—went up in value, [as did] record covers."

The government experts had debunked the Center Art appraisals, which were based on the gallery's own sales. Instead, they referred to auction catalogues, where *Lincoln in Dalívision* was the only print to be sold, and then only once, according to *Gordon's Print Catalogue*, which lists

sales of works by fewer than two hundred artists. But, Weiner asked, what about the *Print World Directory*, which records prices of prints by more than fifteen hundred artists at retail outlets? Do the prints listed in the *Print World Directory* but not in *Gordon's Print Catalogue* have no fair market value?

"How can that be?" Weiner asked. "It can't be, and the reason it can't be is because you [should] look at the retail market. You look at the market in which the item is most regularly sold." The government experts had consciously ignored prices at other galleries, he contended. "They didn't want to know. Deliberate ignorance! They wanted to know nothing that might in some way suggest that these objects have a fair market value different from their conclusion."

Ewell had testified that the value of the prints would be unaffected by whether Dalí had authorized them, if he had not actually participated in their creation. Los Angeles appraiser Dena Hall had said that by the mid-1980s there was an "impaired market" because of the number of knock-off editions.

Weiner said Center Art had done what other legitimate businessmen have done when imitations appear, whether it be Gucci handbags or Rolex watches. "They sued. They brought lawsuits in Europe and they brought lawsuits in the United States, and you heard that from Mr. Stout, their own lawyer, who said he was involved. And, in fact, they won some of those lawsuits. . . . A legitimate business sues to protect its marketplace position."

The culprit, he said, was adverse publicity, which created a lack of confidence in the market.

"How does that become Center Art's fault?" Weiner asked. "Sure, there was talk about some people creating knock-offs, and they [Center Art] took steps. They didn't ignore the problem. They sued. But how did they know the extent of the publicity? How did they know there was going

to be that kind of response, the lack of a catalogue raisonné, that would create an illiquid market, create the inability for people who had bought and for which there were good faith sales? How did they know what was going to happen in 1987, 1988? How do you hold Center Art responsible for things they couldn't foresee?"

The gallery's customers were given no guarantees, Weiner told the jurors, "but, really, that's what you are asking to find is that somehow Center Art guaranteed that nothing was going to happen to the market."

"Totally beyond Center Art's control," he said. "Center Art never knew there would be an impaired market. They never knew there would be investigations elsewhere. They never knew there would be a flood of publicity, and they never knew there would be the inability to determine good from bad [because of the absence of a Dalí catalogue raisonné]."

Weiner had presented a strong and compelling argument, and the jurors were attentive throughout the two-hour summation. As the trial had progressed, the panel had come to recognize Weiner as the only lawyer there with a good knowledge of art. If his knowledge resulted in abrasive exchanges with government experts, that made the trial all the more interesting. It was through such exchanges that these blue-collar jurors, perhaps, had gained an intellectual high, an insight into the art business and the heated differences of opinion among the assorted experts from around the world. The New York art litigator had reviewed those differences and asked the jury to find, at the very least, reasonable doubt that Center Art had deliberately broken any law.

The dynamics of the courtroom quickly changed. It was Brook Hart's turn, and he loaded a table in the courtroom with props to help him along—not Bavarian stones or zinc plates or hand presses. Instead, there was a toy cash register,

a purple shawl, a pair of dark glasses, a golf cap with lettering that spelled "Artpro," and an array of other toys and gadgets. Weiner's role had been to criticize the government's experts; Hart's would be to mock them, to make fun of them and to bring humor into the proceeding.

"I've chosen an hour just after the noon meal, so I know that it's difficult sometimes to stay awake, but I'm going to try to make it interesting for you," Hart told the jurors. Hart had used props and humor in previous trials with some success. As he took the stage in Fong's courtroom, his colleagues and the defendants beamed delightedly. Several jurors chuckled as he began. He wrapped the shawl around his shoulder and belittled Dena Hall, who had worn violet during her testimony. He donned the golf cap, along with a miner's lamp, to poke fun at Bernard Ewell, who acknowledged his Colorado license plates are personalized "ARTPRO" and who used a large magnifying glass strapped to his head in examining the prints. Hart put on the dark glasses and reminded the jury of Robert Descharnes. "Remember that?" he asked. "When a witness comes in here and you can't see his eyes, folks, you remember the day he was putting the dark glasses on in court? Well, whether that tells you whether he's lying or not, it's really just curious that the government would allow its featured witness to testify with those tinted glasses on just so you couldn't see his eyes."

After a few minutes, the smiles on the jurors' faces turned to expressions of indignation. By that time, it may have been too late for Hart to reconstruct his well-planned skit. "My wife warned me not to be the class clown," Hart told the panel. She was right.

Les Osborne's laryngitis had delayed the closing arguments for a week, and he still had not fully recovered. In a raspy voice, the prosecutor had methodically reviewed the evi-

dence with the jury prior to the defense arguments. Now, it was his turn to respond, and he did so in a rancorous tone. He began by recognizing the jurors' makeup, not as Hart had done in viewing them as uneducated service workers needing relief from the boredom of the trial, but as local people with their own ways of viewing things. Noting Wing's question, "Where's the beef?" Osborne wondered aloud whether he was referring to the television commercial or "the local term for 'What's the fight about?'" Answered Osborne: "The fight is about lies, the lies that not one single defense counsel dared to talk about, because they can't explain why their clients lied."

"It's a family operation, he says," Osborne remarked. "Well, you know, Mr. Wing can't have it both ways. He tells you Mr. Mett is such a busy man he doesn't know what's going on. Funny family if he doesn't know what's going on. He knew very well what was going on every day at every store. And it's a funny family when the head of the family lies to his own employees."

Thus ran the theme of Osborne's rebuttal: Mett and Wiseman had lied to their employees, the lies got passed on to unsuspecting customers, and the lies were the basis for life savings being "invested" in fake art.

Former salesman Cary Smith had testified about Wiseman telling new hires that an "original" print meant "the artist would create the image on the stone or on the plate; the artist would then adjust that image until he had exactly what he wanted, at which time he would pull the edition from the plates." Center Art's publications, he added, "were all considered to be original lithographs, because they had been produced under the supervision of the artist, and had all been signed by the artist."

Wiseman had told the salespeople they might encounter stories about presigned paper, according to Smith's testimony. Wiseman, Smith had told the jury, was "quite

adamant that Dalí had been victimized by some of his managers and some of his agents. . . . However, we were not to worry, because . . . all of the blank paper had been accounted for, and that never, at any time, under any circumstance, had Center Art Gallery ever printed anything on presigned paper."

Center Art's principals clearly had lied to their own staff and, when the opportunity arose, to the customers themselves, Osborne asserted.

Osborne looked to the framed prints that the defense had brought to the courtroom. "It's very funny about a fraud trial," he told the jurors. "People who practice fraud get so convinced by their own lies that they often try to continue them during the course of the trial. And you, the jury, as we sit in this room, now are the victims of that continuing fraud. Look around you, look at the clever display against the wall.

"*Christ of St. John* in its beautiful frame is still the same stamped-out tin image it is here," he said pointing to the bas-relief. "The frame doesn't make it any better, but here you are supposed to be convinced it's worth more. *Heralding of Angels* in the lower left side in its expensive gold frame is still a poster, a cheap, photomechanical reproduction." The same was true of the celebrity art on display.

The jurors knew better, Osborne continued. They knew about the watermarks on the paper, about Dalí's failing health, and they had heard the tape recordings of sales pitches. "We have a bushel of letters written by Mr. Mett in which he regurgitates the same lies, in which he tells people Dalí is enjoying working on this piece right now, in which he tells people Dalí signed the prints—not the blank paper, the prints."

There were the lies about "the Vatican and the holy sheep," and about investors' names being registered there and at the Glasgow Museum, Osborne charged.

The government was not defining art, he said. The definitions it was using for an "original print" came directly from the brochures passed out by the gallery itself. "You don't need to worry about what any expert said an original print is. You just worry about what they said an original print is," he said, pointing to Mett and Wiseman.

Robert Descharnes's venture into the print market was not the reason for this trial, Osborne said. "The reason for this case are the victims, who for four months took that stand and told you how they were defrauded and how they were lied to. That's why we are here today. Because Mett and Wiseman for thirteen years filled their pockets with the broken dreams of people who made their investments in their shoddy product. And no matter how you cut it, that's a crime, and the time has come for them to pay."

By the way, Osborne added, Descharnes did not wear dark glasses when testifying. His interpreter did.

The government rested its case. It was now in the hands of the jurors. After a long Easter weekend, they began deliberating on Tuesday, April 17. Judge Fong had instructed them to decide, first of all, if there had been a scheme to defraud Center Art's customers. If the answer was yes, the jury was to review the indictment—count by count, deciding whether the mailing or telephone call cited was made in furtherance of the fraud. The call or mailing need not be fraudulent itself, need not contain a lie, but if it was made to further the fraudulent scheme, that was a crime. The answer was no if they agreed there was no scheme to defraud. Then the jury's job was over.

The wait began.

The only communication was through notes passed from the jury to the judge, and his responses. On day one, the jury asked for a magnifying glass. On the third day, the jurors went home early because one of them had fainted. On the

fourth day, the jury asked for White-Out because of a mistake it had made on a verdict form; the voting had begun. On the fifth day, the panel asked the judge for clarification about the culpability of the Center Art corporation and requested testimony of the Glasgow museum curator; clearly, the jury had gotten beyond the question about whether a fraudulent scheme had been perpetrated.

Finally, after twelve days of deliberation, the jury passed a note to the judge that it had completed its work. Attorneys were called, the news media was alerted and the courtroom became packed. "We did our job," muttered Osborne's boss, U.S. Attorney Dan Bent, as he sat in the gallery. "I just hope they did their job."

The verdict forms were passed to Judge Fong. He reviewed them for several minutes, then announced that the verdicts were guilty on all but six counts that he then cited. Of the seventy-nine counts, Mett was guilty of seventy-three, Wiseman of sixty-three and the corporation of seventy-two. The guilty verdicts applied not only to the Dalí prints but to the celebrity art as well.

Assistant U.S. Attorney Robert Godbey, who had assisted Osborne throughout the trial, immediately asked that Mett and Wiseman be dispatched promptly to jail, rather than be allowed to present "a continuing danger to the community." Fong rejected the request, permitting Mett to remain free on a million-dollar signature bond and increasing Wiseman's bail to a half million.

Court adjourned, and Center Art's attorneys passed out to reporters a typed statement prepared in advance: "We are obviously extremely disappointed by today's verdict and will be filing an appeal. Our belief in our innocence and confidence in our judicial system gives us continued faith that in the end we will be fully vindicated. We are deeply thankful for the support and comfort provided us by our families and friends and are forever indebted to the many wonderful

people at Center Art Galleries and to the many fine artists whose works we represent for their unwavering belief in us. While the path to truth is not always direct or without setbacks, with your continued faith and support we will prevail."

Outside the courthouse, Maui hotel worker Gerald Hoopii and Big Island electrician Hugh Sapp, who had shared the duties of jury foreman, explained to reporters that the jurors agreed Mett and Wiseman had deceived customers. Mett was guilty of more counts because he was more cognizant of the deception.

What is an original print?

"There were many different opinions about it from a lot of the testimony," Sapp said. "Everyone had their own idea of what an original was, but we reached a decision due to Center Art Gallery's version of 'original.' That's what we based any misrepresentations on."

The jury also had discussed what an "original" should be, Sapp said. "There was agreement that the artist should be involved, at supervising or working on the stones or the plates."

Fair Trade

Customers at Center Art Gallery had been given assurance through the years that their artworks were authentic. A "corporate profile" handed to them boasted that "this absolute guarantee is backed by one of the world's largest and most prestigious insurance companies," an arrangement achieved by no other gallery on the planet. In addition, there was a typed statement signed by both William Mett and Marvin Wiseman: "Center Art Galleries–Hawaii, Inc., unconditionally guarantees, with no disclaimers or exceptions, the absolute authenticity of all works of art we sell, by all artists, in all media, or your money back."

In fact, according to prosecutor Les Osborne, the gallery had had an insurance policy for a one-year period, from 1983 to 1984, with a five-thousand-dollar deductible, until it was canceled by the insurance company. Nearly every print sold was less than five thousand dollars and thus was not covered by insurance, even during that one year. And Center Art never told the customers the name of the insurance company.

Naturally, the conviction sent a horde of owners of Dalí prints returning to the gallery for their refunds. They were premature; the issue would not be resolved until the case was exhausted, and a long appeal process had only begun.

Instead, like past disgruntled customers, they were offered merchandise exchanges. Among other things, they were offered Marc Chagall's *Ceiling of the Paris Opera* and numerous other "Chagalls."

Osborne had concluded long before that Center Art's operation was a scam from top to bottom. The original paintings were obscenely overpriced, and the graphics were no more than reproductions of paintings. However, the government had decided to confine its prosecution to the Dalís in an attempt to limit the huge expense of the case, and had added the celebrity artists as an afterthought, realizing the misrepresentations would be fairly easy to prove. Now, even with the conviction, Center Art continued to operate what Osborne saw as an ongoing fraud.

He sought expertise on the Chagalls, turning first to Los Angeles documents examiner Georgia Hanna. She came to the islands four months after the conviction and, with a postal inspector, posed as a customer at Center Art outlets in Waikiki and on Maui. She saw twenty-five Chagall graphics from what she was told had been the collection of New York collector Martin Riskin, and ten from what was claimed to be the "Mourlot" collection. A salesman showed her a computer printout listing 419 works attributed to Chagall that were in stock at the gallery and were valued at more than $1.3 million, mostly from the "Riskin Collection."

Examining the "Chagall" signatures, Hanna concluded it was impossible that the same hand had signed both the "Mourlot" and "Riskin" prints. "I was not in a position to determine with precision whether either of the two separate sets of signatures are genuine. Obviously, both cannot be genuine."

Contacted by authorities, Riskin, who had indeed sold a number of Chagall posters to Center Art, fired off a letter to

the gallery protesting the use of his name in promoting the sales.

Postal inspectors then reached Jean-Paul Gutton, director of Société des Auteurs dans les Arts Graphiques et Plastiques, a French organization similar in fuction to the now-defunct SPADEM. Chagall had joined ADAGP in 1954, and it had been assigned after the artist's death in March 1985 to continue to monitor and supervise the use of Chagall's images. Gutton had noticed the Center Art advertisement for *Ceiling of the Paris Opera* in June 1985, the same month it had aroused the suspicion of my brother (as described in chapter 11).

Gutton immediately brought the advertisement to the attention of Chagall's widow, Valentine Chagall, on June 27, 1985. On July 5, she responded by letter: "This publication has been made without my consent, and I ask that you occupy yourself with this problem." This explained her statement six days later to the Associated Press, in response to the *Honolulu Star-Bulletin*'s inquiry, that she had "already been contacted in this matter, and I have already protested."

Madame Chagall had added to the wire service that there had been a "poster" of the ceiling image but never a lithograph. Gutton explained to the postal inspectors five years later that French publisher André Sauret had used eight sketches for the ceiling to illustrate a book authored in 1965 by Jacques Lassaigne. The plates for those illustrations were destroyed afterward, and no other prints were made. Center Art's *Paris Opera*, Gutton charged, was an unauthorized reproduction lifted from one of the images done for the Lassaigne book.

In addition, Gutton challenged the authenticity of a separate "Chagall" work sold by Center Art as a sketch, measuring nine and a half by thirteen inches, from the Riskin collection, titled *Study for the Paris Opera House Ceiling:*

The Angel of Mozart. The sketch offered by the gallery was "exactly the image" contained in one of the Lassaigne book pictures. "It is interesting to note that *no* signature appears on the Lassaigne book image," Gutton added, "whereas a signature does appear on the CAG promotional piece."

At the sentencing on November 5, 1990, Osborne accused Center Art of operating a grand fraud far beyond the Dalí and celebrity images at issue in the trial, and he accused the gallery of trading fake for fake.

"The sale of photomechanical reproductions and alleged original prints attributed to Marc Chagall, purportedly bearing his signature, goes on unabated at Center today," Osborne said in court papers. "The *Opera Ceiling* piece is a total fraud, and the Chagall estate and those knowledgeable with Chagall's work have labeled it as such."

Forcing a past Dalí purchaser to accept Center Art's merchandise credit "would be to compel a person to submit himself to having his pockets picked," Osborne charged. "A merchandise credit from Center Art is nothing more than a fraud. Condoning a merchandise credit as a way to satisfy the victim's loss would be sanctioning fraud."

Nowhere in Osborne's memorandum did he state how the art gallery was characterizing its Chagall merchandise. If Osborne equated fraud with lying, there were no lies associated with the Chagalls, at least since the conviction. A woman who asked for documentation on the *Paris Opera* print long before the trial, but well into the government's investigation, was shown a paper attesting that it was an original Chagall print, but that the gallery did not know whether he had created or even authorized it. A European visitor who went into Center Art's Waikiki branch late during the trial came away amazed at how little the salesman said about any of the Chagalls. Was that really Chagall's signature? He did not know, nor could the gallery say. Did he participate in its creation? The answer was either no or "We don't know."

Some uncertainty was justified in assessing prints attributed to Chagall. Clinton Adams of the Tamarind Institute notes that in April 1953 Gustave van Groschwitz, curator of prints at the Cincinnati Art Museum, queried New York art dealer Curt Valentin about whether Chagall or the widely known painter and printmaker Albert Carman, who worked with Chagall, had drawn the plates for *The Tales From the Arabian Nights*, which were to be displayed at the museum's biennial exhibition of color lithographs. Van Groschwitz had decided he would not include in the exhibit any print for which the artist had not drawn all the images on the plates. Valentin forward the inquiry to Chagall, and the artist's answer, in French, was less than satisfactory to van Groschwitz.

"Chagall begs the question," van Groschwitz commented to Adams. "I believe Chagall drew the black-and-white areas, and Carman probably drew the color plates for the maquettes (gouaches) which still exist." The *Arabian Nights* prints were not included in the exhibition.

"The consensus is pretty much that Carman, the printer, did those drawings for the *Arabian Nights*," Adams told the author. "It can't be proved because Chagall never clearly stated it one way or the other, and Carman, unfortunately, died right away, so nobody could get any statement from him."

Adams was unaware of queries made to the Mourlot print shop in Paris by Theodore J. H. Gusten, executive director of the Print Council of America, the group of dealers, publishers and museum curators that had adopted the strict standard in 1961 that "the artist alone" had to have created the entire image on master plates for a print to be deemed "original." Questions about lithographs described by Mourlot as Chagall "originals" caused Gusten to write to Fernand Mourlot in December 1961. Were these, in fact, original Chagall lithographs? What work was done by

Chagall and what was done by those whom Mourlot's cata-
logue had described as "collaborators"?

Mourlot responded in February 1962 that the lithographs
contained in the catalogue were, indeed, original prints. "All
Chagall's lithographs in black are made by his own hand,
with no retouching whatsoever by anybody else," he wrote.
The color lithographs were another story. For those, Mourlot
explained, Chagall "makes a watercolor or gouache sketch
on a trial print." He went on:

> Thereupon a designer from the studio exe-
> cutes tracings of the colored outlines. These
> tracings, called dummy outlines, are put on
> zinc, thus becoming dummy transfers. Chagall
> does his coloring on zinc, generally as washed
> drawings.
>
> Since Chagall's colored lithos are often
> printed on large-size outdated presses, it is
> very difficult to make retouches on these
> machines. A "chromer," stretched out on the
> press, implements Chagall's comments, which
> are usually confined to acid burning, which is
> done before the artist's eyes.
>
> Marc Chagall, who spends entire days
> at the shop, keeps careful watch over his
> work. . . .
>
> I myself have been a very skillful litho
> designer (please excuse my lack of modesty)
> and I have trained some of the best-known
> "chromers." It would be a pity if an artist like
> Chagall did not avail himself of the atmo-
> sphere of the studio and of the spirit that
> enlivens it, and of the help and understanding
> offered to the artist so that he may create his
> widely appreciated work.

Joshua B. Cahn, a New York lawyer and a director of the Print Council, was less than satisfied with Mourlot's answer. He wrote Gusten that the Paris publisher "has stated facts from which we must draw the conclusion that the said color lithographs are not original lithographs as that term is used by the Print Council." Clearly, the colored areas of the prints were executed on zinc by technicians who used tracings they had made from Chagall's sketches.

The exchange illustrates the disagreement within the art world about originality in printmaking, and Weiner indicated he was prepared to challenge any government assertions that Chagall was a purist.

Not that Center Art had, in recent days, described its Chagalls as "original prints." After the conviction, according to defense attorney Rusty Wing, Mett and Wiseman circulated a memorandum to their staff ordering them not to use the word *original* in describing any work by any artist. They no longer could say anything about any artist's participation in a graphic or multiple of any kind, except that the artist did the original painting. And there would be no more talk about investment. They were to sell art solely for its beauty.

At any rate, Judge Fong would hear none of it. This had been primarily a Dalí case, and it would remain that way. To consider allegations regarding the Chagalls at this late date would be to embark on an entirely new trial.

A central question at sentencing was just how big a fraud this had been. Fong had been a hard prosecutor who recommended tough sentences when he was an assistant U.S. attorney during the early 1970s, after he was appointed head of that office by President Richard Nixon in 1973 and until his departure to private practice in 1978. He expressed his intention to adhere to that stance after being appointed federal judge at age forty-four by President Reagan in 1982.

Three years later, he presided over a trial that led to the conviction of an investment counselor named Ronald

Rewald for ninety-four counts of mail and wire fraud, tax evasion and perjury. Rewald had taken in more than $22 million in a classic Ponzi scheme that bilked numerous people out of their life savings over a five-year period. Fong had revealed his version of "the book" by sentencing Rewald to eighty years in prison. Before the Center Art trial began, Fong had made several references comparing it in size, complexity and public attention to Rewald, although Hart maintained there were "considerably different personalities" involved.

As for size, Osborne maintained it was many times that of Rewald. At the time of Center Art's indictment, Osborne presented a calculation, multiplying the average sales price for each of the prints or sculptures at issue in the trial by the size of the edition and arriving at a grand total of $113,873,049. And those were only the Dalís cited in the trial, representing "only a segment of the profit realized by Center's fraudulent Dalí print mill," he said. Fong had reacted in anger, calling the figure an absurd guess and demanding a better estimate.

However, two calculating methods result in an estimate not far from what Osborne concluded. Peter Wolff, a Center Art attorney defending the class-action suit, suggested the proposed "class" could total close to twenty thousand customers. An average loss of $5,000 may be considered modest—Martin Steinberg, the plaintiffs' attorney in the case, said his clients lost an average of $10,000—so the total would be $100 million for all Dalí prints and wall sculptures sold. Under the other scenario, Bill Mett revealed during the mid-1980s that the gallery's income for the previous year had been $20 million. Postal inspectors who conducted the 1987 raid estimated that half of the inventory was Dalí. Figuring a yearly average of $10 million in Dalí sales, Center Art could have received $100 million in a decade, three years

less than the period covering the scheme alleged in the indictment.

After the conviction, probation officer Ellie Hayase studied the questionnaires completed by Center Art purchasers of the images at issue in the trial, which had been returned to the postal inspectors. Hayase's total was $5.4 million spent by those completing the questionnaires. If Center Art had sold all the prints and sculptures it had like those in the trial, the total would have been $41 million to $48.5 million. All she really knew was that the fraud was immense.

"I thought the phone calls from victims would never stop," Hayase said. "I couldn't believe how many there were."

Fong rejected the "projection" used by Osborne to arrive at the high totals. "I have to make my decision based on known and provable figures," the judge said. "This is a big case. It is at least a $5 million case; it could be as much as a $40 million case if the government had its opportunity to at least pose its theory." For purposes of sentencing, the judge would peg it at $5.4 million.

That was fairly important. Since the Rewald sentencing, federal sentencing guidelines had been instituted, and they were kind to white-collar criminals. Still, the difference between a $40 million fraud and a $5 million fraud can amount to several years in prison.

A judge is free to depart from the guidelines based on information he receives. That part of the otherwise public process is conducted in secret. Letters are sent to the judge in confidence, and attorneys, although allowed access, are restrained from citing them specifically in either court filings or oral arguments. Fong said he received many letters on behalf of the defendants, including one from Rahjad Hopkins of the Magna Gallery in San Francisco. Fong said Hopkins had been one of Center Art's strong supporters and

had suggested that the way Mett and Wiseman sold art was "the way they [Magna] market it."

That remains true at most art dealerships, Wing told the judge. Artists create paintings and then decide to have lithographs made. "They look at the proofs, they make the corrections, they approve it, they sign it, judge. And I think the evidence is crystal clear that's the way it's done commercially in a vast majority of galleries and commercial art establishments across this country, and that's the way the bulk of artists who produce graphics do it."

If so, then it is a sad day for the art world, Osborne suggested, judging from the opinions of art experts who visited the gallery. "They all said the same thing: What's legitimately in that gallery is obscenely overpriced, and there are many, many other bogus objects there," the prosecutor said. "This case isn't about art; there isn't much art at Center. This case is about lies."

The jury had settled the dispute about art. It was for the judge to determine if Mett and Wiseman, now convicted felons, were bad people. And the defense attorneys embarked on testimonial speeches suitable for *This is Your Life*.

Aside from the present difficulty, Mett "has truly lived a remarkable life in many ways," Wing said of his client. He called Mett "a decent human being concerned with other people," from the time he was a child "peddling vegetables around in a wagon and giving leftovers to elderly folks who couldn't afford them," to helping people in school, his parents and grandparents and, finally, his Center Art "family." His mother, at eighty-three, relied upon Mett in coping with several disabilities.

Wiseman, too, was salt of the earth, devoting himself unceasingly to the welfare of his sister and her son, who would have to withdraw from private school if Uncle Marvin were to be sent down the river. In addition, said

Brook Hart, Wiseman suffered from a back problem, and doctors were recommending surgery, plus "other medical conditions that are truly in need of the kind of regular, ongoing supervision" not available in prisons.

Wing and Hart asked that their clients be allowed to remain free so they could continue making money from art sales and pay the restitution ordered by the court.

Osborne nearly gagged at contemplating such a scenario. "If Center Art were to close because of the sentence this court awards," he said, "that would be a benefit to this community, not a harm. . . ." As for any charitable acts Mett or Wiseman might have performed, he added: "For every single person who Mett or Wiseman may have helped for whatever reason, I will spend hours on the phone tomorrow and the next day and probably for weeks explaining to broken-hearted people whose dreams have been destroyed by these men why they cannot get restitution."

In four months of trial, Wing retorted, there was not "an iota of proof, a scintilla of proof, that lives were destroyed here." Most people lost "somewhere around eight or nine thousand dollars," Hart added. "Now, for some people, that may be a very significant amount on which entire lives can come down. But, given the socioeconomic and life situation of most of these complainants, the likelihood is it was a painful and embarrassing experience but not life-threatening, and certainly not causing the damage which Mr. Osborne claims occurred but for which, in this record, there is no proof."

In fact, Judge Fong had precluded such testimony as potentially inflammatory. In its absence, Fong now agreed with the defense attorneys.

"I don't think anybody's lives are shattered," the judge said. "It didn't reach that point there. I think that's a little bit of emoting and overreaction, but they're out some money."

Fong delivered a rather curious eulogy, praising Mett and Wisemen as brilliant businessmen and unleashing his only harsh word on a victim "who showed his greed," along with that of his wife, by rejecting a refund from Center Art because it did not include interest or the promised profit. "That's an indication of the kind of situation where greed on their part resulted in a nonsettlement of the case."

"I look at this case with a certain bit of sadness," Fong said. "Sad, because I see two enormously talented persons, Mr. William Mett, Mr. Marvin L. Wiseman, who conducted themselves in a manner that they thought were within the bounds of reason and proper business acumen." The two men had set out on "a course that included very aggressive business practices, which included almost fine-line divisions between proper business etiquette and fraudulent misrepresentation."

Fong said Center Art's prices for Dalí art were "originally well within the bounds of reason when they first came out, but somewhere along the line it was determined that . . . perhaps they could be marketed as being business investments, and an investment market is only generated when there is a gain that would induce others to buy this product. This gain came about because Center Art Gallery itself raised prices, and there was no other basis for that. There did not appear to be any strong resale market or any secondary market for resale at all."

Fong's description of Center Art's operation, what Osborne called its "scheme," had an almost antiseptic quality. He minimized what the government maintained was a massive fraud. For example, those supposedly "reasonable, initial prices" to which the judge referred—called "prepublication" prices by the gallery—ranged from $750 to $1,950 for what the experts said were calendar-quality reproductions with values ranging down from a high of $50 to less than the value of the unblemished paper.

The judge hinted that he might have disagreed with the jury, and he flirted with opining about his view of the art market. "But that is all water under the bridge," he said, "because once the jury returned a guilty verdict, it takes the issue of fact away from my hands. I no longer can decide whether or not it is fraud."

It was true, Fong said, that Dalí did not sign the prints, although he may have signed blank paper for the prints, nor did the artist work on the master plates used to produce them. But customers believed what they had been told. Center Art "carried a reputation, which unfortunately was not well earned, and thereby it violated its responsibility to the art market to engage in proper business conduct."

Were Mett and Wiseman bad people? Absolutely not, Fong concluded. They were "two talented men who are, in all other respects, not the criminal type. They don't possess the criminal profile." Mett was even an attorney in a respected Honolulu law firm at one time, the judge noted, not mentioning his previous liability in civil court for real estate fraud. And Wiseman was "a charming man, talented man, a person who has good business skills, the ability to train a very effective work force. This is a talent that could be harnessed if it were properly directed."

But this was too big a case to allow the convicted to go free, facing only community service. "Punishment is the order of the day, and punishment means fine and jail," Fong said. For Mett, that meant three years in federal prison, with no opportunity for early release. Wiseman was sentenced to two and a half years. Both men would be allowed to remain free pending appeal. The judge levied fines totaling more than $1.8 million. For the victims named in the indictment, he ordered restitution of more than $300,000. Purchasers not named in the criminal case would have to stand in a separate line to get theirs.

"I am not a collection agency," Fong said. "I am not here to do their bidding."

The bidding had begun immediately after the jury returned its verdict. Three months after the conviction, Fong and Senior U.S. District Judge Martin Pence announced rulings in civil cases that transcended previous opinions and eased the burden for those seeking refunds, there was money there to pay back the defrauded investors.

Both rulings came in a lawsuit filed by Jeffrey Portnoy, the Honolulu lawyer who recovered a total of $6 million from Center Art Gallery in out-of-court settlements on behalf of some twenty art purchasers, including California avocado grower Roland Vasquez, Japanese physician Dr. Shigenoba Kojima and Leilani Petranek, the recipient of the Dalí sales pitch described in chapter l. Now, Portny was representing Edward and Helen Balog, vacationers from Washington State who began buying Dalís at Center Art in November 1978. Over a period of four years, the Balogs "invested" $36,200 in Dalí prints and wall sculptures, then sat back and waited for their investment to mature. They learned from newspaper and television reports in 1988 that their artworks might be bogus. Portnoy filed the suit in January 1989.

In August 1990, Center Art asked Pence to dismiss the Balogs' lawsuit because it was filed more than four years after the last purchase—the legal threshold under which a person may take court action. Gallery attorney Peter Wolff pointed to three other cases in the nation's courts involving art sales in which lawsuits were thrown out because they were filed too late. The eighty-year-old Truman appointee to the bench looked at the cases cited by Wolff, then looked the other way.

"They were wrong," Pence told Wolff. "They should be reversed, and if I had any power, I'd reverse them."

Pence noted that federal law provides that claims alleging fraud arise when the fraud is discovered or *should have been* discovered. The Balogs trusted Center Art's reputation and felt no need to hire their own experts to tell them what Wiseman already had guaranteed at the time of sale. Nothing had alerted them before 1988 that anything was wrong. In fact, Center Art "took affirmative steps to lull" the Balogs by sending them updated "Confidential Appraisals—Certificates of Authenticity," further assuring them that the bas-reliefs "are the originals and not hubcaps, as they actually were," Pence said.

"When you deal in art and antiques," Pence explained, "when you deal in wines, and there are many others that could be examples, you're not dealing with the ordinary type of 'commercial articles.'"

Several days later, the lawsuit still intact, attorney Portnoy went before Fong and maintained that the issue in the civil suit over the authenticity and value of the Balogs' *Christ of Gala* already had been decided by the jury in the criminal case. Without addressing whether specific misrepresentations had been made to the Balogs, Fong ruled from the bench that Mett and Wiseman would be "precluded from relitigating the issue" in the civil case. The Balogs' *Christ of Gala* was "part of the same batch" that the jury in the criminal case had found to be fakes, and the jury had determined the scheme to be fraudulent. Mett and Wiseman "have had their day in court. They had a chance to litigate the authenticity of that particular piece of work."

Attorney Martin Steinberg's class-action suit on behalf of seventeen Dalí purchasers and "all others similarly situated" who wished to partake was floundering in Hawaii state court. A judge had frozen all action in the case in August 1989 while the criminal case was awaiting trial, protecting the rights of Mett and Wiseman against self-incrimination through civil testimony or production of documents.

Steinberg had collected hundreds of names that had been referred his way by the postal inspectors, lawyers who had refused individual cases as too small, as well as others. But he had no experience in knowing how to handle such a massive case. His clients were reluctant to put much good money after bad to finance such a suit. Other lawyers in Honolulu were dubious about jumping to Steinberg's rescue as it became questionable whether there would be much of a pot of gold at the end of the Dalí rainbow.

In April 1991, Honolulu lawyer Paul W. Soenksen, who had newly signed on as Center Art's attorney in the case, sent Steinberg a letter. The mailman returned it marked "no forwarding address." With little hesitation, Soenksen called for dismissal of the case, saying the seventeen plaintiffs "appear to be on a ship without a captain." After a hearing in which the proposed "class" went unrepresented, Judge Robert Klein dismissed the suit. Steinberg, it turned out, had moved to Colorado less than three months after Center Art's sentencing, in the mistaken belief that a lawyer friend would act in his stead.

As the appeal of the criminal case progressed, Center Art began to show its wear. A bedraggled Mett appeared with Wiseman in court in January 1991 to explain there was not enough money to promptly pay the $1.8 million in fines to the government. The gallery had sold its lease on its Lahaina, Maui, property for more than $1 million, but most of that had been required by the government to be put into the company's pension plan; only $50,000 from that sale had gone toward restitution for the victims. In addition, the defense attorneys were experiencing difficulty in getting paid for their services.

By 1992, Center Art had been reduced to a single gallery in Waikiki. Mett looked drawn and underweight. Had he been a victim of a crooked industry? Was he the real culprit, or were there bigger fish?

Stopping the Presses

Boutique Fraud

As the Federal Trade Commission's case against Federal Sterling Galleries was winding down in 1989, the Arizona judge had a suggestion for David Spiegel: Had the FTC attorney considered going after the supplier of all these Dalí prints?

Spiegel did not take the hint lightly. He had encountered prints produced by Pierre Marcand's Magui Publishers on two occasions—at Austin and at Federal Sterling Galleries— and the prints had turned up at various places in the New York investigation. Marcand appeared to keep operating, unaffected by the attacks on his clients. Spiegel was assigned to those cases as part of the commission's campaign against boiler-room fraud. He could continue on to the next boiler room, but that approach would be "like killing a cockroach," he deduced. His task was not so easy, as Marcand thus far had skated with finesse.

Born in Paris, Pierre Marcand studied mineral chemistry in college but did not work long, if ever, in that trade. Not many years out of school, Marcand found himself in the French protectorate of Tahiti, in charge of overseas sales for a French book publishing company. By 1973, he had come to know French art publisher Jacques Carpentier and Simon Wajntrob, head of the Grapharts Company in Geneva.

Marcand says he bought a twenty-five-lithograph suite called *The Dalínian Horses* from the two men and then bought a few more to sell along with the books he was distributing. Marcand increased his Dalí sales activities and in 1975 bought his first entire suite from Wajntrob, then another, and again another.

A year later, as Marcand tells it, he was in Los Angeles on a stopover from Tahiti to Paris when he met the co-owners of Martin-Lawrence Galleries. He says he sold them sixty-five hundred Dalí lithographs. Soon after that, Marcand says he and Martin-Lawrence engaged in a joint venture in the distribution of Dalí art, including prints produced by Levine & Levine in New York. It was during the changeover of Dalí's stewardship from Enrique Sabater to Jean-Claude Dubarry that Marcand, unable to get backing from Martin-Lawrence, leaped solo into Dalí publishing, buying presigned paper from Carlos Galofre and copyrights from various owners.

Marcand's marketing was noticed by Pierre Argillet of Galerie Furstenberg in Paris. Argillet happened to be in Rome, where he discovered in the Ca' d'Oro gallery fake *Hippies* prints by Dalí to which Argillet owned the copyright. After Argillet complained to police, Marcand was indicted in Rome for having transported 440 of his Dalí productions across the border into Italy in December 1980; absent throughout the proceedings, Marcand was convicted, given a suspended prison sentence and a suspended fine.

Among the copyright owners Marcand contacted was the Glasgow museum. Director Alistair Auld already had sold the rights to reproduce *Christ of St. John of the Cross* to Center Art Galleries in Hawaii, but he offered Marcand the right to make etchings of it. Marcand took it as a challenge.

"I had to retrieve the way the interpretations from original old paintings were done during the seventeenth century in Europe," he says. "It was a challenge, probably more diffi-

cult than the lithograph, in time, in skill, in technique and in applying technique of printing and coloring, and I tried to find some technician to help me in that goal."

Near a second home he maintained in the south of France, Marcand searched the yellow pages in February 1982. He found printer and copper-plate engraver Pascal Giraudon and native Yugoslavian Petar Spalajkovic (later changed to Peter Spalaikovitch). Soon, this group was in full production.

Their activities did not escape the lookout of Genevieve Breban, director of the Argillets' Paris gallery. Only a month after Marcand had met his new friends, she went to the French authorities and accused Marcand of operating a counterfeit engraving network, when only Galerie Furstenberg had the rights to reproduction and commercialization of Dalí's engravings.

At one point, A. Reynolds Morse of the Dalí Museum got wind that Marcand was preparing to advertise his *Christ of St. John of the Cross* in an American magazine, and Morse tried to stop the ad effort. Marcand took one of the prints and visited Morse in St. Petersburg to try to persuade Morse to drop his objection.

"I said, 'You can't run the ad,'" Morse recalls. "He said, 'Well, I'm going to kill myself.' He took out a thirty-eight revolver out of his briefcase and put it up to his head, and I said, 'Go ahead, kill yourself.' In the end, he left me this print of this etching that he had made and he was going to then color it and sell it as an original Dalí print. He left me this thing and, before he left, he tore off the corner with Dalí's fake signature. He said, 'I know you don't like these false signatures.' I've still got the damned print."

When Nice police visited Giraudon's shop in September 1982, they found reproductions of or contracts to reproduce *Christ of St. John of the Cross, The Last Supper, The Madonna With the Rose, The Madonna of Port Lligat,*

Imaginary Self-Portrait of Dalí as a Child in the Arms of His Sister, Moses in Bas-Relief and *The Life of a Dream.* None violated any of Galerie Furstenberg's copyrights. Along with the prints were 977 sheets presigned by Dalí. Investigators found that Marcand had, indeed, bought 15,800 sheets of presigned paper from Galofre. It was impossible for the gendarmes to prove the signatures were false, and almost all the prints were being sold in the United States, so no serious move was made to prosecute Marcand. Marcand explained that each print would carry an explanation that it was etched not by Dalí but by Spalaikovitch.

Marcand would explain later that he had examined antique prints as far back as three centuries ago to see how attribution lines were constructed in the old days, and he had followed their styles.

"My concern when I decided to do the etching of interpretation was to retrieve the same way, the same tools, the same process, which were existing two hundred or three hundred years ago, including this attribution line," he said. It would disclose "the name of the author or conceiver of the image, and it was Salvador Dalí, and followed immediately by the name of the skill artist, who is also an artist, in this case Spalaikovitch, and to disclose the name of the colorist every time the colorist was deserving to have his name there." It also would include the Magui name and the year and month of publication. He alone in the world was affording full disclosure on the face of his prints, at least the etchings.

In 1983, Marcand closed his shop in France and moved everything to Beverly Hills, California, bringing Spalaikovitch with him. After all, America was where most of his etchings had been selling.

Marcand's prints were being passed off in America as something special and genuine, and for high prices. State prosecutor Judith Schultz in New York saw Magui's Dalís

being represented as the artist's original works at several locations, despite the attribution line, which was in French. In October 1984, she received a Magui promotional catalogue with print prices ranging from $1,700 to $5,000. Three months later, she sent a letter to Marcand advising him that representations of his work possibly violated New York State law. Through his attorney, David Paul Steiner, Marcand entered into discussions with Schultz over a one-year period.

Brought into Schultz's office for a deposition on August 7, 1986, Marcand insisted he was doing nothing illegal.

"I don't have any knowledge of another company existing in the world doing the same thing," he said. "What I am doing is called the etching of interpretation. It means that they are etchings done by master engravers and master printers and master colorists, of original works."

He saw nothing wrong with the fact that they were on presigned Dalí paper, even though acknowledging that, just maybe, Dalí had not signed all the paper bearing his supposed signature.

"In my opinion," he told Schultz, "I could say I really doubt the paper was signed by Dalí. But I cannot say this signed paper is not legal, and I will explain why."

"Please do," Schultz said.

"First, Hamon paper is documented by a statement made by Dalí himself, signed by him and countersigned by his wife, on which statement is said, 'I deliver today 25,000 sheets of presigned paper to Mr. Hamon in order to fulfill the agreements he bought from me.' That is one statement, and I will provide you with that document. I have it."

"Please do," Schultz replied.

"Another statement signed also by Dalí and his wife is, 'If I am not in a physical condition to sign the prints, object of the agreement I had with Mr. Hamon, I will provide him with sufficient quantity of presigned paper to fulfill my com-

mitment.' That's another statement," Marcand said. "That gives all authority for Mr. Hamon to release this signed paper and to comfort his purchaser, to make satisfactory the most demanding purchaser."

Marcand went on to say that SPADEM had never "brought any formal negative comment about that signed paper. . . . That paper could have been signed by Mr. Hamon himself. The SPADEM recognized if Dalí, one way or another, didn't fulfill his commitment to this agreement, of course the situation could be very difficult for everybody— Dalí, SPADEM, Hamon, publishers, dealers and collectors."

Schultz did not believe any of the Dalí signatures on the Marcand prints were legitimate. By that time, Dalí had signed an affidavit denying that he had signed blank sheets after 1980, and watermarks on the Magui paper indicated it was manufactured later than that.

At the conclusion of the deposition, Marcand signed a consent decree in which he agreed not to engage "in any act or transaction whatsoever relating to the offer to sell and the sale of counterfeit Salvador Dalí artworks" in New York. Marcand later would point out that he admitted no wrongdoing. Indeed, the decree says he and his company denied the allegations that his prints are counterfeit.

"That's quite the standard in those settlements," Schultz explained.

Marcand walked away from New York undeterred, and he continued sales to such outlets as Federal Sterling, Shelby and Austin galleries, the three companies that would be taken to court by the Federal Trade Commission.

In May 1988, following a judge's preliminary injunction in the Federal Sterling case, the FTC deposed Marcand and got much the same in explanation as Schultz had received. In addition, Marcand pointed out that he had sent a notice to all purchasers of more than five pieces warning that the etchings "are to be sold as graphic interpretations of art

which are printed on presigned paper bearing the signature of Salvador Dalí." By early 1989, Marcand's wholesale prices for these "interpretations" ranged from $800 to $7,500.

In January 1989, Marcand reported a theft of Dalí etchings from his Beverly Hills home. Detective John Ambro visited Marcand to interview him about the theft. Little had changed since Ambro had completed his investigation of T. R. Rogers on Rodeo Drive. Marcand told him he was publishing Dalí and Chagall prints on an "as ordered" basis.

Curious about the ongoing production, Dale Sekovich accompanied Ambro to the Marcand house six weeks later, not mentioning that he was an investigator for the Federal Trade Commission. During the conversation, Marcand told of having sold etchings in the past two or three years to Hang Ups Gallery and Von Bigelow Auctioneers in Orange County; Simmonson Gallery, Collier Publishing and the Upstairs Gallery in Los Angeles; Federal Sterling in Arizona; The Collectors Group in Miami; Patrician Gallery in Atlanta and Hansen Gallery in Beverly Hills; and of having offered Dalí, Chagall and Bernard Buffet etchings in Japan and Taiwan. Sekovitch noticed the Chagalls that Marcand had on hand bore signatures that had been applied "posthumously."

Marcand showed Sekovich his workshop and his three wooden presses, which he boasted were handmade reproductions of ancient machines.

Posing as a customer, Sekovich then visited a few of the galleries that Marcand had mentioned as his clients. At Simmonson Gallery, he expressed interest in *Christ of St. John of the Cross* and was told by the gallery owner the price had not risen from $3,600, despite Dalí's death two months earlier.

At Hang-Ups Gallery, salesman Gary Parks told Sekovich that Dalí etchings published by Magui were an

excellent choice because Magui was Dalí's finest publisher. There, *Christ of St. John of the Cross* was priced at $1,800.

Although Marcand had not mentioned Edward Weston Gallery in Northridge, Sekovich paid that gallery a visit because of newspaper advertisements in which it claimed to have the largest Dalí inventory in the Los Angeles area. Sure enough, Sekovich found two Magui prints there.

Sekovich then got down and dirty, returning to Marcand's home several times in the spring of 1989, each occasion coinciding with the day trash was scheduled for pickup. After the garbage truck picked up Marcand's trash from the curb in front of the home, Sekovich would follow it to the city sanitation center. Helped at times by Ambro, Sekovich then sifted through the trash, gathering evidence.

Soon, David Spiegel decided he had enough information supplied by Sekovich and Ambro. On June 23, 1989, the FTC lawyer filed a complaint in federal court in Los Angeles, charging Magui Publishers and Marcand with deceptive trade practices. U.S. District Judge Ronald S. W. Lew granted a temporary restraining order against Marcand and his company, freezing its assets and placing Magui in receivership. The FTC located only $101,000 in cash, and was unable to tap holdings in two Marcand corporations, real art worth $10 million, a number of automobiles, Marcand's residence in France and possible bank accounts in France and Tahiti. From the available assets, Marcand was to be given a monthly living allowance of five hundred dollars.

The government hauled away three and a half truckloads of property from a warehouse in the San Fernando Valley, including printing presses, about six thousand prints, more than a thousand blank papers carrying Dalí signatures and a thousand Buffet prints that Marcand insisted were awaiting sale for $600,000. A Japanese buyer agreed to purchase two hundred of them for $80,000. He then acquired copies of the

same Buffet images in Europe, and as Marcand claimed exclusive rights, he canceled the deal.

From the business records, Spiegel was able to conclude that Magui had published or marketed thirty-two editions of Dalí prints, from twenty-eight images. Four were produced as lithographs and the remainder as etchings. Records showed sales of 8,675 Dalí prints, which accounted for 84 percent of Magui's sales. The average wholesale price had been $447, from which Spiegel could document gross sales of nearly $4 million. Magui had recorded 171 Chagall print sales in the three years leading up to the seizure, for prices ranging from $100 to $1,800.

Spiegel suspected Marcand's Dalí sales to be much greater, because he had produced twenty-three Dalí titles since 1983, selling them to dealers at prices ranging from $300 to $2,000, allowing him to rake in tens of millions of dollars.

David Steiner, Marcand's lawyer, denounced the Federal Trade Commission action and its "calculated use of the media" in maligning his client. "Clearly this case is about fraud, but the fraud is being perpetrated by the FTC," Steiner told reporters. Marcand's prints were authorized, he said, and they were sold as "interpretations" of Dalí's work. "My client didn't sell these artworks as investments"claimed Steiner. "He sold them . . . because they were esthetically pleasing."

There was little if any evidence to the contrary. Unlike the numerous memoranda and great sales hype in the Center Art case, Marcand had quietly distributed his prints with full disclosure that these were etchings done by Spalaikovitch, even attaching photographs showing the etcher—Spalaikovitch, not Dalí—at work. Of course, it was misleading for Federal Sterling to take those photos and display them below an explanation that "genuine original graphics are works of art which are made by the artist

drawing or etching the image on a stone or plate." But could Marcand be held responsible for that?

When Marcand's case went to nonjury trial before Judge Lew in Los Angeles in January 1991, Spiegel contended Marcand was deceptive in four areas. First, he said, Marcand had stated or implied "that Dalí was connected with the Magui product, either in the production process or by specifically authorizing or approving the prints." Second, there was misrepresentation in claiming each print bore "a genuine Dalí signature," Spiegel said. There were misrepresentations about rarity; Marcand had run off more than one edition of some of the images. Finally, the prints' value was exaggerated.

Colorado art appraiser Bernard Ewell examined the Dalí prints seized from Marcand and found that 1,820 of them were on paper manufactured after 1979. Watermarks revealed 462 of those were milled in 1984 and one was produced in 1985.

Marcand asserted that he paid little attention to the watermarks. "For myself, I was not really concerned. I was satisfied with my conclusion."

His conclusion was based largely on assurances from Jean-Paul Oberthur, the SPADEM director, who examined thirty-five thousand presigned sheets of the Peter Moore-supplied paper in a warehouse in Geneva in 1982, at Dalí's instruction. Brought to Los Angeles as a defense witness, Oberthur also testified that he believed the 1986 Dalí addendum to the 1985 affidavit—both allowed into evidence by Judge Lew—bore a false Dalí signature. The 1986 statement was in English, was on Robert Descharnes's stationery and was peculiarly dated to correspond with the creation of Demart. Oberthur believed the Dalí signatures on the Magui prints to be authentic, and he had given assurance to Marcand that the contracts Dalí had signed were valid.

"Every time I was in Paris buying a new contract, I was always consulting SPADEM," Marcand said, "because with these large quantities of signed paper, I was always doubtful and I needed to be comforted."

Oberthur could not authenticate Dalí's signature on the art paper, but he could provide assurances about the contracts. "SPADEM identified the signature of Dalí as being the right signature of Dalí at the bottom of certain agreements between Mr. Dalí and Mr. Hamon before the delivery of this signed paper," Marcand said. "That is the reason I was comforted."

Apart from the signature, Marcand attorney Lawrence Fox, fresh from being cocounsel with Robert Weiner in the Center Art trial, contended that the government was trying to "legislate through litigation the type of disclosure they believe the art industry should provide to retailers and consumers." Spiegel wanted Marcand to describe his prints as "interpretations" or "afters," but there was no law requiring that, Fox said, and the attribution line on the etchings clearly stated that Spalaikovitch drew them.

In addition, Marcand had sent his clients a brochure in 1987 stating: "Magui spared no effort in reproducing this fine work to the minutest detail. The result is a unique work of art faithful in every detail to Dalí's outstanding creation."

"It's unequivocal, this is a reproductive work," Fox said. "No one could have mistaken it."

Marcand had testified about the painstaking effort to produce quality art at considerable cost. The copyright itself for a given image cost $100,000, including the presigned paper, he said. He paid Spalaikovitch $5,000 a month, and it would take him six months to produce an etching. His assistants had to be paid, thus an additional $40,000. Printing costs were as high as $30 a print. And, of course, there were general administrative costs. In all, he claimed the production cost for each print to be $470, compared with his average

selling price of $447. He claimed to have operated at a loss, and was able to eke out an existence only by selling Van Gogh, Rembrandt and Monet paintings.

"This is not a case involving high-speed presses, ten-minute exercises to create poster-quality prints," Fox told the judge. "This case involves an extraordinary effort to create something unique and valuable and worthwhile, art-work interpreted by artisans in an old manner, the six-teenth- or seventeenth-century manner, using the [same] techniques and presses."

Spiegel looked at the case another way: "What we have in this case is a Magui product. We have a boutique-style fraud instead of a garden variety fraud. Instead of a common, garden Dalí fraudulent poster print, we have a boutique-style of fraudulent print produced at more expense, but nonethe-less a print that has been misrepresented as [being] by Dalí, [and] signed by Dalí, in order to sell it."

Three weeks after hearing the attorneys' arguments, Judge Lew on March 8, 1991, brought them back to court and announced his agreement with Spiegel that there were "misrepresentations of authorship, genuineness of Dalí's sig-nature, size of edition, value and mode of production."

"I am cognizant of the fact that there was testimony that Dalí's signature may be original on some of these papers," the judge said. "I find that if that is the case: it would be minuscule. In any event, it would not impinge upon the real issue in the case, the misrepresentation." Marcand "was aware of the problems with his works due to the investiga-tions and other proceedings conducted, and he did not cure the misrepresentations of the material fact in this case."

With Pierre Marcand run out of business and Leon Amiel dead, many authorities believed the major sources of Dalí fakes had evaporated, along with the largest dealerships. They would discover otherwise.

A Family
Affair

O n October 6, 1988, the Los Angeles Art Expo had assembled an impressive panel to discuss "Art Law in the Print Market" in the Los Angeles Convention Center. Before the panel discussion began, New York art litigator Arnold J. Ross had an announcement to make. Leon Amiel, his long-time client, had passed away, he told the audience. Ross paid tribute to Amiel as a friend to the art business, a man of high integrity whom the art world would greatly miss.

Other panelists, including Postal Inspector Jack Ellis, Sr., could have choked upon hearing Amiel's eulogy for his deceased client. Upon taking over the leadership of the postal inspectors' art fraud probe in October 1986, Ellis had been advised by his predecessor, Robert DeMuro, that Amiel was the principal target of the entire effort.

Amiel had drawn respect in 1966 when he published a book called *The Story of the Exodus*, containing twenty-four color lithographs by Chagall. The book sold at Christie's in New York for $12,000 in 1981.

According to a French government investigator, Amiel imported several very efficient printing presses, utilizing photography and color separation, into his plant in the New York area in 1972. The machines enabled him to produce thousands of lithographs an hour, compared with thirty

using a lithographic stone. He flew in former students of the Robert Estienne School in Paris.

Ellis and DeMuro had heard, and later verified, that Amiel had been the recipient of the French Legion of Honor, either for participating in a U.S. paratrooper operation during World War 2 in France or for serving as a liaison of sorts between America and his ancestral home. Ellis and DeMuro did not much care. A French medal gave him no license to do what they were convinced he was doing.

DeMuro advised Ellis that Amiel was the world's largest and wealthiest publisher of fake Dalís and that he also published suspect Chagalls. He was the direct source for Phil Coffaro's C.V.M. Art Company Limited on Long Island, Andy Levine's A.D.L. Fine Arts and William Mett's Center Art Gallery in Hawaii. DeMuro had been told that Amiel violated copyright laws and regarded civil lawsuits as just part of doing business.

Shrewd and confident, Amiel had approached DeMuro through intermediaries to discuss the fake Dalí market. The inspector thought Amiel was trying to "neutralize" his investigation. Many people in the Dalí art world were afraid of Amiel and believed he possessed "muscle," DeMuro told Ellis. He noted that Andy Levine had been offered plea agreements but turned them down, probably out of fear of Amiel.

Amiel claimed to possess more than forty thousand sheets of Dalí presigned paper at a warehouse in Secaucus, New Jersey, where he had been renting space since 1974. Informants had told DeMuro confidentially that Dalí's signature was a forgery. Amiel was aware of the watermark identification of new paper, and DeMuro figured Amiel was trimming it off. When questioned about the signatures in 1985, Amiel told DeMuro only that Dalí's name was on the prints and denied having told Levine or Coffaro that Dalí had signed the lithographs. He gave much the same explana-

tion about the production of fine prints as he had given this author in July 1985.

Upon returning to New York, Ellis tried to confirm the report Ross had given of Amiel's death, which had been a mere rumor in the days before the Los Angeles exposition. He checked with Interpol, which sought information about the death in France and the United States, and then confirmed that Amiel had indeed died. The art producer had been admitted to a hospital in the Bronx as early as February 1988 for treatment of atrial fibrillation. He died on October 1, 1988, two days before the Barclay Gallery indictment, at Long Beach Memorial Hospital in Nassau County, New York, at age sixty-five.

Ellis may have believed that the Dalí fraud, or much of it, would die also. However, in the summer of 1990, shortly after the Center Art Gallery conviction, Ellis was called by Los Angeles prosecutor Reva Goetz and police detective Bill Martin and told that much of the fake art seized from Upstairs Gallery had come from Amiel after his death. Goetz and Martin told him their evidence showed that relatives of Amiel still were in business. Ellis flew to Los Angeles and met with Martin for a week, gathering information on Lawrence Groeger and the art he had supplied to Upstairs Gallery. He found that Groeger once had bought his Amiel prints from Michael Zabrin, the Chicago area wholesaler who had been one of Tony Tetro's clients and who had supplied some of the Amiel fakes to Austin Gallery in Illinois. More recently, however, Groeger had bought directly from the Amiel family, after Leon's death. The Amiels had followed their father's remains to Long Island and set up shop in a dark-gray one-story building in the suburban community of Island Park, from which the newly marketed prints were shipped. The name of the business had changed from Amiel Book Distributors Corporation to

Original Artworks Limited. Amiel may have died, but his business was alive and well.

To find out more about the Amiel family's activities, the postal inspector began focusing on Zabrin, whose activities also had interested the Federal Trade Commission.

"He seemed like the cog," Ellis later recalled. Zabrin had once worked for Phil Coffaro and Andy Levine, and then had become the Midwest supplier of Leon Amiel's product. Zabrin purchased his prints directly from Amiel until a falling-out forced him to obtain them through Coffaro and then through Mitchell Beja, a Brooklyn distributor who happened to be distantly related to Amiel. Beja preferred dealing with contemporary art and posters, and had once found himself a victim of Tetro's Yamagata "emulations."

Ellis flew to Chicago and presented his findings to an assistant U.S. attorney and to James H. Tendick, a postal inspector. Tendick immediately joined Ellis's art fraud task force and contacted David Spiegel of the FTC to cooperate in putting the squeeze on Zabrin. They mapped out a plan that would be dubbed "Operation Bogart"—for "bogus art"—in the Postal Inspection Service.

Using Washington, D.C., art dealer Nancy Drysdale, who had been cooperating in the FTC investigation, Tendick arranged for a purchase from Zabrin.

On August 28, 1990, following inital contacts, Zabrin visited the home of Drysdale, who was accompanied by Chicago-based postal inspector Patricia Hayes, posing as Drysdale's assistant. Zabrin claimed expertise in the area of what he called the "upside-down, inside-out" Miró market. He sold the dealer two Miró prints for a total of $16,000 and, for each one, provided certificates of authenticity, which Zabrin signed. He claimed the prints had been signed by Miró.

Three weeks later, Postal Inspector Hayes visited Zabrin's two-story, chimneyed townhouse with a statue of a dalmatian next to a fire hydrant in the front yard in the Chicago suburb of Northbrook, Illinois. Zabrin gave her a tour of the house; Miró prints were everywhere—a pile in the basement, others in the attached garage and several rooms and four hanging from walls—in addition to purported Andy Warhol and Picasso prints.

The two prints purchased by the Washington dealer were shown to Jacques Dupin, longtime associate of Miró and the worldwide representative of the Miró estate. He pronounced both of them fakes bearing false signatures.

The buy formed the basis for an October 1990 raid on Zabrin's business and seizure of his records. Zabrin was told he could face racketeering charges, seizure of his assets and a twenty-year prison term. He was given a weekend to decide whether to cooperate with the authorities. He wasted no time in reaching such a pact and, as a bonus, persuaded his friend Mitchell Beja to assist. The postal inspectors proceeded to design two undercover investigations, one directed at Phil Coffaro and the other at the Amiels.

On December 17, 1990, Zabrin placed a telephone call to Coffaro and, during the conversation, Coffaro mentioned seeing prints of Chagall's *Exodus* series in the Amiels' shop,hinting that Amiel had republished them as restrikes from the same plates used in 1966. Sometime later, Zabrin arranged to come to Coffaro's business with a potential new buyer.

Zabrin and Postal Inspector Hayes entered the Coffaro building in the Long Island community of Mineola on January 18, 1991, and Coffaro gave them a grand tour, showing them Miró, Chagall and Picasso prints that he had stored in plastic sleeves next to his desk. Zabrin recognized the Mirós and Chagalls as fakes supplied by the Amiels and

two of the Chagalls as Tetro's product, but said nothing. At the end of the session, Hayes agreed to pay $28,600 for an assortment of Mirós, Chagalls, Picassos and Dalís.

The next step would be to prove that Coffaro knew all of them to be fakes. In a telephone call eleven days after the purchase, Zabrin told Coffaro that he had been disappointed in the Miró aquatints included in the deal. Coffaro responded that the Amiels were scraping "the bottom of the barrel" with the aquatints. When Zabrin speculated that the Amiel women were using a light table to copy Miró's signature, Coffaro replied that Leon Amiel had always practiced the artist's signature, not copied it. But Coffaro had to agree with Zabrin that the prints were too poorly done to be sold to a good customer and be passed off as authentic.

After the phone call, Coffaro examined a Miró book and an authentic Miró belonging to a friend. Two days later, he told Zabrin he had to laugh at the difference between true Mirós and those produced by Leon Amiel.

"It's almost a joke," he told Zabrin. "You get used to his [Amiel's "Miró" prints], and you forget what the real ones look like."

On February 11, Zabrin ordered a four-piece Miró suite from Coffaro, after being assured they were satisfactory and not "crappy" like the previous ones.

"Those things are horrendous," Coffaro said of the Mirós sold earlier. He said he was told that the brother of Leon Amiel's widow, Hilda, had been signing the prints but that the Amiels' daughter, Kathy, had taken over the task.

"They have a lot of inventory that's not fixed [with signatures]," Coffaro said.

On February 27, as Zabrin was buying the Miró prints for $1,500, Mitchell Beja and a second undercover inspector, Waiman Leung, posing as a Hong Kong dealer, entered the business offices of the Amiels. They were greeted by Kathryn J. Amiel, Leon's forty-six-year-old daughter, who

gave them a tour of the business. After being shown the personal offices and storage room, Beja expressed interest in making a purchase, and Kathy retrieved selected lithographs bearing penciled signatures of Dalí, Chagall, Miró and Picasso. Three Picassos were "stone-signed and pencil-signed," she told Leung, while a Chagall series was more expensive because they were "the last ones he ever did."

Leung chose twenty-one pencil-signed lithographs attributed to the four masters for a price of $18,950, and everyone was satisfied.

Meanwhile, Zabrin continued to feign complaints to Coffaro about the quality of the signatures emanating from the Amiel business. Coffaro agreed that recently purchased Mirós were terrible and the Chagalls were "a disgrace altogether." Coffaro told Zabrin he had talked to Kathy Amiel about the problem and told her, "If you're gonna do it, at least do it close to what your dad did."

On April 4, Zabrin told Coffaro that his dealer friend was interested in purchasing one of "Tony Tetro's specials," a Chagall, and Coffaro informed him that he still had some. One of the undercover inspector's "Chagalls" from the February purchase had been a Tetro "Chagall" print titled *Green River.*

Back at the Amiels' shop, Mitchell Beja made continued inroads on behalf of the government. He asked Kathy for documentation supporting the authenticity of the prints in the February purchase and received them in the mail on April 15. A week later, Beja and Leung returned to Island Park to make another purchase—more Mirós, Chagalls, Picassos and Dalís. Kathy prepared an invoice totaling $14,975 for the sale. She accepted a check for $18,950 covering the February purchase.

Phil Coffaro may have been making more deals with postal inspectors than he was with actual art dealers. When he set up a booth at the New York Art Expo on April 27,

Postal Inspector Sara-Ann Levinson, also posing as a dealer, approached and asked about a Chagall and a Miró that were on display. She paid $8,500 for the two prints, along with certificates of authenticity and a written guarantee of full refund if she obtained proof they were not "correct."

In late May, Leung and Raymond Hang, another postal inspector posing as a Hong Kong partner of Leung, returned to give Kathy Amiel a check covering the April purchase, but asked for more "backup" documentation authenticating the prints. Kathy and her twenty-three-year-old daughter Sarina acknowledged the problem, and Kathy agreed to send certificates.

Zabrin continued to voice annoyance at the quality of the Miró signatures on a suite titled *Volume III* that had been purchased by Inspector Hayes. He phoned Coffaro on June 5 and asked if there were *Volume III* prints that did not look like "a piece of crap," which either Kathy or someone else had signed.

Coffaro told Zabrin he thought Kathy's daughter had returned, and the Kathy Amiel signatures now were "looking pretty good." Asked if there were any prints bearing signatures dating to Leon Amiel's day, Coffaro replied, "Leon only did them on order."

Given that news, Zabrin and Hayes paid another visit to the Coffaro shop on June 11, and Hayes bought six more Chagalls and four Mirós. Coffaro said his source for all of them had been Leon, and certificates of authenticity would be mailed. Would they reflect that the prints were originals, signed by the artist and numbered by the artist?

"Yes," Coffaro replied. "It's real important." Hayes gave him a check for $9,000 and mailed him the remainder of $5,250 the next day.

On June 20, Leung and Hang, the supposed Hong Kong dealers, returned to the Amiel shop and made a major purchase: twenty-one purported Chagall and Miró pencil-signed

prints, three Chagalls with facsimile signatures and one print bearing the name of the late Henry Fonda, who had painted and drawn for relaxation since his 1948 Broadway appearance in *Mr. Roberts*. Fonda authorized Amiel to produce four limited-edition lithographs of his paintings in 1981. Kathy and Sarina Amiel told the inspector that Fonda had signed one of the pieces "on his deathbed."

Leung and Hang agreed to a purchase price of $41,050. They received an invoice six days later, bringing the Amiel undercover operation to completion.

On June 27, Hayes received a call from Coffaro's son, who told him his father had arranged to obtain three Miró aquatints for her to purchase for $6,000 apiece. Hayes called the elder Coffaro later in the day and told him she could come to his shop on July 9 between eleven A.M. and noon. Several days later, Hayes called to confirm the date.

As the undercover operation progressed, the postal inspectors were receiving additional assistance. David Crespo, who was vice-president of the Barclay Gallery's Connecticut operation, had become involved in a disagreement with Ted Robertson, the California print dealer involved years earlier in the dispute with Center Art and Marcand over rights to *The Cosmic Athlete*. Robertson had left San Francisco sometime after that copyright dispute and opened shop as Vest-Art and Roma editions in the Los Angeles suburb of Laguna Beach. In 1990, Robertson and his wife Elizabeth returned to the San Francisco area, operating as Art of the Century in the Napa Valley community of Calistoga. When Crespo complained about Robertson to the U.S. attorney's office, Crespo was sent to talk to the postal inspector. Jack Ellis quickly educated Crespo's attorneys about their client. Crespo swiftly went from being a suspect in a federal investigation to being a cooperating witness.

Crespo turned out to be a helpful informant, having been associated with Coffaro since 1984 and having leased office

space from him at the Mineola building. Crespo said Coffaro once had told him that Amiel would print double editions of every single piece he printed for any artist—Miró, Chagall, Dalí and others—but believed quality was important. He recalled Coffaro saying that Amiel had told him in 1988, "At least if I'm going to produce fakes, they will be good ones because I am a good printer."

Crespo said Coffaro had told him Leon Amiel signed the artists' names to the prints. Also, many of the prints were numbered H.C.—for hors commerce—because no one could be sure how many H.C.s the publisher produced or the artist signed. Crespo said he once saw a large number of unnumbered Mirós in the C.V.M. office when he leased space there, and Coffaro joked, "I guess all of these prints will get H.C.s."

After making the purchases at C.V.M. and Original Artworks, the postal inspectors turned over their goods to art experts for close examination.

The Mirós went to Jacques Dupin, who worked closely with Miró from 1956 until the artist's death in 1983 and authored his catalogue raisonné. He was aided by M. Robert Dutrou, the printer of most of Miró's etchings for the last twenty-five years of the artist's life. The Chagalls were examined by Jean-Louis Prat, vice-president and director of the Maeght Foundation and who was in charge of the inventory of Chagall's estate upon his death in 1985.

Prat conferred with Monique Duchateau, an expert restorer of the paper used by Chagall and who had been a consultant to both Chagall and his estate. Mary Bartow, vice-president of Sotheby's print department, examined the Picassos. Colorado appraiser Bernard Ewell, the principal independent Dalí expert for the various prosecutions across the country, looked at the Dalís.

Of all the prints examined by the experts and bought by the postal inspectors, none were authentic works of the named artist.

On July 9, 1991, Coffaro's meeting with Hayes was not the one he had expected. In a sweeping raid that took three days to complete, government agents simultaneously struck both the Coffaro and Amiel operations, gathering evidence and seizing assets as being fruits of fraud. From Coffaro, the postal inspectors seized $854,443 in thirteen bank accounts, two cars and property—the Mineola building and Florida real estate—valued at $655,000.

The Amiel raid was more impressive. There, the agents shoveled in 50,000 prints attributed to Dalí spread among 275 titles, 20,000 Miró prints of 175 titles, 2,200 Picassos of 10 titles and 650 Chagalls bearing 60 titles. Also seized were films, Mylars, plates and other reproduction equipment used to create the lithographs, etchings, aquatints and other prints. The government seized $966,000 in four Amiel bank accounts, $320,845 in cash from a safe-deposit box, $67,614 in securities, New York property valued at more than $1.5 million, and three automobiles, for a total of $2.9 million in assets.

Coffaro, whose conversations with Zabrin and the undercover investigators had been tape-recorded, promptly agreed to cooperate with the authorities. Evidence seized in the raids implicated Tom Wallace, Coffaro's former son-in-law, who had directed a Dalí probe of his own more than a decade earlie. Presented with the evidence, Wallace joined in cooperation with his onetime colleagues in law enforcement.

Learning from the seized business records that many of the Amiels' prints went to an art dealer in Gladsaxe, Denmark, Ellis flew to Europe in September 1991 and found that the Danish dealer had distributed them to galleries in Sweden, Belgium, Germany and Switzerland.

The Coffaro seizure included a Miró aquatint and two Chagall lithographs—all fakes—that Coffaro had received from Ted Robertson of California. Robertson had been identified as a participant in the Dalí distribution ring when Postal Inspector Robert DeMuro turned the investigation over to Jack Ellis in 1986. Two years later, a forty-two-year-old man from the Los Angeles suburb of Van Nuys complained to authorities that six Erté paintings he had bought from Robertson turned out to be forgeries.

Subsequent complaints indicated that Robertson also was selling counterfeit prints, drawings and gouaches bearing the names of Erté, Picasso, Miró, Dalí and Chagall. One California couple told how Robertson had charmed them and displayed great knowledge of the art world in persuading them to part with $23,000 for artworks, even giving them a copy of the videotape of a birthday party he had shared with Erté. (Robertson was born on November 23, 1945, Erté's fifty-third birthday. Erté died in April 1990 at the age of ninety-seven, and the videotape appeared to show Erté and Robertson celebrating together.)

Larry Steinman, owner of the Carol Lawrence Galleries in Beverly Hills, complained to police in March 1991 that Robertson and Coffaro had sold him a Chagall pen-and-ink drawing, titled *Le grand voyage commence*, that turned out to be fake.

Two months later, Robertson left California. In August, 1991, apparently unaware of the raids and Coffaro's agreement to cooperate, Robertson entered Coffaro's Mineola business carrying eighteen "Picasso" prints and as many "Erté" gouaches.

Robertson said he had acquired the Picassos from a French artist and friend named Loppo Martinez, a painter and printmaker who had been a "genius" in inventing a machine that was capable of reproducing high-quality fake prints. It was Martinez who had created Robertson's *Cosmic*

Athlete in 1983, plus another rendition of *Corpus Hypercubicus* and other "Dalí" prints titled *September* and *La Gare de Perpignan.*

Robertson recommended prices of $2,500 to $4,500 for the signed Ertés—compared with the $7,000 to $10,000 price range for authentic ones—and $1,500 for the single unsigned one. Robertson told Coffaro he was on his way to France and asked him to store the pieces and try selling them. Coffaro, wired for sound by the postal authorities, agreed.

Postal Inspector Patricia Hayes returned to action in her undercover role. After Robertson flew to Paris, Coffaro—acting on instruction—phoned him and asked if he could commission Loppo Martinez to counterfeit two Chagall drawings to sell to a wealthy client who was opening a gallery in Chicago. The drawings, he suggested would be identical to fakes that Robertson had furnished Coffaro for marketing in 1990. In several later phone conversations in December 1991, they talked about Martinez counterfeiting Chagall drawings titled *Le grand voyage commence*, like the one sold to Carol Lawrence Galleries, and *Visages.* Robertson agreed to assure that the drawings were executed on the same type of paper that Chagall had used for the real ones and that it would be appropriately aged.

Coffaro mailed Robertson an auction catalogue in which the two authentic Chagall drawings were shown and, when that was slow in arriving, sent, by Federal Express, photographs that had been taken of the two fakes Robertson sold him earlier. Robertson said Martinez would be able to do the pieces quickly. Coffaro advised Robertson it was important the drawings look like the photographs, not necessarily the original Chagalls.

"It should be a matter of a couple of hours," Robertson told Coffaro in early January. "Let's face it. If someone knows how to do it, how long could it take?"

A few days later, Robertson called Patricia Hayes, who was playing the part of the wealthy woman opening a

Chicago dealership. Hayes told him she had presold the Chagall drawings, and the customers had put down deposits. Robertson told her a Paris dealer also had interested a client in Japan with making the purchase, but Robertson added that the pieces could be made available to her instead.

More than a week later, Robertson told Coffaro that Martinez was demanding ten thousand dollars for his work on the Chagalls. Robertson suggested Coffaro tell Hayes that Robertson had bought the drawings in partnership with a Paris dealer who had received word from the Japanese client that he would buy both drawings immediately if they were not sold. A down payment was needed to keep Robertson's partner from selling them to the Japanese client.

Robertson said Coffaro should tell Hayes she must forward that amount as the down payment. Coffaro agreed with Robertson that they could sell the pieces to Hayes for forty to fifty thousand dollars, since Martinez had guaranteed they would be "perfect." Coffaro gave him the good news that Hayes also would buy some of the Picasso prints and Erté gouaches that Robertson had left in storage at Mineola.

The next day, Coffaro wired ten thousand dollars, provided by the postal authorities, to Robertson in Paris. Several days later, Robertson confirmed he had received it. The plan was for Robertson to bring the drawings to New York and present them to Hayes on January 28.

On the day of the planned meeting, Robertson called Coffaro from Paris and said he had received an anonymous call warning him not to go through with it. The caller had told him he was being set up by the postal inspectors in a sting operation, that Coffaro's client might by a postal inspector, and that he would be arrested if he made the trip. Coffaro accepted Robertson's explanation, knowing the anonymous tip was on the mark, as did the postal inspectors who were listening in. The "sting" aspect of Operation Bogart came to an abrupt end.

Two days later, on January 30, 1992, before a packed news conference, the government announced that it had halted the world's biggest source of counterfeit prints. New York Postal Inspector L. R. Heath disclosed that the government had filed a criminal complaint against Leon Amiel's widow, Hilda, daughters Kathryn J. Amiel and Joanne R. Amiel and grandaughter Sarina Amiel. Wallace had agreed to plead guilty to a single count of mail fraud. Coffaro and Zabrin would agree to similar plea agreements in Chicago.

A month later, a federal grand jury indicted the Amiel women—except for the ailing and hospitalized mother Hilda—on twenty counts of mail and wire fraud.

Overwhelmed by the evidence gained by Operation Bogart, in addition to Zabrin's cooperation, Lawrence Groeger agreed to plead guilty not only to the grand larceny charge stemming from the Upstairs Gallery investigation in California but to a new mail-fraud charge leveled at him in New York. It was a plea bargain only in the sense that authorities agreed that he could serve the state and federal prison terms simultaneously.

On March 5, 1992, French police—responding to an Interpol request from the American postal authorities—arrested Theodore John Robertson Jr. at his Paris apartment and held him for extradition to the United States to face charges of mail and wire fraud stemming from the ten-thousand-dollar down payment submitted for the "Chagall" drawings. Awaiting Robertson in California were nineteen counts of grand larceny and securities offenses.

Certainly, other aspects of the fraud will continue to surface from time to time. But Robertson's arrest signaled an end to an eight-year effort, beginning with Judith Schultz and Robert DeMuro and ending with Jack Ellis and Bill Martin, to dismantle the biggest distribution ring of fake art in history.

CHAPTER 22

Epilogue

The owner of a little gallery in a Wyoming resort town was asked by this author in 1989 to describe one of the many "prints" being offered for sale in her shop. Like the others, the picture portrayed an Old West scene, a grizzled cowboy perched on the steps of a rustic saloon. It looked to be nothing more than a photomechanical reproduction of a painting.

"It's a photomechanical reproduction of a painting," the gallery owner said.

Taken aback momentarily, I mentioned that the asking price, one thousand dollars, seemed to be a bit steep.

The owner said that price was modest, and she proceeded to lead me across her shop to another print by the same Wyoming artist, this one depicting a bobcat, for $2,700. She said the price was high because the edition had been limited to *only* 670 prints. The painting had been reproduced only as a limited-edition print, not as a common poster. But what if someday the artist decided to order unlimited reproductions of it? The gallery owner looked horrified at the thought.

"It would destroy her validity as an artist," she responded.

The author did not track down the artist to ask the question similar to the one that Nick Rosen asked of Anthony

Quinn: "Is a painting by a little known Wyoming artist worth two million dollars?" To single out this artist, or even to name her here, would be unfair, because the practice of selling signed and numbered reproductions for two thousand dollars or more has become commonplace. The practitioners generally are painters regarded as "commercial artists" with limited creativity but strong appeal to the masses.

Clinton Adams of the Tamarind Institute sighed in resignation when asked about another, similar artist.

"Fraudulent in a legal sense, probably not," Adams said as he leaned back in his chair in an office at the University of New Mexico, half a block from the small brick building with stucco facade where serious artists were at that moment laboring over limestones to be used for true lithographs. "Even without seeing the images, which I can imagine are obviously pretty horrible, I guess it's still further proof of Barnum's adage," Adams said. "I assume there are suckers who buy these for two thousand dollars. . . . If you like the damn thing, and you know what it is and you want to buy it and you want to spend two thousand dollars for it, I may think you're a horse's ass, but I'll also defend your freedom to do it."

The group of curators, collectors and dealers who formed the Print Council of America in 1956 with the primary purpose of defining an "original print," and spreading the word, abandoned its mission in 1990. At its annual meeting, the council agreed it was "more practical to support the existing regulations that require vendors to fully describe the media, origins and editions of the prints they sell, rather than for us to attempt to define an 'original print.'"

Some artists have expanded their creativity through evolving technologies, including photomechanical methods. The consumer must himself distinguish between the "prints" of artists exercising such creativity and those using the same technologies to reproduce their paintings so they

can line their pockets with gold. It remains easier to define a fake than an "original."

"Eyes, sensibility, common sense, knowledge, experience are the best protection against a fake," June Wayne, founder of the Tamarind Institute, advised us years ago, "and my definition of a fake is anything that pretends to be something it isn't."

Even those factors may be inadequate in assessing the "prints" of Salvador Dalí.

Jean-Paul Delcourt, the French publisher who signed the A. Reynolds Morse contracts, tells about acquiring a dozen "Dalí" lithographs from an American publisher and reselling them to an English dealer. The dealer complained later that Enrique Sabater had declared them to be fakes, and a customer wanted his money back. The American publisher refused to do so because he had certificates of authenticity. Delcourt says he saw Dalí at the Meurice Hotel and showed the prints to Dalí and Gala.

"Dali whispered into Gala's ear, and Gala repeated his statement to me: 'Dalí says the picture is good, the signature is good, but the work is a fake,'" Delcourt recalls.

'Why is it a fake?' Delcourt asked.

"The answer: 'Dalí has not been paid.'"

"This is the guiding thread of the entire affair," Delcourt says. "In all the contracts signed between Dalí and various publishers, Dalí never attached any importance either to moral rights or to the authorization to print. All he wanted was money."

Dalí's Original Lithographs

Albert Field, Salvador Dalí's designated archivist, has determined the following prints will be listed in the catalogue raisonné as original Dalí lithographs. Further information, such as dimensions and edition sizes, needed to determine authenticity will be included in the catalogue. Inquiries should be made to Albert Field, The Salvador Dalí Archives, 2025 29th Street, Astoria, NY 11105, or Phone (718) 274-0407.

Don Quixote. Thirteen lithographs executed by Dalí and published by Joseph Foret, 1956—57.

History of a Great Book. One lithograph executed by Dalí and published by Joseph Foret, 1957.

Beatrice. One lithograph executed by Dalí and published by Jean Schneider, 1964.

Dante. One lithograph executed by Dalí and published by Jean Schneider, 1964.

The Face in the Windmill. One lithograph executed by Dalí and published by Phyllis Lucas, 1965.

Cosmic Rays Resuscitating Soft Watches. One lithograph executed by Dalí and published by Phyllis Lucas, 1965.

Drawers of Memory. One lithograph executed by Dalí and published by Phyllis Lucas, 1965.

Crazy Horse. One lithograph executed by Dalí and published by Yamet Arts, 1966.

Hommage à Meissonier. Four lithographs titled *Gala, Nu Gris, Le Pecheur* and *La Main,* executed by Dalí and published by Schneider, 1967. (A fifth lithograph is not original but was executed after an original Dalí maquette.)

Torero Noir. One lithograph executed by Dalí and published by Schneider, executed on paper by Dalí and transferred to plate, 1969.

Four Ages of Man. Four lithographs executed by Dalí for publisher unknown to Field, 1972.

St. George and the Dragon. One lithograph executed by Dalí and published in Germany by publisher unknown to Field, 1973.

Vietnam Series. Four lithographs executed by Dalí and published by Fidelity World Arts, 1973.

The Golfer. One lithograph executed by Dalí and published by Fidelity World Arts, 1973.

Soccer. One lithograph executed by Dalí and published by Fidelity World Arts, 1973.

Moses. One lithograph not executed by Dalí but containing a remarque executed by Dalí, published by Abe Lublin, 1973.

Colibri. Two lithographs executed by Dalí and published by Colibri Gallery, 1973.

The Black Mass. One lithograph executed by Dalí but rejected by him when he objected that the black was too heavy, obliterating the rest of the image, nevertheless published by EGI, 1974.

Savage Beasts in the Desert. One lithograph not executed by Dalí but containing a remarque executed by him, published by Levine & Levine, 1975.

Pantocrator. One lithograph with collage, not executed by Dalí, but containing a remarque executed by him, published by Beverly Hills Gallery, 1976.

Joan of Arc. One lithograph not executed by Dalí but containing a remarque executed by him, published by Levine & Levine, 1978.

Tarot Cards. Twenty-one lithographs not executed by Dalí but containing remarques executed by him (eighteen lithographs not containing original remarques are not considered original), 1978.

CHAPTER 1: THE PITCH
The chapter is based on a sales presentation tape-recorded by Leilani Petranek in September 1977 at Center Art Gallery. The author transcribed the tape in May 1986 and sent copies of the transcription to various art experts for comment. One of the experts instead sent the copy to the New York attorney general's office. The copy then was given to Postal Inspector Robert DeMuro and eventually found its way back to Hawaii. It was reproduced to allow jurors to follow the replaying of the tape, entered into evidence in the trial of *U.S. v. Center Art Galleries-Hawaii,* Cr. 89-00125 (D.Hawaii), on Dec. 15, 1989.

CHAPTER 2: AVIDA DOLLARS
25 "Dalí as a printmaker . . . an iconoclastic question." "Salvador Dalí Prints: A Dash of Original Sin?" *Economist,* U.S. Edition, March 16, 1981, p. 101.
26 "By the age of six . . . to be Napoleon." Salvador Dalí, *The Secret Life of Salvador Dalí,* trans. by Haakon M. Chevalier, (New York: Dial Press, 1942), p. 1.
26 "I threw him off . . . pee on the sheets." Salvador Dalí as told to André Paranaud, T*he Unspeakable Confessions of Salvador Dalí,* (New York: Quill, 1981), pp. 27-28.
26 "an income that would provide . . . closed to him." Dalí, *Secret Life,* p. 155.
27 "No. None of the professors . . . I retire." Meryle Secrest, *Salvador Dalí: A Biography* (New York: E. P. Dutton 1986), p. 82.
27 "On my arrival . . . had produced on him." Dalí, *Secret Life,* p. 204.
27 "make me die for joy . . . paint them honestly." Dawn Ades, *Dali and Surrealism* (New York: Harper & Row, 1982), p. 38.
29 "Of course, we don't give a damn . . . insufferable, unheard of." Tom McGirk, *Wicked Lady: Salvador Dalí's Muse* (London: Hutchinson, 1989).
29 "an impostor avid for publicity." Arianna S. Huffington, *Picasso: Creator and Destroyer* (New York: Simon and Schuster, 1988), p. 176.

30 "He is very important . . . a friend of his."Dalí, *Secret Life*, p. 217..

30 "I spoke with Gala . . . realm of idea." Ibid., p. 226.

30 He took his finest shirt . . . concoct a "perfume." Ibid., pp. 227-28.

30 I lighted a small alcohol burner . . . a veritable magic operation." Ibid., pp. 228-29.

31 her sublime back . . . of the buttocks." Parinaud, p. 89.

31 "It was for her . . . whole thing lamentable." Dalí, *Secret Life*, p. 229.

32 "The whole situation . . . broken a tooth." Parinaud, p. 101.

32 "By the time Gala got back, I was giddy with gold." Ibid., p. 101.

32 "They were hard up . . . commercialize his work." McGirk, pp. 63-64.

33 "stories that would make good copy . . . the tummeler." Parinaud, p. 179.

34 "was a very good draftsman . . . greatest artistic ambition." Dalí, *Secret Life*, p. 140.

36 "America's No. 1 public madman . . . into mental shambles." Winthrop Sargeant, "Dali," *Life*, Sept. 22, 1945, p. 63.

36 "She is self-effacing . . . will not get lost." Ibid., p. 66.

36 "How many full-page . . . When Dalí says five, he means ten." *Saturday Review*, Mar. 22, 1947, p. 5.

37 Gala repeatedly announced delays . . . in 1981 for $3,850. Secrest, pp. 219-20.

38 "The government was imperiled . . . twice the price to a French publisher." Parinaud, p. 166.

38 "I cannot accept . . . néphrétique [nephritis]." Robert Descharnes, interview with author, Paris, Oct. 16-17, 1990.

38 "As it happened . . . aggressive hyperaestheticism." Salvador Dalí, *Diary of a Genius* (New York: Doubleday, 1965) p. 166.

39 "Mr. Foret came . . . shot the stones." Descharnes interview.

39 "which made more problems . . . He liked that." Albert Field, interview with author, New York, Dec. 6, 1987.

39 "perfect, absolutely direct lithographs by Dalí," Descharnes, interview.

39 John Peter Moore . . . artist was impressed." Secrest, p. 205.

40 "It was then that I thought, I have discovered America." Marius Carol, Juan Jose Navarro Arisa and Jordi Busquets, *El Ultimo Dalí* (Madrid: Ediciones El Pais, 1985), p. 138.

41 "The captain brings in . . . steel tip moves along." Parinaud, p. 267.

41 Dali told one of his biographers . . . Roger Lacouriere. Carlton Lake, *In Quest of Dalí* (New York: Putnam, 1969), p. 237.

41 "Somebody asked Dalí . . . mechanical reproductions." Descharnes interview.

42 "The prints were presented . . . reproduction of an image." A. Reynolds Morse, personal diary, April 14, 1965, Salvador Dalí Museum, St. Petersburg, Fla.

42 "where he didn't work . . . but he did." Field interview.

42 "The printing was so good . . . approved of it." Ibid.

43 "I'm the largest print wholesaler in the world." "The Great Graphics Boom of the '50s and '60s," *Wall Street Journal*, Jan. 5, 1971.

43 "Dalí several times . . . must inevitably be inaccurate." Morse diary, March 9, 1971.

43 "When Dalí was painting . . . That's nonsense." L. Erik Calonius, "The U.S. Art Market Is Said to Be Flooded With Dalí Forgeries," *Wall Street Journal*, March 8, 1985.

44 "I am mad . . . over Lanvin chocolates." Robert Wernick, "The Dauntless Surrealist Paints Less and Less and Sells More and More," *Life*, July 24, 1970.

44 "a business showroom . . . to Dalí ashtrays." Ibid.

45 "They are here to greet me . . . directly for me." Ibid.

46 "was so angry about . . . produced junk." Michael Ward Stout, interview with author, New York, Sept. 17, 1991.

46 "Yes, Mr. Stuart . . . only do the little ones." Lyle Stuart, interview with author, New York, Sept. 17, 1991.

46 "Through a whole series . . . guaranteed Dalí signatures." Ibid.

48 Sabater wanted to retrieve . . . the paper from Stuart's warehouse. Stout interview.

50 "I decided not to buy it . . . sessions at the bar." A. Reynolds Morse, letter to author, June 1986.

51 "When I pointed out . . . left in the literature." Idem, undated memorandum to author, May 1988.

51 "The subject was then sold . . . most widely reproduced painting." Ibid.

CHAPERT 3: THE DALI FLOOD
53 "I have become a snail." "Dali Untangles His Life," *New York Times*, Nov. 22, 1981.
54 "an open letter to Gala . . . I shouldn't see him?" "Salvador Dali's Surreal Life," *New York Times*, Oct. 12, 1980.
54 "anguish over the isolation . . . and for his spirit." Ibid.
54 "You are not curing Dalí . . . a perfect being." Ibid.
54 "tranquilizers which . . . proper medication." Secrest, p. 240, citing *St. Petersburg Times*, March 14, 1981.
54 "We proved pretty well . . . collapsed around him under Sabater." *New York Times*, Nov. 22, 1981.
55 "We all felt that Gala . . . Pretty smart, eh?" Morse diary, May 21, 1980.
55 "a friend and collaborator . . . very important thing." *New York Times*, Nov. 22, 1981.
56 "I sent a psychiatrist . . . psychiatrist died." *New York Times*, Oct. 12, 1980.
56 "They called me immediately . . . didn't know that Obiols had died." Ibid.
56 "an intense antidepressive . . . melancholic variety." Ibid.
57 "the biggest mistake I ever made in my life." Ibid.
57 "I am a little bit the sexual and erotic side of Dalí." *New York Times*, Nov. 22, 1981.
57 "I started to call . . . business with Dalí, call me." Ibid.
58 "You see how my hand . . . it is rotten." Ibid.
58 "I have come to Paris . . . everything from me." Descharnes interview.
59 "I wanted him to know he's been hit." *El Pais*, Feb. 21, 1981.
59 "I declare that for several years . . . resuming our freedom." *New York Times*, Nov. 22, 1981.
60 "The Publisher declares . . . original works of art." *Gallery Alberta and the Deputy Minister of National Revenue for Customs and Excise*, Appeal No. 2243, The Tariff Board, Canada, Jan. 30, 1986.
61 "be the equivalent . . . by anyone else." *New York Times*, Nov. 22, 1981.
61 The truck driver . . . across the border. *El Pais*, March 13, 1981.

61 "number three in the world . . . in Dalí." Judith Goldman, "The Print's Progress: Problems in a Changing Medium," *ARTnews*, Summer 1976, p. 41.

63 "valid and documented." David Paul Steiner, letter to Scott Hanson, May 9, 1984. Exhibit in *Marcand v. Center Art Galleries*, Civ. 84-8299 (C.D. Calif.).

63 "five reams of paper . . . where to sign." Exhibit in *Marcand v. Center Art*.

65 "He has become obsessed . . . talks of it constantly." *Reuters*, Dec. 9, 1983.

65 "The doctors say . . . derisory for Dalí." Ibid.

65 "He has lost the creative urge . . . into a work of art." Ibid.

66 "We get people calling . . . tell them not to come." Ibid.

66 "I rushed into the room . . . get out of bed." Mark Rogerson, *The Dalí Scandal* (London: Victor Gollancz, 1987) p. 37, citing *The Guardian* (London), Aug. 31, 1984.

66 "everything concerning the Dalí affair." Secrest, p. 12, quoting *The Sunday Times* (London), Sept. 9, 1984.

67 "We must do more things." Rogerson, p. 40.

67 "must find out why . . . at such times." Ibid., p. 38.

67 "If we meet again . . . friends like me might interfere." Rogerson, p. 39.

68 "Many people like him . . . appear with his disease." Descharnes interview.

68 "Morse is a typical American . . . for Morse continuously." Descharnes interview.

69 "The figure is incredible . . . for me to do it." *Reuters*, March 14, 1985, quoting *El Pais*, March 14, 1985.

70 "What a figure Dalí cut! . . . his own immortal soul." Morse, diary, April 1, 1980.

70 "If you have a trustworthy man . . . began to resent [its source]." Stout interview.

70 "It is all a great game . . . with his famous name." Morse, diary, Nov. 11, 1971.

71 Kitty Meyer scolding Dali. telephone interview with author, Honolulu-New York, Nov. 18, 1991.

CHAPTER 4: NEW YORK IN DALIVISION

75 Andrew Weiss was greatly . . . punched him in the nose. "Local Art Dealer Arrested," *Washington Post*, March 24, 1979.

75 Weiss earlier had approached . . . vibrancy of a Miró. Tom Wallace, interview with author, Oyster Bay, N.Y., Sept. 19, 1991.

76 "The information we got . . . biggest competitor." Wallace interview.

76 Wallace was teamed . . . pick them up. "Filling In the Numbers," and "Three Dealers Held in Art Forgeries," *Newsday*, March 22, 1979, and Wallace interview.

77 "We thought we were . . . had the source." Wallace interview.

77 "He showed us how they were done . . . very helpful." Ibid.

77 Andrew Weiss . . . probation. "Art Dealer Is Sentenced," *Newsday*, June 8, 1979.

78 Richard Greenberg . . . fined $1,000. "Sentence in Art Scheme," *Newsday*, May 13, 1981.

78 In September 1980 . . . was selling was fake. "Art Dealer Freed on Fraud Charges," *Newsday*, Sept. 11, 1980.

78 In August 1981, Tom Wallace . . . from Leon Amiel. Ibid.

78 In the eyes . . . player in the Dalí fraud. Robert DeMuro, "The Players," unpublished manuscript, Oct. 21, 1986, p. 21, pre-trial exhibit in *U.S. v. Center Art.*

78 "Good morning, Mr. Smith . . . your attention. Thank you." Script, exhibit in *People v. Martin Fleishman and Carol Convertine*, 1069 (N.Y. Sup. Co., N.Y. Co., 1986).

79 "$50,000 for a $2,000 Investment? . . . their Art portfolio." Brochure, exhibit in *People v. Fleishman.*

80 In the 1960s . . . land in Nevada. Rebecca Mullane, argument at sentencing, *People v. Fleishman*, Dec. 22, 1987.

80 what Fleishman regarded . . . clients made money. Martin Fleishman, statement at sentencing, *People v. Fleishman*, Dec. 22, 1987.

80 He became engaged . . . could sell. Carol Convertine, trial testimony, *People v. Fleishman*, Feb. 1987.

81 Marina Picasso had sold . . . "limited edition" dealers. Amei Wallach, "The Trouble With Prints," *ARTnews*, May 1981, p. 69.

81 James Burke was in a halfway house . . . Larry D. Evans Galleries, Ltd. Marion Bachrach, sentencing memorandum on behalf of James Burke, *U.S. v. James Burke, Larry D. Evans, Prudence Clarke and Jeffrey Kasner*, Cr. 722 (S.D.N.Y. 1988), March 29, 1990.

82 Prudence Clarke . . . Original Fine Art. David Gordon, sentencing memorandum on behalf of Prudence Clarke, *U.S. v. Burke*, March 28, 1990.

82 Dennis Huculiak decided . . . Carol Convertine Galleries. Convertine trial testimony, ibid.

82 Another Convertine salesman . . . days on Madison Avenue with Convertine. DeMuro, "The Players," p. 6.

82 Roy Goldsmith left . . . learned at Barclay. Ibid., p. 7, and DeMuro, interview with author, Newark, N.J., Sept. 13, 1991.

82 Richard Greenberg's . . . Metropolitan, Worldwide and others. DeMuro, "The Players," pp. 6—18, and DeMuro interview.

83 Complaints registered with the attorney general's office . . . work it out." Judith Schultz, interview with author, New York, Sept. 15, 1991.

84 The other subpoena . . . sales pitch. DeMuro interview.

84 Schultz phoned DeMuro . . . partnership was formed. Schultz interview.

84 retired high school mathematics teacher . . . "You are the catalogue." Field interview.

85 On February 17, 1955 . . . Field as editor." Field, trial testimony, *U.S. v. Center Art*, Jan. 5, 1990.

86 "The artist does not work . . . wants it to be done." Field interview.

87 Caron Caswel was schooled . . . signed by Marina Picasso, his granddaughter. Caron Caswell, trial testimony, *People v. Fleishman*, Feb. 1987.

87 In November 1984 . . . new portfolio to Farner. transcript, pretrial exhibit, *U.S. v. Burke*.

88 Indeed, *Caesar in Dalívision* . . . renamed the piece *Caesar in Dalívision*. Larry D. Evans, sentencing memorandum, *U.S. v. Burke*, Oct. 13, 1989.

88 After buying black-and-white . . . by Salvador Dalí." Henry Pitman, sentencing memorandum on behalf of the United States, *U.S. v. Burke*, Jan. 31, 1990.

89 "You pay a premium, certainly, for the artist's signature." Caswell.

89 Special Papers, a division . . . problem in the manufacture. Robert Stein, trial testimony, *U.S. v. Center Art*, Mar. 13, 1990.

90 "I was absolutely convinced . . . having to testify." DeMuro interview.

90 In April 1985, the Postal . . . of both galleries. Schultz and DeMuro, interviews.

90 In little more than two years . . . a thousand people. Pitman.

90 Convertine's take was more than $1.2 million. Mullane, sentencing memorandum on behalf of the People, *People v. Fleishman*, Apr. 25, 1990.

90 The issue of the legitimacy of the Dalí signatures . . . limits of his signature. DeMuro interview.

90 Thus, on June 1, 1985, . . . the creator is helpless." Dalí affidavit, June 1, 1985.

91 Stout felt . . . asked for clarification. DeMuro and Stout interviews.

91 "no blank paper . . . notes, etc." Dalí, unsworn statement, Aug. 13, 1986.

92 In a landmark decision . . . under New York law. *People v. Thomas*, 512 N.Y.S.2d 618 (Sup. 1986).

92 his wife Carol maintained . . . will appreciate, too." Convertine, Ibid.

93 "If he was talking . . . kept it in the box. David Riley, trial testimony, *People v. Fleishman*, Feb. 1987.

94 He had worked for Abe Lublin's . . . having twice failed. Richard Ruskin, trial testimony, *People v. Fleishman*, Feb. 1987.

94 "Not likely . . . business unimpeded." Arien Yalkut, summation, *People v. Fleishman*, Feb. 1987.

94 In fact, Postal Inspector DeMuro . . . according to DeMuro. DeMuro, "The Players," p. 1.

95 "You've got to tap . . . alone is enough." Mullane summation, Ibid.

95 declaring Fleishman to be a con man . . . four and a half years. Justice Robert Haft, sentencing statement, *People v. Fleishman*, Dec. 22, 1987.

96 "I still have no proof it was not original." Martin Fleishman, statement at sentencing, *People v. Fleishman*, Dec. 22, 1987.

96 "I emphatically deny . . . by Salvador Dalí." Larry Evans, statement at sentencing, *U.S. v. Burke*, Oct. 13, 1989.

CHAPTER 5: NEMESIS OF THE BRIGANDS

97 A. Reynolds Morse . . . back to Gilbert Hamon. Morse, diary, Aug. 18, 1986.

97 Morse and his wife Eleanor . . . of St. Petersburg, Florida. A. Reynolds Morse, trial testimony, *U.S. v. Center Art*, Dec. 13, 1989.

97 He was shocked in 1965 . . . to commercialize Dalí. Morse, diary, April 14, 1965.

98 Six years later . . . danger his secretary [Captain Moore] represented." Ibid., March 9, 1971.

98 "one good reproduction . . . multiples on paper." Ibid., Nov. 16, 1971.

98 "I told Dalí that I disagreed . . . from a publisher." Ibid.

99 "Even as I write these words. . . . What will burst it, and when?" Ibid., Nov. 24, 1972.

100 In late 1984, while McCracken's girlfriend . . . big moneymaker. Hilton Gerald McCracken, trial testimony, *State v. Ronald Caven and Kurt Caven*, Cr. 42201 (2d Jud. Dist. Ct., Bernalillo Co., N.M. 1986), Feb. 24, 1987.

101 The Cavens' message confirmed . . . cut out the middleman." Ibid.

101 Born in the Ivory Coast . . . Editions d'Art de Lutece. Odile Gorse, trial testimony, *State v. Caven*, March 5, 1987.

102 Delcourt had spent two years . . . American publisdher George Brazilier. Jean-Paul Delcourt, unpublished interview with Michael Gibson for *ARTnews*, Jan. 20-21, 1988.

102 According to American authorities . . . outfox them. DeMuro, "The Players," p. 10.

103 "He was my master in the Dalí business." Gorse.

103 Postal inspectors judged Gorse . . . art forgery section. DeMuro, "The Players," p. 12.

103 Guillard built an association . . . sheets of lithograph paper. DeMuro, "The Players," p. 12.

103 Guillard was Odile Gorse's . . . company, Image. Gorse.

103 Monique Desani . . . any wrongdoing. DeMuro interview.

103 In November 1984, Gorse . . . Shelby Fine Arts of Denver. Gorse.

104 The Cavens had been seeking . . . accumulated 245. Ronald Caven, trial testimony, *State v. Caven*, March 4, 1987.

104 Kurt Caven explained . . . selling them to customers. Douglas Grainger, trial testimony, *State v. Cavin*, Feb. 19, 1987.

104 In July 1984 . . . chain of Shelby galleries. Gorse.

105 Even as McCracken . . . or I could forget about it." McCracken.

105 The judge then suggested . . . something about print-making. Pat Otero, interview with author, Albuquerque, June 25, 1987.

106 On March 1, 1986, . . . Colorado Springs Shelby outlet. "Springs Gallery, Collectors Check Authenticity of Dali Prints," *Rocky Mountain News* (Denver), March 13, 1986.

106 "If there are any fakes . . . be put in jail." "APD Seizes 130 Prints as Possible Dalí Fakes," *Albuquerque Journal*, March 2, 1986.

106 "We deal with distributors . . . anything to worry about." "Dalí Art Investigation Spreads Into Colorado," *Albuqerque Journal*, March 14, 1986.

107 "Salvador Dalí, Real or Fake? . . . using these techniques." Ronald Caven, trial testimony, *State v. Caven*, March 4, 1987.

107 Naturally, Shelby's customers' . . . as the weeks passed. Betty Slade, trial testimony, *State v. Caven*, Feb. 17, 1987.

107 In early July 1986 . . . the newspaper photographer. "Judge Authenticates Dalí Lithographs but Springs Police Won't Halt Probe," *Denver Post*, July 10, 1986.

108 "We are happy to have a chance . . . selling fake [Dalí] prints." "Two Denverites Indicted in Fake Dalís Case." *Denver Post*, Sept. 30, 1986.

108 "world class." *Denver Post*, July 10, 1986.

108 "I never did really get into telling . . . was the seminars." Ronald Caven, trial testimony.

109 Richard Ruskin asserted . . . had become illegible. Richard Ruskin, trial testimony, *State v. Caven*, March 10, 1987.

109 Did Morse know . . . had been voided." Morse, diary, Feb. 18, 1987.

111 Each of the contracts . . . after the original work." A. Reynolds Morse and Jean-Paul Delcourt, contracts, Dec. 15, 1981.

111 Morse took the witness stand . . . no recollection of it." A. Reynolds Morse, trial testimony, *State v. Caven*, Feb. 19, 1987.

112 After leaving the witness stand . . . would then correct the record. Morse, diary, Nov. 9, 1987.

112 She told Brandenburg . . . the state's case. James L. Brandenburg, memo to the file, March 18, 1987.

112 Prosecutors rolled their eyes . . . Salvador Dalí print. Otero, telephone interview with author, Honolulu-Abuquerque, March 1987.

113 "go through this . . . innocent verdict." "Mistrial Declared in Art Fraud Trial," Associated Press, March 18, 1987.

13 "We are ecstatic . . . they are real." Ronald Caven, letter to customers, Sept. 24, 1987.

14 "the Menorah created . . . Israeli watercolors." Morse diary, March 21, 1980.

14 Today, Eleanor and I . . . allegedly sculpted by Dalí." Morse diary, Dec. 12, 1981.

15 "That was the whole idea . . . learned a lesson." Morse, telephone interview with author, Honolulu-Cleveland, Feb. 9, 1992.

CHAPTER 6: CALIFORNIA CAPERS

117 "I had just seen them . . . in shock." "Tunnel No Illusion: Dalí Art Stolen," *Orange County Register*, June 6, 1984.

117 "The problem is that if somebody . . . massive security to stop it." "Dalí Theft a Reminder No Security Is Fail-Safe," *Orange County Register*, June 7, 1984.

117 Frizzell could find no alarms . . . Marcand returned the call. Craig Frizzell, police report, Oct. 22, 1984, pretrial exhibit in *Federal Trade Commission v. Magui Publishers, Inc., and Pierre Marcand*, Civ. 3818 (C.D. Calif. 1989).

118 In Frizzell's mind . . . *Il Tiempo*, and a translation of it. Frizzell, interview with author, Newport Beach, Calif., Oct. 4, 1991.

119 The article, dated April 1, 1984 . . . insufficient evidence. "False Dalís: French Trafficker Convicted," translation, *Il Tiempo*, April 1, 1984.

119 Through Interpol . . . attributed to Dalí. Frizzell, police report.

119 "As for the burglary . . . the burglary succeeded." Ibid.

119 Frizzell phoned Michael Ward Stout . . . as to their authenticity. Frizzell interview.

120"They are color-enhancing . . . left the house, incredulous." Ibid.

120 On May 8, 1985. . . . They were the same. Frizzell, police report, Feb. 10, 1986, exhibit in *FTC v. Magui*.

121 A month later, Frizzell . . . wrongdoing to allow that. Frizzell interview.

121 Through the glass of the frame . . . variety of signatures." "Authenticity of Stolen Dalí Art Questioned," *Sun* (San Bernardino, Calif.), Sept. 14, 1985.

121 "She is hardly an expert . . . as do other artists." Ibid.

122 Albert Field arrived . . . simply reproductions. Ibid.

122 During a vacation trip. . . . The offer was declined. Dena Hall, letter to Frizzell, July 16, 1985.

122 Frizzell phoned museum curators . . . were fakes. Frizzell interview.

122 Scores of people . . . documentation of their prints. Ibid.

122 "I never received one slide . . . mobile home sales." Ibid.

122 About a year after the artworks . . . had done all he could. Ibid.

123 A San Francisco recipient . . . to file an official complaint. John Ambro, telephone interview with author, Honolulu-Beverly Hills, Calif., Oct. 29, 1991; also, Jean-Christophe Argillet, telephone interview with author, Honolulu-New York, Nov. 27, 1991.

123 Jean-Christophe Argillet . . . venting his anger. Ibid.; also, Complaint, *Galerie Furstenberg v. Philip Coffaro, Thomas Wallace, Carol Convertine, Julian Aime, Andrew Levine, T. R. Rogers and Melton Magidson*, Civ. 9355 (S.D.N.Y. 1988).

124 "It was giving his Paris gallery a bad name . . . Argillet's own publications." Ambro interviews.

124 Argillet became angrier . . . to $160,000 each. Argillet interview.

124 The next day, August 14 . . . in several boxes. Ibid.

124 "As far as we're concerned . . . drawings are authentic." Ibid.

124 In his native Texas . . . keep on drilling. Order of permanent injunction by consent, *Securities and Exchange Commission v. Capital Oil Corp. et al*, Civ. CA3-5927-A (N.D. Tex. 1972), June 26, 1972.

124 When the Securities and Exchange Commission . . . convicted him of contempt. *U.S. v. Tom R. Rogers*, Cr. 3-75-145 (N.D. Tex. 1975.).

125 Rogers moved on to Phoenix . . . restitution to investors. Default judgment, *State of Arizona v. Hovic Corporation, Thomas Reed Rogers and Jane Doe Rogers*, C-429422 (Ariz. Superior Ct.), Oct. 20, 1982.

125 He began buying . . . Melton Magidson. Complaint, *Galerie Furstenberg v. Coffaro*.

125 In January 1988 . . . wanted the money. Ibid.

126 "preposterous." "Beverly Hills Art Dealer Sued Over Alleged Dalí Fakes," Associated Press, March 16, 1987.

126 The court filing was quite detailed . . . money laundering. Complaint, *Galerie Furstenberg v. Coffaro.*

126 "It's such a complicated subject matter, they're having a hard time." "Police, Art Gallery Snagged by Questioned Dalí Prints," Associated Press, Oct. 28, 1987.

126 "They don't want to know . . . not responsible." Ambro interview.

127 Ambro continued . . . owner on Rodeo Drive. Ibid.

127 Through their New York attorney . . . dropped the suit. Thomas Ré, telephone interview with author, Honolulu-New York, Nov. 27, 1991.

127 The Upstairs Gallery was founded . . . furniture in Long Beach. "Art Boom: A Market for Fraud," *Los Angeles Times*, Oct. 30, 1989.

127 Symonds bought some art from mass-marketer Abe Lublin. William McKelvey, pretrial testimony, *People v. Lawrence Paul Groeger*, Cr. BAO26233 (Muni. Ct., Los Angeles Co., Calif.), Feb. 28, 1991.

127 Founded by onetime gold miner . . . statuary at fairs. Jessica Mitford, *The American Way of Death* (New York: Simon and Schuster, 1963), pp. 148-60.

128 Forest Lawn . . . mortgage and loan company. Ibid., p. 157.

128 "He had changed the focus . . . if he were dead." McKelvey.

129 "We converted that information . . . by the supplier." Ibid.

129 Attuned to the fake print problem . . . state's evidence. "Art Dealer Detours From the Fast Lane," *Los Angeles Times*, June 25, 1990.

129 Lerner told authorities . . . Metropolitan Museum of Art in New York City. Ambro; also, "More Than 1,61 Artworks Seized," *Los Angeles Times*, Sept. 29, 1989.

130 On September 27, 1989, . . . Rolls-Royce and Ferrari. *Los Angeles Times*, Sept. 29, 1989.

130 Lee Sonnier was charged . . . with no art to show for it. "second Dealer Charged in Art Fraud Case," *Los Angeles Times*, Oct. 25, 1989.

130 De Marigny pleaded . . . two and a half years. "No Contest Pleas Told on Art Forgery Charges," *Los Angeles Times*, June 16, 1990.

131 "There was a problem. . . . We did the right thing." "1,51 Prints in Art Fraud Probe Called Authentic," *Los Angeles Times*, April 1990.

131 "possibly authorized . . . not done by the hand of the artist." Bernard Ewell, telephone interview with author, Honolulu–Colorado Springs, Colo., November 1991.

131 "I know that there were many Mirós . . . family to [do so]." Howard Russeck, pretrial testimony, *People v. Groeger*, Feb. 27, 1991.

CHAPTER 7: THE GREAT EMULATOR

133 "I did not paint that!" "Artist Helped Break Up Nationwide Forgery Ring," Associated Press, Aug. 9, 1990.

134 "through the back door." Mark Henry Sawicki, trial testimony, *People v. Anthony Eugene Tetro*, Cr. BA1141 (Sup. Ct., Los Angeles Co. 1990), May 20, 1991.

134 "knock-offs." Ibid.

134 "A photograph in a magazine . . . illusion of [being] a lithograph." Anthony Eugene Tetro, trial testimony, *People v. Tetro*, May 29, 1991.

135 "For well over ten years . . . getting your car searched." "The Repro Man," *Los Angeles Times*, Jan. 20, 1991.

135 Tetro's customers . . . Carter Tutweiler. Tetro.

135 In the spring of 1988 . . . had charged the retailers. Sawicki.

136 In December 1988, for months . . . avoided calls from Tetro. Ibid.

136 In March 1989 . . . fully wired. Ibid.

136 Once inside . . . as soon as Tetro called him, and he left the condo. Transcript, tape-recorded conversation on April 18, 1989, exhibit in *People v. Tetro*, May 21, 1991.

139 "The forger in this case . . . in business for a long time." "Artist Helped Break Up Nationwide Forgery Ring," Associated Press, Aug. 9, 1990.

139 In December 1990. . . . Champagne would be served. "Tetro's Testa Rosa," Exclusive News Relations, press release, Dec. 5, 1990.

140 "Would you please tell us what [the term *knock-off*] meant?" Reva Goetz, examination of Sawicki, *People v. Tetro*, May 22, 1991.

140 "A forgery or a fake work of art." Sawicki.

140 "I enjoyed emulating . . . defeated the purpose." Tetro.

141 "I wasn't concerned . . . bulk of my business." Ibid.

142 "We probably do more re-creation . . . over three hundred some odd years." Ernest Cummins, trial testimony, *People v. Tetro*, May 24, 1991.

143 "I investigated through various art dictionaries . . . for purposes of deception." Jessica Darraby, trial testimony, *People v. Tetro*, May 1991.

143 "I haven't painted . . . walking on egg shells, you don't hop." Tetro.

144 "We didn't know what piece . . . pieces of paper." Gary Helton, telephone interview with author, Honolulu-Los Angeles, Nov. 26, 1991.

CHAPTER 8: "THE WELL NEVER RAN DRY"

145 "international distributors . . . in value almost immediately." Federal Sterling Galleries, brochure, mailed to author in 1987.

147 "Wife Objection Close . . . has gone up substantially." *Federal Trade Commission v. Federal Sterling Galleries Inc., Churchill Gallery Inc., Robert Sweeney and David Kadis*, plaintiff's memorandum, Civ. 87-2072 (Arizona), Sept. 28, 1988.

148 "I couldn't understand . . . well just never ran dry." Ronald Hunter, declaration, exhibit in *Federal Trade Commission v. Austin Galleries, Donald S. Austin and Joanne Granquist*, Civ. 88 C 3845 (N.D. Ill.), July 2, 1988.

148 Hunter was told not to sorry . . . turned in their resignations. Ibid.; also Fred Laidlaw, declaration, exhibit in *FTC v. Austin*, July 27, 1988.

149 "If our store was running low . . . prints at $4,10." Jacqueline Renier, declaration, exhibit in *FTC v. Austin*, July 26, 1988.

149 "Please understand that in dealing . . . remain an enigma." Don Austin, letter to Dr. William E. McDaniel, Feb. 16, 1988.

149 Austin's Dali prints were coming . . . north of Chicago. Kathryn L. Lunetta, declaration, exhibit in *FTC v. Austin*, July 28, 1988.

150 Zabrin was a client of Tony Tetro, the master emulator from California. Tetro, trial testimony, *People v. Tetro*.

150 Gordon first looked . . . prints numbered "H.C." *FTC v. Austin*, complaint, May 6, 1988.

151 "We rely upon our suppliers . . . are represented to be." Associated Press, May 6, 1988.

152 In 1968, Salvador Dalí . . . Nelson Rockefeller Collection, Inc. U.S. District Judge Pierre N. Leval, memorandum and order, *Werbung und Commerz Union Anstalt v. Robert LeShufy*; and *LeShufy v. American Express Travel Related Services Co., Inc., The Nelson Rockefeller Collection, Inc., Maecensas Press, Ltd., Max Munn and Collectors Guild, Ltd.*, 84 Civ. 7393 (S.D.N.Y.), June 19, 1985.

152 "original lithographs by Salvador Dalí . . . original works of art by Salvador Dalí." Ibid.

153 "The prints appear . . . deceptive practices." Leval, opinion and order, _Werbung und. Commerz Union Anstalt v. Robert LeShufy_, Dec. 22, 1987.

154 "art for the serious . . . hand-colored etchings." *State v. Hermes International, Inc., Gregory Stula, Gordon Stula, Robert Carver and Philip Andrew Koss*, 87CV1777 (Cir. Ct. Dane Co., Wis.), summons, April 1, 1987.

154 Actually, they were reproductions . . . Galerie de Philipe. Ibid.; also, Barbara Matthews, interview with author, Honolulu-Madison, Feb. 21, 1992; *State v. Magnum Opus International Publisher, Ltd., Gallery One Fine Art Portfolio, Inc., and James J. Raemisch*, 87CV3568 (Cir. Ct. Dane Co., Wis.), stipulation, July 2, 1987; and *In the matter of the trade practices of Galerie de Philipe, the Phönix Corporation, H. Philipp Huffnagel and Philips A. Koss*, Wisconsin Dept. of Agriculture, Trade and Consumer Protection, No. 1999, complaint, March 8, 1988.

155 The action did not halt . . . three years in prison. Matthews.

156 "HELLO, DALI! . . . "Dalí Institute" in Europe. Phillips Publishing Inc., brochure, August 1989.

157 "An original print . . . created for that purpose." *Gallery Alberta and the Deputy Minister of National Revenue for Customs and Excise*, The Tariff Board, Appeal No. 2243, decision, Jan. 30, 1986.

157 Quebec police in February 1981 . . . Zurich headquarters. *Montreal Gazette*, Feb. 26, 1981.

158 "I heard that maybe . . . paper after that." Judge Francois Doyo, telephone interview with author, Honolulu-Montreal, Feb. 21, 1992.

158 "The Art of Investing . . . "original etchings." Intercontinental Fine Art, Ltd., brochure, exhibit in *Her Majesty the Queen v. IFA Intercontinental Fine Art, Ltd.*, 51-27-016884-902 (Montreal, Quebec 1990).

158 In September 1990 . . . fined $11,10. Ibid., order of prohibition, June 26, 1991.

158 "The Consumer Affairs . . . damn about the consumers." Paul G. Nagy, telephone interview with author, Honolulu-Gloucester, Ont., Feb. 21, 1992.

159 Gérard Roumier and Christian Roumegoux . . . more than 11,10 other "Dalís." Robert Wernick, "The Great Dalí Art Fraud," *Reader's Digest* (Intl. Ed.), Feb. 1991, pp. 67-70.

CHAPTER 9: PICTURE IN PARADISE
163 "Every painting in our supermarket . . . into an art buyer." "One Dealer Who Thinks Artists Shouldn't Starve," *Honolulu Advertiser*, Oct. 28, 1982.

164 "The first things an artist . . . nothing to brag about": Ibi
164 He said, "If we find an undeveloped artist . . . Hollywood style." "Cory Says Isles Have Talent," advertisement, *Sunday Honolulu Star-Bulletin & Advertiser*, Jan. 3, 1971.

164 Those big eyes . . . a series of lithographs." Ibid.

164 Margaret Keane did not . . . in limited editions. Margaret Keane, trial testimony, *Margaret Keane v. Walter Keane* (D.Hawaii), May 8, 1986.

165 "because I was having . . . lots of fun." *Honolulu Advertiser*, Oct. 28, 1982.

165 In January 1973 . . . $31,10. *William Mett v. Culphton LeGrande Whetstone*, Civ. 53188 (Cir. Ct. Hawaii 1977).

165 William D. Mett . . . skyrocketed in value. "Chain Carves Prominent Place In Art World," *Washington Post*, Oct. 7, 1984.

165 Mett received $42,10 . . . interest and attorney fees. *Theresa A. Redel v. William Mett*, Civ. 39148 (Cir. Ct. Hawaii 1973).

166 He told of having been raised in Boston as a foster child. Frank Iverson, trial testimony, *U.S. v. Center Art*, Feb. 8, 1990.

166 Wiseman began his first job . . . job interview with Mett. Marvin L. Wiseman, deposition, *Center Art v. Lee Catterall and Gannett Pacific Corp.*, Civ. 86-0775 (Cir. Ct. Hawaii 1986), March 20, 1986.

166 In 1973Cory and Mett . . . famous clocks. "Dalí Draws Hawaii From Far, Far Away," *Honolulu Star-Bulletin* (Associated Press), April 23, 1974; also, Ted Kurrus, *Aloha Magazine*, July/Aug. 1986, p. 45.

167 "I have been on an airplane . . . already existed inside." *Honolulu Star-Bulletin* (AP), April 23, 1974.

168 "There are only sixty-five original . . . to purchase those very pieces." Marvin L. Wiseman, memorandum to staff, March 19, 1978.

169 Through Ed Cory's wife . . . contact Bill Mett. Brigitte Eitingon, trial testimony, *U.S. v. Center Art*, Feb. 21, 1990.

169 "French Connection I." Idem. letter to Mett and Wiseman, June 22, 1984.

169 "If only those froggies used BAN [deodorant]." Ibid.

169 Such was Roland Vasquez . . . $4,950 for a gold. Nora Junk, deposition, *Roland Vasquez v. Center Art*, Civ. 02117 (C.D.Calif. 1979), Aug. 7, 1979.

170 "seeks to give only advice . . . in contemporary art today." Mett, letter to Roland Vasquez, Sept. 1, 1978.

171 Salvador Dalí came across . . . the unauthorized production. Stout interview; also, Stout, trial testimony, *U.S. v. Center Art*, Jan. 11, 1990.

172 "Mr. Dalí felt that the etching plates . . . works of art." Stout testimony.

172 "Mett is very personable . . . were his friends." Stout interview.

172 "I called him the next day . . . my primary client." Ibid.

173 "I walked into this sort of basement . . . like a sales ploy." Ibid.

173 "A recent conversation . . . artisans at the foundry." Mett, memorandum to staff, March 23, 1979.

174 An analysis years later . . . stamped out. Fred Roster, trial testimony, *U.S. v. Center Art*, March 14, 1990.

174 "a truly magnificent . . . ecstacy of the Resurrection." Mett, memorandum to staff, May 14, 1979.

174 In July 1979 . . . 6,81 of the plaques." Stout, letter to Mett, July 11, 1979; also, Mett, letter to Italcambio, July 6, 1979.

174 Dalí had just completed . . . for $150,10. Enrique Sabater, letter to Mett, Dec. 23, 1979; also, Sabater and Mett, contract, Feb. 22, 1980.

174 Meanwhile, the avocado farmer . . . and he got it. *Vasquez v. Center Art.*

175 Miller learned that . . . in early July. *Center Art v. Robert Miura and Financial Dimensions, Inc., v. Mett, Bernie Schanz and Wiseman*, Civ. 59276 (Cir. Ct. Hawaii 1979), Nov. 20, 1979.

175 Honolulu physician . . . investing $89,10. *Allan R. Kunimoto v. Center Art, Mett, Schanz and Wiseman*, Civ. 60148 (Cir. Ct. Hawaii 1980), Jan. 11, 1980.

175 "consent judgment." Stanley D. Suyat, letter to Peter G. Wheelon, Feb. 7, 1980.

176 The proposed binding agreement . . . the filing of an official complaint. Ibid.

176 Miller prepared a proposed court order . . . "out of business." Jeffrey Portnoy, interview with author, Honolulu, June 25, 1991.

177 Miller took the proposed court order . . . seize its property. David Dezzani, offer of proof, *Gannett Pacific Corp. v. Corinne K.A. Watanabe*, Civ. 86-0437 (Cir. Ct. Hawaii 1986), Nov. 25, 1986; also, Robert Miller, interview with author, Nov. 25, 1986. Miller affirmed Dezzani's offer of proof as to the content of what Miller's court testimony would be, were he allowed to testify.

177 Feeling cocky . . . turned out to be right. Portnoy interview.

CHAPTER 10: THE POPE'S FLOCK

179 "the contracts . . . the artist will then sign it." Mett, letter to Raymond F. Bechtel, March 17, 1982.

180 "have been removed . . . surviving husband, Salvador Dalí." Barbara Jensen, letter to "Friends," undated.

180 "Due to this extremely serious . . . adjust Dalí prices." Mett, memorandum to staff, Aug. 15, 1983.

180 "the time to acquire . . . without notice." The Madonna of Port Lligat, Corpus Hypercubicus, brochures, Center Art Galleries-Hawaii, undated.

180 In May 1981 . . . Hamon's violations. *Center Art v. Gilbert Hamon*, verdict, Ct. of High Instance, Paris, March 22, 1983.

182 In July 1981 . . . individually numbered." Mett, letter to National Gallery of Art, July 17, 1981.

182 "Typically, the gallery . . . by the National Gallery. Carol K. Cavanaugh, trial testimony, *U.S. v. Center Art*, Feb. 6, 1990.

182 Mett phoned the museum . . . production of this lithograph." Patricia Bascom, trial testimony, *U.S. v. Center Art*, Jan. 17, 1990.

183 On Aug. 21, 1981, . . . final publication. Alastair A. Auld and Mett, partial assignment of copyright, Aug. 21, 1981.

183 About two months later . . . true lithographs. Ruedi Wolfensberger, trial deposition, *U.S. v. Center Art*, Nov. 30-Dec. 1, 1989.

183 "We prefer our lithograph . . . at greater length." Mett, letter to Wolfensberger, Oct. 23, 1981.

184 "exclusive lithographic . . . to the publisher's discretion." Dali and Mett, contract, Cadaques, Spain, Oct. 17, 1981.

184 "We are pleased . . . like the brochure. Thank you." Mett, letter to Wolfensberger, Feb. 19, 1982.

184 "This etching . . . magnificent work." Lawrence Ettinger, letter to "Client," March 18, 1982.

185 "an insult to the artist . . . once and for all." Mett, letter to Auld, Feb. 23, 1982.

185 In Marcand's view . . . was settled out of court. *Marcand v. Center Art*, Civ. 82-74 (Hawaii).

185 "I must admit . . . on this lithograph." Auld, letter to Mett, Feb. 1, 1983.

186 "They said they would try and find somebody else." Wolfensberger.

186 "From the specially bred . . . Vatican Museum." "The Vatican Museum Collection," brochure, Center Art, Feb. 1983.

186 "I laughed first . . . simply untrue." Msgr. Eugene V. Clark, trial testimony, *U.S. v. Center Art*, March 1, 1990.

186 "It is a very serious matter . . . Vatican Museum." Clark, letter to Center Art, Sept. 30, 1986.

187 In fact, Center Art . . . Vatican officials. Maurice Alexander, letter to Most Rev. Paul C. Marcinkus, Aug. 16, 1982. Also, telegrams to Alexander by Marcinkus on Sept. 11, 1982 and Oct. 21, 1982, and letter to Alexander by Walter Persegati.

187 "These people have almost a fetish . . . thank-you letter back." Clark testimony.

187 Tetuan was printed . . . or the USA." Brigitte Eitingon, letter to Mett, Nov. 24, 1982.

188 Mett cited a contract . . . and Gala. Mett, letter to Eitingon, Sept. 10, 1983.

188 David began work . . . part of the sculpture. Eitingon, trial testimony, *U.S. v. Center Art*, Feb. 21, 1984.

188 The St. Maur foundry . . . end of that month. Eitingon, letter to Mett and Wiseman, June 22, 1984.

189 "I am so happy . . . dying to possess it!!!" Eitingon, letter to Mett, Nov. 18, 1984.

189 As with all prints . . . would number them. Suzanne Sixberry, trial testimony. *U.S. v. Center Art*, March 7, 1990.

190 On one occasion, Mett . . . used in the reproduction. Mett, letter to Leon Amiel, Feb. 23, 1984.

190 At the beginning of 1986 . . . returned to New Jersey. Wiseman, letter to Leon Amiel, Jan. 7, 1986.

190 "In essence . . . never happen again." Leon Amiel, letter to Wiseman, Jan. 9, 1986.

190 As far as Sixberry knew . . . through the years. Sixberry.

190 "was very particular . . . by someone else." Frank Iverson, trial testimony, *U.S. v. Center Art*, Feb. 8, 1990.

190 "Salvador Dalí was very old . . . working for him." Nora Junk Johnson, trial testimony, *U.S. v. Center Art*, Dec. 12, 1989.

191 "The unusual thing . . . and unnumbered. Milton Bergthold, trial testimony, *U.S. v. Center Art*, Feb. 6, 1990.

191 "There was a lot of talk . . . signing the Dalís." Gary Camara, grand jury testimony, cited in pretrial memorandum, *U.S. v. Center Art*, Nov. 17, 1989.

192 "a network . . . we use cash." *Washington Post*, Oct. 7, 1984.

192 "The sophistication . . . too much to expect." Nick Rosen, "Centre of The Dalí Trade," *Harper's & Queen*, London, Jan. 1985.

CHAPTER 11: CEILING OF THE PARIS OPERA

193 Jennifer McMullan and her husband . . . from a larger edition. Jennifer M. McMullan, letter to author, July 21, 1988.

194 The print was accompanied . . . value was $1,51. Better Business Bureau of Hawaii, exhibits with complaint by Jennifer M. McMullan, June 2, 1988.

194 With tax, the amount . . . the door with it." McMullan.

195 "Marc Chagall, July 7, 1887 . . . offering from Center Art Galleries-Hawaii." Advertisement, *New Yorker*, June 17, 1985.

196 Feher, seventy-seven years old . . . senior curator at the academy. *Honolulu Advertiser*, May 28, 1987.

197 "His wife, Valentine . . . were so close." Joseph Feher, interview with author, July 11, 1985.

197 "He never made a lithograph . . . have already protested." Associated Press, message from Paris bureau to Honolulu bureau, July 11, 1985.

200 "a poster may be produced . . . "no alternative" but to sue the *Star-Bulletin*. Renton L. K. Nip, letter to author and John E. Simonds, July 11, 1985.

202 "would draw the key stones . . . a retreat from originality." Clinton Adams, interview with author, July 12, 1985.

202 "I usually get paid . . . involved in some way in it." Peter Morse, interview with author, July 12, 1985.

203 "He always did it himself . . . "a very big poster." Valentine Chagall, telephone interview with author, Honolulu-France, July 12, 1985.

203 "Mr. Amiel's relationship with Chagall . . . a personal relationship." Arnold Ross, telephone interview with author, Honolulu-New York, July 15, 1985.

203 "In other words . . . dollars or more." Leon Amiel, telephone interview with author, Honolulu-New York, July 15, 1985.

203 "not cognizant" . . . lithographic plate out of it." Ross.

204 Amiel insisted that Chagall . . . never did that in his life." Amiel interview.

204 "if they're beautifully printed." Morse.

204 "A photographic offset print. . . . They are not lithographers." Amiel interview.

205 "Spoke to attorney and he does not wish to be bothered." Ruby Mata, note to author, July 16, 1985.

205 "a matter of confidentiality." Ross, interview with author, Honolulu-New York, July 16, 1985.

205 "It's definitely a fake . . . where it has been added." Associated Press, message from Paris bureau to Honolulu bureau, July 17, 1985.

206 "It would have been nice . . . to check it out." Tom Jordan, "Covering Controversy With Care," *Honolulu Magazine*, Oct. 1985, p. 32.

207 In 1988, after suffering . . . complained to the gallery. McMullan.

207 "absolutely no doubt . . . important commission, *The Ceiling of the Paris Opera*." Kim von Tempsky, letter to Jennifer M. McMullan, June 20, 1988.

CHAPTER 12: THE BATTLE OF TETUAN
210 "a reasonable consumer . . . what you're talking about:" Mark Nomura, interview with author, Feb. 10, 1986.
210 "only business in Hawaii . . . as a "Knifbihler." Renton Nip, testimony before Hawaii Senate Committee on Consumer Protection and Commerce, undated.
211 A small group . . . "Let"s support it." "Art Panelists Support Expanded Disclosure for Fine Prints Sales," *Honolulu Star-Bulletin*, March 10, 1986.
211 Several days later . . . Nip asserted. "Two Art Measures, Two Sets of Standards," *Honolulu Star-Bulletin*, March 13, 1986.
212 Under the letterhead of David Ezra . . . and Guy Buffet. "Re: Proposed Fine Print Legislation," letter, undated.
213 "an original because . . . okay by my signature." "Senate Panel Rejects Bill to Tighten Regulations on Sale of Fine Prints," *Honolulu Star-Bulletin*, March 25, 1986.
213 "I don't think . . . expense of the artists," Ibid.
213 "a problem in the industry . . . what they're buying." Ibid.
213 "To me, it's theft . . . not an original." Ibid.
214 "To be sure . . . to the art buyer." Stephen Murin, letter to Hawaii Senate Committee on Consumer Protection and Commerce, March 24, 1986.
214 "This will enable . . . or their contributions." Sen. Neil Abercrombie, letter to Rep. Mits Shito, April 14, 1986.
215 "I thought I had . . . value in time." Randy C. Miller, interview with author, Honolulu, Feb. 14, 1986.
215 "I don't want to get . . . opening it up." Ryk Burgess, interview with author, Feb. 14, 1986.
216 "signed each lithograph . . . other members of the press." Nip, letter to author and John E. Simonds, Feb. 16, 1986.
216 Center Art filed suit the next day . . . mental distress and suffering." *Center Art Galleries-Hawaii Inc. v. Lee Catterall and Gannett Pacific Corp.,* Feb. 21, 1986.
217 "marching orders." James J. Bickerton, affidavit, Oct. 28, 1986, exhibit in *Gannett Pacific v. Watanabe*, Nov. 25, 1986.
217 "Unlike Mr. Bickerton . . . Do you have the documents with you?" Transcript of hearing on motion to compel compliance with subpoena duces tecum, *Center Art v. Catterall*, July 8, 1986.
219 "However, as a small . . . legal costs." "Libel Suit Dropped by Center Galleries," *Honolulu Star-Bulletin*, Sept. 18, 1986.

220 "These facts reveal . . . denial is proper." Bickerton, memorandum in support of application, *Gannett Pacific v. Watanabe*, Oct. 29, 1986.

CHAPTER 13: HOOK, LINE AND SINKER
221 "obsessive and consuming." "Chapman's Art Obsession Called Link to Mental State," *Honolulu Advertiser*, Dec. 11, 1980.
221 "From what I could see . . . researching things." Ibid.
222 "Abruptly stopped calling me . . . couldn't find a buyer." Ibid.
222 "We had a drink . . . keep reassuring him." "His Treasure Financed N.Y. Trip," *Honolulu Star-Bulletin*, Dec. 11, 1980.
223 "dull normals . . . inner impediments." Hans von Hentig, *The Criminal and His Victim: Studies in the Sociobiology of Crime* (New York: Schocken, 1979), pp. 414-426.
224 "I told him I was looking . . . wanted to buy them," Howard M. C. Char, trial testimony, *U.S. v. Center Art*, Feb. 9, 1990.
225 "They told me this . . . I was beside myself." Janet Owskey, interview with author, Honolulu, March 2, 1987.
225 "just someone to talk to . . . back on their feet." *Victimology: An International Journal*, vol. 3, 1978, nos. 1-2, Visage Press, p. 65, quoting S. Fogelman, "Compensation to Victims of Crimes of Violence: The Forgotten Program," unpublished, M.S.W. thesis, University of Southern California.
226 "We walked into the gallery . . . as a moderate-income family." Thomas Waltz, trial testimony, *U.S. v. Center Art*, Dec. 19, 1989.
227 "he had a real live one." Lt. Col. Pat Reese, interview with author, Honolulu, Feb. 1987.
228 "Ugly pictures . . . something to hang on the wall." Jacob and Carla Hergert, interview with author, Honolulu, Feb. 26, 1987.
229 "I like Anthony Quinn . . . buy this artwork." Vassilios Macheras, trial testimony, *U.S. v. Center Art*, Feb. 22, 1990.
230 "They were talking in terms . . . for almost nothing." Robert L. Wacloff, trial testimony, *U.S. v. Center Art*, Jan. 4, 1990.
231 "They sent me two Dalís . . . I'd been pretty dumb." Dr. Richard Silberg, telephone interview with author, Honolulu-Baltimore, June 11, 1987.

232 "It was strictly a matter of outbluffing them," Gayle Dendinger, telephone interview with author, Honolulu-Denver, Spring 1987.

232 "Oh, this is a very important piece . . . paintings from that gallery." Denise Wheeler, trial testimony, *U.S. v. Center Art*, Dec. 15, 1989.

CHAPTER 14: AN UNTIMELY DEATH

235 From September 1981 . . . at least two of the paintings to be fakes. *Dr. Shigenoba Kojima v. Center Art*, Civ. 85-164 (Hawaii).

236 "in various stages of review and completion." Jeffery Portnoy, letter to Mark Nomura, June 13, 1985, quoting earlier letter from Nomura to Portnoy.

236 "This is not the first time . . . gallery's sales programs and policies." Ibid.

237 "taking the time . . . allegations in your complaint." Mark Nomura, letter to Portnoy, June 28, 1985.

237 "Your attorneys represent . . . heads of the Office of Consumer Protection." Portnoy, letter to Nomura, July 3, 1985.

238 "already on the heels." Hans Wilking, interview with author, date.

238 "It was a real merry-go-round . . . anything about it." Ibid.

239 "I wasn't sure . . . kind of odd." Thomas Maxwell, interview with author, Honolulu, October 1989.

240 "He said they'd never had any complaints . . . That's what I was told." Ibid.

241 "this would be a great investment . . . which I was. "More than forty People File Complaints With Consumer Protector on Artworks," *Honolulu Star-Bulletin*, Oct. 24, 1986.

241 "inappropriate." Nomura, telephone interview with author, Honolulu, May 1986.

242 "I said I especially liked . . . ten thousand dollars for one item." Michael Crivelli, trial testimony, *U.S. v. Center Art*, March 2, 1990.

243 Steinberg filed a class action lawsuit. *Richard Battin, et al. v. Center Art*, Civ. 87-0828 (Cir. Ct. Hawaii 1987), March 12, 1987.

245 "Fuck it . . . Dalí-related material." Eva Young, affidavit, pretrial exhibit, *U.S. v. Center Art*, Dec. 22, 1987.

245 "Had they asked me . . . voluntary request." "The Six O'Clock News," KHON-TV (Honolulu), April 15, 1987.

245 "unconscionable and, to our attorney, illegal." Ibid.

246 "Of necessity, we will have to do enough paying work to make a living." "Hart Hopes to Continue Helping Defend the Poor," *Honolulu Star-Bulletin*, Nov. 20, 1971.

246 "far and away the biggest fraud . . . anywhere on Earth." Defense pretrial exhibit quoring Peter Morse grand jury testimony, *U.S. v. Center Art.*

247 "that spans a decade . . . tip of the iceberg." "Center Art Gallery Raid Ruled Illegal," *Honolulu Star-Bulletin*, Jan. 26, 1988.

247 "a general, exploratory rummaging . . . anything they saw." Ibid.

248 "primarily on corruption . . . corporate business records." Maxwell, affidavit, exhibit to government response to various defense motions, May 23, 1989.

249 "I am all the time worried . . . may happen at any time." "Salvador Dalí's Condition Worsens," Reuters, Nov. 28, 1988.

249 "Dalí, the Siren . . . endure with us forever." *Center Art*, press release, Jan. 23, 1989.

250 "The government waited . . . what was so about his work." Brook Hart, press conference, Honolulu, Jan. 26, 1989.

250 "Thank you for joining us . . . with Center Art for so many years." Mett, press conference, Honolulu, Jan. 26, 1989.

CHAPTER 15: SOW'S EAR OR SILK PURSE?

253 "May it please . . . works of art." Les Osborne, opening statement, *U.S. v. Center Art*, Dec. 5, 1989.

254 "The students, the young . . . verdict in this case." Judge Harold Fong, remarks, *U.S. v. Center Art*, Nov. 28, 1989.

255 "drawn by the hand of the artist to whom it is ascribed." Superseding indictment, *U.S. v. Center Art*, Aug. 31, 1989. Dalí-attributed prints cited were *Angels of Gala, The Annunciation, Arithmosophic Cross, Battle of Tetuan, Christ of Gala, Christ of St. John of the Cross, Corpus Hypercubicus, Discovery of America by Christopher Columbus, Gala Commemorative Cross, Guardian Angel of Cadaques, Heralding of Angels, Hommage à Gala, Impressions of Africa, Journey to Bethlehem, Kingdom of Gala, Lincoln in Dalívision, Madonna of Port Lligat, Madonna of the Doves, Metamorphosis of Narcissus, Sacrament of the Last Supper, Sacre Coeur, Victorious Athlete* and *Visage du Christ.*

Dalí-attributed bas-reliefs cited were *Christ of St. John of the Cross* and *Sacrament of the Last Supper.* Dalí-attributed free-standing sculpture cited was *Trojan Horse.* Anthony Quinn-attributed print cited was *A Glance in the Mirror.* Red Skelton-attributed print cited was *Freddie's World.*

255 "Ladies and gentlemen, that's only one . . . other view-points." John R. Wing, opening statement, *U.S. v. Center Art,* Dec. 5, 1989.

255 "It was Bill Mett's family . . . to defraud people." Ibid.

256 "did the best they could . . . view of the world." Hart, opening statement, *U.S. v. Center Art,* Dec. 5, 1989.

257 "particularly important to the defense . . . in connection with artworks." Robert A. Weiner, argument on motion, *U.S. v. Center Art,* Dec. 5, 1989.

257 "I made a mistake on this one, I admit it." Fong, oral ruling, *U.S. v. Center Art,* Dec. 5, 1989.

257 "good, decent quality, available for postcard reproduc-tions." Elizabeth Harris, trial testimony, *U.S. v. Center Art,* Feb. 7, 1990.

258 "very, very skillfully drawn plates by a very, very compe-tent hand." Clinton Adams, trial testimony, *U.S. v. Center Art,* Jan. 12, 1990.

258 "such speed and with such little attention . . . before it had this put on it, frankly." Jennifer Vorbach, trial testimony and col-loquy with Judge Harold Fong, *U.S. v. Center Art,* Jan. 18, 1990.

259 "This word original . . . this is what you get!" Weiner, argument on motion, *U.S. v. Center Art,* Jan. 3, 1990.

260 "They are given the generic name . . . afters'." Vorbach and Weiner, colloquy, *U.S. v. Center Art,* Jan. 18, 1990.

261 "lithographs based on the artist's original gouaches." Dalí, *Aliyah* (New York: Shorewood, 1968), p. 29.

261 "It's not a clear distinction . . . prices which are asked for art." Bernard Ewell, trial testimony, *U.S. v. Center Art,* Feb. 28, 1990.

262 "At one point . . . I would agree with you." Dena Hall, trial testimony and colloquy with Hart, *U.S. v. Center Art,* Feb. 14-15, 1990.

263 "I could have one hundred . . . the difference, it does," Osborne responded. Weinger and Osborne, colloquy, *U.S. v. Center Art,* Feb. 14, 1990.

263 "complete or whole editions of graphic works." Dalí, written statement, Aug. 13, 1986.

263 "raise more questions . . . reliability of the Dalí statements." Pre-trial defense memorandum, *U.S. v. Center Art*, November, 1989.

263 "The difference between a madman . . . when I tell the truth." *American Way Magazine*, Nov. 5, 1989. p. 69.

263 "the prisoner of Pubol," *Philadelphia Inquirer*, Sept. 9, 1984, quoting *El País*.

263 "If Dalí is not kidnapped yet, he is not far from it." Pre-trial defense memorandum, *U.S. v. Center Art*, November , 1989.

264 "opening up a Pandora's box" . . . what he was doing in 1985." Fong, oral ruling, Dec. 12, 1989.

265 "conned" . . . "a little greedy." A. Reynolds Morse, trial testimony, *U.S. v. Center Art*, Dec. 13, 1989.

CHAPTER 16: THE GATEKEEPER

268 "the grand old lady." Andrew Decker, "Rights Go Wrong," *Art & Auction*, Feb. 1988, p. 58.

268 "As Salvador Dalí's attorney . . . member of SPADEM." Michael Stout, letter to Jean-Paul Oberthur, Feb. 17, 1981.

268 "We want to make it clear . . . some matters for Dalí. Jean-Paul Oberthur, letter to Martin Bressler, March 3, 1981.

268 "be very prudent . . . ties and scarves." Oberthur, telegram to Martin Bressler, March 10, 1981.

268 "investigate potential markets . . . ties and scarves." Ibid.

269 "Please do nothing . . . handle this matter directly." Salvador and Helene Dalí, letter to Stout, May 23, 1981.

269 "We are at a loss . . . its face value." Jeremy Berman, letter to Bressler, June 9, 1981.

269 "will not collaborate with us concerning Dalí and thus mistrusts him." Oberthur, letter to Martin Bressler, Jan. 12, 1982.

270 "a peculiar copyright position . . . directly from SPADEM." Stout, telegram to Oberthur, Feb. 3, 1982.

271 "speak, decide, judge and sell . . . totally aware of the deal. "Is It for Real?" *Passion*, Paris, Summer 1986, p. 25.

271 "because the agreement did not take place . . . signed by the artist?" Jordi Corachan, "Asi Trafican con la Firma del Pintor," *Interviu*, (Spain), Sept. 12-18, 1984.

272 "the first ray of Dalí sunshine in six years." A. Reynolds Morse, diary, July 11, 1986.

273 "All is guaranteed, absolutely . . . "original, by his [Dalí's] permission." Edouardo, statement to author, Barcelona, Oct. 10, 1990.

274 "was in a very bad health . . . burn them than continue selling them.'" Descharnes, trial testimony, *U.S. v. Center Art,* Feb. 1, 1990.

274 "Before you testified . . . I would love to know about it." Descharnes and Robert Weiner, trial colloquy, *U.S. v. Center Art,* Feb. 2, 1990.

278 "has the sole world rights . . . in the various media." Magna Gallery, undated document, trial exhibit in *U.S. v. Center Art,* Feb. 2, 1990.

279 "made the decision to communicate . . . the master in the future." Descharnes, letter to William Mett, March 4, 1988.

279 "It looks like . . . photocopy of a letter." Descharnes and Weiner, ibid.

279 "I think it's not . . . I do change my opinion." Brook Hart and Descharnes, trial colloquy, *U.S. v. Center Art,* Feb. 2, 1990.

280 "The Scandal of the Century." Gilles Néret, "C'est le Scandale du Siecle," *Le Figaro magazine,* April 1990, p. 94.

CHAPTER 17: BREAK A LEG

281 "that sells for $995 in a run of one thousand . . . I didn't set the prices." Nick Rosen, "Center of the Dalí Trade," *Harpers & Queen* (London), Jan. 1985.

282 "make fine additions to our future presidential collection." "White House Vetoes Center Galleries Ad," *Advertising Age,* June 10, 1985.

282 "was an extraordinary success . . . was excellent."

283 "This is embarrassing . . . use the photograph." *Advertising Age,* June 10, 1985.

283 "were to be used . . . Center Art Galleries executives." Eileen Mortenson, "Fact Sheet," unpublished, undated.

283 "And good news . . . double within a year." *Honolulu Advertiser,* May 15, 1978.

283 "He just stated to us . . . worth a lot of money." Denise Wheeler, trial testimony, *U.S. v. Center Art,* Dec. 15, 1989.

284 "Do you sell those . . . and he walked out." Red Skelton, trial testimony, *U.S. v. Center Art,* Feb. 6, 1990.

287 "I just explained . . . close to a million dollars." Skelton and Osborne, trial colloquy, *U.S. v. Center Art,* Feb. 6, 1990.

287 "I am seventy-seven . . . a year on Maui." Skelton.

287 "wants control of every business . . . Any gallery will do that." Skelton, statement to reporters, Honolulu, Feb. 6, 1990.

288 "To them it was just a nice way . . . coming out of the closet." "Tony Curtis: Penthouse Interview," *Penthouse*, Dec. 1987, p. 98.

289 "I or Phil helped Tony . . . trace-sketch of a transparency." Nalani Markell, undated statement attached to her letter to Equal Employment Opportunities Commission, EEOC Charge 378-88-137, Nov. 3, 1988.

289 "That's partially . . . as it was laid out." Tony Curtis, telephone interview with author, Honolulu-Los Angeles, Feb. 9, 1989.

289 "I'm not going to paint . . . Hawaiian as I want to get." *Hawaii Business*, April 1987, pp. 22-23.

290 "Time and time again . . . Get your things and go!" Markell, statement with letter to EEOC.

291 "I have . . . Absolutely not." Curtis, trial testimony, *U.S. v. Center Art*, Jan. 3, 1990.

292 "It sounds strange . . . very grateful to him." Anthony Quinn, trial testimony by deposition, *U.S. v. Center Art*, March 24, 1990.

293 "is extremely significant . . . Quinn is great!" Mett, memorandum to staff, Oct. 19, 1983.

294 "send some money . . . finest art I have ever seen." Quinn.

CHAPTER 18: WHERE'S THE BEEF?

299 "The United States rests . . . avoid calling additional witnesses." Les Osborne, trial statement, *U.S. v. Center Art*, March 14, 1990.

300 "We think the government called all of them." Brook Hart, trial statement, *U.S. v. Center Art*, March 14, 1990.

300 "Excellent." Marvin Wiseman, trial statement, *U.S. v. Center Art*, March 14, 1990.

301 "Where's the beef? . . . mishmash." John Wing, summation, *U.S. v. Center Art*, April 11, 1990.

302 "Well, what is it? . . . to determine bad from good [because of the absence of a Dalí catalogue raisonné]." Robert Weiner, summation, *U.S. v. Center Art*, April 11, 1990.

306 "I've chosen an hour . . . not to be the class clown." Hart, summation, *U.S. v. Center Art*, April 11, 1990.

307 "the local term for 'What's the fight? . . . his own employees." Osborne, summation, *U.S. v. Center Art*, April 11, 1990.

307 "the artist would create . . . anything on presigned paper." Cary Smith, trial testimony, *U.S. v. Center Art*.

308 "It's very funny about a fraud trial . . . has come for them to pay." Osborne, summation.

310 "We did our job . . . did their job." Dan Bent, remark to author, Honolulu, May 4, 1990.

311 "There were many different opinions . . . working on the stone or the plates." Hugh Sapp, interview with author, Honolulu, May 4, 1990.

CHAPTER 19: FAIR TRADE
313 "this absolute guarantee . . . insurance companies." Center Art Gallery, "Corporate Profile," undated.

313 "Center Art Galleries-Hawaii . . . your money back." Center Art Gallery, "Certificate of Warranty of Authenticity," undated.

313 The gallery did have . . . name of the insurance company. Les Osborne, summation, *U.S. v. Center Art*, April 11, 1990.

314 "I was not in a position . . . cannot be genuine." Georgia Hanna, undated affidavit, exhibit at sentencing, *U.S. v. Center Art*, Nov. 5, 1990.

315 "This publication . . . with this problem." Valentine Chagall, letter to Jean-Paul Gutton, July 5, 1985.

315 "exactly the image . . . Center Art Gallery promotional piece." Jean-Paul Gutton, affidavit, Oct. 4, 1990, exhibit at sentencing, *U.S. v. Center Art*, Nov. 5, 1990.

316 "The sale of photomechanical . . . sanctioning fraud." Osborne, sentencing memorandum, *U.S. v. Center Art*, Nov. 1, 1990.

316 The answer . . . "We don't know." Tony Catterall, conversation with author, April 1990.

317 "Chagall begs the question . . . which still exist." Clinton Adams, *American Lithographers, 191-1960: The Artists and Their Printers* (Albuqerque: University of New Mexico Press, 1983), p. 149.

317 "The consensus . . . any statement from him." Adams, interview with author, Albuquerque, Dec. 2, 1987.

318 Were these, in fact . . . "collaborators?" Theodore J. H. Gusten, attachment to letter to Fernand Mourlot, Dec. 16, 1961.

318 "All Chagall's lithographs . . . his widely appreciated work." Fernand Mourlot, letter to Gusten, Feb. 13, 1962.

319 "has stated facts . . . used by the Print Council." Joshua B. Cahn, letter to Gusten, March 5, 1962.

320 "considerably different personalities," "Center Art Fraud Trial Underway," *Honolulu Star-Bulletin*, Nov. 28, 1989.

320 "only a segment . . . fraudulent Dalí print mill." *U.S. v. Center Art*, government's statement concerning bail, Feb. 10, 1989.

320 "class" could total close to 20,10 customers. Peter Wolff, statement in pretrial hearing, *Battin et al. v. Center Art*, Civ. 870828 (Cir. Ct. Hawaii), May 10, 1989.

321 "I thought the phone calls . . . how many there were." Inspector Michael Baum, "Dalí or Not Dalí? That Is the Question: The Case of Center Art Galleries-Hawaii," *Postal Inspection Service Bulletin*, Feb. 1991, p. 23.

321 "I have to make my decision . . . the way they [Magna] market it." Judge Harold Fong, sentencing, *U.S. v. Center Art*, Nov. 5, 1990.

322 "They look at the proofs . . . produce graphics do it." John Wing, sentencing, *U.S. v. Center Art*, Nov. 5, 1990.

322 "They all said the same thing . . . about lies." Osborne, sentencing, *U.S. v. Center Art*, Nov. 5, 1990.

322 "has truly lived . . . couldn't afford them." Wing, ibid.

322 "other medical conditions . . . ongoing supervision." Brook Hart, sentencing, *U.S. v. Center Art*, Nov. 5, 1990.

323 "If Center Art were to close . . . cannot get restitution." Osborne, ibid.

323 "an iota of proof . . . destroyed here." Wing, ibid.

323 "somewhere around eight or nine thousand . . . there is not proof." Hart, ibid.

323 "I don't think anybody's . . . resale at all." Fong, ibid.

324 "prepublication" . . . $750 to $1,950. Center Art, leaflet, undated.

325 "But that is all water . . . do their bidding." Fong, ibid.

326 "They were wrong . . . ordinary type of 'commercial articles'" U.S. District Judge Martin Pence, oral ruling, *Edward and Helen Balog v. Center Art*, Civ. 89-33 ACK (Hawaii), Aug. 7, 1990.

327 "precluded from relitigating . . . particular piece of work." Fong, oral ruling, *Balog v. Center Art*, Aug. 10, 1990.

328 "appear to be on a ship without a captain." *Battin v. Center Art*, motion to dismiss, May 2, 1991.

CHAPTER 20: BOUTIQUE FRAUD

331 "like killing a cockroach." David Spiegel, telephone interview with author, Honolulu-Washington, Dec. 6, 1991.

332 "I had to retrieve . . . help me in that goal." Pierre Marcand, trial testimony, *FTC v. Magui*, Feb. 12, 1991.

333 "I said, 'You can't . . . I've still got the damned print." A. Reynolds Morse, telephone interview with the author, Honolulu-Cleveland, Dec. 6, 1991.

334 "My concern when I decided . . . to have his name there." Marcand, ibid.

335 "I don't have any knowledge . . . publishers, dealers and collectors." Marcand, deposition by New York Assistant Attorney General Judith Schultz, Aug. 7, 1986.

336 "That's quite the standard in those settlements." Schultz, trial testimony, *FTC. v. Magui*, Feb. 5, 1991.

339 "calculated use of the media . . . esthetically pleasing." *Los Angeles Times*, June 30, 1989.

340 "that Dalí was connected . . . genuine Dalí signature." Spiegel, summation, *FTC v. Magui*, Feb. 14, 1991.

340 "For myself . . . was comforted." Marcand, trial testimony.

341 "legislate through litigation . . . techniques and presses." Lawrence Fox, summation, *FTC v. Magui*, Feb. 14, 1991.

342 "What we have in this case . . . is order to sell it." Spiegel, summation.

342 "misrepresentation of authorship . . . material fact in this case." U.S. District Judge Ronald S. W. Lew, verdict, *FTC v. Magui*, March 8, 1991.

CHAPTER 21: A FAMILY AFFAIR

343 On October 6, 1988 . . . world would greatly miss. Jack Ellis, telephone interview with author, Honolulu-New York, Feb. 8, 1982.

343 Upon taking over . . . of the entire effort. DeMuro, "The Players," p. 2.

343 According to a French government investigator . . . photomechanical reproduction. Judge d'Information Alain Sauret, unpublished interview with Michael Gibson for *ARTnews*, Paris, Dec. 1987.

344 Ellis and DeMuro . . . and his ancestral home. Ellis interview.

344 DeMuro advised Ellis . . . Dalí had signed the lithographs." DeMuro, "The Players," pp. 1-2.

345 Upon returning to New York . . . Nassau County, at age sixty-five. Ellis interview; also, Leon Amiel death certificate, pretrial exhibit in *U.S. v. Center Art*.

345 However, in the summer of 1990 . . . similar plea agreements in Chicago. Ellis interview; also, James H. Tendick, affidavits, undated; also, Ellis affidavit, July 8, 1991.

CHAPTER 22: EPILOGUE

360 "Fraudulent in a legal sense . . . freedom to do it." Clinton Adams, interview with author, Albuquerque, Dec. 2, 1987.

360 "more practical . . . attempt to define an 'original print.'" Print Council of America, minutes of 1990 annual meeting, Princeton, N.J., attached to letter by Jay M. Fischer, president, to Print Council members, Aug. 15, 1990.

361 "Eyes, sensibility, common sense . . . something it isn't." June Wayne, "On Originality," The Print Collector's Newsletter, May-June 1972, pp. 28-29.

361 "Dalí whispered into Gala's ear . . . wanted was money." Jean-Paul Delcourt, unpublished interview by Michael Gibson for *ARTnews*, Paris, Jan. 20, 1988.

APPENDIX: Dali's Original Lithographs

363 Field, interview by author, Field's home in Astoria, N.Y., on Sept. 11, 1991, and in a letter by Mr. Field to the author on March 9, 1992.